PAINTING OF THE

RENAISSANCE

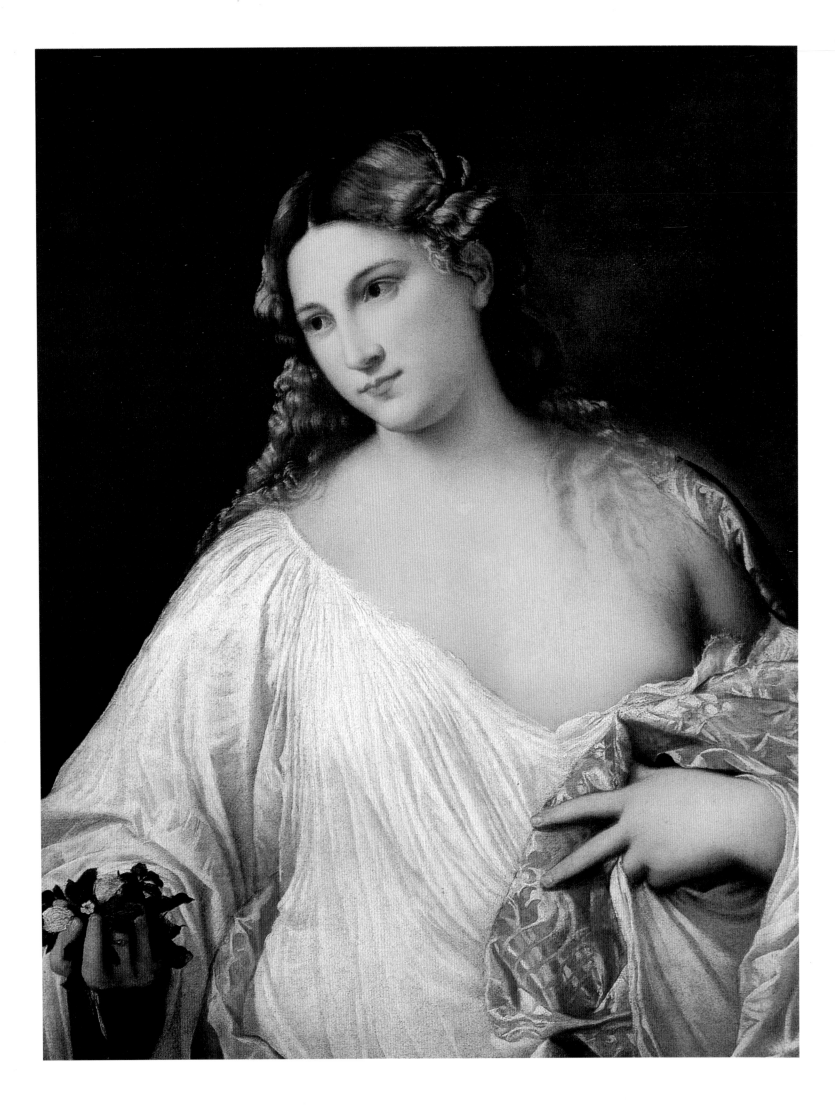

EPOCHS & STYLES

PAINTING OF THE
RENAISSANCE

Edited by
Ingo F. Walther

by Manfred Wundram

TASCHEN

KÖLN LISBOA LONDON NEW YORK PARIS TOKYO

Page 2:
Titian
Flora, c. 1514
Oil on canvas, 80 x 63.5 cm
Florence, Galleria degli Uffizi

**This book was printed on 100% chlorine-free
bleached paper in accordance with the TCF standard.**

© 1997 Benedikt Taschen Verlag GmbH
Hohenzollernring 53, D-50672 Köln
Editing and production: Ingo F. Walther, Alling
Cover design: Angelika Taschen, Cologne; Mark Thomson, London
English translation: Karen Williams, High Raw Green;
Gisela Parker, Twickenham

Printed in Portugal
ISBN 3–8228–8254–2
GB

Contents

NETHERLANDS

SPAIN

FRANCE

GERMANY

EARLY RENAISSANCE

European painting in the 15th century

During the Early Renaissance, painting rose to a position of primacy amongst its fellow disciplines for the first time in the history of Western art. A new relationship was born between the work of art and the spectator: the painting no longer sought merely to fulfil a function, but issued its own challenge to the person before it.

Amongst the great innovations of this new era were the exploration of perspective and proportion, a new understanding of portraiture as the likeness of an individual, and the beginnings of landscape painting.

Artists increasingly trod a path away from superficial "naturalness" in their works and towards a more profound understanding of the natural world, a trend seen in Italy in Masaccio, Uccello, Piero della Francesca, Botticelli and Mantegna and in Germany in Multscher and Witz. In the Netherlands, meanwhile, panel painting flowered at the hands of the van Eyck brothers, Rogier van der Weyden, Hugo van der Goes, Memling, and in the mysterious spectral world of Hieronymus Bosch.

In Venice in the late 15th century, Antonello da Messina and Giovanni Bellini in particular spearheaded a revolution in painting whose impact would reverberate beyond the High Renaissance and into the 16th century.

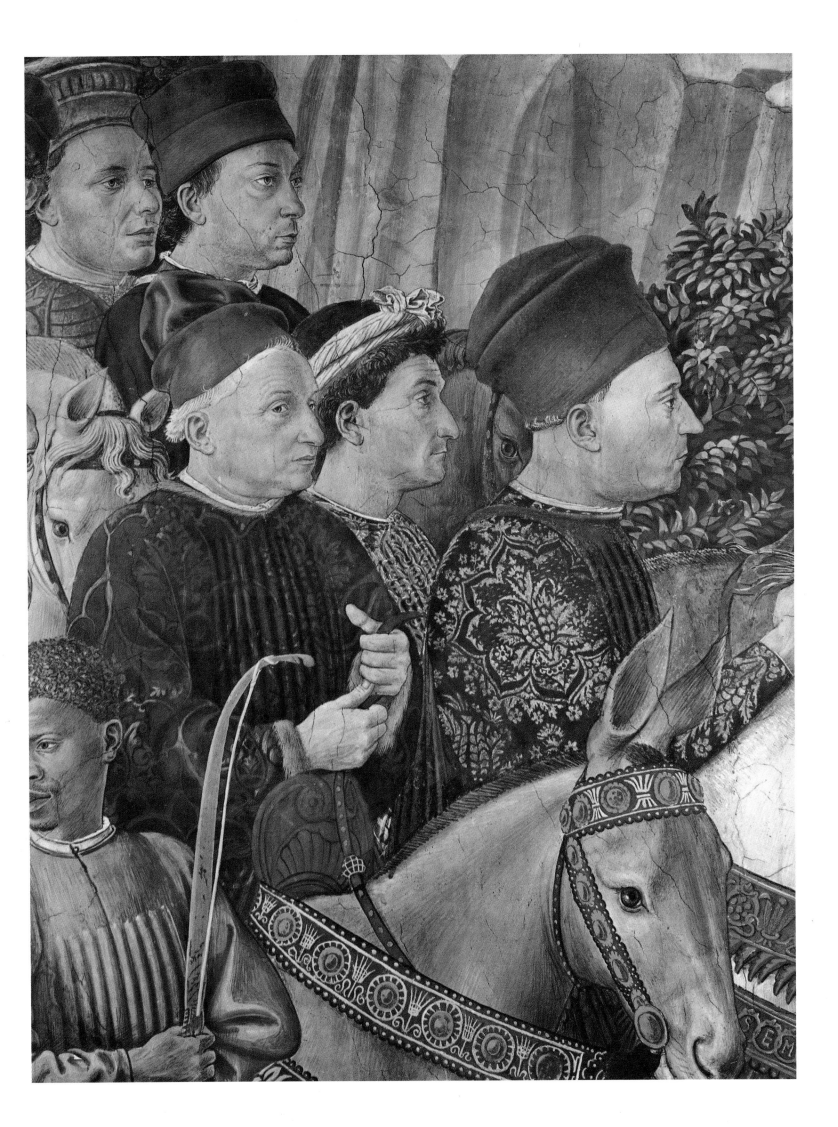

Early Renaissance and Late Gothic

The major stylistic epochs into which we like to divide Western art – Pre-Romanesque, Romanesque, Gothic, Renaissance and Baroque – are no more than pointers offering us a primitive means of orientation. They are approximations within a development which, while often driven by artistic innovation, might equally well imply the revival of earlier design principles; a development characterized less by clear breaks than by ongoing evolution. And even within this evolution; phase displacements must be taken into account which challenge the validity of any single definition of the epoch. Thus while the Early Gothic was emerging and unfolding in northern France in the 12th century, the Romanesque style was reaching its peak in the southern reaches of France and in Germany and Italy.

Since fine art is simply a means of expression of our general cultural and intellectual history, so historical, religio-historical, sociological and cultural-geographical conditions play a decisive role in shaping the art forms and artistic developments of each era. Without placing in question the value of interpreting a painting purely from an aesthetic point of view, it should be borne in mind that these neighbouring disciplines can provide vital clues to understanding a work of art – just as a work of art can shed light on other, broader cultural issues. In seeking to adopt an interdisciplinary approach, however, we should not forget that works of fine art can communicate their information only via the eye, and hence rely on the accuracy of our powers of observation. Any interpretation for which there is no visual evidence must remain in the realms of speculation.

There can be few other epochs in our European past which so stubbornly refuse to fit under a generalized heading than the 15th century. While in Italy around 1400 the dawn of the Early Renaissance was heralding a new age in art – the competition for the two bronze doors for the Baptistery in Florence in 1401 is seen as a pivotal event in this development – the countries north of the Alps were experiencing an unparalleled flowering of what is termed the Late Gothic. The Renaissance is generally perceived to have arrived here only one hundred years later, in particular in the wake of the two trips which Albrecht Dürer (1471–1528) made to Italy in 1496 and 1506/07.

It has for a long time been clear, however, that this polarization into Early Renaissance and Late Gothic frequently

fails to describe the forms adopted by art in the 15th century. The introduction of the terms "Early German" and "Early Netherlandish" for painting north of the Alps in order to distinguish it from Gothic art simply postponed the problem. Similarly, the term "Sondergotik" (special Gothic) coined by Kurt Gerstenberg in 1917 to describe 15th-century German architecture is merely a means of demarcating the latter from the Late Gothic, without clearly identifying its character. Is it possible, then, to find other categories for the art – and specifically the painting – of the century from 1400 to 1500 which more aptly describe its different and common traits?

Florence and the advent of the Early Renaissance

Let us turn first to Italy, seemingly the most "progressive" region of Europe in the early 15th century. Florence, a centre of moderate political but large economic importance, was emerging as the cradle of a new development in art which, in the eyes of the historians of the 19th century and in particular Jacob Burckhardt (1818–1897), was comparable only to Athens in the 5th century BC. At the chronological forefront of this new trend stood a number of outstanding sculptors, amongst them Lorenzo Ghiberti (1378–1455), Nanni di Banco (c. 1375–1421) and Donatello (c. 1382/86–1466). They replaced the drapery-clad statuary of the Middle Ages with the figure sculpture of the Renaissance, developed out of the organic structure of the human body, and created a style of relief which permitted them to carve highly naturalistic multi-figural scenes with a spatial depth previously unknown. A similar development took place in architecture around 1420, in the early works of the architect Filippo Brunelleschi (1377–1446) – the Foundling Hospital, the Old Sacristy at San Lorenzo and the church of San Lorenzo itself. Here, Gothic architecture was replaced by a new style whose dimensions were reduced to a humanly comprehensible scale and which adopted individual elements from the architecture of Ancient Rome. Finally, starting in 1424 and within a rapid space of just five years, there followed the works of the painter Masaccio (1401–1428), whose portrayal of perspective and anatomy pointed the way forward for the entire century.

Classical antiquity thereby served as a source of inspiration to all three branches of art. The statues of Donatello and Nanni di Banco revived the contrapposto figure sculpture, whereby the figure stands poised with most of its weight on one leg and with the other leg relaxed. Such references to the past were made doubly clear in other details, such as the reappearance of the Roman toga. This revival of late Antique and early Christian forms was most apparent of all in architecture. Meanwhile, as Emil Maurer has shown in the case of the fresco of the *Tribute Money* (ill. pp. 24/25), Masaccio was probably familiar with the early Christian mosaics in San Paolo fuori le mura in Rome.

Benozzo Gozzoli
Procession of the Magi, 1459–1461
Fresco (detail), width c. 750 cm
Florence, Palazzo Medici-Riccardi
Four members of the Medici family can be identified amongst the riders: Cosimo the Elder (with the reins in both hands) and, to the right, his sons Giovanni and Piero di Cosimo, together with Cosimo's illegitimate son Carlo (at the top, with the tall red hat)

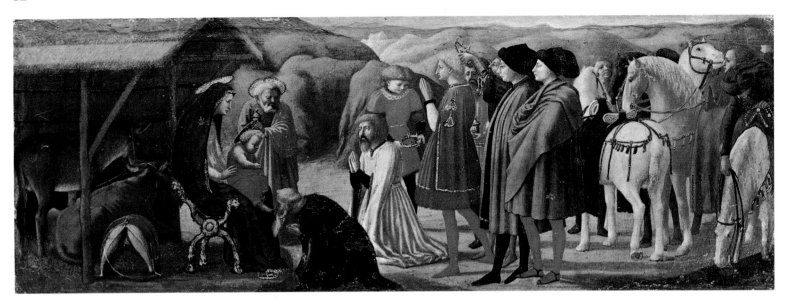

Masaccio
Adoration of the Magi, 1426
(panel from the predella of the Pisa Polyptych)
Tempera on wood, 21 x 61 cm
Berlin, Gemäldegalerie, Staatliche Museen zu Berlin – Preußischer Kulturbesitz

Is it therefore true that, as art-historical tradition has long maintained, the Florentine Early Renaissance represented a revival of sculpture, architecture and painting in the spirit of classical antiquity? The body of art surviving from the period before 1400 quite clearly proves the opposite. In Tuscan architecture of the late 11th and early 12th century, which Burckhardt has described as "Proto-Renaissance", we find the same classicizing decorative forms and the same harmoniously balanced organization of interiors and walls employed by Brunelleschi in his early works. The Baptistery and the façade of San Miniato in Florence are the most important surviving examples of this Renaissance movement, which can also be seen less explicitly in the Tuscan Gothic. The heritage of antiquity thus runs throughout like an unbroken thread, more or less close to the surface. If we remember that Brunelleschi, according to his biographer Antonio Manetti (1423–1491), held the Baptistery to be an original Antique building, we are justified in seeing his work as part of a home-grown tradition, and not as something conditional upon a study of the ancient monuments in Rome.

A similar situation applied to sculpture. Here, too, the important influence of late Antique and early Christian models was never questioned. Nicola Pisano (c. 1220–before 1287), his son Giovanni (c. 1245–after 1314) and his pupil Arnolfo di Cambio (c. 1254–c. 1302) indeed revived sculpture in the spirit of classical antiquity; both in their own creations and in other outstanding works by Florentine cathedral stonemasons dating from the latter decades of the 14th century, classical models were copied on a scale which, after 1400, was found only in exceptional instances. Without wishing to dispute the fact that this exploration of antiquity was continued by the Early Renaissance, it may be said that classical

antiquity was not the decisive force which propelled Western art across the threshhold from the Middle Ages into the Renaissance.

This conclusion is reinforced by the origins of the term "Renaissance". In his *Lives of the Artists*, first published in 1550 and subsequently reprinted in an expanded edition in 1568, Vasari was the first to speak of the *rinascità*, the rebirth of art. By that, however, he did not mean a rediscovery of antiquity, but rather the *rinascità* of "good art", something in his eyes synonymous with a renunciation of the art of the Middle Ages, with its formal vocabulary abstracted from nature, and in particular of the severe linear style derived from Byzantine art, which he termed the *maniera greca*. For Vasari, a – if not *the* – decisive chapter in Italian art began with the painting of around 1300, represented above all by Giotto (1266?–1337). More recent research, not least in neighbouring disciplines within the humanities, has itself pondered the question of whether the transition from the 13th to the 14th century was not indeed more profound than that from the 14th to the 15th. The new experience of reality which was reflected particularly in painting as from 1300 made an enduring impression both upon contemporary observers and on subsequent generations, as the following extract from the *Decameron* (1348–1353) by Giovanni Boccaccio (1313–1375) reveals: "The other, whose name was Giotto, was a genius so sublime that there was nothing produced by Nature, mother and mover of all things in the course of the seasons, that he could not depict to the life, whether his implement was a stylus, a pen or a paintbrush: his depiction looked not like a copy but the real thing, so that more often than not the viewer's eye was deceived, convinced that it was looking at the real object and not his depiction of it."

Thus the "rediscovery of the world and of man" postulated by Burckhardt as the prime mover of the Early Renaissance had its roots in the 14th century. Amongst Giotto's successors, and in particular the great Sienese painters Simone Martini (c. 1280/85–1344), Ambrogio (c. 1290–c. 1348) and Pietro Lorenzetti (c. 1280/90–1348 ?), this exploration of the phenomena of here-and-now reality was pursued to an astonishing degree. The focus in Giotto's era upon the large, summarized form was thereby both enriched and at the same time replaced by the precise study of details.

We can therefore state the following: firstly, it was not classical antiquity but the entry into art of the real world of human experience – the reproduction of figure, space and landscape – which laid the foundations for the Early Renaissance. Secondly, the years around 1400 represent a major stage, but not an abrupt break in this development. The Early Renaissance was not an artistic revolution, but the end of an evolution. Just how great the continuity between the 14th and 15th centuries was, and just how little contemporaries were conscious of living in an era of great change, is evidenced many times over in Florentine art. Thus the formal design and even the angle of the vault of the dome of Florence cathedral, for example, widely viewed as the first great example of Early Renaissance architecture, was already largely determined before Brunelleschi took over the project. And in 1401, when a competition was held for a new set of bronze doors for the Baptistery, the artists were required to orient the general organization and framework of their designs towards the older bronze doors executed by Andrea Pisano (c. 1295–after 1349) in 1330–1336.

What is it then which entitles us to see in the 15th century a new chapter in Western culture? Vasari once again provides a clue to the answer. While in Giotto he praised the naturalness of the painter's style, in the leading artists of the Early Renaissance he admired the perfect imitation of nature. For him, Giotto and Masaccio represented the first and second stages in the *rinascità*; in terms of fidelity to nature, Masaccio was a Giotto on a higher level, so to speak. To see things in this light, however, is an inadmissible simplification of the truth.

It is true that Leonardo da Vinci (1452–1519) also praised Masaccio for his faithful study of nature; offering an important insight into the epoch, however, he also added that nature should not simply be copied, but shown in all its perfection. "Painting preserves that harmony of corresponding parts which nature, with all its powers, is unable to maintain. It keeps alive the image of a divine beauty whose natural model is soon destroyed by time and death."

It is thus the search for the ideal norms underlying the outer face of nature which distinguishes the 15th from the 14th century. The inner kinship between classical antiquity and the Early Renaissance lies in this interpenetration of the real and the ideal, and not in the sphere of outer similarity.

Piero della Francesca
Senigallia Madonna, c. 1460–1475
Tempera on wood, 61 x 53.3 cm
Urbino, Galleria Nazionale

The fact that artists nevertheless looked back to their classical heritage was conditioned by their search for "natural" forms – in accordance with the maxim of Denis Diderot (1713–1784): "Il faut étudier l'antiquité pour voir la nature" (one must study antiquity to see nature). Cause and effect are here stood on their head: it was not the wish to copy antiquity that led artists to adopt naturalistic forms, but the desire to reproduce natural forms that opened their eyes to antiquity.

There is a second, no less important factor distinguishing the 15th from the 14th century. While the portrayal of space and the human figure during the 14th century was based largely on pragmatical values, from about 1420 it began to assume a mathematical dimension. Perspective and the theory of proportion, especially, were discussed and investigated from a scientific point of view. This was the consequence of a philosophical awareness arising from man's new conception of his status within Creation. The new value attached to the individual, unknown in the Middle Ages, was reflected in the fine arts in the emergence of a new genre: portraiture in the modern sense of the word, i.e. the picture of a unique, unmistakable personality. The portrayal of donors changed for the same reason; having been accorded only diminutive stature in medieval art in line with their perceived insignific-

ance, they now assumed the same size as saints and other figures from religious history.

Up till now we have only discussed the concept of the Renaissance in terms of Florence. To what extent is it justifiable to speak of a pan-Italian Early Renaissance after 1400? In seeking a reply, we are immediately confronted with the difficulty of agreeing upon a single definition for the 15th century. Traditions and developments in northern Tuscany were different to those even in southern Tuscany, such as the Siena region, where many characteristics of painting remained indebted throughout the century to the innovations of the previous century. The "modern" vocabulary of form only filtered through gradually and in isolated details.

The art centres of Upper Italy

A comparison of Florence with the art-producing regions of Upper Italy, and in particular Lombardy and Venice, spotlights a number of positively contradictory phenomena. Lombardy and Venice were, alongside Tuscany, the most important centres of Italian art; following the return of the papacy from Avignon (1376) and the Great Schism (1378–1417) which followed, Rome had been relegated for the time being to artistic obscurity. During the opening decades of the 15th century, Milan remained entirely under the spell of the International Gothic, while the Venetian art of the same period developed strictly along lines established in the 14th century. Where Renaissance forms were adopted at all, they were simply added onto Gothic structures. The artistic disparities between Florence, Lombardy and Venice can be

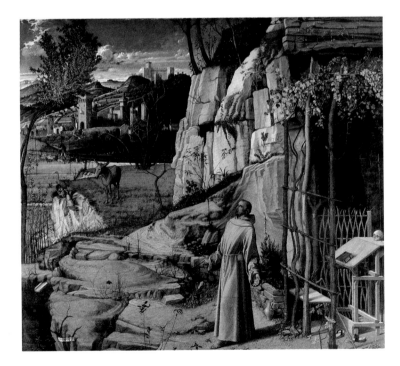

Giovanni Bellini
St Francis in the Wilderness, c. 1480
Tempera and oil on wood, 124.4 x 141.9 cm
New York, The Frick Collection

partly explained by the undoubtedly very different traditions prevalent in each region. Lombardy, owing to its geographical position and trade links, had always had closer ties with northern Europe than central Italy, while Venice remained strongly influenced by the Byzantine sphere due to its economic orientation towards the East. More important factors in the equation, however, were the very different social conditions reigning in each of the three centres.

Alongside the Church, the major patrons of art in Lombardy remained the dukes of the house of Visconti and, after 1447, those from the Sforza line. Giangaleazzo Visconti (1351–1402) planned to establish a united kingdom of Italy under his own rule – an ambitious scheme which came to nought following his early death in 1402. Venice, although nominally a republic, was *de facto* the most glittering feudal state south of the Alps. Florence, on the other hand, had been governed by its citizens since the 12th century. All major official commissions were issued by the city council. There is no more typical example of this than the new cathedral, whose founding charter of 1296 announced that the work was to be built to the glory of the city and the Virgin Mary. In 1331 responsibility for the continuation of its construction was transferred to the Arte di Lane – the wool weavers' guild. The supervisory committees were made up of experts, citizens and just one representative of the cathedral chapter. The list of similar examples goes on.

In contrast, therefore, to the art centres of Upper Italy, we find in Florence a culture shaped by civic requirements. The middle classes towards the close of the Middle Ages had only partly established their own artistic traditions, however. Having risen to prosperity and political influence, they began in the years around 1400 to create their own forms of expression – forms which could draw upon tradition but were not bound to it. Church and nobility, on the other hand, had always claimed their legitimacy through tradition and were eager that this should be perpetuated into the future. For them, holding on to the forms of the past was a natural desire.

Furthermore, bankers, wool weavers and cloth merchants would have felt a much closer intellectual affinity with the phenomena of the real world than art patrons from the spheres of the Church and the nobility. The roots of the Early Renaissance may thus be seen to lie in a movement instigated first and foremost by the middle classes – their first great cultural achievement. In the new forms of artistic expression adopted as a result, we simultaneously find a drawing up of "demarcation lines" separating the new from the old.

Early 15th-century painting north of the Alps

What positions did the fine arts, and in particular painting, occupy in the early 15th century north of the Alps? Can we still speak of a polarization of Early Renaissance and Late

Gothic? How great were their fundamental differences? To what degree might it also be possible to draw parallels between them?

Since the 1430s – corresponding surprisingly closely, in other words, with Masaccio's chief phase of activity – a series of outstanding masters had emerged in Flanders and in the southwest of the German-speaking region. These artists addressed themselves to the portrayal of space, figure and landscape with the same passion as their Italian contemporaries. The Ghent Altar (ill. p. 55) was begun at some point before 1426, the year of the death of its main artist, identified in its inscription as Hubert van Eyck (c. 1370–1426). It was completed in 1432 by Jan van Eyck (c. 1390–1441). During this same period Robert Campin (c. 1380–1444) produced the first of his mature works. The Magdalene Altar by Lukas Moser (c. 1390–after 1434), the *Mirror of Salvation* altarpiece by Konrad Witz (c. 1400–1445) in Basle (ill. p. 72), Campin's Werl Altar (ill. p. 56) and the Wurzach Altar (ill. p. 73) by Hans Multscher (c. 1390–c. 1467) all date from between 1430 and 1440.

These and the works of numerous other masters took as their themes, with varying degrees of emphasis, the representation of foreshortened space, the three-dimensional figure modelled to appear like a statue, and the natural landscape. Their artistic goals thus directly paralleled those of Masaccio, Paolo Uccello (c. 1397–1475) and Andrea del Castagno (c. 1421/23–1457). In the case of Witz and Castagno, it even led to identical ends, insofar as both perfected in their art the free-standing polychrome statue to the degree that painting and sculpture became interchangeable. In this case, the north even had the chronological edge over the south.

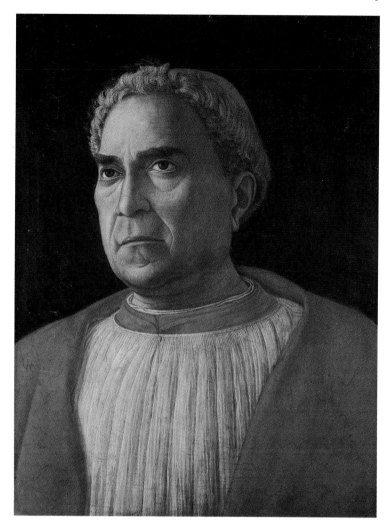

Andrea Mantegna
Portrait of Cardinal Lodovico Trevisano, c. 1459–1469
Tempera on wood, 44 x 33 cm
Berlin, Gemäldegalerie, Staatliche Museen
zu Berlin – Preußischer Kulturbesitz

Painting and sculpture

In the north as in the south, therefore, a close relationship existed between the two main branches of fine art. It was now sculpture, however, which exercised a direct influence on painting – a reversal of the situation in the early 14th century, when Giotto and his followers had provided important stimuli for sculpture. We have already briefly mentioned that the Tuscan painters of the Early Renaissance had their most important teachers in the great sculptors and bronze founders. Significantly, the situation north of the Alps was the same. The works which the Netherlands sculptor Claus Sluter (c. 1355–1406), appointed to the court of Philip the Bold in Dijon, produced for the Carthusian monastery at Champmol near Dijon – the portal figures, the so-called *Well of Moses* (begun in 1395) and the Duke's tomb – are regularly cited as important stylistic sources for Campin, Witz and the Master of the Annunciation Altar in Aix-en-Provence (active c. 1442–1450). Indeed, the links are in places so close that the painters may be assumed to have studied the sculptures.

The influence of sculptors on painters in the early 15th century demands closer examination. One figure deserving greater attention in this regard is Madern Gerthner (c. 1360–1430/31), about whom still too little is known. And in Multscher's workshop, it is possible that painter and sculptor were one and the same person: either the most important German sculptor and carver of the first half of the 15th century was also one of the leading painters of his day, or first-rate painters employed by him assimilated the sculptural types of the workshop to the extent that they became identical with their art.

This close relationship between painting and sculpture was not the only characteristic linking the north and the south at the start of the Early Renaissance; another was the chronological order in which the two disciplines appeared. Just as, south of the Alps, the painting of the Early Renaissance arrived on the scene almost a generation later than sculpture, so in the north sculpture preceded painting. Sluter produced his authenticated works in the last decade of the 14th century and the first decade of the 15th; Gerthner

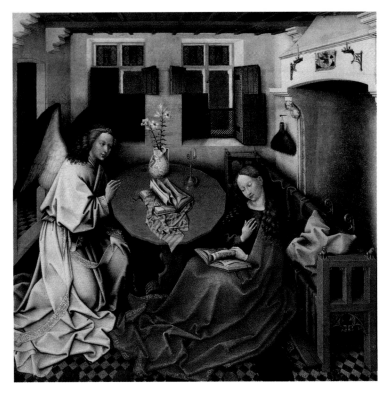

Robert Campin
Annunciation, undated
Tempera on wood, 61 x 63 cm
Brussels, Musées Royaux des Beaux-Arts

belonged to the generation born around 1365. Since the portrayal of the human body was the central theme of both disciplines, we need to find an explanation for the time lag between their respective embracing of the empirical world. The very attempt to search for a solution must surely bring us closer to a comprehensive definition of the 15th century.

It is important to be aware of the differing degrees of reality present in the various disciplines of art. The three-dimensional work of sculpture, and above all the statue, possesses by its very nature the highest degree of reality – it comes closest to being identical with the object it represents. In his *Ästhetik oder Wissenschaft des Schönen* (Aesthetics or Science of Beauty), published in 1846–1857, Friedrich Theodor Vischer (1807–1887) distinguished between the necessity of indirect idealization in painting versus the necessity of direct idealization in sculpture. In other words, idealization in painting is a two-stage process: the object to be portrayed first has to be translated into a two-dimensional medium which inevitably robs it of its immediacy. Only then – if it is not to remain simply a naturalistic copy – can it be idealized. In the three-dimensional medium of sculpture, on the other hand, the object retains its palpability and can be idealized in a single step. Where idealization is not introduced, sculpture simply remains identical to the object it portrays, in the sense of a perfect optical illusion such as achieved in the Pop Art of George Segal (*1924) and Andy Warhol (1928–1987). In view of the fact that sculpture, as the branch of art related most closely to

the object it portrays, was chronologically the first to manifest the forms of the Early Renaissance, we are once again tempted to conclude that the driving force behind the Renaissance was not classical antiquity, but a new artistic confrontation – unknown in the Middle Ages – with the phenomena of the real world.

Similarities and differences

In attempting to find a common denominator for the painting of the early 15th century north and south of the Alps and hence to arrive at a definition applicable to the epoch as a whole, we must take into account both the differences as well as the similarities in the styles being produced. In this context we may take a closer look at the Ghent Altar executed by the van Eyck brothers. Both in its dimensions and wealth of compositional devices and with regard to its outstanding artistic quality, the Ghent Altar was as important for painting north of the Alps as Masaccio's works for the beginnings of the Early Renaissance in Italy. Despite the differences in their techniques – Masaccio worked predominantly in fresco, the van Eycks in oil tempera –, a comparison between them becomes all the more compelling when we consider that all were working at the same time.

In its closed position, the Ghent Altar features an *Annunciation* in the top section and the donors venerating John the Baptist and John the Evangelist in the lower section. It thereby employs compositional solutions which can be directly compared with those in Masaccio's frescos. The Virgin and the Angel in the *Annunciation* are presented in a perspectivally foreshortened interior whose wealth of vanishing lines suggests extraordinary volume – we are given the impression of looking through the open front of a deep box. The figures are powerfully modelled, so that anatomical volume and perspective space intensify and augment each other. But while closely related to Masaccio's artistic principles up to this point, in other areas the Ghent Altar also reveals profound differences. These may be laid at the door of tradition rather than style, however. While Masaccio, in his fresco of the *Trinity* in Santa Maria Novella (ill. p. 23), for example, establishes spatial depth with precisely calculated perspectival means, the van Eyck brothers work from their intuition; they create space using pragmatical values which are derived from accurate observation but which are not subjected to mathematical processing. Correspondingly, the three-dimensional modelling of their figures appears absolutely convincing at first sight, but upon closer inspection reveals a lack of understanding of the organic structure of the body beneath the draperies. Masaccio's figures, on the other hand, make clear their "natural" proportions even through their robes.

At the same time, however, many of the compositional principles employed in the lower section of the Ghent Altar come remarkably close to those of the Italian Early Renaissance. The donors, Jodocus Vyd and his wife, are the same

size as the saints with whom they appear. This move away from the portrayal of donors on a diminutive scale testifies to the same shift in contemporary consciousness documented in Masaccio's donor figures. More still, the Vyds are both given such unmistakably individual features that there can be no doubt that these are portraits. The larger scale assumed by donor figures and the emergence of the portrait characterized the painting of the early 15th century in both the south and the north at the same time and to the same degree. The donors are portrayed in colour, underlining the immediacy of their presence; in contrast, the two Johns are rendered in shades of white and grey, distinguishing them from the donors and at the same time rendering them timeless. We are presented here with "painted sculptures".

Other aspects of the Ghent Altar differ profoundly from Masaccio, however. While the Italian subordinated detail to the larger form, the Flemish painters composed the larger form out of a wealth of accurately observed details. The same is true of the composition as a whole, irrespective of its different function as an altarpiece rather than as part of a fresco cycle. Although the top and bottom, sides and centre of the Ghent Altar are convincingly linked by colour correspondences between the *Annunciation* and the two Johns, in contrast to Masaccio – whose compositions are conceived first and foremost as a whole – the individual panels establish their own independence.

While fully aware of the dangers of generalization, it may thus be said that in their confrontation with reality, Masaccio and the van Eyck brothers were all, and to the same degree, representatives of a new phase of development which we may call the Early Renaissance. The differences between them were the same as those characterizing both the preceding and all future stylistic epochs: individualization in the north versus idealization in the south, or in other words subjectivity in the north, and the striving for objectivity in the south, and finally – no less important – intellectualization of artistic phenomena south of the Alps, and intuition based on feeling north of the Alps.

"Detail realism" and new techniques

As the north increasingly endeavoured to portray the individual as faithfully as possible, so the detail – whether in portraits, in the representation of interiors and landscapes, or in the reproduction of fabrics and trimmings – acquired a significance never attained (because never sought) in the south. The term "detail realism" has been specially coined to describe Netherlandish painting in the 15th century. It is here that several of the genres of panel painting which would emerge in the 16th and above all 17th century have their roots, namely the still life, the landscape, and the domestic interior. Efforts to render details with the greatest possible realism demanded new techniques and media. As throughout the history of art, it was not new technical "inventions"

which led to new artistic solutions, but artists facing new compositional challenges who developed for themselves the practical means best suited to their ends.

Netherlandish painting of the early 15th century marked the start of a decisive new chapter in the history of colour in European painting. According to Vasari (1550), Jan van Eyck "invented" oil painting. While we may dispute the absoluteness of this claim, it undoubtedly contains a kernel of truth. The tempera techniques of previous centuries had already used oil as a binder, although other non-transparent substances, such as fig-tree juice and egg yolk, were more common. Such binders produced a colour that was absolutely opaque. Gradations were subsequently achieved by "heightening" forms with different or slightly varied shades of colour. In the age of the van Eyck brothers, oil – a transparent binder – assumed increasing importance in tempera painting, since it allowed several translucent layers of colour to be applied on top of each other. The paint surface thereby acquired a previously unknown depth and luminosity, which in turn lent the fabrics, jewellery and flowers portrayed in the new medium a naturalness touching the border between

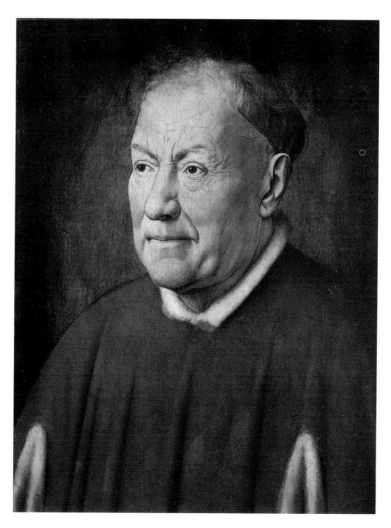

Jan van Eyck
Portrait of Cardinal Nicola Albergati, c. 1432
Oil on wood, 34 x 26cm
Vienna, Kunsthistorisches Museum

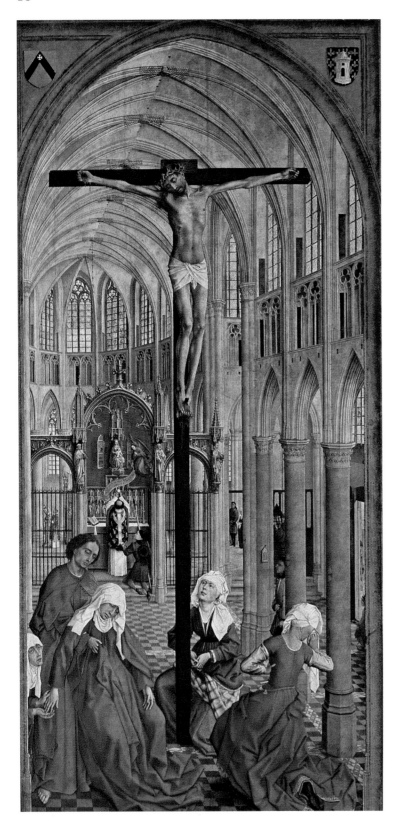

Rogier van der Weyden
Crucifixion in a Church, c. 1445
(central section of the Altar of the Seven Sacraments)
Tempera on wood, 200 x 97 cm
Antwerp, Koninklijk Museum voor Schone Kunsten

reality and reproduction and rapidly admired throughout the whole of Europe. The feastday side of the Ghent Altar marks a first climax in this development.

The artistic innovations north of the Alps no more implied a "revolutionary" new beginning than in Italy; rather,

they developed out of the traditions of the 14th century. Thus space, figure and their mutual interpenetration had already been central themes of the workshop of sculptor Peter Parler (c. 1354–1387/88). The series of busts which he began shortly after 1370 for the triforium in the choir of Prague cathedral represent, moreover, a milestone in the evolution of the "modern" portrait. Also in the second half of the 14th century, painting in Bohemia, under the guidance of Master Theoderich (fl. 1359–1381), relinquished its previous emphasis upon boundary and contour line in favour of colour modulation. And we may already suspect a greater proportion of oil in the panels by the Master of Trebon (active c. 1380–1390) dating from the end of the century, which seem to contain an inner radiance. Perspective effects, meanwhile, increasingly became the goal of painters in the latter third of the century, as seen for example in the work of Master Bertram of Minden (c. 1340–1414/15), albeit only in "localized" form. Above all, however, it was Flemish-Burgundian manuscript illumination which, in its rendering of architecture and landscape, prepared the ground for the new illusionistic character of Early Renaissance painting. As was the case south of the Alps, the new sense of realism erupting at the beginning of the 15th century in the fine arts was not a revolution, but the end of an evolution.

Regional differences

A third parallel between north and south sheds further vital light on artistic developments in the 15th century. Campin, the van Eyck brothers, Rogier van der Weyden (c. 1400–1464), Moser, Multscher, Witz and the Master of the Aix Annunciation all grew up in an intellectual climate which was strongly influenced by a civic patriciate. Internationally famed as centres of trade and industry, Ghent and Bruges, Rottweil, Ulm and Basle were free of a past shaped by a dominant ecclesiastical or feudal authority. The forms assumed by painting here were very different to those in cities where the course of the arts had been steered for centuries by the Church and powerful family dynasties, such as Cologne, or which remained closely tied to religious institutions, such as Hamburg. Thus it was possible for the Ghent Altar to arise during a period which, in Hamburg, saw Master Francke (c. 1380–c. 1436) painting his St Thomas Altarpiece with its predominantly spiritual character, and which in Cologne saw the rise of a school of painting which, in the tradition of the 14th century, held firm to gold grounds, figures whose corporeality is only hinted at, and settings intended for identification purposes only. "Modern" design principles only reached the Lower Rhine with the arrival from the Lake Constance area of Stefan Lochner, mistakenly seen as the embodiment of Cologne painting. Lochner fused the heritage of his Swabian home with Cologne tradition in a highly sensitive way.

Regional differences were thus as pronounced north of the Alps as they were in Italy. Here, as there, they arose out of different social conditions. "Progressive", or in other words "Renaissance" trends issued from the sphere of the middle classes. The thesis that the Early Renaissance was the first great cultural achievement of the middle classes is thus confirmed in the north. The polarization of Early Renaissance and Late Gothic thereby naturally appears in a very different light. There was no fundamental difference between Italy and the art centres north of the Alps, but rather a distinct line drawn between tradition and "progress", one which cannot be expressed in geographical terms since it was largely determined by patrons' wishes.

The importance of the sacred and the secular

One question that inevitably arises out of the discussion so far, and which goes far beyond the bounds of art history, is this: Did the trend which would belong to the future, here described as the Early Renaissance in the strict sense of the term, imply a secularization of art? The answer is frequently given as yes. Seemingly correctly. The Early Renaissance was indeed a decisive step along the path leading away from a theocentric world picture, i.e. one in which God is the prime concern, towards an anthropocentric world picture in which man is the measure of all things. If it had been the task of medieval art to communicate a message of salvation which went beyond that which could be experienced with the senses, painting and sculpture were now determined by direct sensory perception. Although the symbol was not replaced by the illustration, the symbolic was now expressed through the illustrative.

The thesis that art underwent a secularization in the age of the Early Renaissance is nevertheless one to be vigorously refuted. In terms purely of volume, for one, there was little growth in secular painting over previous centuries. It is all too easy here to draw the wrong conclusion from the corpus of surviving works. Secular painting in the Middle Ages was chiefly limited to frescos. We know that castles, palaces and wealthy town houses were decorated with large-scale fresco cycles. Fresco painters in the Middle Ages employed an *a secco* technique which involved painting onto a layer of plaster which had already dried. Works executed in this manner were not very durable and offered little resistance to weathering. Thus the entire body of medieval fresco painting, sacred as well as secular, has today been reduced to a fraction of its original size. Furthermore, we can also place the number of secular frescos deliberately destroyed as higher than those in church interiors suffering the same fate.

Other points, admittedly, are more important. We may speak not of a trend towards secularization in the realm of sacred art, but rather of a shift of emphasis in the understanding of what actually was sacred. Thus the "rediscovery" of nature as worthy of representation had important roots in

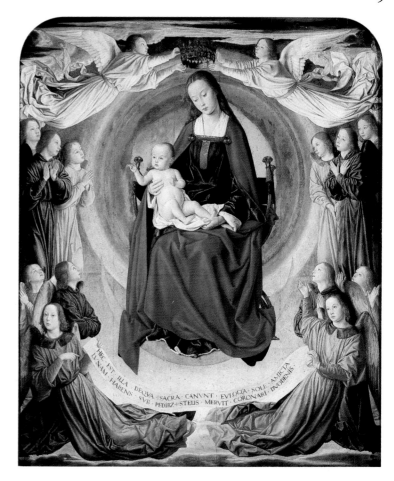

Jean Hay (Master of Moulins)
The Virgin in Glory, surrounded by Angels, c. 1489–1499
(central section of the triptych in Moulins cathedral)
Tempera on wood, 157 x 133 cm
Moulins, Notre Dame

the Franciscan movement. When St Francis sang the praises of Brother Sun and Sister Moon, when he glorified God's creation in birds and plants, he directly pointed art in the direction of new pastures. This link has long been acknowledged. In 1885 Henry Thode (1857–1920) published his great work on *Franz von Assisi und die Anfänge der Kunst der Renaissance in Italien* (Francis of Assisi and the Beginnings of the Art of the Renaissance in Italy). And the Franciscan call for *compassio*, compassion, signified a new appreciation of the value of the individual, who thereby began to emerge as separate from the "collective" of the church.

Not as directly tangible, but indirectly of no less significance, was the theology of the German Dominicans, and in particular mysticism. When Master Eckhart (c. 1260–1328) and his contemporaries spoke of the "inner man", and when Johannes Tauler (b. before 1300 in Strasburg of patrician parents; d. 1361) wrote: "For on this depends all: on an unfathomable relinquishing of existence in an unfathomable nothingness", they were challenging not only the worldliness of the Hohenstaufen era but also the legitimacy of illustrative qualities in art.

The painting and sculpture of the early 14th century north of the Alps reflected this concept of a "relinquishing of

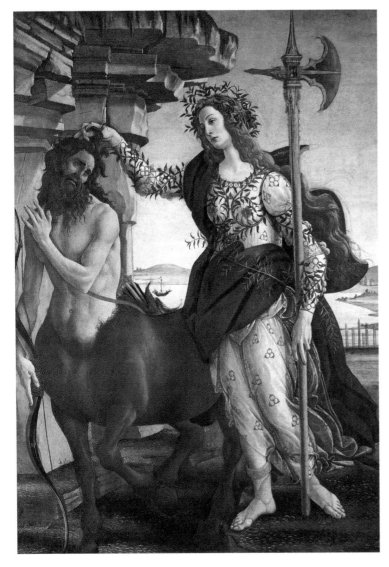

Sandro Botticelli
Pallas and the Centaur, c. 1482
Tempera on canvas, 207 x 148 cm
Florence, Galleria degli Uffizi

underlying reasons for Eckhart's excommunication, however, were his thesis of the dignity and responsibility before God of the individual, who thus no longer necessarily needed the mediation of the Church, and his rejection of legalism, something which anticipated Protestant thinking.

Mutually related changes in religious thought and in society thus led to a new appreciation both of the individual and of God's creation as experienced via the senses. This process was reflected in the art of the 14th century and found a provisional conclusion in the Early Renaissance. The aim was not to identify an independent aesthetic value in the world of empirical experience, but to explore – in the areas of perspective and proportion, for example – the order of the God-created cosmos.

Interaction between north and south

Parallel lines of development and related artistic phenomena raise the question of possible interaction between the north and the south. To what extent were there direct exchanges across the Alps in the 15th century? The problem deserves to be discussed in greater depth than has been the case up till now, since a closer examination of the situation might significantly broaden our understanding of Early Renaissance art.

There is no reason to suggest that it was fundamentally uncommon, in the Middle Ages and the early years of the Renaissance, for sculptors and painters who had completed their apprenticeships to spend a few years as travelling journeymen. The fact that the historical records remain silent on the matter should not tempt us to draw hasty conclusions. In the sketchbook of Villard de Honnecourt (active c. 1230–1235), for example, we possess the priceless testimony of a travelling architect. We also know that Jean Fouquet (c. 1415/20 – c. 1480) and Rogier van der Weyden made trips to Italy around the middle of the century, and that Joos van Gent (c. 1435 – after 1480) was active at the Urbino court from 1472 to 1475. Written records, too, tell us that Francesco Sforza (1401–1466), Duke of Milan, sent the painter Zanetto Bugatto (d. 1476) to train under van der Weyden for three years; the letter of thanks which the Duchess wrote to Rogier in 1463 has survived for posterity.

To dismiss such instances of artists travelling from the north to the south and vice versa as exceptions to the rule goes against the generally accepted, stylistically widely demonstrable influence which the Netherlands exerted upon the German-speaking realm. This influence extended not just to those regions geographically the closest to the Netherlandish border, but also to southern Germany. First-hand knowledge of Netherlands art was an essential part of the "education" of every good painter in the second half of the century, and may be taken as read in the case of the outstanding artists of the Early Renaissance. Remembering, however, that the mobility of Europeans remained unchanged up to

existence", of "withdrawing from the world of appearances" (Goethe) in many different ways. Yet in speaking of the individual, the representatives of mysticism revealed a different, extremely "modern" side to their religion: on the one hand, it preached a renunciation of worldly pleasures, and thereby appeared thoroughly medieval; on the other hand, however, it was characterized by an individualism unknown in the Middle Ages. This is seen particularly clearly in the case of Master Eckhart. In 1339, the year of his death, he received a bull of excommunication from the pope in Avignon, on the grounds that 28 of his doctrines were heresies. According to doctrine 11, for example: "Everything in human nature that God the Father gave to his only begotten Son He has also given to me. From this I except nothing, neither the unity nor the holiness…". Doctrine 18 states: "Let us not bring forth outer works which do not make us good, but inner works performed and effected by the Father dwelling within us". On the surface this was suggestive of blasphemy, an arrogant inflation of the status and role of the individual. The

the time of Goethe and beyond, we are justified in asking whether this lively artistic exchange followed an east-west direction rather than north-south.

Awareness of the latest innovations was undoubtedly transmitted through the import and export of art works. We know that Netherlandish masterpieces were collected in Venice, in Urbino, and above all in the Aragonese court in Naples. The Portinari Altar (ill. p. 63) by Hugo van der Goes (c. 1440/45–1482), installed in Florence in 1478, also influenced Tuscan painting of the late 15th century. Written records bear witness to the fact that Italians were informed about the art of the north, and in particular about its high quality. In his *De viribus illustris* (Illustrious Men), written between 1455 and 1457, the Neapolitan Bartolomeo Facio (c. 1405–1457) named Gentile da Fabriano (c. 1370–1427), Pisanello (1395–1455), Jan van Eyck and "Rogerius Gallicus" (i.e. Rogier van der Weyden) as the four most famous painters in the world. Facio thus accorded north and south proportionally equal importance, although he strikingly makes no mention of the masters who, for us, were the founders of the Early Renaissance in Italy. A few years later, Giovanni Santi (c. 1435–1494), father of Raphael (1483–1520), also named Jan van Eyck and Rogier van der Weyden as amongst the most important artists of the century – albeit alongside a host of Italian masters.

In the north, no comparable written records have survived. We should thereby remember that a "modern" sense of history emerged earlier in Italy than north of the Alps, and that archive material was also better preserved in the south during the following centuries. We may confidently assume, however, that Italian Early Renaissance paintings would have been collected by the big Tuscan business houses and banks and displayed in their Netherlands offices, where they would have been accessible to local artists.

We may take our enquiry one – albeit tentative – step further. Did an artist such as Domenico Veneziano (c. 1410–1461), about whose training and early years we know next to nothing but whose painting demonstrates a mastery of light and atmosphere previously unseen in Italian art, develop his new technique simply from studying individual works by Netherlands artists, or could it be that he actually spent time in the north? Did the Florentine Alessio Baldovinetti (1425–1499) absorb the strong Netherlandish influences which characterize in particular his landscapes in the very country of their origin? And asking the same question in the opposite geographical direction: had the founders of the Early Renaissance in the north – Campin, the van Eyck brothers, Moser, Witz – seen Italy with their own eyes? To assume the possibility of such lively and immediate exchanges would be to lend flesh and blood to the simultaneously homogeneous and heterogeneous nature of the 15th century, something which we have here sought to explain not primarily in terms of the difference between northern

and southern Europe, but as a consequence of the diversity of cultural and socio-political developments across the whole of what was then the West.

Stylistic change after 1450

The course of European art in the first half of the 15th century might encourage us to expect a continuous development towards the High Renaissance, the period around 1500. This expectation is fulfilled neither south nor north of the Alps. After the middle of the century, a stylistic change took place in all the artistic displines which might be termed a "Gothic revival", and which was characterized by a return to earlier traditions and in particular the International Gothic. The fact that this process took place in equal measure in the north and the south once again confirms the fundamental homogeneity of the epoch. The artistic and

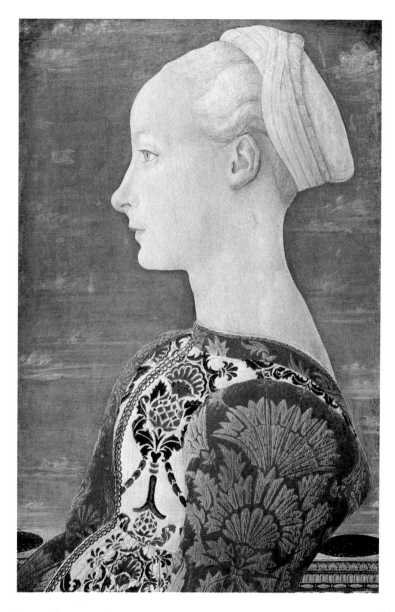

Domenico Veneziano
Portrait of a Young Woman, c. 1465
Tempera on wood, 52.5 x 36.5 cm
Berlin, Gemäldegalerie, Staatliche Museen
zu Berlin – Preußischer Kulturbesitz

philosophical reasons for this stylistic change have been the subject of frequent debate, and developments within the Church have been regularly offered as an explanation. It is doubtful, however, whether such developments alone, or even on a significant scale, can explain the phenomenon. Without claiming to offer a definitive solution to the problem, we shall discuss the inner logic of the stylistic change after 1450 from two points of view.

In historical terms, stylistic development in the second half of the 15th century appears thoroughly consistent. The major achievement of the first decades – the convincing portrayal of human figure, spatial depth and landscape in their overall combination – was followed both in the north and the south by a concentration upon finer details, with a view to "correctly" mastering anatomy, foreshortening, and the built or natural environment. The most suitable means of describing details is not the modelling of large forms, however, but the line. Van der Weyden had already begun to tread this path in the Netherlands; the same trend can be seen in Multscher's workshop in south-west Germany in the evolution from the Wurzach Altar (1437) to the Sterzinger Altar (1457/58).

In Italy, Sandro Botticelli (1445–1510), Filippino Lippi (c. 1475–1504) and Luca Signorelli (c. 1450–1523) were all protagonists of this development. This new path led away from the overall whole and towards the individual component – a trend which has numerous parallels in the history of Western art. The Italian painting of the generations after Giotto is a particularly illuminating example, and even the art of the 16th century which followed the short-lived peak of the High Renaissance would, for all its stylistic diversity, demonstrate related tendencies.

If we assume, however, for the purposes of this brief overview of the painting of the 15th century, that developments in art history are driven not simply by their own dynamic, but are conditioned by and reflect larger cultural movements, so we must widen our vision to include the broader historical context. There was very clearly a change of attitude amongst the middle classes around the 1450s. Having played a decisive role in the early 15th century in the shaping of the Early Renaissance, as a means of carving out for themselves an identity distinct from tradition and traditional patrons of art, the middle classes now began to display a very different tendency. With their increasing wealth, which simultaneously signified power, they began to exhibit a desire for the glittering pomp of court society. The story of the house of Medici is an outstanding example of this development, and the frescos by Benozzo Gozzoli (1420–1497) in the chapel of the Palazzo Medici-Riccardi are the most significant art works illustrating this turnabout (ill. p. 32). We may assume that a similar change of sentiment took place in Ghent and Bruges, Cologne and Nuremberg, Ulm and, later, Augsburg, to name just a few. It was reflected not only in painting, sculpture and carving, but also in architecture. The choir of the church of St Lorenz in Nuremberg, for example, and the Town Hall in Löwen testify to the same civic desire for aristocratic display. The urge to create a separate identity in the first half of the century was succeeded after 1450 by the urge to merge. Economic and social history can here contribute much to our understanding of artistic developments.

During this same period, too, the major courts began to adapt the achievements of the Early Renaissance, a fact that served to defuse the antagonism between the art of the middle classes on the one hand, and that of the Church and feudal society on the other. For all its backward-looking tendencies, however, the stylistic change which followed 1450 should not be misunderstood as a retrograde step. There is nothing in art history which is either a pure step "forward" or a pure step "back". The relinquishing of territory that has been won is invariably counterbalanced by the conquest of new terrain.

The sum of the diverse and complex developments of the 15th century would be totalled up around 1500 by the High Renaissance, in the words of Heinrich Wölfflin (1864–1945) the "classic art" of the Renaissance. The High Renaissance would fuse the large-scale vision suggestive of reality embraced by the early 15th century with the realistic detail of the later 15th century, once again in a lively exchange between north and south.

MASACCIO

1401–1428

Masaccio's *Trinity* fresco, painted for a Florentine patrician family yet to be definitively identified, is one of the founding works of Renaissance painting. Here, for the first time, three-dimensional space is projected onto the two-dimensional plane with the aid of the linear perspective newly rediscovered by Filippo Brunelleschi. Solid wall truly appears to have been breached – the foundation of all later "illusionistic" painting in which reality and appearance are rendered indistinguishable to the eye, and above all that of Mannerism and the Baroque.

Masaccio enables the viewer to identify directly with the painted world of the fresco by portraying the figures in life size and by calculating the perspective from the very position of the onlooker in real space. While the forms of the architecture are borrowed from antiquity, they are also to be found in the first works of Early Renaissance architecture, such as San Lorenzo by Brunelleschi and the sculptured tabernacle in Orsanmichele by Andrea Orcagna – references through which the artist again lends his fresco an overwhelming degree of realism.

The Trinity should be appreciated not simply for its revolutionary illusionistic qualities, however, but also for the highly intelligent organization of its figures. The donors kneeling in front of the framing pilasters lend depth to the foreground and reinforce the connection between the viewer and the fresco. At the same time, the grouping of all the figures into a steep-sided triangle – a geometric form – acknowledges the frontality of the plane.

This fresco, unfortunately damaged during the construction of the Baroque altar, is located on the lower right-hand side of the window in the Brancacci Chapel. It shows a scene from the Acts of the Apostles. Peter had exhorted the early Christians to give up all their worldly possessions and to share them evenly amongst the community. As Peter was distributing the goods, Ananias – who had secretly kept back a part of his wealth – fell dead.

Here again, Masaccio offers a dramatic contrast to the older International Gothic style still flourishing on Florentine soil, of which Gentile da Fabriano's more or less contemporary *Adoration of the Magi* is a particularly potent example. Masaccio's figures are conceived as polychrome statues and stand in a staggered arrangement whose depth is emphasized by contrasts of light and shade.

The impression of receding space is heightened by the crosswise architecture and the view of a mountainous landscape behind, probably inspired by the hills around Florence. (Is the merloned palazzo in the background the Villa Torre di Gallo?). It is not Masaccio's intention to reproduce a recognizable scene, however. In contrast to the numerous elements opening up the background, the foreground figures – and in particular the body of the dead Ananias – are positioned parallel to the pictorial plane.

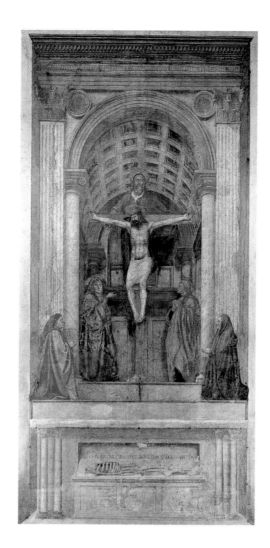

Masaccio
The Trinity, 1425/26
Fresco, 667 x 317 cm
Florence, Santa Maria Novella

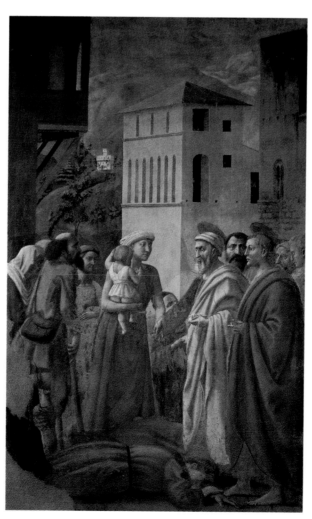

Masaccio
St Peter Distributes the Goods of the Community and The Death of Ananias, c. 1426/27
Fresco, 230 x 162 cm
Florence, Santa Maria del Carmine, Brancacci Chapel

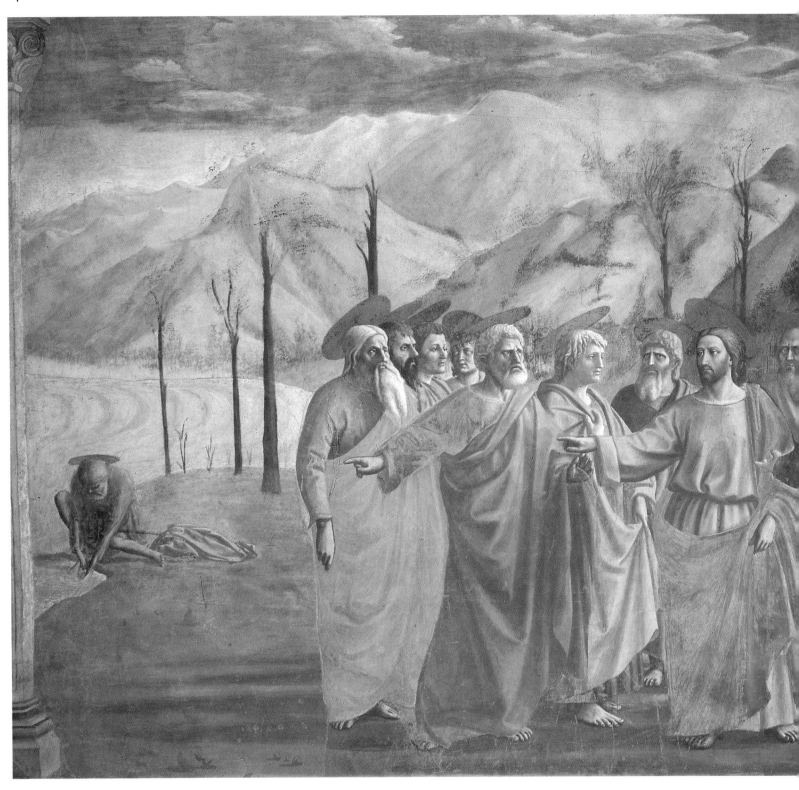

MASACCIO

1401–1428

Around 1424 Masaccio and his older colleague Masolino embarked upon the decoration of the Brancacci Chapel, which was dedicated to St Peter. Recent research has disproved the former thesis that Masolino was Masaccio's teacher and originally began the cycle on his own. The first areas of the frescos to be painted were the backgrounds, and since these are entirely indebted to Early Renaissance architecture, they can only have been executed by the artist who also painted the *Trinity*-fresco in Santa Maria Novella.

All Masaccio's pictorial means are concentrated in the scene of the *Tribute Money*. Despite the elongated format and the division of the narrative into three scenes, Masaccio achieves a compositional homogeneity which the viewer unquestioningly accepts. In the centre we see Christ instructing Peter to go and catch a fish, saying that he will find a coin in its mouth; on the left we see Peter obeying Christ's command, and on the right rendering the tribute money to the tax collector. Rather than dividing the pictorial plane into three symmetrical fields and thereby threatening the lively animation of the whole, Masaccio presents the scenes in a seemingly loose relationship. The various groups are nevertheless linked by a large number of differentiated means: by "complementary figures" such as the tax collector, for example, who is seen in rear view in the centre and frontally on the right, and by the disciple on the right-hand edge of the main group and the pointing figure of Peter. A similar purpose is served by correlations of colour and, most emphatically of all, by the artistic but nevertheless natural rhythm established by the facial expressions

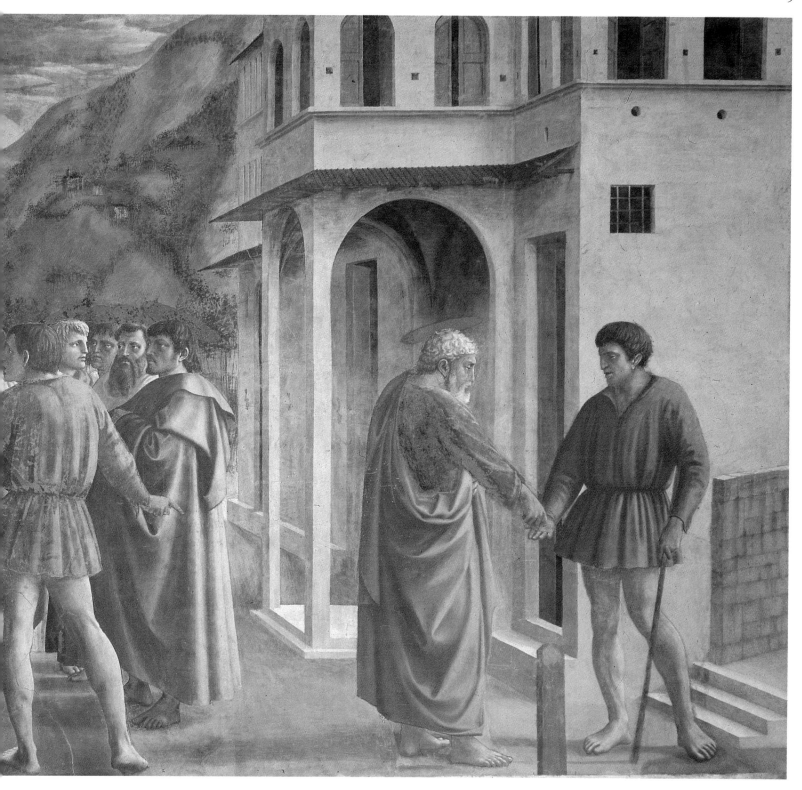

worn by the figures and the directions in which they are standing and looking. Here we may recognize early aspects of the "stage management" which would culminate in Leonardo's *Last Supper* (ill. p. 91). Landscape and architecture are also designed to serve the homogeneity of the overall picture. The mountain ranges "pin" the scene together, and the vanishing lines of the architecture converge in Christ's head.

Where do the sources of Masaccio's art lie? The painting of the previous generation offers little in the way of an answer. Rather, the sculptural qualities of Masaccio's figural style suggest that he was profoundly influenced by the early works of Donatello and the statues of

Nanni di Banco. His "statuary" approach thereby places him in a long line of Florentine painters reaching from Giotto to Michelangelo. And in Giotto we find the second point of reference for Masaccio's work. For Masaccio was the true heir to Giotto, albeit with a new degree of naturalism. He shared with Giotto the concept of the three-dimensional figure, the reduction of details to the absolute minimum required by the narrative, and finally the use of architecture and landscape as integral components of the composition.

Having lost much of their brightness over the course of the centuries, the frescos have recently been cleaned and restored to their original glory.

Masaccio
The Tribute Money, 1426/27
Fresco, 255 x 598 cm
Florence, Santa Maria del Carmine, Brancacci Chapel

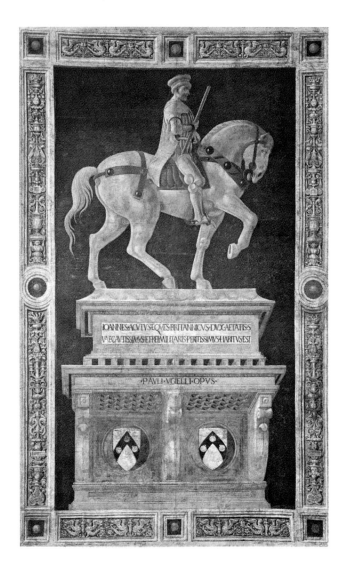

Paolo Uccello
Equestrian Portrait of Sir John
Hawkwood, 1436
Fresco, transferred to canvas,
732 x 404 cm. Florence, Duomo

PAOLO UCCELLO
C. 1397–1475

Behind this work, signed and dated 1436, lies
a lengthy history. Sir John Hawkwood was an
English mercenary leader known in Florence
as Giovanni Acuto. An original plan to honour
his distinguished name with a marble tomb
was shelved, for reasons of cost, in favour of an
equestrian portrait, duly painted by Agnolo
Gaddi. Deemed old-fashioned in 1433, this
was replaced by the present work, in which
Uccello uses the new means of foreshortening
and three-dimensional figure representation to
create a "painted sculpture".

The base appears to project out of the wall
on three consoles. The view of the coffered
underside creates a sense of tangible three-
dimensionality which is reinforced by the
muted palette. In light of the numerous pre-
liminary studies for stereometric bodies surviv-
ing from Uccello's hand, we may assume that
here, too, the foreshortening of the individual
architectural elements was precisely calculated
in advance.

So important did Uccello consider the bril-
liant rendition of the three-quarter view and
underside of the base that he was willing to
compromise the integrity of the perspective
system governing the overall composition.
Thus base and rider are in fact seen from differ-
ent angles – the base from below and the rider
in strict profile from the side.

It would be wrong to deduce from this that
Uccello changed his mind half-way through.
There could be no question of a worm's-eye
view for the heraldic figure of the rider, and in
Uccello's eyes the bravura composition of the
base made up for the break in perspective.
Horse and rider, powerfully modelled, stand
out forcefully against the dark background.
The influence of sculpture first felt in Masac-
cio's painting ten years earlier now fully deter-
mines Uccello's figural style.

Uccello's *St George and the Dragon* is a prime
example of his late work. The heroic
monumentality of his large-scale frescos and
battle scenes has here given way, in accordance
with the changing tastes of the times, to a
more narrative phase. For all its deliberate
drama, the scene might be an illustration
taken from a book of fairy-tales. The slender
princess holds the already conquered dragon,
its wings patterned in different colours, on a
delicate lead, while the knight appears to be
charging in from the right. The grey belongs
to the breed of powerfully modelled horses in
Uccello's battle paintings. The large, gloomy
cavern on the left is echoed on the right in the
swirling storm clouds behind St George.

The division of the landscape into geomet-
ric lots is also something continued from Uc-
cello's battle paintings (right). Here, however,
pictorial space opens up continuously from the
foreground, across the middle ground, to the
background. A second version of this composi-
tion is housed in the Musée Jacquemart-André
in Paris.

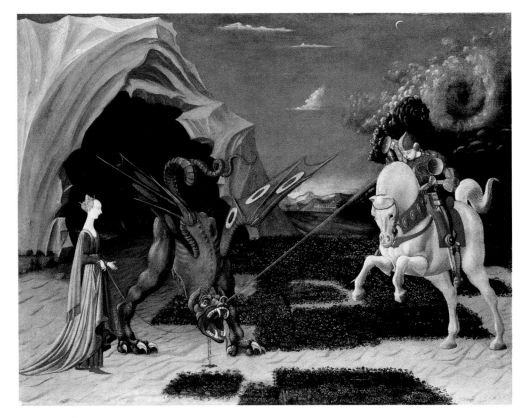

Paolo Uccello
St George and the Dragon, c. 1456
Tempera on canvas, 57 x 74 cm
London, National Gallery

The three-part painting of the *Battle of San Romano* was probably executed for the city palace of the Medici; it is certainly mentioned there in an inventory of 1491. It depicts a famous episode from recent Florentine history. On 1 June 1432 the mercenary leader Niccolò da Tolentino, commemorated in the equestrian portrait of 1456 by Andrea del Castagno in Florence cathedral, routed the Sienese in a surprise raid near San Romano. At a time when the Medici were already on their way to feudal supremacy, this celebration of an event from Florence's republican past was probably a piece of political calculation. There were clearly some who wanted to veil the truth, at least to the outside world, about the actual balance of power.

The three panels form a cyclical composition. On the left-hand side (housed in London), Niccolò da Tolentino, depicted in the centre on a grey charger with his commander's baton pointing the way forward, heads the attack on San Romano. In the middle panel (housed in Florence), Bernadino della Carda, the leader of the Sienese mercenaries, is knocked from his horse by a blow from a lance. Uccello thus portrays the decisive moment in the battle at the centre of the entire composition, although avoiding any semblance of rigid symmetry by shifting the figure of Bernadino della Carda slightly right of the central axis. The right-hand panel (housed in Paris) shows Niccolò da Tolentino coming to the aid of the mercenaries of the Florentine condottiere Michelotto da Cotignola and forcing the Sienese to defend themselves on two fronts.

The composition only makes full sense when the three panels are seen together. Uccello establishes a movement which travels simultaneously from the groups of riders on the left-hand edge of the London picture and the right-hand edge of the Paris painting, passes through the two equestrian figures at the centre of each of these panels, and culminates in the middle of the Florence panel. The groupings of lances similarly play an important role in linking together the frieze-like composition. The repeated obliques of these lances serve to emphasize the pictorial surface and at the same time are characteristic of Uccello's style, which is determined by a certain process of abstraction. Thus the silhouettes of horses and riders are simplified in favour of powerful plastic volumes – one may compare here the horses in Gentile da Fabriano's *Adoration of the Magi*, which Uccello would have studied – while side views predominate over Uccello's admittedly masterly foreshortenings. The landscape, which echoes the rising backgrounds in Ambrogio Lorenzetti's *The Effects of Good Government* in Siena Town Hall, is parcelled into geometric lots.

Interestingly, Uccello would prove a notable source of inspiration for the early 20th-century tendency within Italian painting grouped around the magazine *Valori Plastici* (Plastic Values), leading to a re-appraisal of his importance within the history of art.

Top:
Paolo Uccello
Battle of San Romano, c. 1456
(left panel)
Tempera on wood, 182 x 317 cm
London, National Gallery

Middle:
Paolo Uccello
Battle of San Romano, c. 1456
(middle panel)
Tempera on wood, 182 x 323 cm
Florence, Galleria degli Uffizi

Bottom:
Paolo Uccello
Battle of San Romano, c. 1456
(right panel)
Tempera on wood, 180 x 316 cm
Paris, Musée National du Louvre

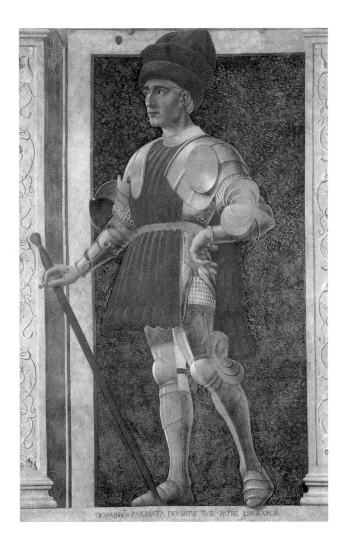

Andrea del Castagno
Farinata degli Uberti, c. 1450
(from the series of Uomini famosi in
the Villa Pandolfini, Legnaia)
Fresco, 245 x 165 cm
Florence, Galleria degli Uffizi

ANDREA DEL CASTAGNO
C. 1421/23–1457

Around 1450 Andrea del Castagno executed a
fresco cycle of *Uomini famosi* in a room in the
Villa Pandolfini in Legnaia, near Florence.
Larger than life in size, these "Famous Men
and Women" comprise a mixture of figures
from history, mythology and art, in line with
the thinking of early humanism.

Alongside the mercenary leaders Niccolò
Acciaiuoli, Farinata and Pippo Spano, they in-
clude the poets Dante, Petrarch and Boccac-
cio, the Cumaean Sibyl, and queens Esther and
Tomyris. The theme of the cycle dated back to
Petrarch and the early 14th century. During
the Early Renaissance, however, it assumed a
particular relevance: in the celebration of great
individuals lay the roots of the Renaissance
cult of genius.

Not until Michelangelo's Sistine ceiling
would the painted sculpture – a challenge so
variously interpreted – find a more convincing
form. The suggestion of the interchangeability
of painting and sculpture is heightened by the
manner in which the figures appear to project
forward out of the mock architecture. Suffi-
cient fragments of the background, itself a vir-
tuoso display of perspective, have survived to
enable us to reconstruct its original appear-
ance. The figures appear to cross the threshold
between pictorial and real space.

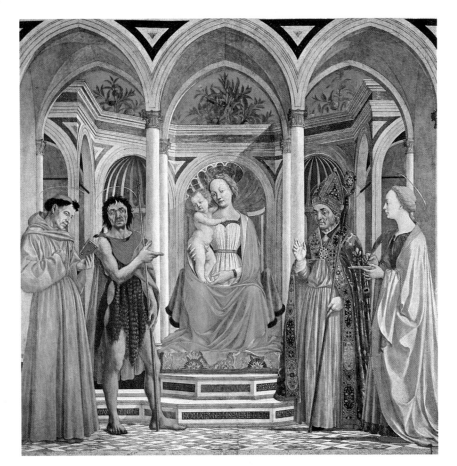

Domenico Veneziano
Madonna and Child with Saints (St Lucy Altarpiece), c. 1442–1448
Oil on wood, 209 x 213 cm. Florence, Galleria degli Uffizi

DOMENICO VENEZIANO
C. 1410–1461

This altarpiece, showing the Virgin enthroned
between the saints Francis and John the Bap-
tist on the left and the saints Zenobius and
Lucy on the right, ranks amongst the most im-
portant works of the Italian Early Renaissance
on two counts. It dealt a major blow to the
polyptych, a genre still lingering on far into
the 15th century, in which the Virgin and ac-
companying saints were traditionally
presented on individually framed, hinged
panels. Domenico here links the figures
within a single panel, firstly by means of his
architecture, whose charming mix of classical
and Gothic forms may reflect the influence of
Ghiberti, and secondly by arranging them in a
concave semicircle. His palette, moreover,
must also have made a revolutionary impact
on his contemporaries.

In contrast to the strong local colours
preferred by Florentine painters, Domenico
achieves a wealth of delicate nuances by ad-
ding a greater proportion of oil to his tempera
as a binder. For the first time in Renaissance
painting, sunlight is rendered with paint
rather than with gold, as was previously
usually the case. In this, Domenico prepared
the ground for the subsequent achievements of
his pupil Piero della Francesca.

PIERO DELLA FRANCESCA

C. 1420–1492

Piero's *Baptism of Christ* was originally painted
as an altarpiece for a church, demolished in
the 19th century, in the town of Borgo San Se-
polcro. It was subsequently incorporated into a
triptych on an altar in the town's cathedral,
flanked by two outer wings – still housed in
the cathedral today – by the Sienese artist Mat-
teo di Giovanni. In contrast to contemporary
works of Florentine painting, the landscape is
rich and differentiated in design and flooded
with light. Piero here continues along the
path signposted by Domenico Veneziano in
the St Lucy altarpiece. In his figural style,
Piero thereby begins to move away from the
ideals of the Florentine Early Renaissance. He
is no longer quite so interested in establishing
the three-dimensional solidity of his charac-
ters, for all their powerful modelling; outlines
have become noticeably simpler, and so too
the details of the draperies.

The landscape reveals Piero as a master of
spatial depth, as evidenced in the river Jordan
winding its way into the background and mir-
roring the landscape around it. At the same
time, however, Piero honours the shallowness
of the plane in the relief-like arrangement of
his characters, whereby the grouping of two
figures at right angles to each other plays an
important role. The constellation of Christ and
the tree, and the planimetric superimposition
of Christ, the baptism bowl, John's hand, the
dove and the tree-top, also serve to emphasize
the flatness of the pictorial plane.

The angels have been linked to the carya-
tids on the Acropolis, but Piero could not have
known these at first hand.

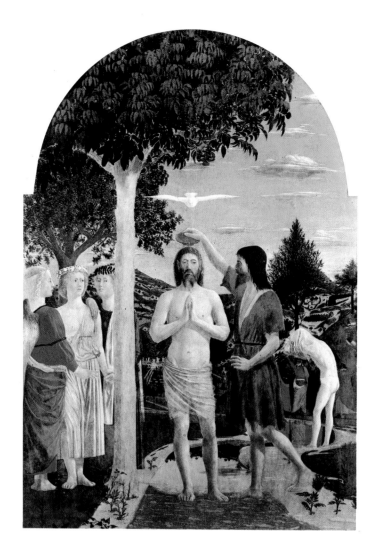

Piero della Francesca
The Baptism of Christ,
c. 1440–1450
Tempera on wood, 168 x 116cm
London, National Gallery

In choosing to portray his sitters in strict
profile – a pose influenced by the art of medal
engraving and involving a greater degree of
idealization than the three-quarter views
preferred by Flemish painters, with their ob-
sessive love of individual detail – Piero is fully
in line with Italian Early Renaissance tradi-
tion. Entirely without precedent in Italian
painting, on the other hand, is his pre-
sentation of the figures at a pronounced height
above the background landscape, which ap-
pears as a sweeping expanse below. It must be
assumed that Piero was here assimilating in-
fluences from Netherlandish painting, ulti-
mately deriving from Jan van Eyck's *Virgin of
Chancellor Rolin* (ill. p.53).

What in the Netherlands artist, however,
was the consequence of a theological pro-
gramme has here become an exercise in compo-
sition. Piero had the opportunity of studying
Netherlandish painting at the Urbino court,
both in the Duke's collection and in the per-
son of Joos van Gent. Flemish influence is also
visible in his technique. In the delicate oil
glazes with which he renders the jewellery
worn by Battista Sforza, for example, Piero
achieves a realism comparable in contempor-
ary Italian painting only to that of Antonello
da Messina.

On the reverse of the dipytch, the ducal
couple are shown in a triumphal procession in
Antique style.

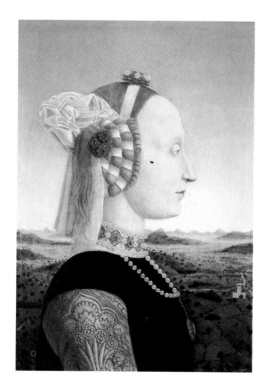

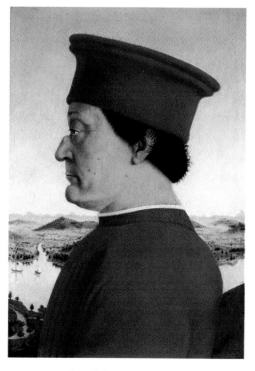

Piero della Francesca
Double Portrait of Federigo da Montefeltro
and his Wife Battista Sforza, c. 1470
(front of a diptych)
Tempera on panel, each 47 x 33cm
Florence, Galleria degli Uffizi

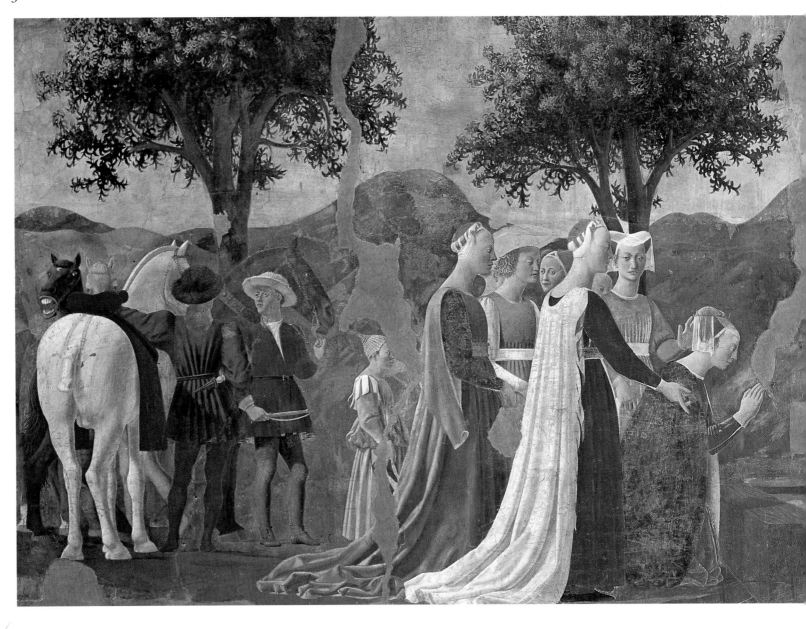

PIERO DELLA FRANCESCA

C. 1420–1492

The cycle of frescos in the choir of San Frances-
co was originally commissioned by the richest
family in Arezzo, the Bacci, who had decided
as early as 1416 to decorate the main choir
chapel. Bicci di Lorenzo, a Florentine painter
working in the Late Gothic style, eventually
started on the vault in 1447, but died in
1452. Piero della Francesca probably took over
the cycle immediately after this. On the end
wall and two side walls of the choir, he pro-
ceeded to illustrate the legend of the True
Cross as related in the *Legenda aurea* (Golden
Legend) by Jacobus da Voragine (1230–
1298/99) – a subject which, although not new
in Franciscan iconography (Agnolo Gaddi had
also painted a cycle on the same legend in the
choir of Santa Croce in Florence in 1380), had
assumed a new relevance in the mid–15th cen-
tury.

During this period, Pope Pius II sought for
the last time in Western history to rouse the
princes of Europe to launch a Crusade against
the Turks, who appeared to be heading for
inevitable victory in Jerusalem. The fresco
cycle in Arezzo may well be a form of propa-
ganda for the Crusades: it is surely indicative
of wishful thinking that episodes from Vo-
ragine are supplemented here by scenes drawn

from another source, showing the defeat of the
Persian king Chosroes, who had stolen the
True Cross from Jerusalem, at the hands of
Emperor Heraclius, and the subsequent return
of the Cross to Jerusalem.

Piero approached the two windowless side
walls of the choir as a compositional unity. In
each case, a central fresco in an architectural
setting is sandwiched above and below be-
tween scenes in an open landscape. In each
fresco, the grouping of the figures establishes a
division between left and right which, while
remaining free and unconstrained, plays an im-
portant role in structuring the whole. Piero
also spans subtle stays across the width of the
choir, whereby he links the two walls from a
purely artistic point of view, without regard to
the literary chronology of the legend.

In the lowest position on both walls are the
two battle scenes. They are followed at mid-
height by the frescos set in a built environ-
ment, whereby the main verticals established
by the painted architecture are in both cases
shifted slightly out of the central axis, inject-
ing a rhythmic impulse into the pictorial
plane. Finally, the landscapes in the lunettes at
the top represent, respectively, the start and
the close of the cycles to which they belong,

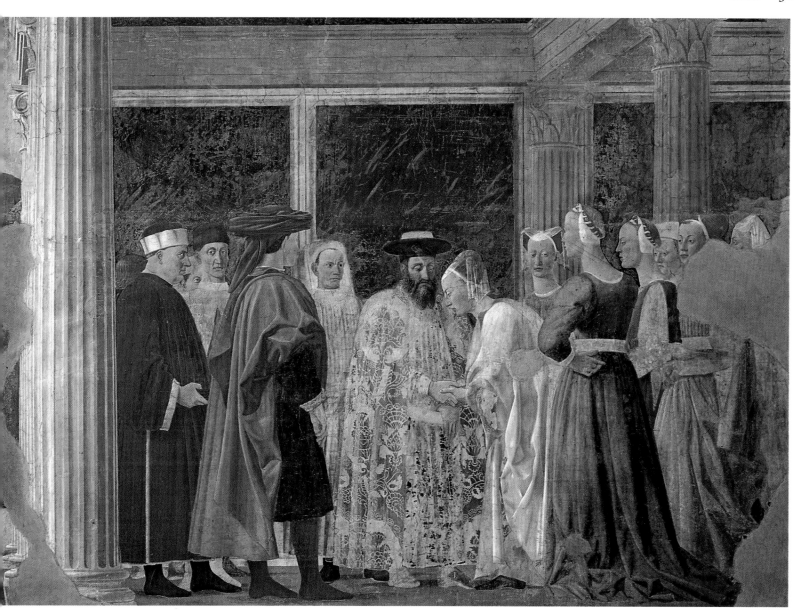

with each seemingly the pendant of the other in the relationship between the distribution of the figures and the accentuation provided by the trees.

The fresco illustrated here forms the central field on the right-hand wall and combines two scenes. On her way to King Solomon's palace, the Queen of Sheba reaches a bridge across a stream. She recognizes the wood from which the bridge is made as that which will later provide the material for Christ's cross, and she kneels before it in prayer. On the right we see the Queen meeting King Solomon in his palace.

Piero's painting reaches full maturity in this cycle. The landscape on the left reveals the same sense of sweeping space and – even in its present, sadly damaged state – the abundant light that we encountered in the *Baptism of Christ* (ill. p. 29). In the arrangement of the figures and in the hills running from left to right in the background, Piero thereby deliberately compromises spatial depth in favour of reconciliation with the two-dimensionality of the plane.

This can be seen even more clearly in the columned hall of Solomon's palace. Drawing for its details upon classical architecture, the interior evokes a suggestive impression of spatial depth. According to Paolo Uccello, Piero was the greatest theoretician and practitioner of perspective of the Early Renaissance. Rather than seeking to show off his skills, however, Piero chooses to balance the vanishing lines of his architecture with emphatic horizontals.

Piero's significance for the monumental painting of the Early Renaissance is seen nowhere more clearly than here. Whereas the first decades of the century had been devoted to the exploration of spatial depth and the illusionistic breaching of solid walls, Piero reaffirmed the validity of the plane. In integrating three-dimensional space and a two-dimensional plane within his effortless mastery of perspective, he secured himself a key position in European fresco painting between Masaccio and Raphael.

Piero's execution of detail is characterized by a further simplification of outlines and contours, which here assume an almost archaizing severity. The faces resemble abstract portraits, while the architecture is reduced to elementary stereometric forms. Thanks to the painted light with which they are flooded, the frescos nevertheless exude a festive, joyful atmosphere.

Piero della Francesca
The Discovery of the Wood of the True Cross and The Meeting of Solomon and the Queen of Sheba, after 1452
Fresco, 360 x 750 cm
Arezzo, San Francesco

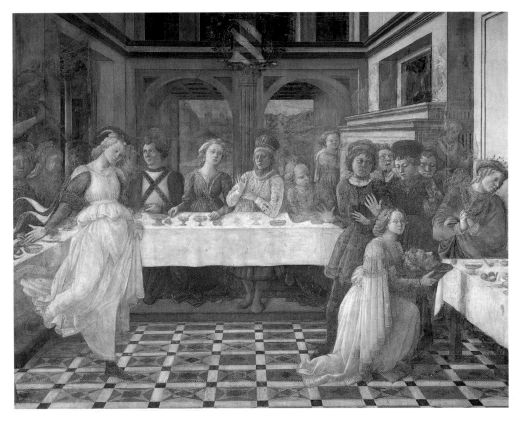

Fra Filippo Lippi
The Feast of Herod
Salome's Dance, c. 1460–1464
Fresco, width c. 880 cm
Prato, Duomo, Cappella Maggiore

FRA FILIPPO LIPPI

c. 1406–1469

Salome, asked by her mother Herodias for the head of John the Baptist, requested that her father Herod should grant her a wish, which he promised to do if she would dance for him at dinner. Using the pictorial device of continuous representation (whereby two or more episodes from a narrative are combined in a single image), Fra Filippo Lippi shows Salome dancing on the left and the head of John the Baptist being delivered on a platter on the right.

The composition has its roots in representations of the Last Supper. Filippo Lippi would have known Andrea del Castagno's fresco in the refectory of Santa Apollonia in Florence; here, however, he seeks to establish greater spatial depth by arranging the tables in a pronounced horseshoe and by foreshortening the tiled floor.

From this point of view, the fresco represents an important forerunner to Domenico Ghirlandaio's *Last Supper* in the convent of San Marco in Florence (ill. p. 38). Insofar as the present composition appears to be seen from varying heights, Filippo is not yet attempting to fuse pictorial space with real space. Filippo's late style is characterized by a tendency towards affected movements and a decorative drapery style, both of which are seen in the present fresco, executed between 1460 and 1464.

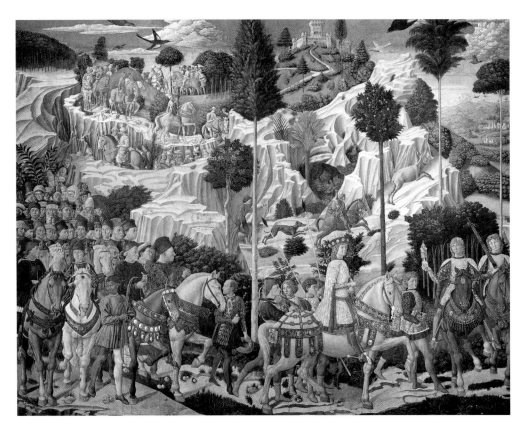

Benozzo Gozzoli
Procession of the Magi, 1459–1461
Fresco (detail), wall width c. 750 cm
Florence, Palazzo Medici-Riccardi

BENOZZO GOZZOLI

1420–1497

The present detail is taken from a continuous fresco of the *Procession of the Magi* covering three walls of a small chapel in the Palazzo Medici-Riccardi. Barely a decade after the frescos of Uccello and Castagno had broken new ground in the portrayal of space and figures, Gozzoli presents us with an extraordinary work in which the spirit of the International Gothic seems to breathe again. An extravagant pageant of figures, sumptuous robes and costly trappings is portrayed in front of and passing through a magnificent mountain landscape. The composition seems to draw its inspiration from Gentile da Fabriano's *Adoration of the Magi* painted a generation earlier. With its rich selection of portraits, such as the young Lorenzo the Magnificent seen here on horseback, and its almost inexhaustible wealth of contemporary styles of dress, the fresco must have seemed a mirror of the present.

Benozzo's narrative skills, his love of detail – inherited from his days as a goldsmith's apprentice under Ghiberti – and his fresh palette here combine to maximum effect. The rocky landscape which rises from bottom to top of the pictorial plane points to Gozzoli's first-hand exposure to Ghiberti's "Gates of Paradise" doors for the Baptistery in Florence. The painter builds on the achievements of the preceding generation and adds to them his own artistry as an enchanting story-teller.

ANTONIO DEL POLLAIUOLO

1432–1498

Chiefly active as a sculptor of bronzes, Pol-
laiuolo addressed himself more than any of his
contemporaries to the portrayal of animated
figures designed to be seen from different
angles. He takes up the same challenge in his
paintings, amongst which the present *Martyr-
dom of St Sebastian* – probably executed with
the assistance of his younger brother Piero –
takes pride of place. The subject, involving
more than just the isolated single figure of
sculpture, must have particularly appealed to
his temperament, which leaned toward dra-
matic intensity. The archers, portrayed in
highly diverse poses, resemble small bronzes,
translated into the medium of painting. In the
main group, compositional freedom and disci-
pline are combined in admirable fashion: St Se-
bastian, lashed high above the ground to the
stump of a tree, is surrounded by a circle of
archers whose animated poses at first appear
freely composed, but which on closer inspec-
tion reveal themselves to be precisely calcu-
lated, each a counterweight to the other. Like
the unusual view of the saint, presented
against the horizon in the top half of the pic-
ture, so too we are offered an unusual view of
the landscape stretching far into the distance,
executed with great precision in a delicate gra-
dation of tones. Here Pollaiuolo reflects his
knowledge of Antonello, who may have passed
through Florence on his way to Venice.

Antonio del Pollaiuolo
The Martyrdom of St Sebastian,
1475
Tempera on wood, 292 x 203 cm
London, National Gallery

Below:
Melozzo da Forlì
Sixtus IV, his Nephews, and his
Librarian Palatina, c. 1480
Fresco, transferred to canvas,
370 x 315 cm. Rome, Musei
Vaticani, Pinacoteca Vaticana

MELOZZO DA FORLÌ

1438–1494

In the monumentality of its perspective set-
ting, constructed with great confidence, in
the calm dignity of its powerfully modelled
figures, and in its two groups of three subtly
animated figures, Melozzo's Vatican Library
fresco anticipates the achievements of the
High Renaissance more than any other paint-
ing of its day. The clear, simple outlines of
the figures point to the influence of Piero
della Francesca. But while Piero always
sought the type behind the individual,
Melozzo reveals himself to be a portraitist of
great psychological sensitivity. His architec-
ture combines a knowledge of classical build-
ings with a sophisticated taste in decorative
detail. A skilful play upon the boundary be-
tween painted and real space reveals itself in
individual elements: the corner pilasters, for
example, seem to project outwards towards
the viewer, an impression reinforced by the
concave moulding of the plinth on the left,
while the hem of the robe worn by the kneel-
ing Platina spills over the edge of the in-
scribed tablet.

The painter clearly took into account the
natural light source of the fresco's original, un-
known location: the pillars on the left are in
shade, while those on the right are fully lit.
Fra Angelico's fresco of the *Ordination of St
Lawrence* may have provided the model for
this composition.

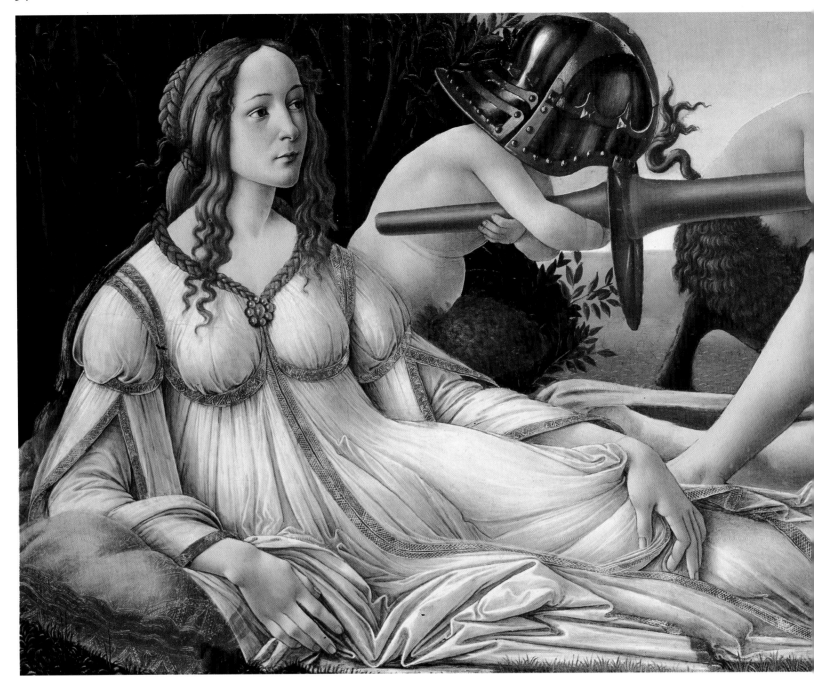

SANDRO BOTTICELLI

1445–1510

This panel is one of the most potent witnesses to the changes taking place in Florentine painting in the latter half of the 15th century – changes reflecting the development from an emphatically civic culture to a court culture.

In 1439 the Council of Union, which was intended to re-unite the Western and Orthodox Churches, was transferred from Ferrara to Florence at the wish of the Medici – a clear display of Medici influence and the family's claim to power. The Byzantines brought with them a series of writers and philosophers who gave new impetus to Florentine humanist interests.

A display of pomp on a princely scale was seen twenty years later in the banquet which Piero de' Medici held for Pope Pius II and Galeazzo Sforza, Duke of Milan. The Medici thereby placed themselves on a par with the most powerful figures in Italy. Benozzo Gozzoli's frescos for the Medici chapel in the Palazzo Medici-Riccardi (ill. p. 32) not only documented the pageantry of the festivities

but provided an exemplary illustration of the structural shift in Florentine society after 1450.

It is against this historical backdrop that Botticelli's panel must be seen. Mars, the God of War, has been conquered by Venus, the Goddess of Love. Reclining upon the ground, the handsome youth has fallen asleep. Naked and robbed of all his weapons, which are now in the hands of the fauns in the middle ground, he embodies a beautiful ideal from whose mind all thoughts of war are banished. Venus, on the other hand, richly dressed like a young woman from a distinguished family and thereby removed from the context of eroticism, remains alert and in this way symbolizes the permanence of peace.

Botticelli's reinterpretation of this mythological love scene can only be understood with reference to the Platonic Academy which, planned by Cosimo de' Medici, blossomed during the era of Lorenzo the Magnificent. Its

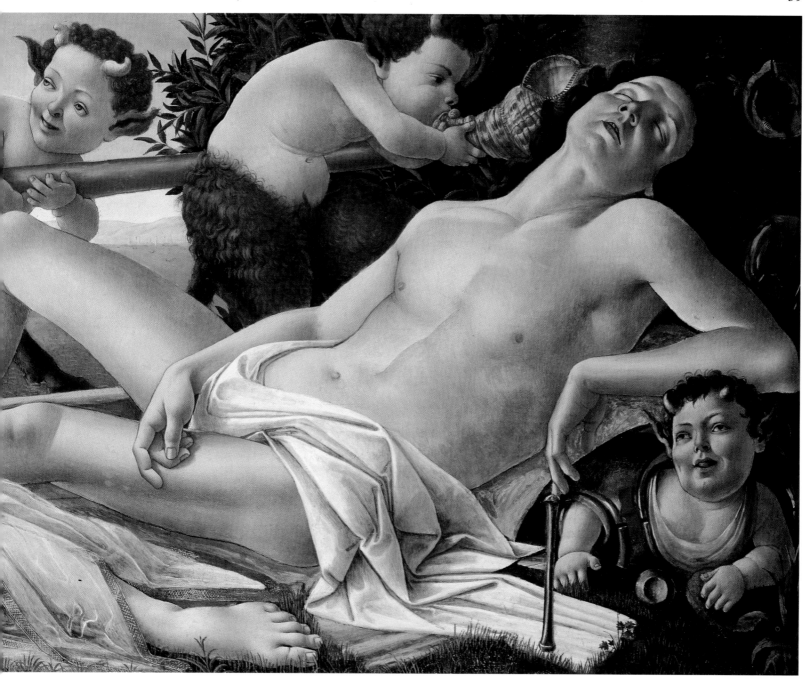

leading spirit was the poet and philosopher Marsilio Ficino and its thinking was influenced first and foremost by Plato. Seen in this light, Botticelli's painting takes on a new meaning: love, understood in the Platonic sense as a chiefly spiritual power, has conquered the horrors of war and violence. Classical philosophy here meets Christianity under what would become known as neo-Platonism.

Through the brilliant ingenuity of his composition, Botticelli overcomes the limitations of what might be considered an unfortunately long and narrow format within which to portray such a small number of figures. Equally balanced, Venus and Mars are virtually mirror images of each other. They establish the shape of an inverted triangle which is concluded at the top by the three fauns with the lance. Although expressions and poses are allowed to unfold freely in three-dimensional space, the geometric figure of the triangle informs all the details with the constraints of the plane.

Activity and passivity are exquisitely balanced in the two main figures: from a literary point of view, the alert figure of Venus, her upper body held upright, represents the active part of the scene, while the sleeping figure of Mars, his head leant back, represents the passive part. Within the syntax of the plane, however, their roles are reversed. The line of Venus' body falls in a slant from top left to bottom right, signifying repose – an impression reinforced by her self-contained silhouette. Mars, on the other hand, traces an oblique which rises from bottom left to top right, implying activeness, while his splayed limbs are indicative of movement. Botticelli thus creates a fascinating tension between his thematic motifs and their artistic expression.

The figure of Mars may be seen as an immediate forerunner to Adam in Michelangelo's *Creation of Adam* on the Sistine ceiling (cf. ill. pp. 98/99), painted some thirty years later (c. 1510).

Sandro Botticelli
Venus and Mars, c. 1480
Tempera on wood, 69 x 174 cm
London, National Gallery

Sandro Botticelli
Madonna del Magnificat, c. 1481/82
Tempera on wood, diameter 115 cm
Florence, Galleria degli Uffizi

Sandro Botticelli
Pietà, after 1490
Tempera on wood, 140 x 207 cm
Munich, Bayerische Staatsgemäldesammlungen, Alte Pinakothek

SANDRO BOTTICELLI

1445–1510

This panel of the Madonna and Child surrounded by angels takes its name from the open book in which Mary appears to be writing the text of the Magnificat. Painted shortly after 1480, it continues the trends already introduced in Botticelli's *Primavera*. The composition is hallmarked by delicate, flowing contours and a supremely sensitive treatment of the draperies. Details – decorative hems, hair, billowing veil, crown with glory – are executed with a precision and care that point to Botticelli's apprenticeship in a goldsmith's workshop. The incorporation of the figural group into the circular format of the tondo is mastered with an ease and assurance unprecedented in earlier painting. Not until 1515 would Raphael perfect this compositional principle once again in his *Madonna della Sedia*. Botticelli here pays what is for him unusual attention to the landscape in the background. The figures are grouped in a staggered arrangement which lends depth to the foreground and thereby connects them to the landscape opening up behind. The overall impression is thus not dissimilar to looking into a hemisphere.

In his late work, Botticelli moved away from the ideals of perspective and anatomy. He thereby aligned himself with an international trend which followed on from the powerful rendition of reality of the first half of the 15th century.

The type of Pietà reduced solely to the figures of the Virgin Mary and Christ never established itself in central Italy. In contrast to Venetian painting, which leaned more strongly towards contemplative themes and in which the Pietà in a landscape setting rose – particularly through Giovanni Bellini – to become a popular subject, the Florentine temperament tended towards discussion and dramatic intensification, and demanded multi-figural compositions in which the nature of the event taking place is reflected in the faces and gestures of those attending it. The setting of Botticelli's scene in front of the rocky tomb lends it an additional dimension: the devotional Pietà so popular north of the Alps here becomes a station between Deposition and Entombment. The work, probably executed with the help of assistants, illustrates Botticelli's last stage of development. The silhouettes and contours of the figures and the rocks are sharply drawn. Pain is directly embodied in the – at times – almost harsh contrasts of colour, and above all in the dramatic contrasts of expression and movement. The panel may thereby reflect the influence not only of Netherlandish painting, but also of the general cultural climate in Florence at the turn of the century, following the end of the glittering epoch of Lorenzo de' Medici (called *il Magnifico*, the Magnificent) and after the public burning of Girolamo Savonarola (1498).

Probably executed in 1477/78 for Pierfrancesco de' Medici's villa in Castello, this panel combines a monumental format (including life-size figures) with a technique reminiscent of miniature painting. Like the *Birth of Venus*, it testifies to the change in artistic thinking which took place in Florence after 1450. While the literature of classical antiquity continued to provide a source of thematic inspiration, its formal influence became virtually insignificant.

The encoded content of the *Primavera* can be unravelled with the help of a poem by Angelo Poliziano, who himself drew upon Ovid. The figure standing in the centre is Flora; on the far left, Mercury is scattering fog, while on the far right a wind god is chasing a fleeing nymph. Perspective and anatomy are no longer central themes of the composition, which is dominated instead by a sensitive handling of line and elongated proportions. The pale figures, some dressed in transparent robes, stand out against the dark background. In contrast to the strong colours which characterized the early years of the century, Botticelli's palette is restrained and muted. Where he appears to cite classical motifs, as in the case of the Three Graces on the left, he draws not upon antiquity directly, but on Ghiberti's bronze doors for the Baptistery in Florence (specifically, upon the group of serving maids in the relief of Jacob and Esau).

The view expressed in recent research that the *Birth of Venus* was painted at the same time and as a counterpart to the *Primavera* can be countered on a number of points. Firstly, the two paintings employ formats of considerably different size; secondly, they may be considered to represent different phases in the artist's development; and thirdly, they differ in terms of technique. The composition of the *Birth of Venus* is more rigorous in structure – it has been related to the traditional Baptism of Christ – and is infused with a harmony of line and movement. The additive principle which governs the *Primavera* has been overcome. The central figure of Venus standing on the scallop, her pose infused with a momentum that is ultimately still Gothic, is indebted to an ideal of beauty which Botticelli used in various forms, for example in *The Calumny of Apelles* (Florence, Galleria degli Uffizi) probably painted a few years later. Whether his model was Simonetta Vespucci, extolled in Poliziano's verses, is a question which must remain unanswered. A striking feature of the *Birth of Venus*, and indeed of Botticelli's œuvre as a whole, is his lack of interest in landscape, something to which he openly admitted in a conversation recorded by Leonardo da Vinci.

The art historian Jan Lauts has shown that the *Birth of Venus*, on the surface a composition whose content is self-evident, in fact reflects some of the complex thinking of the Platonic Academy which met regularly in the Medicean Villa Careggi under the guidance of Marsilio Ficino.

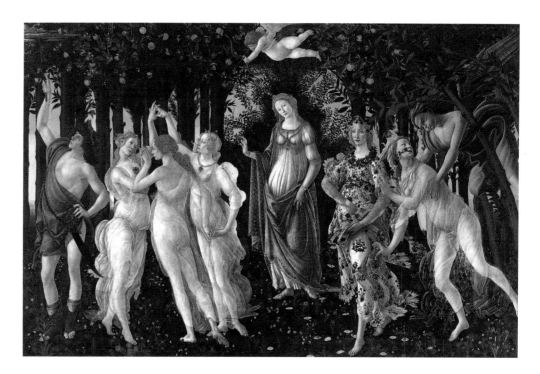

Sandro Botticelli
La Primavera, c. 1477/78
Tempera on wood, 203 x 314 cm
Florence, Galleria degli Uffizi

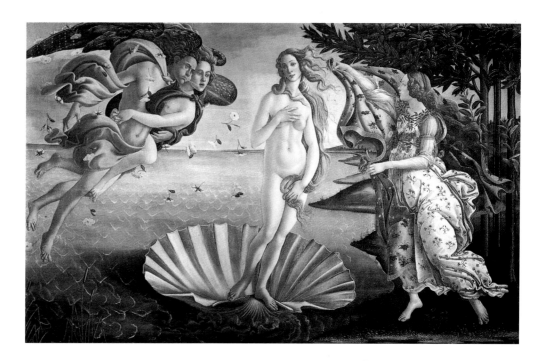

Sandro Botticelli
The Birth of Venus, c. 1485
Tempera on canvas, 172.5 x 278.5 cm
Florence, Galleria degli Uffizi

DOMENICO GHIRLANDAIO

1449–1494

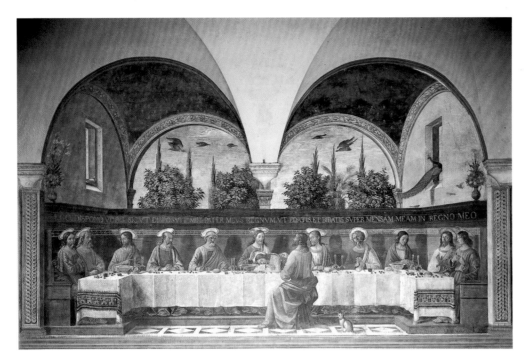

Domenico Ghirlandaio
Last Supper, 1480
Fresco, total width 812 cm
Florence, Convent of San Marco, Refectory

This fresco marks the most important stage between the Last Suppers of Andrea del Castagno and Leonardo (ill. p. 91). While Domenico Ghirlandaio, with his regular disposition of calm figures around the table, may not achieve the same expressive power as Castagno, he goes significantly beyond him in his efforts to merge real and pictorial space. For the first time, the perspectival composition is calculated from the actual height of the spectator's eye, so that the viewer indeed feels himself to be looking down on the painted marble floor.

The fact that the figures are also life size and that the vaulted ceiling of the refectory appears to pass uninterrupted into the fresco heightens the impression that we are looking into a real podium. The sense of spatial depth is reinforced by the painted view of the monastery garden behind.

Domenico Ghirlandaio endeavours to render details – the tablecloth with its pleats and patterned border, the objects on the table, the trees and birds in the background – with the greatest possible fidelity to nature. Here the influence of Netherlandish painting is clearly visible.

The fact that this *Last Supper* is, in all but a few details, an exact copy of one which Ghirlandaio had completed shortly beforehand in the refectory of Ognissanti shows just how closely his style matched contemporary taste.

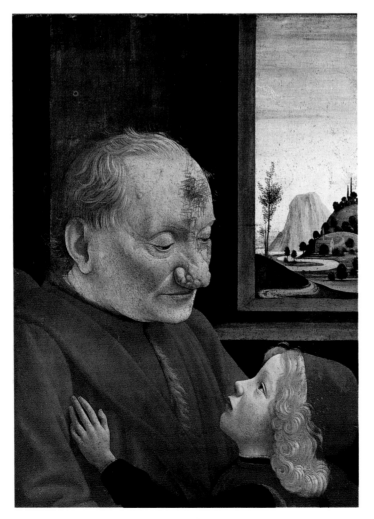

Domenico Ghirlandaio
Old Man and Young Boy, 1488
Tempera on wood, 62 x 46 cm
Paris, Musée National du
Louvre

This panel occupies a special position in Florentine portraiture of the Early Renaissance. Never before in the name of realism had such careful attention been paid to ugly, even disfiguring detail. From here the path lay clear to the physiognomical studies by Leonardo, who also sought to record abnormalities. Both artists reflect the enduring influence of the Portinari Altar (ill. p. 63); only by looking closely at the heads of Hugo van der Goes' kneeling shepherds can we begin to understand Ghirlandaio's portrait.

Although a slight questionmark still hovers over the attribution of this panel, a number of features link it closely to Ghirlandaio's late work. His frescos for the choir of Santa Maria Novella include numerous portrait busts of elderly men which similarly make no attempt to idealize the characteristics of old age. The head of the child, too, with his gleaming hair heightened with gold, recalls the heads of youths in other panels by Ghirlandaio.

The relationship between grandfather and grandson is vividly brought to life in the kindly, thoughtful expression worn by the old man and the trusting, beseeching look in the child's eyes.

In its precise detailing of every element, yet its deliberately unspecified location, the landscape falls fully in line with Florentine tradition. In the contrast between the solid wall and the view through the window, the artist may be referring on the one hand to the old life that is almost over, and on the other to the young life with so much before it.

ANDREA DEL VERROCCHIO

C. 1435–1488

The fact that the artist who painted this composition was also a sculptor is apparent in the carefully pondered poses of the standing figures and in the precise rendition of their anatomical details.

In line with his personal artistic temperament, Andrea del Verrocchio lends a dramatic intensity to the scene: Christ is no longer portrayed strictly frontally as in Piero della Francesco, but turns towards John the Baptist who, captured in mid-step, appears to be entering the picture from the right. Here Verrocchio anticipates some of the compositional principles which would shortly afterwards inform his bronze group of *Christ and St Thomas*.

The main foreground scene is stylistically dominated by line: robes and exposed parts of the body are traced with an almost graphic sharpness, and the individual layers of rock and stones stand out from one other with a similar clarity. Not so, however, the two angels and the river landscape behind: here, line gives way to colour modulation as the chief means of composition. Outlines increasingly lose their focus and colours lighten as they recede into the distance.

Leonardo, at that time active in Verrocchio's workshop, clearly assisted his master on this painting.

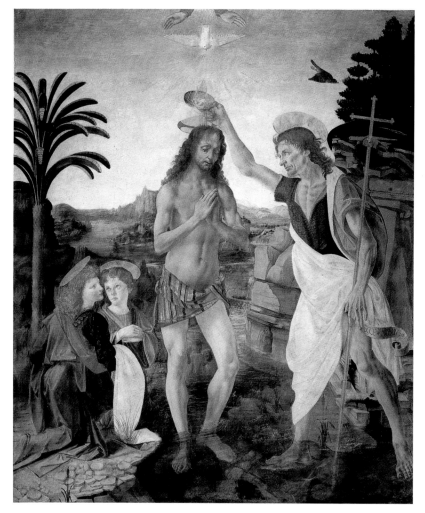

Andrea del Verrocchio The Baptism of Christ, c. 1475
Tempera on wood, 177 x 151 cm. Florence, Galleria degli Uffizi

FILIPPINO LIPPI

C. 1457–1504

Dating from around 1486, this painting marks the first high point in Lippi's development. The formative influence of his great teacher Botticelli is clearly visible in the pose and expressions of the figures, the sensitive drawing of the heads and the rich movements of the draperies. The restless multiplicity of the composition, on the other hand, looks ahead to Filippino's large fresco cycles, in particular in Santa Maria Novella (Florence, 1501).

Filippino sets the main foreground group against a rocky outcrop which rises to a peak behind the Virgin and St Bernard. Further back on the right we seen scenes from the lives of Franciscan monks. The motif of the truncated donor figure serves to suggest that the scene is simply an excerpt taken at random from a larger whole, and was probably derived from Donatello. The painting exudes an overall impression of seemingly spontaneous arrangement rather than calculated composition. A comparison between Filippino's work and Perugino's treatment of the same subject (ill. p.41) is particularly illuminating in this respect. In contrast to the sense of permanence and stability in the Perugino, Filippino's Virgin seems to have materialized before St Bernard just an instant ago.

It is evident from the powerful luminosity of the palette that Filippino employed a large proportion of oil in his tempera binder.

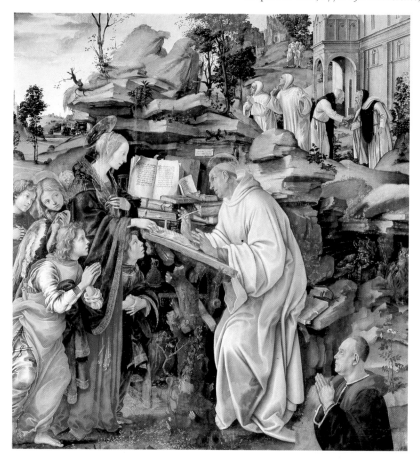

Filippino Lippi
The Vision of St Bernard, c. 1486
Tempera on wood, 210 x 195 cm. Florence, Badia Fiorentina

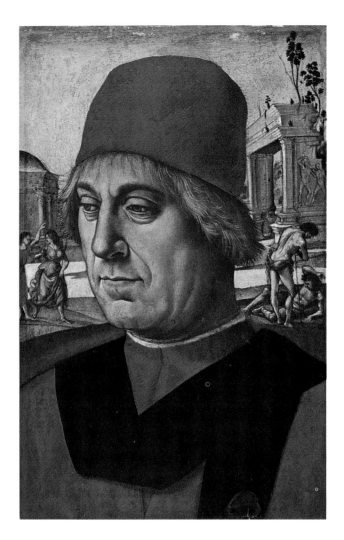

Luca Signorelli
Portrait of a Lawyer, c. 1490–1500
Oil on wood, 50 x 32 cm
Berlin, Gemäldegalerie, Staatliche
Museen zu Berlin – Preußischer
Kulturbesitz

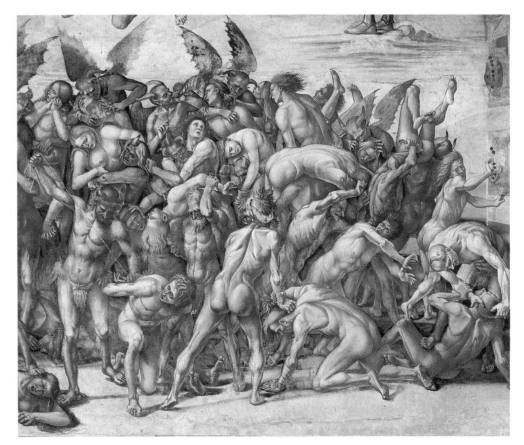

Luca Signorelli
The Damned Cast into Hell, 1499–1503
Fresco (detail), total width c. 670 cm
Orvieto, Duomo, Cappella di San Brizio

LUCA SIGNORELLI
C. 1450–1523

Whereas Italian portraiture in the first half of
the 15th century had been dominated by the
strict profile familiar from coins and medals,
Signorelli – like his contemporaries – adopted
the three-quarter view developed in Nether-
landish painting, which allowed a greater de-
gree of individualization. In line with his artis-
tic temperament, Signorelli reveals himself as
a cool observer in this portrait of an unidenti-
fied man. Despite the small format, he
achieves a remarkable sense of monumentality
through his use of simplified, unbroken out-
lines and the homogeneous red of the man's
tunic and hat. The facial features, and in par-
ticular the furrows around the eyes, nose and
mouth, might almost have been chiselled and
confirm Signorelli's affinity with sculpture –
something also evident in the middle ground
and background.

The painter renounces landscape in the
proper sense of the word in favour of anim-
ated figures and classical-style architecture,
portrayed on a much smaller scale far behind
the foreground plane. Of particular interest is
the group of two naked men on the right, in-
spired by classical sculpture; frequently em-
ployed by Signorelli as staffage, they are also
the forerunners of the ephebes in Michelange-
lo's *Doni Tondo* (ill. p. 97). The triumphal
arch on the right-hand edge of the painting
is the most prominent feature of the back-
ground. The narrow side facing the viewer
bears a relief of figures fighting. Rather than
modulating his palette, Signorelli employs
clear contours and strong local colours. The
painting is dominated by the red of the sit-
ter's clothes and the stone-like hues of the
background.

Fra Angelico and Benozzo Gozzoli had origin-
ally started decorating the San Brizio Chapel
in 1447, but the commission was only revived
at the end of the century. Signorelli here
reaches the peak of his development, with a
portrayal of the Last Judgement and the story
of the Antichrist on a scale more ambitious
than any previously seen in Western painting.
He reduces the landscape background to a
bare minimum and concentrates on human
figures in dramatic poses. Not until Michel-
angelo would the sculptural approach at the
heart of Tuscan painting come so clearly to the
fore as in this cycle.

Colour serves exclusively to describe objects
and, more important still, to heighten their
plastic qualities through contrasts of light and
shade. Line is the chief means of composition,
establishing hard contours and clear-cut sil-
houettes.

Signorelli displays an inexhaustible invent-
iveness in the positions and angles of his
figures. While echoing the 14th-century Last
Judgement reliefs on the façade of Orvieto ca-
thedral, they are more closely related still to
the genre of the small bronze emerging in the
late 15th century. Signorelli's Orvieto frescos
represent the most important forerunners to
Michelangelo's *Last Judgement*.

PIETRO PERUGINO

C. 1448–1523

In the fresco cycle decorating the lower section of the lateral walls of the Sistine Chapel, Perugino's *Christ Giving the Keys to St Peter* stands out above all the rest. The painter of expressive and atmospheric altarpieces here proves himself a master of large form and compositional organization. The descending diagonal running from Christ to the kneeling figure of Peter instantly draws our eye to the central event, which is accented further by the octagonal building in the centre background. Piero weights the accompanying groups of figures freely and evenly on either side. While the triumphal arches in classical Roman style in the background are symmetrically positioned on the left and right-hand edges of the fresco, we see them as if set against each other at a slight angle.

The origins of Perugino's art are clearly apparent. In his confident use of perspective, his emphasis upon pictorial zones running parallel to the plane, and the solemn mood of the composition, the influence of Piero della Francesca is unmistakable. The structure of his figures and the modelling of the draperies, on the other hand, reflect the impact of Perugino's first extended stay in Florence, where he is known to have resided as from 1472 and where he worked in Verrocchio's studio. A carefully balanced composition and a tendency towards expansive, as it were soundless backgrounds are stylistic features inherited from Perugino's Umbrian roots, and characterize his entire œuvre.

Executed for the church of Santa Maria Maddalena dei Pazzi in Florence, this panel marks one of the high points of European painting in the late 15th century. It depicts the Virgin Mary appearing in a vision to St Bernard of Siena. The confidence with which Perugino constructs the multi-aisled columned hall and composes his standing figures reflects the fruits of his years spent studying and working in Florence.

In terms of expression, admittedly, Perugino could hardly be more different to contemporary Tuscan masters: his figures appear to be caught up in a dream. Within their balanced grouping, reinforced by the square format, Perugino nevertheless introduces a certain animation: St Bernard's prie-dieu stands slightly to one side of the central axis, while Mary has stepped out of the line of pillars in an indication of her approach. The colours are powerful and luminous, but do not sound the frequently "loud" chord found in the work of Florentine artists. Similarly Umbrian is the loving treatment of the landscape, which unfolds into the distance at the very centre of the composition and serves as a vehicle for the overall mood. Echoes of Umbrian sacred buildings, too, may be heard in the lofty arcades of the architecture.

All the elements of the composition are in perfect harmony. With just a gentle nudge, the spell would be broken and the holy company aroused from its dream – and the threshold to the High Renaissance would be crossed.

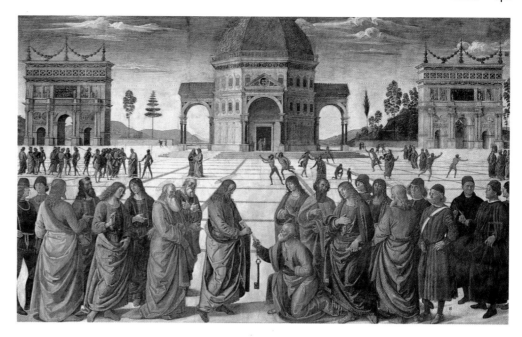

Pietro Perugino
Christ Giving the Keys to St Peter, c. 1482
Fresco, 335 x 550 cm
Rome, Vatican, Sistine Chapel

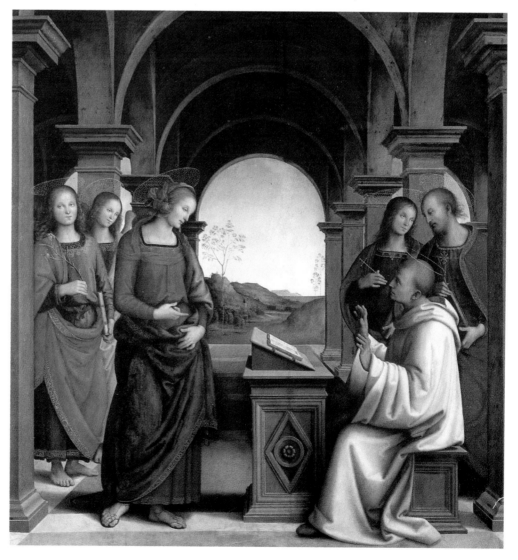

Pietro Perugino
The Vision of St Bernard, 1489
(from Santa Maria Maddalena dei Pazzi, Florence)
Tempera on wood, 173 x 170 cm
Munich, Bayerische Staatsgemäldesammlungen,
Alte Pinakothek

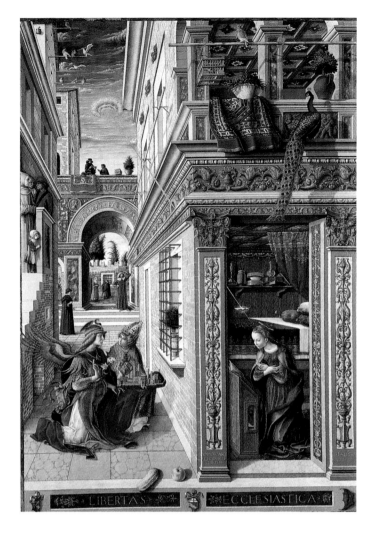

Carlo Crivelli
Annunciation with St Emidius,
1486
(from Santa Annunziata,
Ascoli Piceno)
Oil on canvas, transferred to
wood, 207 x 147 cm
London, National Gallery

CARLO CRIVELLI

C. 1430/35 – C. 1500

This panel of 1486 is a prime example of Cri-
velli's late style. The ostensible subject of the
painting, the Annunciation, takes up a surpris-
ingly small space.

There is no direct contact between the
small figures of Gabriel and the Virgin, who
are separated by the wall of the palace. Their
relationship is further interrupted by the
figure of St Emidius carrying a model of the
town of Ascoli. We have the impression that
the angel is talking to the saint.

The eye is drawn instead to the architec-
ture, with its bold perspective features and lav-
ish decoration. Typical of Crivelli is the man-
ner in which his compositions are compiled
from copious individual details. Elements bor-
rowed from classical architecture are heaped
together without their original character
being able to shine through.

Details from the sphere of the still life,
such as the peacock on the cornice in the
upper foreground, the expensive-looking car-
pet billowing in the wind and held down by a
flower pot, and the two men standing on the
parapet in the background, recall Antonello da
Messina's painting *St Sebastian* from around
1476 (ill. p.47).

Crivelli, here still signing himself a Vene-
tian (his signature can be seen at the base of
the front pilaster), may have painted this panel
during a trip to Venice.

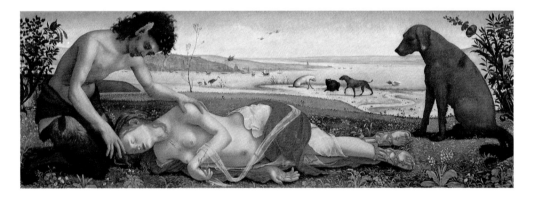

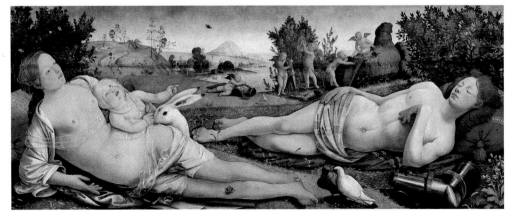

Above:
Piero di Cosimo
Death of Procris, c. 1510
Oil on wood, 65 x 183 cm
London, National Gallery

Below:
Piero di Cosimo
Venus and Mars, c. 1498
Oil on wood, 72 x 182 cm
London, National Gallery

PIERO DI COSIMO

1462–1521

Despite the different datings they have been
given, these two panels may have formed part
of a cycle illustrating themes from ancient
mythology. Considering that they stem from
the hand of a Florentine artist, both demon-
strate an unusual interest in landscape. The
progression towards lighter colours in the
background and the accompanying softening
of focus reflect Leonardo da Vinci's new the-
ories of colour.

The upper panel shows the death of Procris,
killed by mistake, while out hunting, by a
javelin thrown by her husband Cephalos – a
javelin which Procris had been given by King
Minos and which never missed its mark. The
dog on the right was also a gift from Minos.

Venus and Mars invites comparison with
Botticelli's version of the same subject (ill.
pp. 34/35). Both paintings arose out of the
philosophical thinking of the Medicean Pla-
tonic Academy: the conquest of war by love.
Piero's version is much richer in entertaining,
narrative detail, and at the same time more
sensual: both figures are naked. Here, too,
Mars has been robbed of his weapons, and the
pair of doves in the foreground symbolize
peace. Venus holds the boyish Cupid beneath
her left arm, while a hare – a symbol of *vo-
luptas*, or lustfulness – peeps up over her hip.

FRANCESCO DEL COSSA

1436 – C. 1477/78

The scholarly programme for the decoration of the large banqueting hall in the Palazzo Schifanoia was drawn up by Pellegrino Prisciani, a professor of astrology. Twelve fields, extending from a painted plinth right up to the ceiling, were each assigned to one month of the year. Each field is divided horizontally into three zones. The top zones show the astrological rulers of the month in triumphal procession. The narrower middle zones feature the signs of the zodiac and astrological demons. Finally, the bottom zones – twice as high as the middle fields – are devoted to a scene from court life linked to the month in question. The cycle was carried out by Cossa and Cosmè Tura between 1460 and 1470. Only the frescos on the east wall, showing March, April and May, have survived relatively intact. They mark the pinnacle of Cossa's artistic development.

From the freshness of the palette and the relaxed and entertaining narrative style, the impartial observer would never guess that the frescos were based on a strict theoretical programme. Cossa's hunting parties and tournaments are characterized by powerfully modelled figures, confidently foreshortened architecture and numerous quotations from antiquity. In the case of certain details, we must assume that Cossa drew his inspiration from his contact with miniature painting, at that time flowering at the Ferrara court.

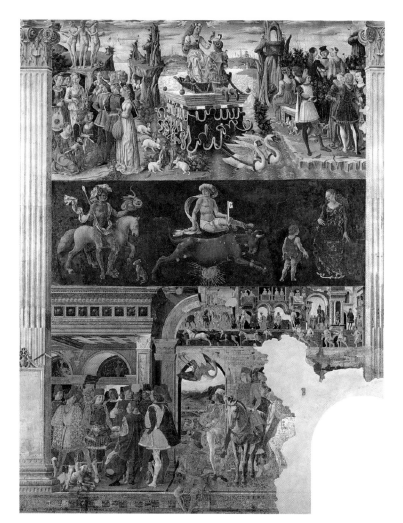

Francesco del Cossa
Allegory of the Month of April (overall view), 1470
Fresco. Ferrara, Palazzo Schifanoia, Sala dei Mesi

Below:
Cosmè Tura
St George and the Dragon and The Princess,
c. 1470
Tempera on canvas,
413 x 339 cm
Ferrara, Museo del Duomo

COSMÈ TURA

C. 1430–1495

These two panels form the outside of a pair of organ shutters which Cosmè Tura, the founder of Ferrarese Renaissance painting, executed for Ferrara cathedral. They open out to reveal an *Annunciation* on the reverse. Their style is typical of a specific school of Ferrarese painting, as distinct from Tuscany as it was from Venice, in which "modern" Renaissance elements are combined with almost medieval qualities in a highly original fashion. St George's battle with the dragon, dramatically intensified by the spiralling sweep of the composition, and the king's fleeing daughter are set against an imaginary, utterly unreal landscape. The figure of the princess is reminiscent of Etruscan models. The nervous lines of the draperies frequently give rise to abstract, inorganic ornament.

The palette is dominated by dark tones; where light values appear, as in St George's steed, they emit a pallid gleam. The overall impression is nevertheless one of costliness, resulting both from the decorative quality of the draperies and, above all, from the artist's inclusion of copious ornamental elements and his rich use of gold leaf.

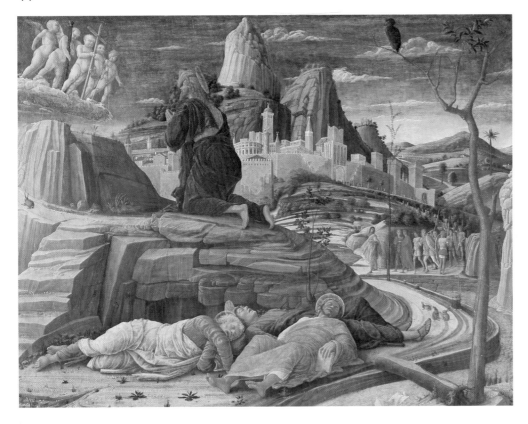

Andrea Mantegna
Agony in the Garden, c. 1460
Tempera on wood, 63 x 80 cm
London, National Gallery

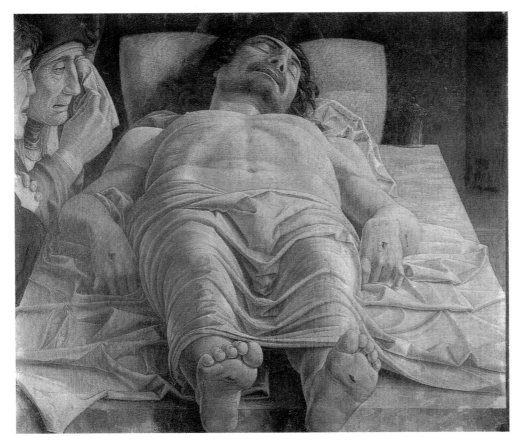

Andrea Mantegna
Dead Christ, c. 1480
Tempera on canvas, 66 x 81 cm
Milan, Pinacoteca di Brera

ANDREA MANTEGNA

1431–1506

Mantegna's painting, which although signed is not dated, has been variously assigned to very different phases of his œuvre. The graphic sharpness with which both landscape and draperies are etched suggests a date of around 1460, a period during which Mantegna was still processing the influence of Donatello's Paduan works. The additive nature of the composition, made up of multiple parts, also places the work amongst those produced during Mantegna's early maturity.

The expressive power of the figure of Christ, who faces towards the group of angels in the top left-hand corner, is amplified by the staggered elevation of the landscape in the foreground and background, the upthrusting silhouette of the town and the soldiers seen approaching from the right in the middle ground.

In aligning the main scene along a diagonal descending from top left to bottom right, Mantegna underlines the inescapability of Christ's fate, whereby the disciples sleeping beneath the fissured rock seem to allude to the Entombment. Is the plank which continues the diagonal across the stream intended as a reference to the wood from which Christ's cross would be made?

The mountains in the background and the portrayal of Jerusalem are pure figments of the artist's imagination and show no evidence of having been studied from nature. The panel nevertheless testifies to the antiquarian interests which Mantegna developed during his time in Padua, insofar as the townscape cites individual motifs from ancient and medieval Rome: the Colosseum, Trajan's Column, and the Torre delle Milizie tower.

Already famed in the 16th century as the *Cristo in scurto*, this painting was for a long time admired first and foremost for its extraordinary display of perspective virtuosity. And indeed, a figure presented in drastic foreshortening had never before been seen in Western painting. If we compare this dead Christ with the nearest of the disciples in the panel above, we can see the extent to which Mantegna had perfected his artistic skills. The two works would appear to be separated by almost a whole generation.

To concentrate solely on the technical mastery exhibited in the *Dead Christ* would be to miss its expressive content, however. The wounds seen from above in Christ's hands and feet, the helplessness suggested by his foreshortened upper body, and our oblique view of his slightly tilted head give visual expression to the finality of death in a previously unknown manner. The palette, which borders on grisaille, reinforces the impression of desolateness. The composition seems to exclude all hope of a Resurrection.

The figures of Mary and John, sliced by the edge of the canvas, are painted in a surprisingly coarse fashion and appear clumsily inserted into the scene. Could it be that they were added at a later date?

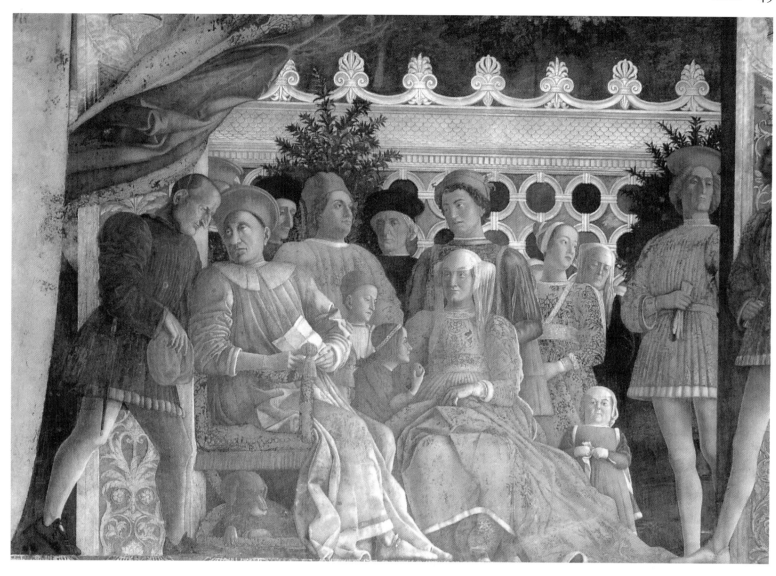

In 1460 Mantegna was appointed painter to the Gonzaga court in Mantua. Amongst his most important commissions was the decoration of the Reggia, the ducal apartments in the Castello di San Giorgio. Only the frescos in the Camera degli Sposi – the bedroom of Lodovico Gonzaga and his wife – have survived. The loss of the cycles in the other rooms is a reminder of the fragmentary and chance nature of our knowledge of the art and culture of the Early Renaissance.

Mantegna's frescos represent the boldest example of "illusionism" found anywhere in the entire 15th century. Two walls of the room are painted with pilasters and curtains, while the other two depict a contemporary event: the meeting between Cardinal Francesco Gonzaga and his parents in 1472. To understand the significance of the subject in its own day, it should be remembered that Francesco's elevation to the high ecclesiastical rank of Cardinal represented an enormous honour for a family which had only relatively recently risen from being landowners and condottieri to becoming lords of Mantua.

On the entrance wall (not shown), Marchese Lodovico is seen meeting his son Francesco, whereby the life-size figures are lent the physiognomic characteristics of portraits in masterly fashion. They are presented against a mountainous landscape, incorporating a walled city which – like the Jerusalem in *Agony in the Garden* – is entirely fictitious, but which includes numerous quotations from classical architecture.

The fireplace wall from which the present detail is taken depicts the Gonzaga family in contemporary costume, something which would have made their presence all the more immediate to the spectator. The portrayal of the figures as powerfully modelled "statues" was probably influenced by the work of Andrea del Castagno and his *Uomini famosi* (ill. p. 28): Mantegna was in Florence in 1466 and 1468, and would have been able to study the latest developments in Early Renaissance painting there at first hand. His integration of real and painted architecture is also derived from Castagno.

In Mantegna's frescos, too, individual characters appear to stand in front of the painted architectural features structuring the wall. But Mantegna goes a step further, insofar as certain figures appear to be climbing up into and down out of the picture via a flight of steps leading from the mantlepiece.

Here Mantegna anticipates the playful manipulation of the "aesthetic boundary" (E. Michalski), i.e. the dividing-line between real and painted space, which would become a central compositional feature of Mannerism and the Baroque.

Andrea Mantegna
The Gonzaga Family and Retinue, finished 1474
Fresco (detail), 600 x 807 cm
Mantua, Palazzo Ducale, Camera degli Sposi

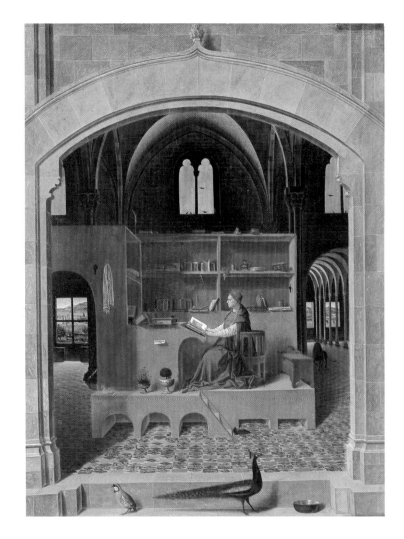

Antonello da Messina
St Jerome in his Study,
c. 1456
Tempera on wood,
46 x 36 cm
London, National Gallery

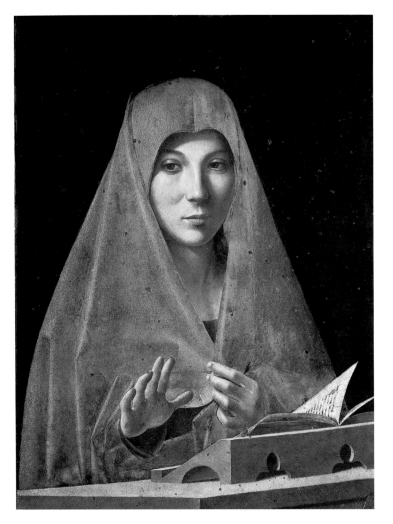

Antonello da Messina
Virgin Annunciate, c. 1475
Oil on wood, 45 x 34.5 cm
Palermo, Galleria Nazionale
della Sicilia

ANTONELLO DA MESSINA
C. 1430–1479

This small panel, executed after Antonello's de-
parture from Messina, shows his close depend-
ence upon Netherlandish painting. In its vir-
tuoso mastery of foreshortening, however, it
simultaneously demonstrates the artist's as-
similation of the achievements of the Early Re-
naissance.

The painted arch which frames the scene is
a motif taken from Flemish painting and par-
ticularly familiar since Rogier van der
Weyden. Gothic architectural elements and
small details from the world of the still life –
the bowl on the front step, the floor tiles, the
view of the landscape beyond – also point to a
study of Netherlandish artists. It was above all
his adaptation of a Netherlandish oil tech-
nique, however, which enabled Antonello to
achieve an effect previously unknown in Italy.
By increasing the proportion of oil in his tem-
pera, he was able to apply several layers of
paint, or glazes, on top of each other and
thereby to lend depth and luminosity to his
colours.

Antonello's panel nevertheless differs from
contemporary Netherlandish works in the dis-
position of the study, inserted like a monu-
ment into the architectural framework, and in
its incorporation of numerous carefully calcu-
lated views in what almost amounts to a de-
monstration of the different possibilities of per-
spective.

The *Virgin Annunciate* is an iconographically
unusual subject which Antonello painted on
several occasions. The distance separating the
early *St Jerome in his Study* from the present
panel, in which Mary is seen half-length and
without the angel Gabriel, is extraordinary.
What was previously composed of multiple
small details has here given way to a large,
closed form. The figure is contained within a
triangular shape, a geometric tendency em-
phasized by the folds of the drapery. The com-
position nevertheless avoids the severity of an
icon. Offset slightly left of the central axis,
Mary appears to be making a cautious
counter-movement with her shoulder and
head. Her eyes are not directed at the specta-
tor but are averted slightly leftwards. Spatial
depth is indicated by several diagonals in the
table, lectern and manuscript, which recede
rightwards into the painting. Particularly ad-
mirable is the "language" spoken by Mary's
hands in the interaction between her ex-
tended right hand, its palm in shadow, and
her brightly-lit left hand pointing inwards.
Did Leonardo da Vinci know these hands and
did he vary them in his *Madonna of the Rocks*
in the hand of the Virgin held out over the in-
fant Christ (ill. p. 92)?

The *Virgin Annunciate* has been called the
chief example of the "severe style" (J. Lauts) in
Messina's œuvre. The delicate glazes making
up the blue of the Virgin's cloak and the dif-
ferentiation between areas of light and shade,
particularly in the hands and face, date the
panel to the artist's Venetian period. Its closest
parallel is found in the *Sacra Conversazione* (ill.
p. 47).

The works which Antonello produced during a short stay in Venice in 1475/76 mark the culmination of his artistic development. They testify to his encounter with a second, equally important source of inspiration alongside Netherlandish painting: a study of the works of Piero della Francesca.

St Sebastian became a popular subject of altarpieces in the latter years of the 15th century. The reason for this lay not simply in his patronage against the plague, but also because he offered artists an opportunity to portray a male nude in an ecclesiastical context. Antonello's Sebastian is "a Christian Apollo" whose sharp silhouette and sculptural physique, composed of precisely defined, almost stereometric forms, can be traced back to Piero's influence. The buildings lining the square in the background are also resolutely cubic. These sculptural forces seem to crystallize out in the cylindrical section of column lying on the ground – a symbol of the heathenism conquered by the martyr's steadfastness. Here too, the close-up focus and the multi-component structure of Antonello's early works have yielded to the large form.

The artist nevertheless retains his gifted eye for still-life detail: the "contemporary" architectural setting, with the carpets hanging over the parapet of the loggia, and the views glimpsed through the arches beneath are amongst the most exquisite in all 15th-century Italian painting. Antonello also carried his treatment of light a step further in his *St Sebastian* panel, a development again reflecting his exposure to Piero.

Antonello's *Sacra Conversazione*, painted in 1475/76 for San Cassiano in Venice, would establish the pattern of all subsequent Venetian versions of the subject right up to Titian. Sadly, the panel was sawn up in the 17th century and its parts lost or scattered amongst various collections. On the basis of the three fragments which have survived in Vienna, together with other visual sources, it is nevertheless possible to reconstruct the original composition. In the barrel-vaulted apse of a domed church, the Virgin and Child are enthroned on a high pedestal, surrounded by eight saints below. The confident handling of perspective and the balanced but not rigidly symmetrical grouping of the figures recall the *Madonna and Child with Six Saints* of c. 1472–1474 which Piero della Francesca painted for Federigo da Montefeltro. The richness with which Antonello renders the materials and lavishly ornamented costumes is counterbalanced by the strictly geometrical organization governing both overall composition and details, as seen for example in the dominant triangular shapes making up the lower section of the Virgin's robe.

Although there is still argument as to whether Antonello's panel preceded Giovanni Bellini's *Pala di San Giobbe* of c. 1487/88 (ill. p. 50), it seems likely to be the case. It was only after 1475, having been exposed to the depth and luminosity of Antonello's palette, that Bellini entered the new phase of development that would determine his entire future œuvre.

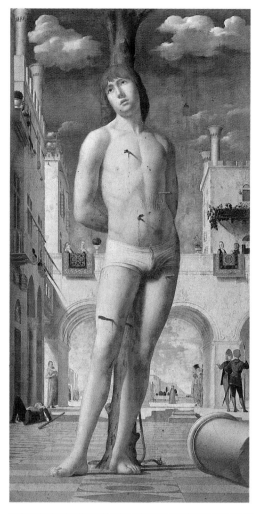

Antonello da Messina
St Sebastian, c. 1476
Tempera on wood, transferred to canvas,
171 x 86cm
Dresden, Gemäldegalerie Alte Meister

Antonello da Messina
Sacra Conversazione, 1475/76 (from San Cassiano, Venice)
Tempera on wood (fragment). Saints Nicholas and Anastasia, 56 x 35cm
Virgin and Child, 115 x 63cm; Saints Dominic and Ursula, 57 x 36cm
Vienna, Kunsthistorisches Museum

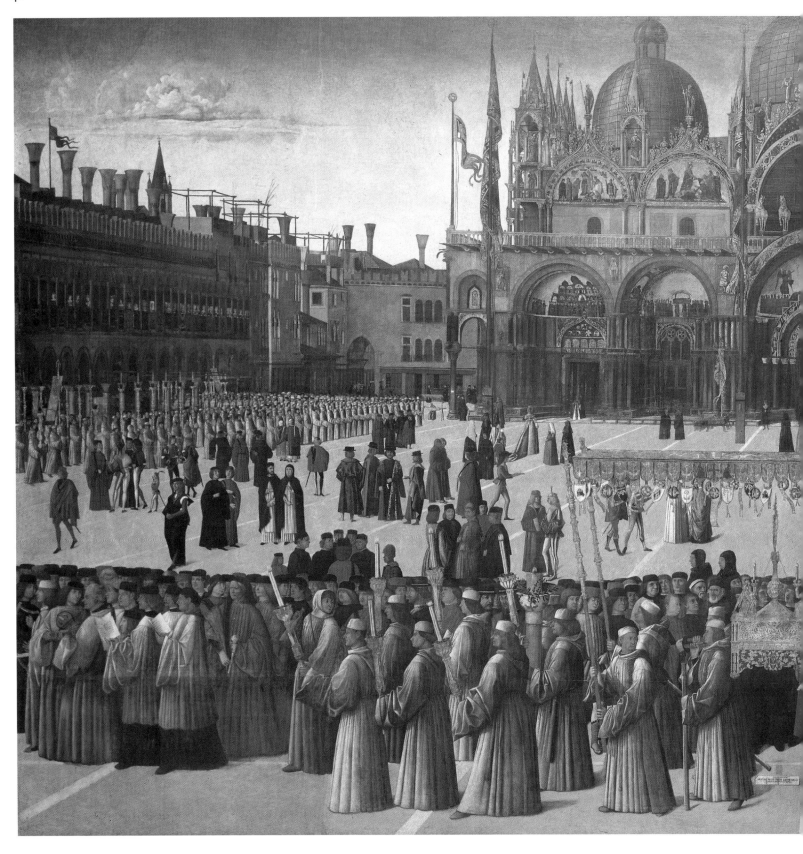

GENTILE BELLINI

1429–1507

Gentile Bellini, eldest son of Jacopo Bellini and Mantegna's brother-in-law, was official artist to the Venetian government and was ennobled by Emperor Frederick III in 1479.

Towards the end of the 15th century, Gentile painted a series of large-format canvases showing scenes from the legend of the True Cross, commissioned by the Scuola di San Evangelista. The cycle clearly testifies to the legacy of his father Jacopo, but while the elder artist conjured landscapes and buildings out of

his imagination, the younger painted them directly from true life. His fidelity to detail was rooted in the sober distance which he maintained from the object, which thus remained uncoloured by emotional response – an approach well suited for large-scale history paintings.

The procession across St Mark's Square is a visual document of the first order. With his precise eye for detail, the painter shows us just how the piazza looked in the late 15th cen-

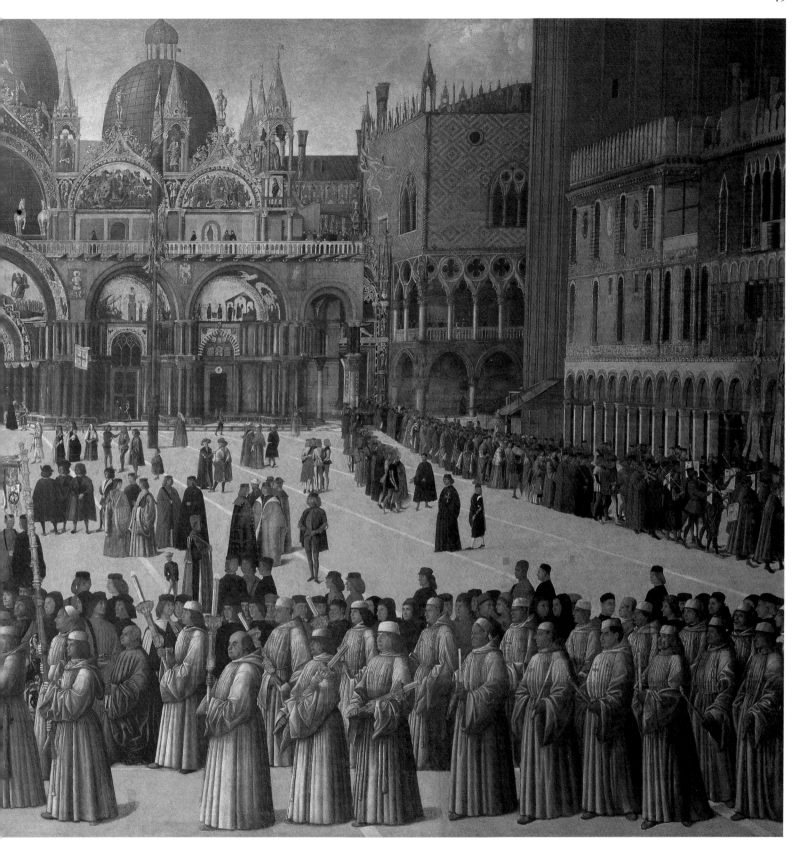

tury, before the offices housing the Venetian adminstration were extended. Such is the historical accuracy of the painting that we may take it as a record of the medieval mosaics on the façade of San Marco. Its huge format is lent a systematic structure by the architectural backdrop and by a geometrical stage-managing of the figural groups. For all its fidelity to external detail, however, Gentile's cycle lacks the "holistic" vision underpinning the altarpieces painted during this same period by

his brother Giovanni and marking the transition to the High Renaissance. In its descriptive character, the cycle heralds the birth of the genre of *vedutà* painting which would later become a Venetian speciality, one which would flower at the hands of Canaletto and Guardi in the 18th century.

Gentile Bellini
Procession in St Mark's Square, 1496
Tempera on canvas, 367 x 745 cm
Venice, Galleria dell'Accademia

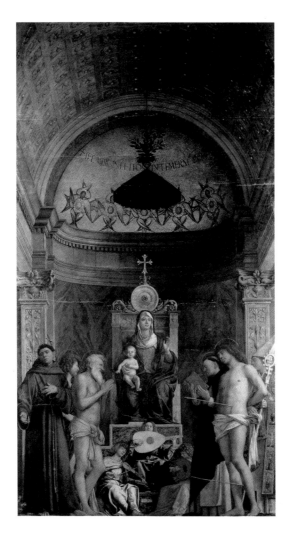

Giovanni Bellini
Sacra Conversazione (Pala di San
Giobbe), c. 1487/88
Tempera on wood, 468 x 255 cm
Venice, Galleria dell'Accademia

GIOVANNI BELLINI
c. 1430–1516

This monumental panel with its almost life-size figures was probably painted in 1487/88 for San Giobbe church, where its magnificent marble surround can still be found. This surround originally served to integrate the altarpiece into its setting, insofar as it amplified the spatial depth created within the painting (whose upper edge has since been altered) and at the same time established a fascinating interplay between reality and illusion.

The Virgin, Child and saints are here gathered together beneath a coffered barrel vault terminating in an apse. There is no longer any need to structure the enormous panel from without. Even though the poses adopted by individual figures are characterized by a maximum freedom from constraint (e.g. St Sebastian), the composition is underpinned by an overall artistic concept in which each element has its fixed place. This stability is created from inside out, as it were, via correspondences of colour, movement and expression which extend across the pictorial surface and beyond. The trio of angels at the foot of the throne repeats the pyramid formed by the main figures, while the strains of their music seem echoed in the harmony of the composition.

While the luminosity of the palette and the supremacy of colour modulation over drawing point to the influence of Antonello da Messina, they simultaneously place Giovanni Bellini at the forefront of a development which, in the Venetian painting of the 16th century, would grant colour a new role as a compositional means in its own right.

This panel is highly typical of a phase in Bellini's œuvre during which he was assimilating the important influence of Andrea Mantegna. Bellini establishes compositional depth via the receding planes indicated by the foreground, the rocky plateau, and the summit of Mount Tabor with the transfigured Christ between the prophets Elijah and Moses. Since each of these planes also appears above the next, Bellini thereby neatly lends visual height to the mountain.

The disciples, seen asleep or awaking with a start, are portrayed in complex foreshortened poses which testify to the artist's new interest in depicting anatomy beneath draperies.

Bellini's debt to Andrea Mantegna – and hence indirectly also to Donatello's Paduan bronzes – is visible above all, however, in the almost calligraphic incisiveness of his line. This is equally evident in the drawing of the rocks and in the folds of the draperies, which might almost be cast in metal. The palette is correspondingly characterized by strong local colours serving an emphatically representational function.

It is probable that the top of this panel was originally arched and that it featured the figure of God the Father surrounded by cherubim. For unknown reasons, however, it was cut off before 1780.

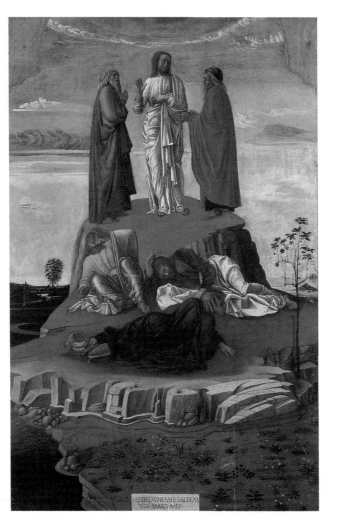

Giovanni Bellini
Transfiguration of Christ, c. 1460
Tempera on wood, 134 x 68 cm
Venice, Civico Museo Correr

The new genre of portraiture taking root in Tuscan and Flemish painting in the early 1400s failed to establish itself in Venice to the same degree. Only in the late 15th century, not least under the influence of Antonello da Messina, was the freedom to paint the individual finally won.

This late work by Bellini, dating from the opening years of the 16th century, marks the high point reached by Venetian portraiture at the gateway from the Early to the High Renaissance. The artist demonstrates equal mastery in his treatment of physiognomical detail and of fabrics and decorative detail. Modelling arises exclusively from the interplay of light and shade. There is no attempt to employ conventional means of perspective; the fact that the doge's head is slightly turned is indicated by the strings falling from his hat.

Something of an icon-like quality lingers on in Bellini's portrait in the unspecified nature of the doge's setting, his appearance reminiscent of a marble bust, and his distant expression.

It is difficult to decipher the subject-matter of this scene, which numbers amongst the chief works of Bellini's mature period. Although certain figures – including St Sebastian, St Paul dressed in red and wielding a sword, and the Virgin enthroned – can be directly identified, they provide no clues to the meaning of the whole.

The panel inaugurates a series of partly Christian, partly mythological scenes, the key to which probably lies buried in the corpus of 15th-century theological humanist literature. The present panel is possibly one known to have been painted in response to a commission from Isabella d'Este for a Nativity; unwilling to fulfil the wishes of his noble patroness, Bellini executed a different panel in line with his own ideas.

Attempts to decode this painting have been further complicated by subsequent alterations to the composition. The oriental man at the left-hand edge is a clear addition, since the grass over which he has been painted is visible through his robes. Meanwhile, the figures of Sebastian and Job (or Jerome?) on the right do not share the same quality of modelling.

Bellini shows himself in full possession of his compositional skills in every area. His easy mastery of perspective is demonstrated in the terrace in the foreground, its marble slabs arranged in an artistic and complex pattern, while the qualities of the different materials are evoked in an almost illusionistic fashion. Above all, however, Bellini reveals himself here to be the great Italian landscape painter of the late 15th century. He thereby achieves his spatial depth not with linear perspective but with colour modulation. Following in the footsteps of Antonello da Messina, Bellini arrives at a rich gradation of light which looks forward to the painting of Giorgione.

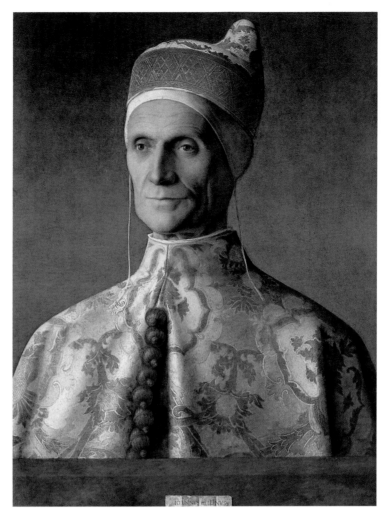

Giovanni Bellini
Portrait of Doge Leonardo Loredan, c. 1501–1505
Tempera on wood, 62 x 45 cm
London, National Gallery

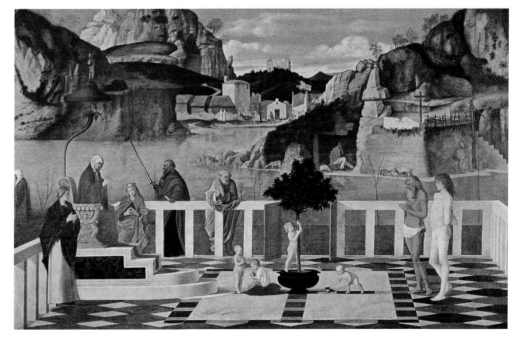

Giovanni Bellini
Christian Allegory, c. 1490
Tempera on wood, 73 x 119 cm
Florence, Galleria degli Uffizi

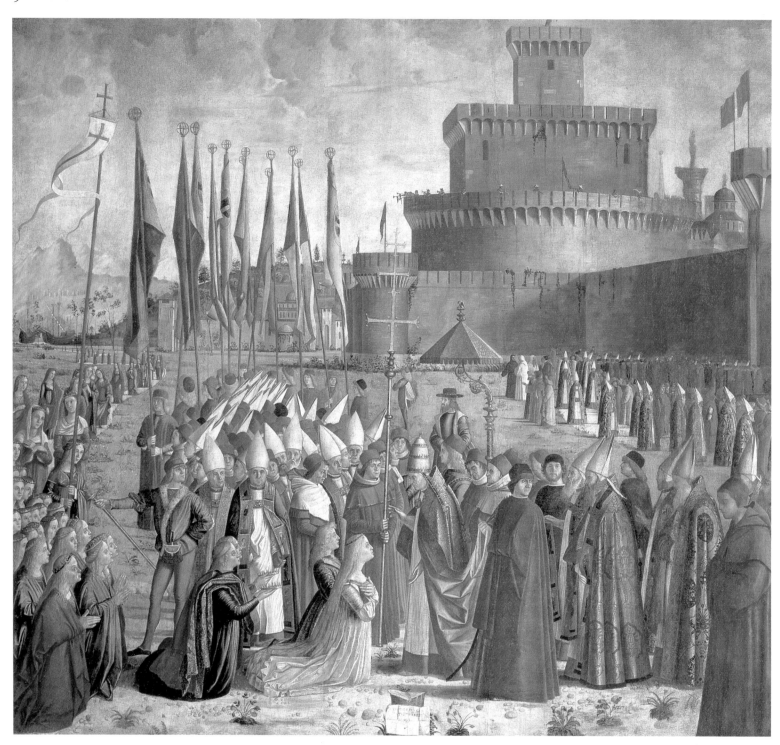

Vittore Carpaccio
Scenes from the Life of St Ursula:
The Pilgrims are met by Pope Cyriacus
in front of the Walls of Rome, c. 1491
(from the Scuola di Santa Orsola, Venice)
Tempera on canvas, 281 x 307 cm
Venice, Galleria dell'Accademia .

VITTORE CARPACCIO

C. 1455/65 – 1526

Alongside Hans Memling's *Martyrdom of St Ur-sula* (ill. p. 61), the nine large canvases which Carpaccio executed for the confraternity of St Ursula in Venice represent the most detailed treatment of the legend of St Ursula in Early Renaissance painting. Carpaccio's approach to history painting is directly related to that of his teacher Gentile Bellini, although without the absolute fidelity to background setting and architecture. While Bellini painted his native city of Venice, Carpaccio had to portray the various stops along the pilgrimage from England to Rome made by St Ursula and her betrothed, none of which he knew at first hand. Although the present scene, in

which the couple are met by the Pope, takes place against the backdrop of the Castel Sant'Angelo, the latter is set amidst the hills of the Venetian mainland. The artist would have seen the castle in drawings or engravings of Roman monuments.

Carpaccio creates order within his large canvas using similar compositional means as his teacher: the main group of figures in the foreground, aligned parallel to the plane, is bounded to the left and right by other groups leading into the background. The solid block of the Castel Sant'Angelo is linked to the foreground by the row of flags, which simulta-neously connect the front and rear, top and bottom of the canvas. In contrast to the severe style of Bellini the painter-chronicler, Carpac-cio treats details with an imaginative flair and employs a cheerful palette.

JAN VAN EYCK

C. 1390–1441

Jan van Eyck painted this wedding portrait of Giovanni Arnolfini, a merchant from Lucca who was based in Flanders, in 1434. The painter clearly attended the marriage celebration, since an inscription on the back wall between the chandelier and the mirror reads: "Johannes de eyck fuit hic 1434" (Jan van Eyck was here 1434). The convex mirror, which is framed by small medallions depicting scenes from the Passion, shows the two main figures from behind and two smaller male figures from the front – an ingenious way of reflecting the spectator's side of the room into the painting.

The composition is symmetrical in layout, with the central axis emphasized by the chandelier, the mirror, the couple's joined hands and the dog in the foreground. Spatial depth is created less by vanishing lines than by the way in which figures and objects overlap. The foreshortened side walls are repeatedly reinterpreted in verticals.

The faces of the two figures, who are wearing contemporary dress, are surprisingly lacking in the individuality associated with portraiture. By contrast, smaller details exude all the more "personality": the shimmering chandelier in which a single wedding candle is still burning, for example, together with the mirror, the clothes, the rug, and the window at the left, with its glimpse of the world beyond. Jan van Eyck thereby lends his materials – fur, velvet, silk, linen head-dress, dog's coat – an almost tangible quality.

Nicolas Rodin, Chancellor of Burgundy and Brabant and employed by Philip the Good as from 1422, commissioned this panel for the collegiate church in Autun. The donor is the same size as the Virgin before whom he kneels in supplication. His face is clearly a portrait and he is dressed in a brocade coat rendered in highly naturalistic detail. The room in which the scene takes place appears to be located in a tower and is decorated with princely splendour. The artist largely renounces vanishing lines and instead organizes the foreground figures and arches parallel to the plane. Two figures seen from behind on the crenellated parapet outside lead the eye to a lower-lying landscape, through which a river meanders away towards a distant range of hills. This type of landscape, seen from a superior vantage point, forms one of the roots of the "global landscape" which developed as from the early 15th century.

The modern viewer must guard against explaining these features purely in terms of a new approach to reality, however. Van Eyck's painting clearly draws upon 12th-century treatises on the Virgin Mary and the Song of Solomon by Honorius Augustodunensis, which provided the literary source of such details as the setting in a tower overlooking the town, the crenellated battlement, the course of the river, the snow-capped mountains in the background and even the activities of the town's inhabitants. Artistic innovation and iconographical tradition cannot be seen as independent of each other.

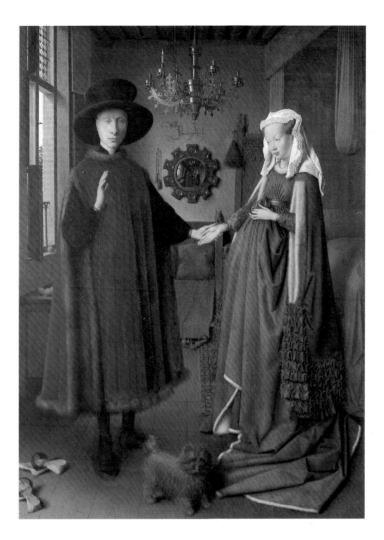

Jan van Eyck
Giovanni Arnolfini and his Wife Giovanna Cenami (The Arnolfini Marriage), 1434
Tempera on wood, 82 x 60 cm
London, National Gallery

Below:
Jan van Eyck
The Virgin of Chancellor Rolin, 1434–1436
Oil on wood, 66 x 62 cm
Paris, Musée National du Louvre

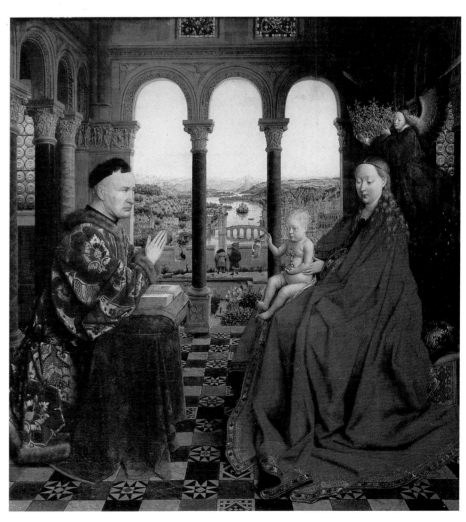

Jan or **Hubert van Eyck**
Madonna in a Church, c. 1437–1439
Oil on wood, 31 x 14 cm
Berlin, Gemäldegalerie, Staatliche Museen
zu Berlin – Preußischer Kulturbesitz

Below:
Jan van Eyck
The Virgin and Child in a Church, 1437
(central section of a portable altar)
Oil on wood, 27.5 x 21 cm
Dresden, Gemäldegalerie Alte Meister

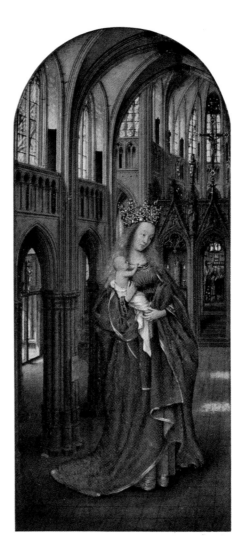

JAN VAN EYCK

C. 1390–1441

While the modelling and the serpentine pose
of the Madonna are indebted to the Interna-
tional Gothic, the church interior is charac-
terized by an extraordinary wealth of keenly
observed detail. Despite certain inconsisten-
cies within the perspective system – Mary is
portrayed on a disproportionately large scale –
the painter creates a powerful impression of
space, not least by positioning the outsized
figure of the Virgin in the middle of the nave.
The interior clearly belongs to the sphere of
the Burgundian Gothic. In contrast to Italy,
the northern artist's interest in individual de-
tail is clearly apparent.

The panel below, once the central section of a
portable altar, demonstrates a new freedom in
its handling of space. The Virgin is portrayed
deep inside the church interior, its depth em-
phasized by the receding flight of different-col-
oured columns. In comparison to the *Madonna
in a Church*, the size ratio between architecture
and figures is more natural, while the architec-
ture itself belongs to a more advanced style.
Purely Gothic forms have given way to Re-
naissance elements: the plinths and pillars
now have a base, shaft and capital; the rounded
has replaced the pointed arch; and the horizon-
tals over the arcades are emphasized. In his
rendering of the material qualities of the car-
pets, canopy and ornament, Jan van Eyck
reaches the pinnacle of his abilities.

The Ghent Altar represents the founding work
of Netherlandish Early Renaissance painting.
In its open position, the central section shows
the approximately life-size figure of Christ (or
God the Father?) between Mary, intercessor for
humankind at the Last Judgement, and John.
Underneath we see the inhabitants of the City
of God adoring the Lamb. Common to all four
panels are their exquisitely luminous colours
and their painstaking reproduction of details –
sumptuous robes, sparkling jewels, and indi-
vidual facets of the landscape and architecture.
In terms of its artistic qualities, the Ghent
Altar is without rival in painting around 1430.
 The altarpiece is unusual, however, in its ar-
rangement of large single figures above a scene
smaller in scale and of much greater complex-
ity. Equally surprising is the contrast between
the setting in the upper three panels – re-
stricted to a tiled floor – and the sweeping
landscape below. Have two different projects
here been combined into a single altarpiece?
Has the uncertainty surrounding the identity
of the central enthroned figure (Christ or God
the Father?) in fact arisen out of the belated
superimposition of the Holy Ghost and God
the Father above the Lamb (i.e. Christ), lend-
ing the whole the nature of a Trinity?

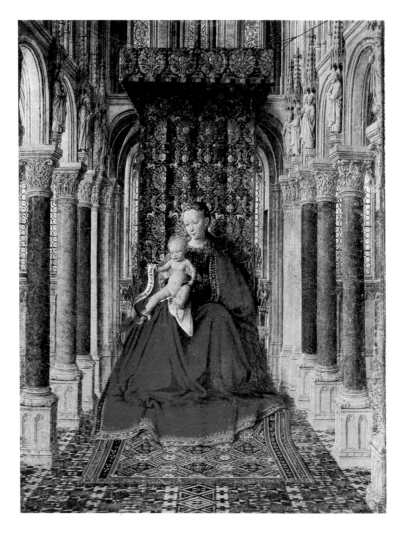

Jan van Eyck
Ghent Altar (central section), 1432
Oil on wood. Virgin and John the Baptist: each
167 x 72 cm; Christ: 210 x 80 cm; Adoration of
the Lamb, 134 x 237 cm. Ghent, St Bavon

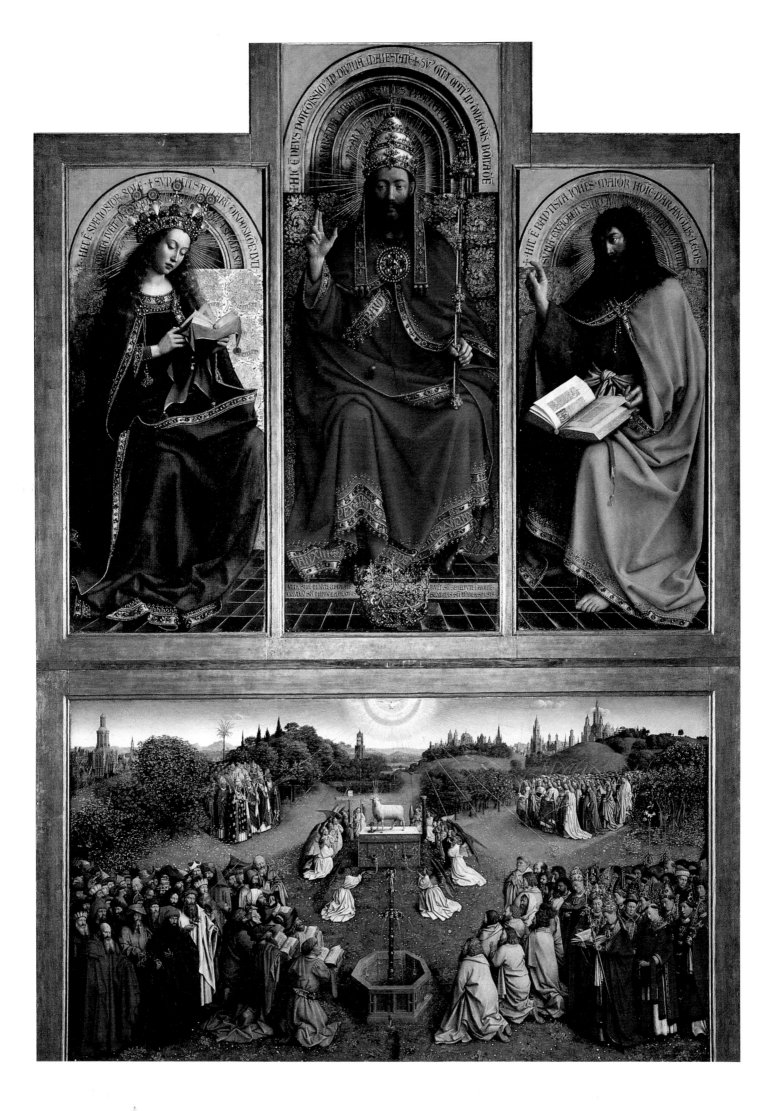

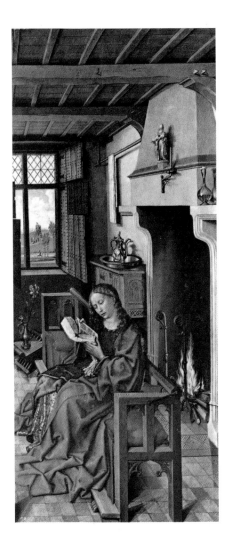

Robert Campin
St Barbara, 1438
(right wing of a triptych)
Tempera on wood, 101 x 47 cm
Madrid, Museo del Prado

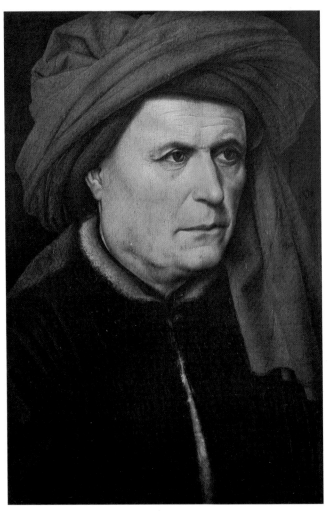

Robert Campin
Portrait of a Man, c. 1435
Tempera on wood, 41 x 28 cm
London, National Gallery

ROBERT CAMPIN
C. 1380–1444

While not all doubt has been finally removed, the painter long known as the Master of Flémalle is now generally accepted to have been Robert Campin, Rogier van der Weyden's teacher. No other Netherlandish painter of the early 15th century dedicated himself so passionately to the perspective study of receding interiors. The composition of the present painting, which forms the right-hand wing of a triptych, is deliberately oriented towards the central panel to its left. A host of vanishing lines leads from the right-hand foreground to the window rear left, whereby the tiled floor, the fireplace, the sideboard, the open shutters, the ceiling beams and, in particular, the unusually long bench with its eye-catching red cushions all combine to draw the eye into the depths. The figure of St Barbara, ostensibly the main theme of the painting, is thereby relegated to second place: the true subject of this panel is space itself!

Unlike his Italian contemporaries, however, Robert Campin bases his perspective system not on mathematical calculations but on "personal" experience. Thus the floor and the ceiling, for example, have very different vanishing points. The room nevertheless seems to accelerate away into the depths of the composition in what has been graphically described as a "precipitous" fashion.

The artist strikingly omits all reference to feudal or sacred architecture. St Barbara is presented in a purely middle-class interior, whereby the painter's painstaking attention to detail is directed towards everyday objects, not the trappings of court life.

The winged altar, painted in 1438, is also known as the Werl Altar after its donor, and is the only dated work by Campin. The central panel is today lost; the left-hand wing shows the donor, Heinrich von Werl, kneeling beside John the Baptist.

Alongside Jan van Eyck, Robert Campin embraced the new genre of portraiture with a fervour matched by no other painter north of the Alps at the beginning of the 15th century. Campin thereby respected the opportunity it offered for capturing an individual likeness (even by the time of Rogier van der Weyden, a certain degree of stylization had begun to set in.)

The present portrait is characterized by a tendency towards three-dimensional modelling and by the observation of even the smallest detail, typically illustrated in the differentiated treatment of the eyes and the mouth. It is thereby conceived in relation to a female pendant also housed in London,

While the palette is limited to a small number of dominant hues, the artist nevertheless achieves a range of extremely delicate nuances through the use of light and shade. The treatment of the different textures of skin, fabric and fur collar renders them almost tangible.

A surprising feature of this portrait is the manner in which the half-length figure is firmly held between all four edges of the panel, whereby his red head-dress extends beyond the top and the right-hand side of the composition.

ROGIER VAN DER WEYDEN

c. 1400–1464

This *Sacra Conversazione* may have been painted in 1450, the year in which Rogier visited Rome. Iconographical details indicate that it was probably commissioned by the Medici family (Saints Cosmas and Damian on the left were the Medici's patron saints, and a modified Florentine lily appears in the coat of arms).

The composition, in which the figures are grouped in a stepped, semicircular arrangement whose gentle curve is restated in the upper arch of the frame, may have been inspired by Domenico Veneziano's St Lucy altarpiece (ill. p. 28). A comparison of the two works nevertheless also reveals the fundamental differences between Flemish and Florentine painting around the middle of the 15th century. Rogier's figures stand close together; in comparison to Domenico's distinctly separate figures, Peter and John here appear directly connected. Their proportions are elongated (compare, for example, the two Johns) and they are given solidity more by the outlines of their robes than by the organic structure of their bodies.

In the precision and texturing of his details, on the other hand, as seen in the plants and vase in the foreground, the glass bottle in St Cosmas' hand, and the sumptuous damask inside the tent-like baldachin, Rogier introduced his Florentine contemporaries to what must have been a whole new experience of painting.

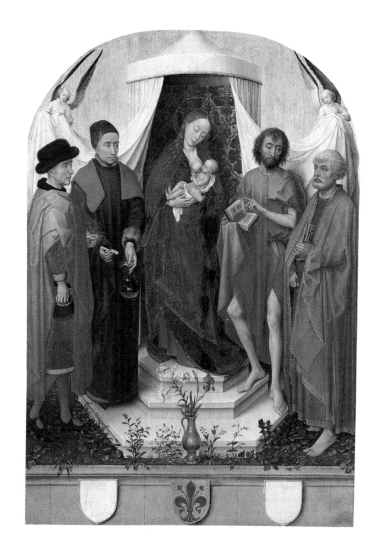

Rogier van der Weyden
Madonna with Four Saints
(Medici Madonna), c. 1450
Tempera on wood, 53 x 38 cm
Frankfurt am Main, Städelsches
Kunstinstitut

Rogier was clearly thinking of an altar shrine with carved figures when he painted this panel, something evidenced not simply by the background with the flat moulding and ornamental tracery in its upper corners, but also by the composition of the figures as if in high relief.

Rogier's artistic temperament, so fundamentally different to that of Jan van Eyck, is here illustrated in exemplary fashion. In contrast to van Eyck's intuitive style of composition, Rogier adopts an intellectual approach in which everything is thought through to a remarkable degree. The pictorial plane is structured by means of corresponding or complementary lines of movement and direction, as illustrated in the figures of John on the far left and Mary Magdalene on the far right – mutually corresponding for all the differences in their expression and modelling – and in the repetition of the dead Christ's pose in the fainting figure of the Virgin Mary. Christ and Mary's arms directly trace the two directions governing the composition.

In comparison to the powerfully modelled but, beneath their draperies, relatively undifferentiated figures of van Eyck, Rogier renders his figures in greater detail and allows their anatomical structure to emerge more clearly despite their elongated proportions.

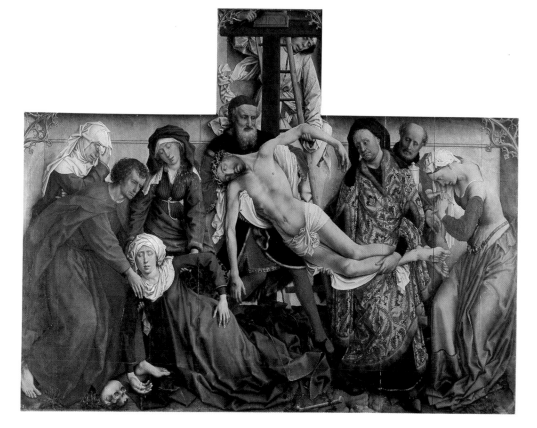

Rogier van der Weyden
Descent from the Cross,
c. 1435–1440
(central section of a triptych)
Tempera on wood, 220 x 262 cm
Madrid, Museo del Prado

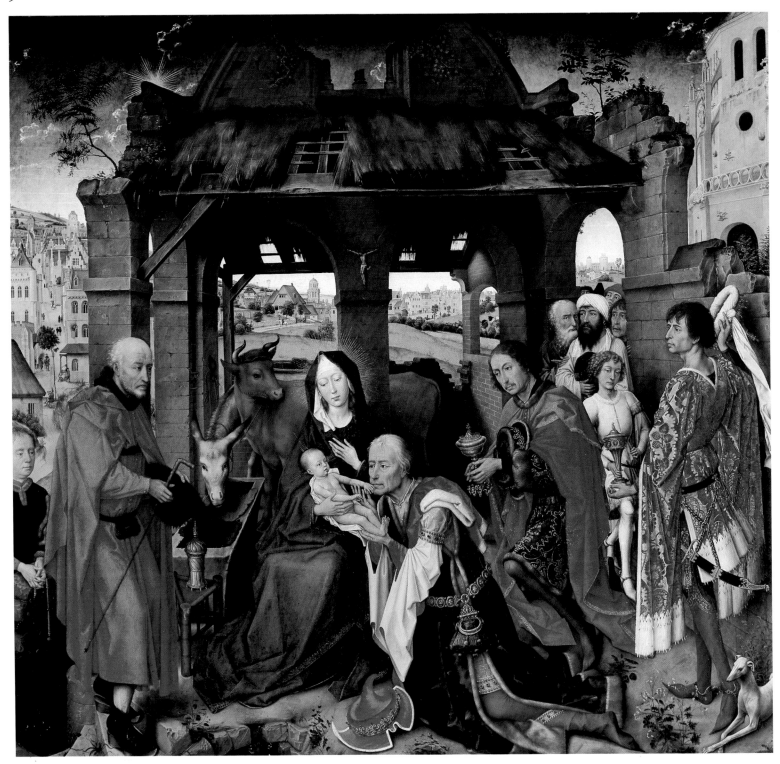

Rogier van der Weyden
Adoration of the Magi, c. 1455
(central section of the St Columba Altar) from
St Columba, Cologne
Tempera on wood, 138 x 153 cm
Munich, Bayerische Staatsgemäldesammlungen,
Alte Pinakothek

ROGIER VAN DER WEYDEN

C. 1400–1464

Rogier was at the height of his artistic powers
when, in around 1455, he painted the *Adora-
tion of the Magi* altarpiece for the church of St
Columba in Cologne. He had by now fully as-
similated the impressions left by his trip to
Italy ten years earlier. The central panel of the
Adoration is flanked on the left by an *Annunci-
ation* and on the right by the *Presentation of
Christ in the Temple*.

The composition of the present panel dem-
onstrates a masterly balance between freedom
and discipline. The Virgin and Child are
shifted slightly to the left of the middle axis,
which appears to run through the central pillar
and down into the hat of the kneeling king. In
fact, however, even these two details lie
slightly left of centre. This left-hand bias is
compensated by the figures of the second kneel-
ing king and the third, youngest king, visually
strongly accented by his expansively angled
pose. The asymmetrical ruins of the stable
correspond precisely to the composition of the
main group. Insofar as Rogier arranges his
figures from left to right in the style of a relief
and orients his architecture parallel to the pic-
torial plane, he remains true to the principles
underlying his *Descent from the Cross*. Here, how-
ever, he displays a more sovereign mastery of
the organic structuring of the human figure
and the partial creation of spatial depth.

The central panel of the Braque triptych shows Christ between the Virgin Mary and the half-length figure of John the Evangelist; the left-hand wing portrays John the Baptist, and the right-hand wing Mary Magdalene. The exterior, today in poor condition, bears the coat of arms of the donor and the names Braque and Barban. Since Jehan Braque, a Tournai knight, died in 1452, and since "un tableau à cinq ymaiges" is mentioned in the estate of his wife Cathérine de Brabant, this altarpiece can probably be dated to 1452 or thereabouts. Triptychs featuring half-length figures were previously unknown north of the Alps, although they had been familiar in Italy since the 13th century. In this respect, the Braque altarpiece reflects another of the influences to which Rogier was exposed during his visit to Italy.

Rogier describes the figure of Mary Magdalene in unbroken contours which emphasize the various components of her body. The three-quarter view must be seen in conjunction with the other two panels. In place of complex folds of drapery, we are struck by the ornamental pattern decorating the red and gold fabric of her sleeve.

The collected, introspective expression on Mary Magdalene's face matches the calm mood of the landscape stretching far into the distance. On the right-hand edge of the panel rises a steep rock; corresponding to the head of the figure, it also serves to conclude the triptych as a whole.

Rogier's *Entombment* was originally housed in the Medici family's Villa Careggi and was therefore probably executed around 1450 in Florence. Once again, it bears witness to the painter's confrontation with Italian art. The composition is based on a predella panel by Fra Angelico from the former high altar of San Marco in Florence, from where Rogier borrows the upright figure of Christ – a pose not commonly found in conventional treatments of the subject – between the Virgin Mary and John, and the tomb inside the rock behind. Rogier nevertheless counters the taut, almost geometric arrangement of Fra Angelico's panel with a freer composition involving a larger number of figures. Christ has been released from the rigorous confines of the central axis. The kneeling figure of Mary Magdalene leads our eye into the picture and, through her connection with John the Evangelist stepping forward on the left, initiates a sequence of movement which is underlined by the oblique angle of the door of the tomb. The angled position of Christ's body, in combination with the three crosses on Calvary hill behind and the shroud spilling forward across the tombstone at Christ's feet, suggests that Rogier is sharing with us a scene in the events somewhere between the Deposition and the Entombment.

In comparison to Fra Angelico, the individual detail everywhere supplants the typical – in the physiognomies, expressions and landscape features. As Cyriacus of Ancona noted of one of Rogier's paintings in 1449: "The faces that the painter wanted to show as living we see breathing, and the departed as perfectly resembling a corpse."

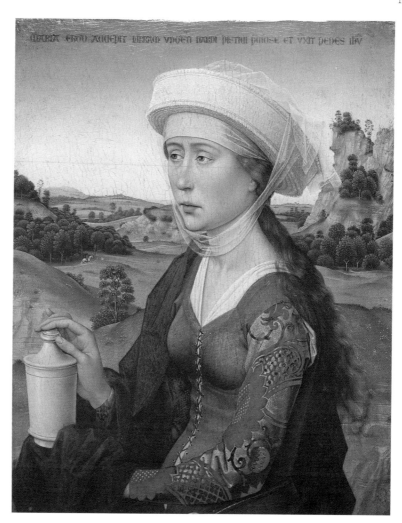

Rogier van der Weyden
Mary Magdalene, c. 1452
(right wing of the so-called Braque Altar)
Oil on wood, 41 x 34 cm
Paris, Musée National du Louvre

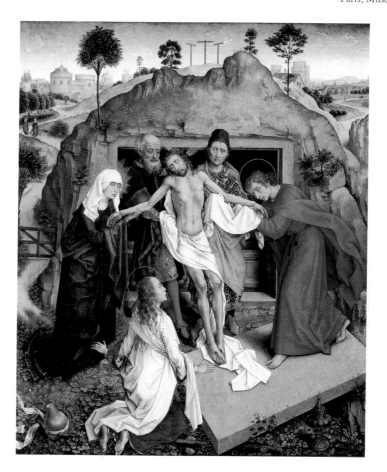

Rogier van der Weyden
Entombment, c. 1450
Oil on panel, 110 x 96 cm
Florence, Galleria degli
Uffizi

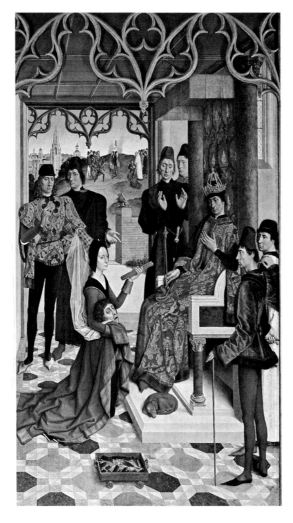

Dieric Bouts
The Empress's Ordeal by Fire in front of Emperor
Otto III, c. 1470–1475
Tempera on wood, 324 x 182 cm
Brussels, Musées Royaux des Beaux-Arts

Below:
Dieric Bouts
Last Supper (central section of an altarpiece),
1464–1467
Tempera on wood, 180 x 150 cm
Louvain, Sankt Peter

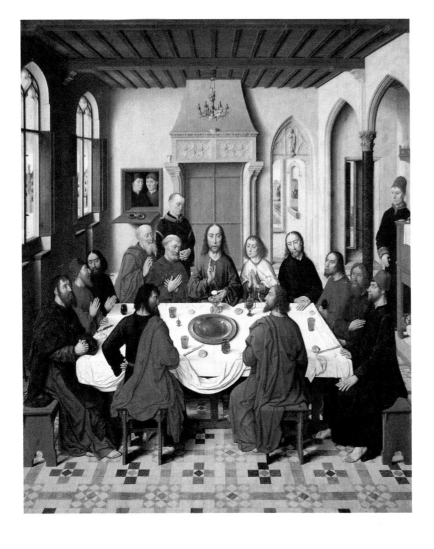

DIERIC BOUTS

C. 1410/20–1475

In 1468 Bouts was commissioned to paint four panels, their subjects serving as an exhortation to justice, for the courtroom of the city of Louvain. By the time he died, however, he had only finished one painting, with a second in progress. His work is said to have been admired by Hugo van der Goes.

The episode related in the present panel concerns calumny. The Empress is denouncing the innocent Count, whom she attempted to seduce, to Otto III. She is subjected to an ordeal by fire which proves the Count's innocence. The story is derived from the Biblical tale of Potiphar's wife, who tried to seduce Joseph in Egypt and who levelled false accusations at him when he refused her. Bouts may have taken his inspiration from Rogier van der Weyden, who painted similar subjects for the Town Hall in Brussels in 1436; these were destroyed in 1695, however.

In contrast to the *Last Supper* below, the composition is dominated by an extreme tendency towards the vertical, something already established by the format. The figures are strikingly elongated; those at the edges of the picture, especially, serve to visually restate the lateral sides of the frame and almost seem to fulfil the function of architectural elements. Physical volume is thereby entirely negated. Although an expansive landscape opens up in the background, the eye is primarily led not into the depths of the painting, but to the top. Within Netherlandish painting, Bouts' Justice panels designate the most advanced point reached by the Gothic revivalist tendencies characteristic of larger towns and cities in the second half of the 15th century.

This *Last Supper* from Sankt Peter in Louvain forms the central panel of a winged altarpiece commissioned by the confraternity of the Holy Sacrament. The painter was bound by contract to execute the work himself and thereby to follow the directions of two professors of theology.

For the first time, we are shown not the moment when Christ announces his impending betrayal, but the establishment of the Host. By its very nature, therefore, it is not a scene of intense drama – something which clearly suited the artist's temperament. In comparison to the masters of the early 15th century, Bouts undoubtedly creates a spacious setting, but one which feels more "empty" than solid. The impression of depth is countered by the verticals typical of the period after 1450, as seen in the portrait format, the almost bird's-eye view of the floor, and the many perpendicular elements in the side walls.

The severity of the composition makes the whole seem less lifelike and distances us from the scene. The skilfully emphasized central axis is also the axis of symmetry. The corporeality of the figures is sharply reduced, and the disciples seen from the rear in front of the table almost resemble flat planes of drapery folds. Overall, the panel contrasts sharply with the sensual wealth so characteristic of the 15th century.

HANS MEMLING

c. 1430/40–1494

The carved and gilded shrine in the form of a small church containing the relics of St Ursula is decorated with paintings on all four sides. The two lateral sides each feature three scenes from the life of St Ursula, while the two narrower ends show the saints and the 11,000 virgins, the Virgin and Child and the donors. The decoration of the shrine occupies a central position in Hans Memling's wide-ranging œuvre and demonstrates both his outstanding qualities and his limitations as an artist. His energies are devoted above all to the portrayal of single figures in graceful poses, to the realistic observation of detail, and to an exquisite palette which is often reminiscent of miniature painting. Although Memling is a narrator, dramatic climax is foreign to his temperament even in a scene of martyrdom. He lacks depth of expression and the ability to convincingly "stage-manage" crowd scenes. Instead, he provides a wealth of inexhaustibly varied details which together "add up" into the overall composition. A comparison with Carpaccio's more or less contemporaneous treatment of the St Ursula legend (ill. p. 52) is particularly illuminating.

Memling was clearly familiar with Cologne at first hand, as demonstrated by his accurate portrayal of the city skyline in the background, showing the unfinished cathedral, the distinctive tower of Great St Martin's church and, on the left, the church of St Cunibert.

This portrait is a typical example of the genre and its stage of development within late 15th-century Netherlandish painting. While the variegated marble pillar in the background indicates a rather grander setting than, for example, the architecture of Robert Campin (cf. ill. p. 56), the location in fact plays only a secondary role. Perspective details are lacking, and the distance between the front edge of the picture and the parapet draped with the carpet behind appears to be extremely short. The half-length figure of the genteel young man is correspondingly lacking in physical depth; although seen in a three-quarter view which incorporates the room beyond, the positioning of his hands and the elements of his costume convert three-dimensional space into two-dimensional plane. In place of powerful sculptural volumes and a balancing of horizontal and vertical values, we find here an emphasis upon the perpendicular and a precise observation of detail, both in the figure and the clothing, as evidenced by the differentiated modelling of the eyes, the sensitive, slightly asymmetrical drawing of the lips, and above all by the almost photographic rendering of the fingers. Memling displays the same painstaking care in his treatment of the richly trimmed sleeves.

In providing a glimpse of landscape in the right-hand corner, Memling obeys a convention which was common in Early Renaissance portraiture and which would remain popular even into the 16th century. In keeping our view into the outdoors narrow, he neither distracts our attention from the sitter nor influences the mood of the scene.

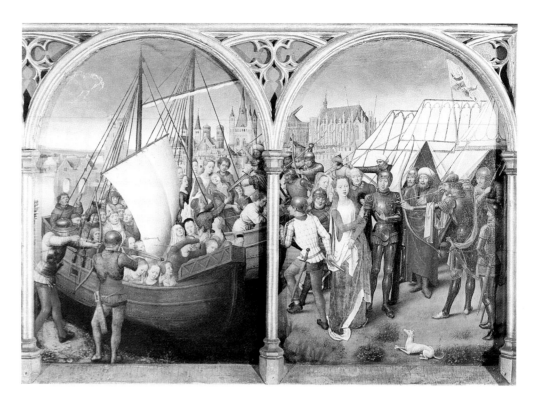

Hans Memling
The Martyrdom of St Ursula's Companions and
The Martyrdom of St Ursula
From the Shrine of St Ursula, consecrated in 1489
Oil on wood, each 35 x 25 cm
Bruges, Sint Janshospitaal

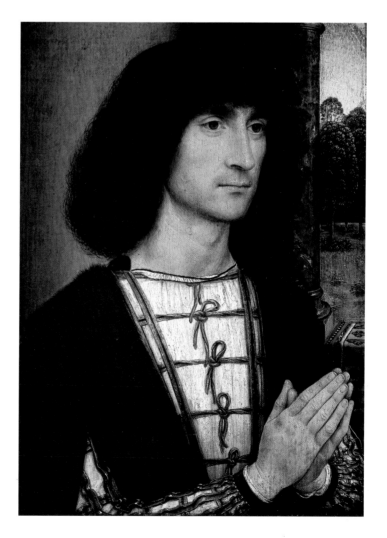

Hans Memling
Portrait of a Praying Man,
c. 1480–1485
Oil on wood,
29.2 x 22.5 cm
Castagnola, Sammlung
Thyssen-Bornemisza,
Schloss Rohoncz

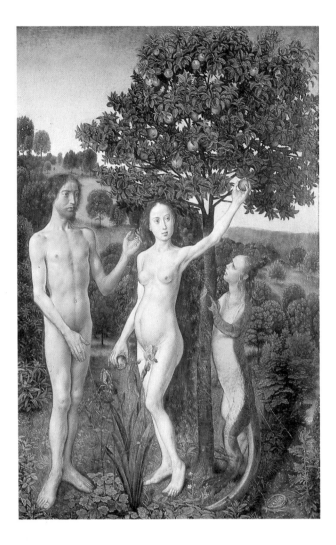

Hugo van der Goes
The Fall of Adam, before 1470
(left side of a diptych)
Oil on wood, 34 x 23 cm
Vienna, Kunsthistorisches Museum

HUGO VAN DER GOES
C. 1440/45–1482

This panel is one of the earliest surviving
works by Hugo van der Goes. The figures of
Adam and Eve look back to the Ghent Altar
by Jan van Eyck. In his development of ana-
tomical detail, however, Goes goes beyond the
older master, whereby he models his figures
less with the aid of line and contour and more
by means of colour modulation.

The composition is still largely governed
by the laws of the plane: Adam, Eve and the
serpent, here with a human head, are pres-
ented side by side, very close to the front edge
of the picture. Together with the Tree of
Knowledge, they form a sort of relief layer, set
against the foil of the landscape behind. The
shady middle ground plays a minor role in
visual terms. Only on the right are we offered
a glimpse into the far distance.

The miniature-like format is matched by
the artist's precise execution of detail: the
grasses, flowers and leaves in the foreground
are each treated as independent and distinct.
The irises, one of which points to Eve's womb,
may also refer symbolically to the Virgin
Mary. It is interesting that Goes chooses the
blue iris rather than the white lily, a tradi-
tional symbol of purity in Annunciations, for
example.

Although Hugo van der Goes' artistic develop-
ment can only be traced over a short period of
time, it nevertheless spans a wide stylistic
range. The Berlin *Adoration* thereby represents
the painter's mature phase, and the Portinari
Altar his late period. The present panel was
originally flanked by two wings showing the
Nativity and the *Presentation in the Temple*. It is
also missing most of the top section which
once extended above the figure of the kneeling
king, and in which a circle of angels floating
in the sky provided a harmonious conclusion
to the composition.

In comparison to *The Fall of Adam*, the
figures have gained in volume, the spatial or-
ganization in freedom, and the composition in
inner stability. So, for example, while the three
main figures are positioned at different dis-
tances from the front edge of the picture, they
are planimetrically contained within a
triangle. The youngest king standing on the
right provides the composition with its inter-
nal conclusion. The architecture running at a
slant away from the spectator leads the eye
into the picture and at the same time lends
rhythm to the main group.

The most convincing explanation for this
astonishing artistic development would be
that Hugo van der Goes made a trip to Italy.
In view of the lively trade which flourished be-
tween Flanders and Florence, and in particular
in view of the personal links between Hugo
van der Goes and the Portinari family, such a
direct exposure to Italian stimuli seems more
than likely.

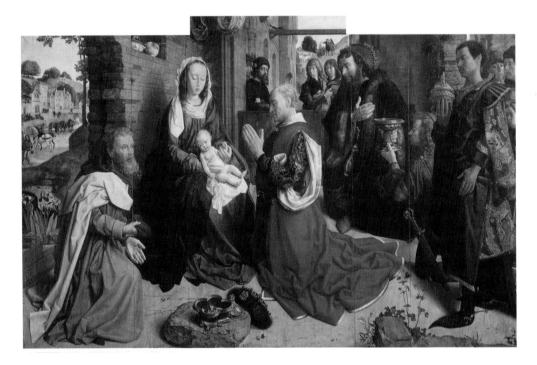

Hugo van der Goes
Adoration of the Magi, c. 1470
(centre panel of the Monforte Altar; from the
Monforte de Lemos cloister, Spain)
Oil on wood, 147 x 242 cm
Berlin, Gemäldegalerie, Staatliche Museen
zu Berlin – Preußischer Kulturbesitz

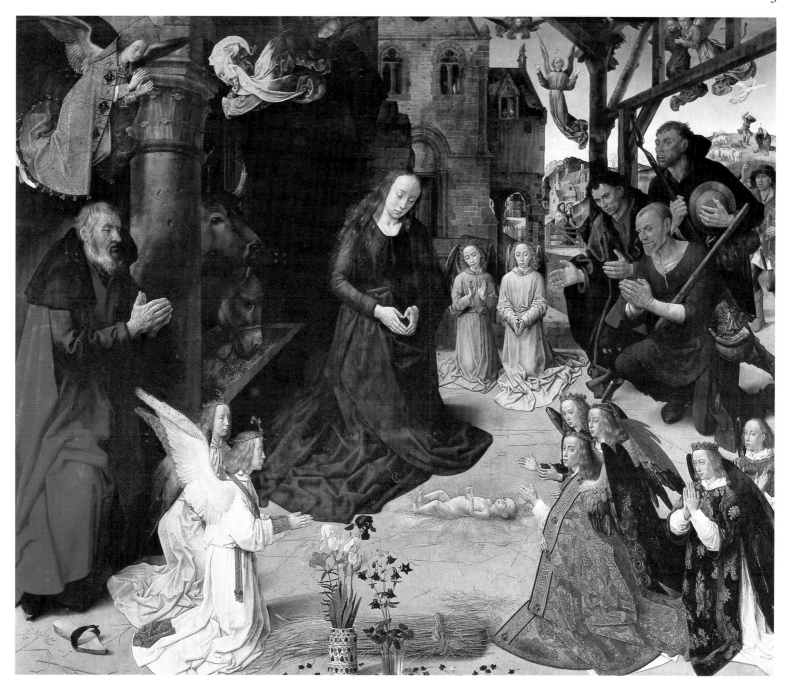

The *Adoration of the Shepherds*, the most important work by the greatest Netherlandish painter of the late 15th century, has a unique historical and artistic significance. The altar was donated to the Florentine church of San Egidio by Tommaso Portinari, who since 1465 had been living in princely style in Bruges as manager of the Medici family's commercial interests. The central panel is flanked by two wings depicting other members of the Portinari family and the family's patron saints, with a grisaille *Annunciation* on their reverse.

From an artistic point of view, the differences between this work and those of the preceding generation, and indeed earlier paintings by the same master, are astounding. While space and anatomy are easily mastered, they are no longer major themes of the composition. The infant Jesus lies within an aureole in an outdoor square, surrounded by his parents, clusters of angels and the worshipping shepherds. The more or less circular arrange-

ment of the figures can be perceived equally in three-dimensional and two-dimensional terms. While the figures may have lost volume in comparison to the Monforte Altar, their faces and gestures have gained in expressiveness. A certain impression of spatial depth is suggested by the figures' varying distances from the front of the picture and by the oblique line running from the Antique-style column beside Joseph in the left-hand foreground, through the manger with the ox and ass, and on through the buildings in the middle ground. Its logic is overthrown, however, as the artist reverts to the medieval system in which figures are portrayed on a scale directly related to their importance. Thus the angels in the foreground are surprisingly small in comparison to Mary and Joseph – a contrast repeated in the sizes of the donors and saints portrayed in the wings.

Details such as the angels in their copes and the still life of flowers in the foreground are executed with an exquisite delicacy unsur-

Hugo van der Goes
Adoration of the Shepherds,
1476–1478
(central section of the Portinari Altar)
Oil on wood, 253 x 304 cm
Florence, Galleria degli Uffizi

passed in the entire painting of the Early Renaissance.

The influence of the Portinari Altar, which was erected in Florence in 1478, was felt by many of the Florentine painters and is reflected in particular in the works of Ghirlandaio and Leonardo.

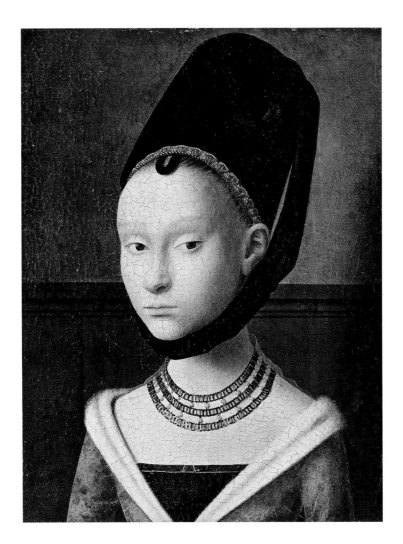

Petrus Christus
Portrait of a Lady, c. 1470
Oil on wood, 28 x 21 cm
Berlin, Gemäldegalerie,
Staatliche Museen zu
Berlin – Preußischer
Kulturbesitz

PETRUS CHRISTUS

C. 1410/20 – C. 1472/73

This portrait of a young woman denotes a new stage of development in Netherlandish portraiture. The sitter is no longer set against the foil of a neutral, impersonal ground, but is now placed in an actual physical context: it appears to be a room. Direct contact is established between the spectator and the subject in her own environment.

The work bears witness to a stylistic change which took place after the middle of the 15th century. The emphasis upon volume encountered in the portraits of Roger Campin and Jan van Eyck is here sharply reduced. The elongation evident in the proportions of the narrow upper body and head is heightened by the V-shaped neckline of the ermine collar and the cylindrical hat.

The middle-class realism embraced by the generation of artists at the start of the 15th century is here replaced by an element of aristocratic sophistication. The strip of moulding separating the wood panelling on the lower back wall from the plaster above divides the painting exactly in half; with its emphatic horizontal, it provides a harmonious counterbalance to the vertical format and as such forms an essential component of the composition. In the delicate execution and almost tangible textures of the costume, trimmings and jewellery, Christus reveals himself a pupil of Jan van Eyck.

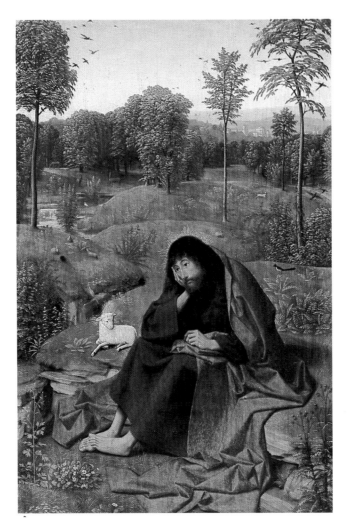

Geertgen tot Sint Jans
St John the Baptist in the
Wilderness, c. 1485–1490
Oil on wood, 42 x 28 cm
Berlin, Gemäldegalerie, Staatliche
Museen zu Berlin – Preußischer
Kulturbesitz

GEERTGEN TOT SINT JANS

C. 1460/65 – BEFORE 1495

Although Geertgen's early death, and the many gaps in his poorly documented œuvre, make it difficult to assess his role within the Netherlandish painting of the 15th century, this small panel, hardly bigger than the page of a large book, gives us some idea as to his importance.

St John the Baptist, sunk in thought, is positioned close to the front edge of the picture, to which he is directly linked by the tumbling folds of his cloak. His figure, although here small, could easily be translated into monumental scale.

The sense of introspection is reinforced by the muted palette of blue and purple. The background setting, one of the most beautiful of the 15th century, appears little more than "tacked on", although it matches the saint's mood in its tranquility and expansiveness; one is tempted to describe it as one of the earliest examples of a mood landscape.

Its extension across the entire picture is a typical feature of the Haarlem School, as is the precise execution of details such as the plants in the foreground, trees and birds. The suggestion of depth contained in the view of the distant city and hills, and reinforced by the paler hues and increasingly blurred outlines of the background, recalls contemporary works by Bosch and also Leonardo's new theories of colour.

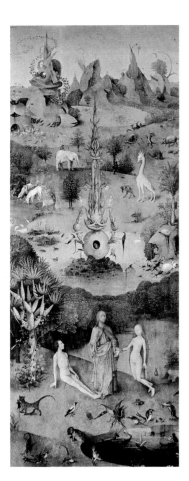
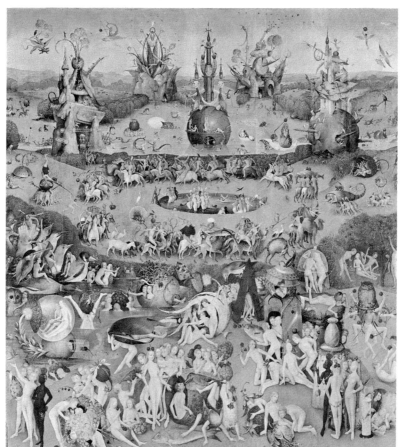
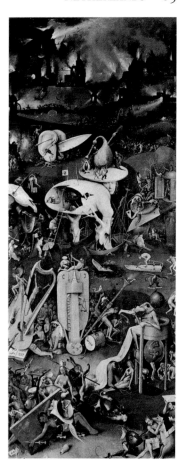

HIERONYMUS BOSCH

C. 1450–1516

Like the *Haywain* triptych (Madrid, Prado) and the *Last Judgement* (Vienna, Gemälde-galerie der Akademie der Bildenden Künste), the so-called *Garden of Delights* defies conventional iconographical categorization. *The Garden of Delights* is the largest, most complex and probably the last to be painted of Bosch's great triptychs and may be called his most important work. Its title dates right back to the 16th century: when it was brought to El Escorial on 3 July 1593, it was described as "una pintura de variedad del Mundo".

The familiar world of Christian art is encountered only in the left-hand wing. In the foreground, God the Father unites Adam and Eve so that they may live in harmony with nature and all its creatures. The Garden of Eden is made up of gentle hills, meadows, hedges and a lake, and is populated by animals and plants, including a number of strikingly exotic varieties. Only the bizarre silhouettes of the rocky mountains in the background seem to point to the possible disruption of this peaceful co-existence. Whether the strange, pinnacle-like structure rising from the surface of the water should be interpreted as a phallic symbol, pointing to the physical delights so openly enjoyed in the central section of the triptych, is a question that must remain open.

Whatever the case, the central panel shows humankind giving itself entirely to the pleasures of the flesh, portrayed in inexhaustible variations which reveal themselves only upon closer inspection. In the middle ground we see

a pond filled with bathers. Its circular shape is emphasized by a train of riders, almost all of them naked, processing in a ring around it. Is this the fountain of eternal youth, a popular subject of 16th-century painting, or a body of water in which the bathers want to cleanse themselves of their sins? In the right-hand wing, Bosch portrays the torments of Hell to which all of humankind is subjected. There are no just and no damned as in versions of the Last Judgement, but only sinners with no hope of salvation. Was Bosch, under the influence of the unrest in the Church and with a premonition that the centuries-old belief in the truth of salvation was about to collapse, giving vent to a profound sense of pessimism? Whatever the case, he paints a demonic, oppressive, nightmarish world of torments beyond number. Below right, for example, a man must endure being embraced by a pig. In the middle we see a monstrous, deformed figure; his body is hollow and he wears a disc on his head, on which small monsters are dancing. His legs, resembling dead tree stumps, stand on two boats. At the right-hand edge of the picture a ghoulish figure is swallowing people, only to disgorge them again straight away.

In our efforts to decipher the content of Bosch's triptych, we should not overlook its artistic qualities. Despite being made up of many parts and small details, the underlying composition of the triptych is nevertheless carefully planned. Paradise and earth are linked by their bright palette and their landscape, sharing the same horizon. The slender stone form in the centre of the lake in the Garden of Eden also reappears in the middle panel – in five different variations. In conjunction with the

circle of water and riders, these forms lend a certain degree of order to the initially seemingly impenetrable mass of figures. Hell, on the other hand, bears no relation to the other two panels; in this world of darkness, there is no hope of any glimmer of light. The luminous palette of the left wing and central section has been compared to Persian miniatures (L. v. Puyvelde), while the grandiose portrayal of night in the upper part of *Hell* looks forward to the night scenes of 16th and 17th-century painting.

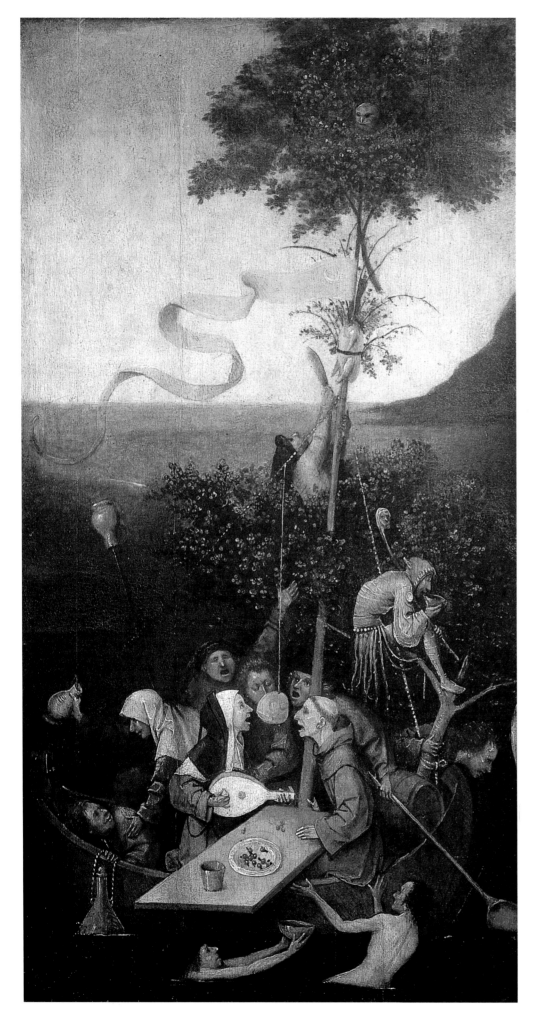

Hieronymus Bosch The Ship of Fools, after 1490
Oil on wood, 57.8 x 32.5 cm. Paris, Musée National du Louvre

HIERONYMUS BOSCH

C. 1450–1516

Towards 1500, the foolishness of the world, the vanity of a life of luxury and the secularization of the Church were themes preoccupying art, literature, philosophy and theology alike. A potent illustration of these trends can be seen in the rigorism with which, in 1494, following the death of Lorenzo the Magnificent, Savonarola sought to end the heyday of the arts in Florence. Within the literary sphere, 1494 also saw the publication of Sebastian Brant's satirical portrait of the follies of the world, *Das Narrenschiff* (The Ship of Fools).

Bosch here offers a literal pictorial interpretation of Brant's *Ship of Fools*. People are drinking, eating and making music in a boat. Seated at the centre of the company, significantly, are a monk and a nun. Other figures are calling for yet more wine and food. No one has noticed, however, the devil's mask looking out from the centre of the treetop above the gaily fluttering pennant. The meaning of the scene is encapsulated in the figure of the man dressed in typical fool's costume perched on a rotten bough. The loose technique and in particular the pastel colours of the landscape and sky place this panel amongst Bosch's late works.

Bosch here applies his eerie imagination to the depiction of a saint whom the 15th century generally tended to portray as a contemplative writer in his study. The lion (left) and cardinal's hat (bottom right) simply serve as accessories, as St Jerome himself lies prone with his hands clasped in seemingly vain prayer, surrounded by elements from Hell. Plants, trees and rocks assume anthropomorphic forms. Its nightmarish apparitions, which also incorporate sexual symbols, align the painting with representations of *The Temptation of St Anthony*. The saint's small size reinforces the impression of his helplessness as he is overtaken by the powers of darkness. The religious unrest spreading in the Netherlands in the late 15th century would have exerted a profound influence on Bosch's haunted world.

Opening up in the background is a landscape of the highest artistic quality, which bears no direct relationship to the main foreground scene. There is no continuous development of space from the front edge of the picture into the depths; instead, the eye is led from the main scene over a sharp drop to a plain, which in terms both of composition and colour forms the link between the foreground and the background. Bosch uses a technique not unlike stippling to paint the hills bordering the lake. Contours, too, are softened and dissolved, and the palette lightens towards the horizon.

Hieronymus Bosch
St Jerome, c. 1500
Oil on wood, 77 x 59 cm
Ghent, Musée des Beaux-Arts

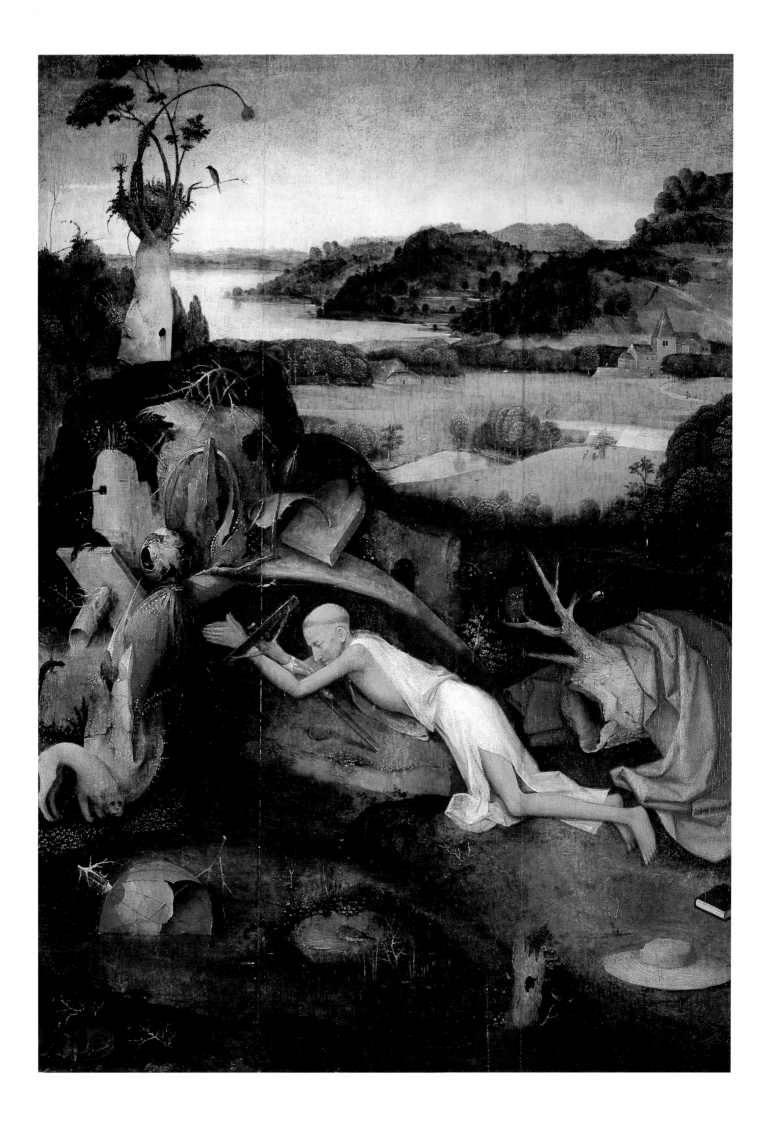

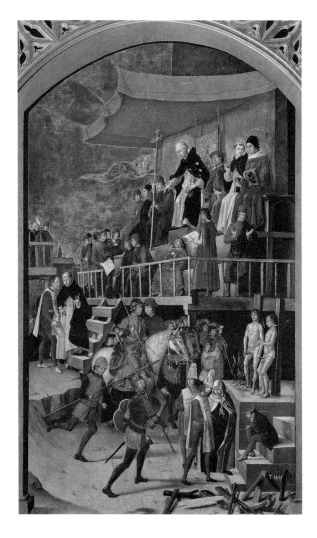

Pedro Berruguete
Court of Inquisition Chaired by St Dominic,
c. 1500
Tempera on wood, 154 x 92 cm
Madrid, Museo del Prado

PEDRO BERRUGUETE

C. 1450/55 – C. 1504

In Castille in the 15th century, Netherlandish and Italian influences mingled with local traditions, not least as a result of the royal family's passion for art collecting. This late work by Berruguete is astonishing in the extent to which it points the way forward to the 16th century.

We are presented with a richly populated scene viewed at an oblique angle running from front right to rear left. Compositional balance is nevertheless preserved through the use of precisely calculated artistic means: St Dominic, as the main figure, is shifted to the right of the central axis, while the illuminated front of the canopy and the fluttering pennant are presented virtually parallel to the pictorial plane.

While the overall composition may look ahead to the future, it remains indebted in its details to the trends of the late 15th century and even bears certain late-medieval traits. Thus the individual figures and figural groups in the foreground are conjoined in an additive fashion.

The medieval "scale of importance" also continues to dominate over the logical construction of space: the two condemned heretics in the foreground are relatively small compared to the bailiffs, for example, and appear all the smaller in comparison to St Dominic and the members of the court.

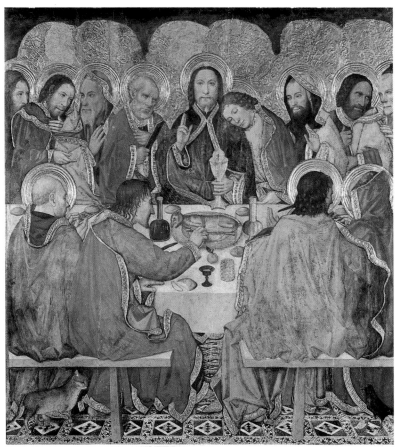

Jaume Huguet
Last Supper, after 1450
Tempera on wood, 162 x 170 cm
Barcelona, Museu d'Art de Catalunya

JAUME HUGUET

C. 1414–1492

The profound social and political differences which existed between Spain's art centres in the 15th century gave rise to a broad range of styles. The present panel by Huguet thereby lies at the opposite end of the spectrum to that by Berruguete above. Catalonia remained indebted to the Middle Ages to a degree unique within the Early Renaissance. In Huguet's altar retables, importance is attached not to the mastery of space or anatomy, but solely to the hieratic representation of the religious subject.

This *Last Supper*, showing the disciples grouped around the table, employs a compositional format dating from the 14th century, in which different levels of height are used as a substitute for linear perspective as a means of indicating spatial depth. Only the foreshortened tiles of the floor, which we see from above, lead the eye some distance into the painting.

The emphatically frontal figure of Christ occupies the central axis and is set against a gold ground richly ornamented with relief. The disciples are organized into equally balanced and almost symmetrical groups. Judas, second from the left in the foreground, is identified as a traitor by the fact that he has no nimbus. We are shown not the tense moment in which Christ announces his impending betrayal, but the establishment of the Host: the cup, the Host and Christ's gesture of blessing make up the central subject of the painting.

ENGUERRAND QUARTON
c. 1410–1461 (?)

This unusual combination of the Coronation of the Virgin with a Crucifixion and Last Judgement follows the most exhaustive written programme to survive for a 15th-century painting. The donor, Canon Jean de Montagnac, prescribed its every detail for the painter, including the parity of God the Father and Christ (which probably goes back to a resolution by the Council of Union which met in Florence in 1439), the names of the members of the heavenly host, the portrayal of the cities of Rome and Jerusalem, the vision of Moses in front of the Mass of St Gregory (bottom left), and the inclusion of the resurrected and the dead as the basis of the entire composition. Beneath the cross in the central axis, the donor is seen kneeling in prayer, wearing his Carthusian habit.

Despite the complexity of the commission, the painter succeeds in establishing an overwhelming sense of unity. This is achieved above all by the sweeping robes of luminous red, blue and gold worn by the three main figures, who are grouped almost into a circle. This circle corresponds to the dark, crescent-shaped segment which stands out against the gold ground and which is probably intended to represent the earth. The central axis is firmly established by the crucifix, the exquisitely painted cope of the Virgin and the dove of the Holy Ghost.

In the almost crass differences in scale employed in the various zones, Quarton reveals himself still thoroughly indebted to the Middle Ages. In his treatment of detail, on the other hand, his pronounced delight in realistic reproduction surges to the fore. This is especially true of the small figures in the Last Judgement scene at the bottom of the panel and of the city views above them: Quarton, who had never been to Rome or Jerusalem, uses buildings which can still be seen in Avignon and Villeneuve.

This *Pietà* has only very recently been identified as another of Quarton's major works. It, too, is likely to have been commissioned by Jean de Montagnac, whose portrait appears in the kneeling figure of the donor on the left.

In contrast to the court art of such painters as Jean Fouquet, this important master represented a different school of thought, one still medieval in character, in which figure and space simply served as the visual means through which to deliver a message beyond the rational grasp of the senses. The silent lamentation of the beloved disciple John, the Virgin Mary with her hands clasped in prayer, and the weeping Mary Magdalene holding the jar of ointment are portrayed with the minimum of physical detail. The extensive gold ground, the reduction of landscape to a mere suggestion and the silhouette of Jerusalem appearing like a vision in the background (the domed building has been identified as Hagia Sophia) all combine to detach the scene entirely from this earthly life. The subtly varied expressions of pain on the faces of the three main figures are heightened by the contrasting directions established by the Virgin and Christ.

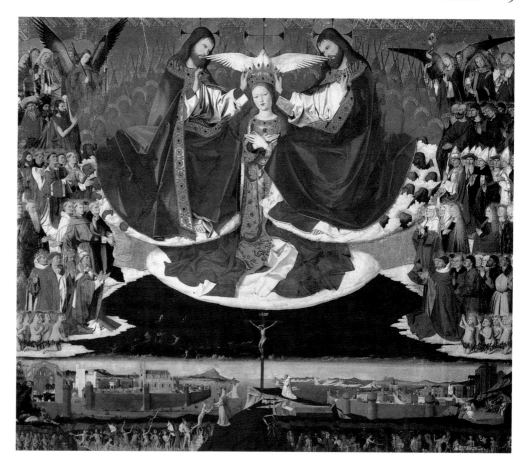

Enguerrand Quarton
Coronation of the Virgin, 1453/54
Tempera on wood, 183 x 220 cm
Villeneuve-lès-Avignon, Musée de l'Hospice

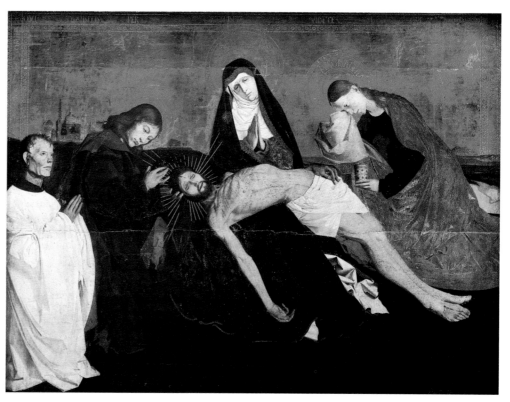

Enguerrand Quarton
Pietà, c. 1460
(from the Carthusian monastery of Villeneuve-lès-Avignon)
Tempera on panel, 162 x 217 cm
Paris, Musée National du Louvre

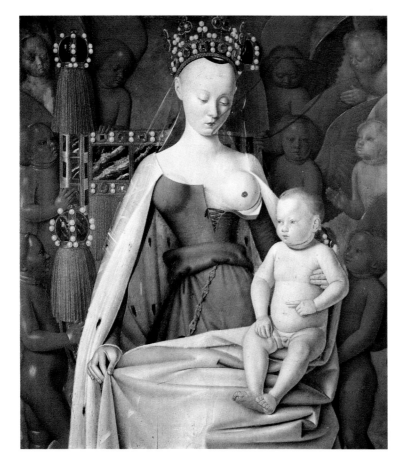

Jean Fouquet
Madonna and Child, c. 1450
(left half of the Melun Diptych)
Tempera on wood, 91 x 81 cm
Antwerp, Koninklijk Museum voor Schone Kunsten

JEAN FOUQUET
C. 1415/20 – C. 1480

This panel forms the left-hand side of the
Melun Diptych commissioned for the tomb of
Etienne Chevalier, treasurer to King Charles
VIII of France. The right-hand panel (Berlin)
shows the figure of the donor being recom-
mended to the Virgin by a saint.

Although the outwardly sacred character of
the subject is emphasized by the presence of
the angels, the panel nevertheless seems to
cross the border into the sphere of the profane.
This impression is reinforced by the portrait-
like features of the Madonna – the model for
whom is traditionally said to have been Agnes
Sorel, the King's mistress – and by the expo-
sure and modelling of her breast, a motif not
demanded by the subject but possessing an
erotic value in its own right.

Here we see a prime example of a work of
art hallmarked by the conventions of its social
background. Fouquet, court painter to the
king, accorded aristocratic sophistication – in-
deed, affectation – a significance unique in the
painting of the mid–15th century. Even the
unreal contrast of red and blue in the angels
fails to erase the panel's sense of worldliness.
The painter shows no interest in the logical
composition of spatial depth. Colours are
strongly contrasted. In his execution of the or-
namental details of the crown and throne, how-
ever, Fouquet displays a high degree of sensi-
tivity, evidence that he was familiar with early
15th-century Netherlandish art.

In Fouquet's work, the Italian and French art
of the Early Renaissance forge their closest
links. The portrait of Jouvenal des Ursins
thereby represents the most compelling illus-
tration of this symbiosis.

In contrast to the Madonna in the Melun
Diptych, the volume of the present figure has
dramatically increased and is reinforced by the
oblique angle of his pose – a development
which may be traced to the trip which Fou-
quet made to Italy in the 1440s. On the other
hand, Fouquet elaborates his details with an
enthusiasm demonstrated by none of his Ita-
lian contemporaries. The portrait, which in
line with Netherlandish tradition adopts the
three-quarter view, shows the artist at pains to
render every facial wrinkle and bulge as realis-
tically as possible. The textural qualities of the
fur collar and cuffs and the richly ornamented
purse hanging down from the belt are also
treated in a naturalistic fashion – another re-
flection of Netherlandish influence.

The thoroughly secular nature of the por-
trait is emphasized by the gilt architecture of
the background, incorporating pilasters, a
classical-style entablature and slabs of imita-
tion marble. But while every detail documents
the artist's knowledge of Italian ornament, the
basic architectural structure is ultimately lost
under the web of decoration.

A preliminary drawing for this portrait is
housed in the Kupferstichkabinett in Berlin.

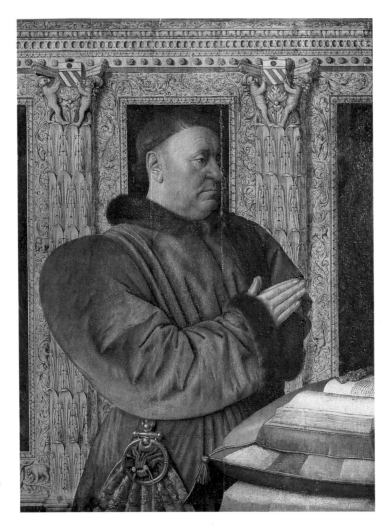

Jean Fouquet
Portrait of Guillaume
Jouvenel des Ursins, c. 1460
Oil on wood, 92 x 74 cm
Paris, Musée du Louvre

NICOLAS FROMENT

C. 1430 – C. 1485

The present panel forms the central section of
Froment's most important work, a triptych
commissioned by King René. The wings show
the king and his wife accompanied by their
patron saints. In line with an iconographical
tradition dating back to the Middle Ages, the
figure of God who appeared to Moses in the
burning bush in the Old Testament version of
the story is here replaced by a vision of the Ma-
donna and Child. The fact that the bush re-
mains unconsumed by the flames may be a
symbolic reference to Mary's virginity. In the
motif of the Madonna and Child the artist
takes up the theme of the Virgin of the Rose
Garden. At the same time, the angel entering
from the left represents a play upon the An-
nunciation. Various thematic motifs thus
come together within this composition.

In comparison to his earlier work, Froment's
narrative skills in this panel have developed
considerably. The angel turns towards Moses
with a lively gesture, while Moses is in the
process of removing his second shoe – not a
genre motif, but a gesture of humility and
respect. In his treatment of details, the Pro-
vençale artist betrays the lingering influence
of Netherlandish painting; the angel, for
example, is one of the most beautiful figures
since Rogier van der Weyden. The view of the
distant landscape, on the other hand, is a re-
minder that Froment had also visited Tuscany.

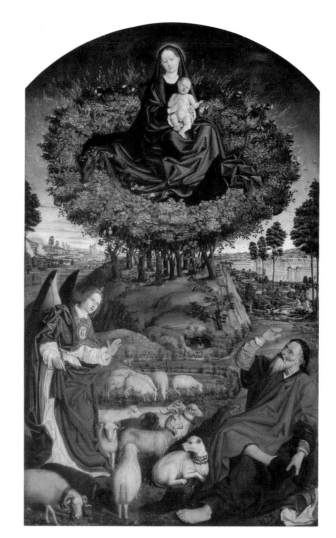

Nicolas Froment
Moses and the Burning Bush, 1476
(central section of a triptych)
Tempera on wood, 410 x 305 cm
Aix-en-Provence, Cathédrale
Saint-Sauveur

MASTER OF MOULINS

ACTIVE C. 1480 – AFTER 1504

Jean Rolin, son of the Chancellor painted by
Jan van Eyck (cf. ill. p. 53), commissioned this
altarpiece in 1480 for the cathedral in his
home town. While the painting reveals an evi-
dent knowledge of Netherlandish art, it is also
characterized by certain features belonging spe-
cifically to a French Early Renaissance. It is
just as far removed from the relief-like compo-
sition of paintings by Rogier van der Weyden
as from the continuously receding back-
grounds found in contemporary Italian works.
Instead, the Master of Moulins – only recently
identified as Jean Hay (or Hey) – places Mary
and Joseph behind the crib and the kneeling
angels, with the large-format figure of the
donor even further back. The stable area is con-
cluded at the rear by a fence running parallel
to the plane, while the landscape beyond is
similarly developed primarily from left to
right, giving rise to a succession of internal
zones arranged one behind the other, yet each
acknowledging the two-dimensionality of the
pictorial plane.

Verticals dominate, as evident in the details
of clothing, stable walls and fence. The overall
composition is based on an orthogonal system,
giving the painting a "classical" touch. The
subtlety of the palette ensures that coolness is
avoided, however, with delicate glazes lending
the colours a radiant luminosity in an echo of
the lessons of Netherlandish painting.

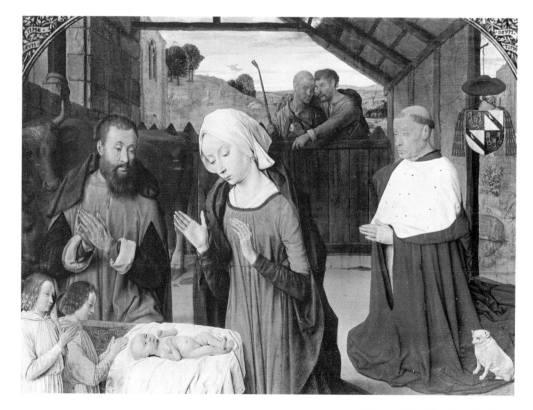

Master of Moulins (Jean Hay)
The Nativity of Cardinal Jean Rolin,
c. 1480
Tempera on wood, 55 x 73 cm
Autun, Musée Rolin

Konrad Witz
Sabobai and Benaiah,
c. 1435
(wing from the
Mirror of Salvation
altarpiece from St
Leonhard, Basle)
Tempera on wood,
102 x 78cm
Basle, Öffentliche
Kunstsammlung
Basel, Kunstmuseum

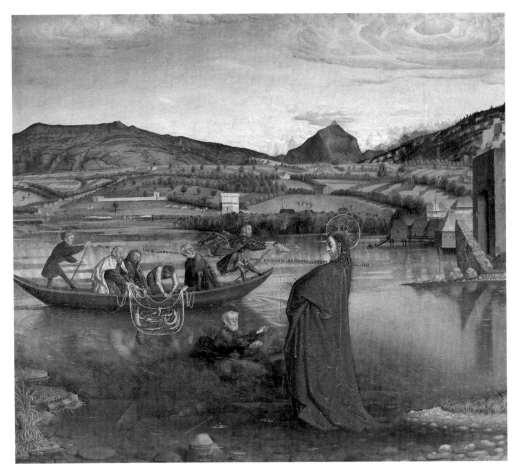

Konrad Witz
The Miraculous Draught of Fishes, 1444
Tempera on wood, 132 x 154cm
Geneva, Musée d'Art et d'Histoire

KONRAD WITZ

C. 1400–1445

This panel originally formed part of an altar-
piece which Witz executed for St Leonhard's
church in Basle. Although the altarpiece,
which comprised several such panels, has not
survived intact, it can be largely recon-
structed. The subjects are drawn from a medie-
val devotional, the *Speculum humanae salvationis*
(Mirror of Salvation), in which scenes from the
Old and New Testament are juxtaposed. The
events taken from the Old Testament thereby
prefigure those in the New.

The present panel with the two knights
must be read in conjunction with the panel
immediately to its left, which shows Abishai
kneeling before David. Together, Sabobai, Be-
naiah and Abishai are bringing David water
from the Bethlehem cistern. The scene was
considered the Old Testament counterpart to
the Adoration of the Magi. In presenting the
painted figure in terms of sculpture, the *Mir-
ror of Salvation* altarpiece was as important for
painting north of the Alps as Andrea del Cas-
tagno's cycle of *Uomini famosi* (ill. p. 28) for
Italy. If this sculptural treatment of his
figures suggests that Witz had previously
travelled to Italy, the remarkable realism of
the different materials of armour, clothes and
gold brocade also points to a knowledge of
Netherlandish art.

In his representation of these "polychrome
statues", however, Witz goes significantly
beyond his Italian (Masaccio) and Nether-
landish (van Eyck) contemporaries; so much so,
in fact, that it has occasionally been suggested
that he was also active as a wood carver. No
conclusive evidence for this has yet been
found, however.

The Miraculous Draught of Fishes, the left wing
of an altarpiece dedicated to St Peter, ranks
amongst the milestones of Early Renaissance
painting. For the first time in Western art we
are shown a clearly identifiable landscape,
namely the shores of Lake Geneva. The distinct-
ive silhouette of the mountain behind Christ's
head is that of the Dôle. The fundamental
similarities and differences between painting
north and south of the Alps can be seen here
with particular clarity. While both are devoted
with equal fervour to rendering the human
body, spatial depth and landscape "correctly",
the northerner devotes himself to the indivi-
dual detail, the southerner to the principle be-
hind the whole.

The powerful robed statue of Christ, and
the delicate glaze technique creating the mas-
terly reflections on the surface of the water,
point to the influence of Jan van Eyck. The
contrast between the animated poses of the dis-
ciples and the monumental figure of Christ
serves to isolate the latter from his immediate
context and thereby emphasizes the miracu-
lous nature of the events taking place.

The heads, damaged in a wave of icono-
clasm in 1529, are the result of two restora-
tions. The frame bears the inscription: "Hoc
opus pinxit magister conradus sapientis de ba-
silea 1444" ("This work was painted by Mas-
ter Konrad Witz of Basle 1444").

HANS MULTSCHER

C. 1390 – C. 1467

The present panel, executed by "hansen muolt-scheren von richenhofen burg ze ulm" (Hans Multscher of Burg Richenhofen near Ulm), forms part of the Wurzach Altar, so-called after the last location in which it was housed. Alongside the works by Konrad Witz, it represents the most important example of a specifically German Early Renaissance style. The reconstruction of the altar, predella and frame remains provisional. Two wings of the altarpiece survive, each with two panels on its front and rear.

The painter here attempts to take reality by storm, not without a certain violence, and with no fear of ugliness or even vulgarity. The prime focus of his interest is the human figure, to which he gives powerful volume. Beneath draperies and clothing, the bodies are modelled with a three-dimensional plasticity which suggests that the artist was a sculptor as well as a painter.

Multscher employs the same forcefulness in establishing the setting. The tomb is angled into the depths of the painting, while the circular group formed by the sleeping watchmen is taken up in the curves of the wooden fence and the trees in the background. Despite a few lingering Gothic references – in the rocky arrête derived from Byzantine painting and the gold ground in the upper section of the painting –, the overwhelming impression is one of realism.

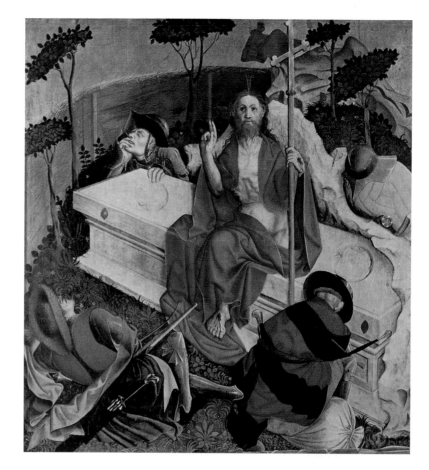

Hans Multscher
Resurrection, 1437
Tempera on wood, 148 x 140 cm
Berlin, Gemäldegalerie, Staatliche Museen zu Berlin – Preußischer Kulturbesitz

MARTIN SCHONGAUER

C. 1450–1491

Despite the late year in which it was painted (on its back the panel is dated 1473), Schongauer's masterpiece belongs to the tradition of the International Gothic. On its insertion into its splendidly carved frame in the early 16th century, the panel was trimmed all round, but a smaller-scale copy in Boston gives us an idea of what the original composition must have looked like. It is estimated that the panel formerly stood some 2.5 m tall.

Even though its appearance would thus have been somewhat larger than it is today, the overall impression would still have been dominated by the multiple details subdividing the pictorial plane. Figures, garden seat and rose bower, plants, flowers and birds are woven together into a tapestry, while the gold ground removes all suggestion of a real setting.

Stefan Lochner, in his treatment of the same subject a generation earlier, had placed much greater emphasis on spatial depth and the human body. Schongauer instead chooses to concentrate upon the detailed execution of the rose hedge and the ornamental details of the crown – an echo of his study of Netherlandish painting. In the restless, billowing robes of the angels we may recognize something more akin to the contemporary style represented south of the Alps by Botticelli, for example.

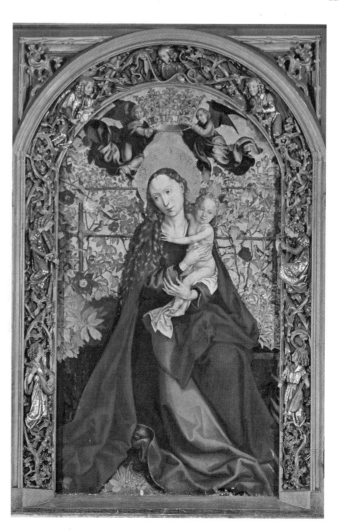

Martin Schongauer
Madonna of the Rose Bower, 1473
Tempera on wood, 200 x 115 cm
Colmar, Eglise Saint-Martin

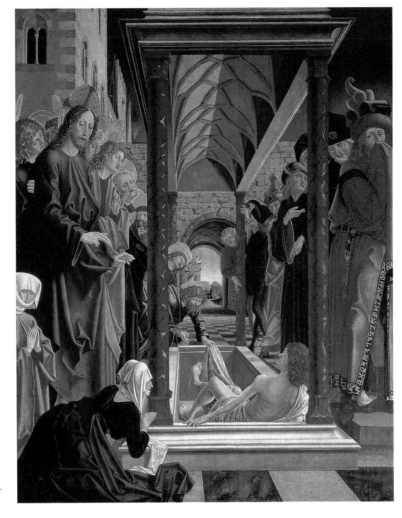

Michael Pacher
The Resurrection of
Lazarus. From the
St Wolfgang Altar,
1471–1481
Tempera on wood,
175 x 130cm
St Wolfgang, high altar
of St Wolfgang

Below:
Michael Pacher
St Augustine and
St Gregory, c. 1480
(cental section of the
Church Fathers' Altar)
Oil on wood, each
212 x 100cm
Munich, Bayerische
Staatsgemäldesammlun-
gen, Alte Pinakothek

MICHAEL PACHER

C. 1435–1498

The Resurrection of Lazarus deviates from icono-
graphical tradition in a number of respects.
Firstly, the scene is moved into an indoor set-
ting whose architecture reveals an astonishing
mixture of contemporary forms borrowed from
both the sacred and the secular spheres. Sec-
ondly, the narrative unfolds not from left to
right, but from foreground to background. It
is true that Lazarus' sisters are kneeling par-
allel to the pictorial plane in the foreground,
and that Christ is gesturing in the same direc-
tion, but Lazarus himself is seen from behind
and foreshortened towards the rear. The main
lines of the composition reinforce this inward
movement – the vaulted canopy above the
tomb, for example, the arrangement of the
figures into lines resembling a guard of hon-
our, and finally the view through the arch in
the central axis out into the distant landscape.
The New Testament subject is effectively ob-
liged to take second place in this demonstra-
tion of the painter's supreme mastery of per-
spective.

Pacher must undoubtedly have studied the
works of Andrea Mantegna, and the figure of
Lazarus almost seems to anticipate the latter's
Dead Christ (ill. p.44). The principle under-
lying Pacher's composition points even further
into the future, however, insofar as the vanish-
ing lines converge not upon one central object
or figure, but rather allow the eye to escape, as
it were, out into the open countryside.

Executed for Neustift monastery near Bressa-
none, this altarpiece translates the subject of a
carved shrine into panel painting. It thereby
follows on from Rogier van der Weyden's *De-
scent from the Cross* (ill. p.57), but goes far be-
yond the earlier painting in its optical mixing
of the two genres.

The altarpiece is a depiction of the four
great Fathers of the Church, of whom the sec-
ond and third are seen here. On the far left,
Jerome is portrayed as a cardinal with the lion
from whose paw he drew the thorn. Next
comes Augustine, accompanied by a child in a
reference to one of the legends surrounding his
life: one day, while walking by the sea sunk in
thought, the saint came across a child scoop-
ing up water with a spoon. In reply to his en-
quiry as to the sense in this activity, the child
replied that it was just as pointless as August-
ine's own attempts to understand the holy es-
sence of the Trinity with his rational mind.
Third comes Pope Gregory the Great, who is
seen delivering Emperor Trajan from purga-
tory, and finally, on the far right, the arch-
bishop Ambrose, busy writing. The dove of
the Holy Ghost appears beside all four saints
as a symbol of their divine inspiration.

The foreshortened floor tiles combine with
the apparently projecting baldachins to con-
fuse the eye, as real and pictorial space seem to
overlap. The virtuosity of the foreshortening is
not matched by the modelling of the figures,
however, who acquire their volume primarily
from the suggestive power of the vaulted ca-
nopy above them.

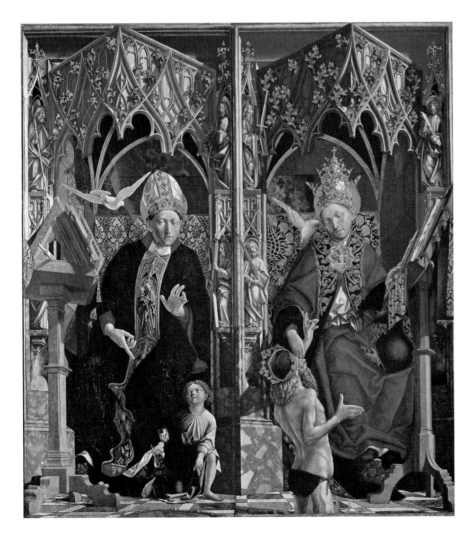

RENAISSANCE AND MANNERISM

European painting in the 16th century

In the painting of the Renaissance, Western art reached its absolute zenith. The new intellectual horizons opened up by the natural sciences and the great voyages of discovery, together with the religious tensions of the era and its political and social unrest – all were reflected in painting. The real and the ideal, the secular and the sacred, ecstatic absorption and cool scepticism flourished side by side.

It was Leonardo da Vinci who took the decisive step by abandoning the balance which had previously been maintained between colour and line, and choosing instead to modulate his contours by means of colour. Raphael and Michelangelo followed his example and created forms which would set the standard for the whole of Europe. At almost the same time, Giorgione, Titian, Tintoretto and Veronese in Venice were crafting a new artistic vision in which man and nature were combined into a single unity.

In Germany, painting saw an unprecedented flowering at the hands of Dürer and Grünewald, Altdorfer, Holbein and Lucas Cranach. While in the Netherlands the creative genius of Pieter Brueghel outshone all else, the epoch found its final voice in the religious visions of El Greco.

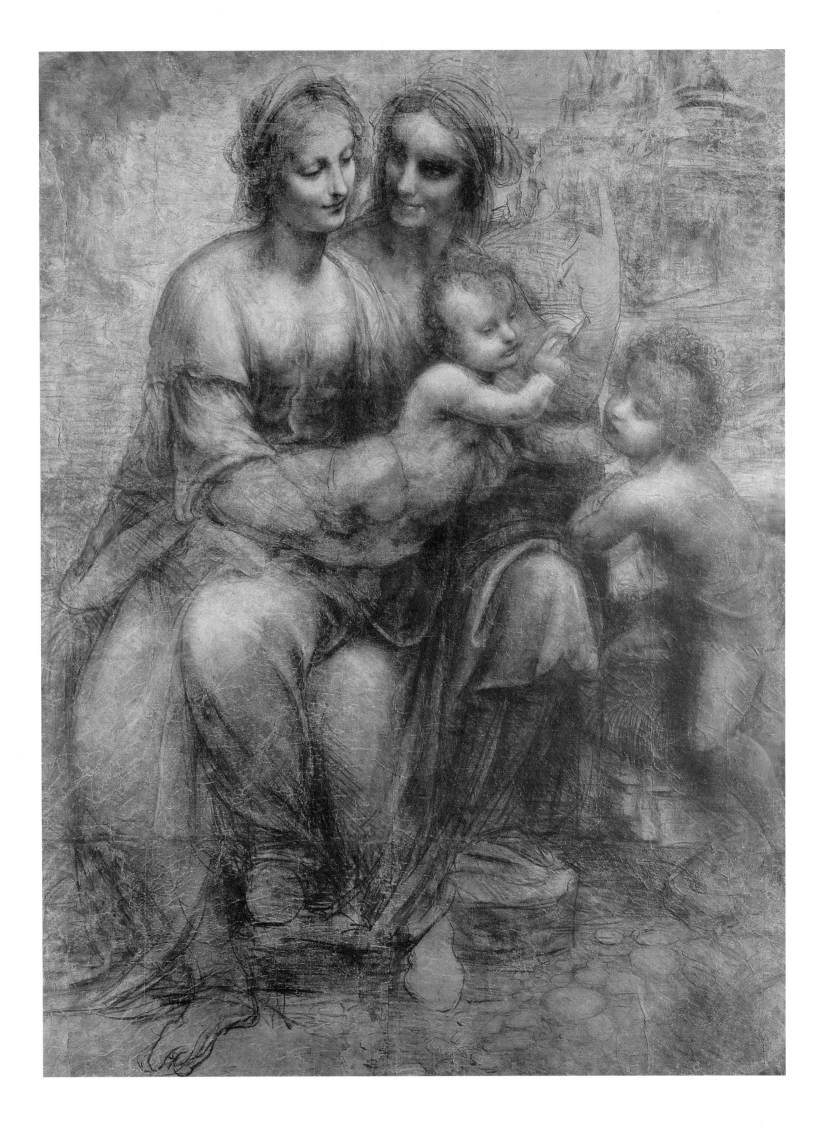

The 16th century: an epoch and its names

The era in European art which we call the age of the Renaissance, namely the two centuries between 1400 and 1600, reached its supreme peak in the decades around 1500. It is this brief period that we may term the High Renaissance. In every branch of art, the many and varied means of expression that had developed over the course of the 15th century were now integrated within a single, unifying concept. In the latter years of his life, Burckhardt sought to define this phenomenon. On 18 December 1895 he wrote to Wölfflin that only at the beginning of the 16th century had there been one glorious moment when "simplification and greater economy" had risen to replace "realistic individualization". One year later he again remarked to the Wölfflin: "…you will note – perhaps for the hundredth time – the renunciation of the manifold (even where this was very beautiful) in favour of the monumental and especially the animated." For Burckhardt, the High Renaissance – and in particular the work of Raphael – was the only epoch in recent art on a par with classical Greece. In 1898, his pupil Wölfflin subsequently formulated the term "classic art" to describe the development in Italian art which took place in the years around 1500.

And indeed, at no other time before or since has art come so close to classical antiquity. Its aim was thereby not to imitate the past; that would have led not to "classic" art but to "classicism", as in the late 18th and early 19th century. Rather, it strove to reveal the ideal which lay behind the natural model.

Typical of the High Renaissance, as of all classic art, is its perfect balancing of contradictory – and hence seemingly mutually exclusive – artistic positions. Real and ideal, secular and sacred, movement and rest, freedom and law, space and plane, line and colour are thereby reconciled in a happy harmony.

By its very nature, such a perfect equilibrium of all opposing forces leaves no room for further dramatic development. It can only lead either to stagnation or to its own abolition by the artist. European, and in particular Italian, art took the latter path. It was the very protagonists of the High Renaissance – and above all Leonardo da Vinci, Michelangelo and Raphael – who thereby opened the door to new artistic possibilities. In the sense that its elements can almost all be traced back to the High Renaissance, the subsequent phase in art from around 1520 to 1600 may thus aptly be termed the Late Renaissance. It must be said, however, that High Renaissance ideas were employed by the subsequent gener-

ations, at times in an entirely new context: the vocabulary was adopted, so to speak, but the grammar was new. Against a backdrop of far-reaching cultural changes, "anti-classic" tendencies thereby began to spread which have more recently been described under the heading of Mannerism rather than Late Renaissance. In attempting to identify binding stylistic categories for the art of the 16th century, the question of an appropriate name for the epoch will need to be constantly rethought.

Painting around 1500 in Italy

Florence was undoubtedly the centre of the revival in the arts which took place during the 15th century. It was here, between 1400 and 1450, that the Early Renaissance in the narrower sense of the term first arose, and it was from here after 1450 that decisive stimuli went out to the other art centres of Italy. This should not blind us to the fact that the preliminary steps towards "classic art" were nevertheless taken outside Tuscany. Piero della Francesca (c. 1420–1492), who for all his virtuoso handling of perspective was profoundly convinced of the fundamental importance of the plane, and whose "atmospheric lighting" was at the same time highly significant for the history of colour in European painting, is thereby no less important than his fellow Umbrian Pietro Perugino (c. 1448–1523). Perugino's work was unfairly overshadowed by that of his greatest pupil, Raphael, who nevertheless owed him a very great deal. Perugino's importance lay not in his portrayal of expressive figures, but in his specifically Umbrian tendency towards spaciousness, his emphasis upon landscape, his shift away from line in favour of modulated transitions, and above all his understanding of pictorial and mural surfaces as organic wholes which, although they might not yet achieve the fluency of the works of Raphael, marked a vital stage along the path to ever greater fluidity of movement.

In a very similar fashion, albeit with more differentiated means, the Venetian Giovanni Bellini (c. 1430–1516) was treading his own path towards the High Renaissance; in his late works, indeed, he became the only one of the great 15th-century painters to cross the threshold from the Early to the High Renaissance. According to Erich Hubala, Bellini "had been working his way towards the High Renaissance ever since birth… Bellini was born with his compass needle pointing to classicism".

It was not by chance that, around 1500, the emphasis in Italian art shifted to Rome and Venice, and Florence had to relinquish its leading role. The reasons for this were undoubtedly rooted first and foremost in political and social changes. The collapse of Medici rule in 1494 and the rise to prominence of Girolamo Savonarola (1452–1498), a Dominican monk preaching an eschatological vision, brought an abrupt end to the flowering in the arts that had reached its high point under Lorenzo the Magnificent (1449–1492). After Sa-

Leonardo da Vinci
Virgin and Child with St Anne and St John the Baptist, c. 1495
Charcoal, heightened with white, on cardboard, 141.5 x 104 cm
London, National Gallery

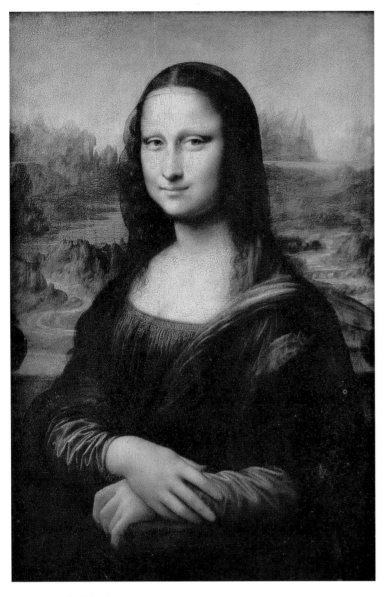

Leonardo da Vinci
Mona Lisa, c. 1503–1505
Oil on wood, 77 x 53 cm
Paris, Musée National du Louvre

vonarola was burnt at the stake in 1498, Florence became the political football of rival forces until the return of the Medici from exile in 1512. During precisely those twenty years in which "classic art" produced its most important works, therefore, Florence was without major patrons of the arts. Venice, on the other hand, passed from the 15th to the 16th century with its feudal ruling class still politically and economically intact, and hence with its market for art uninterrupted. Above all, however, it was the papacy which, having re-consolidated its power over the course of the Early Renaissance, now renewed its efforts to establish Rome as the cultural centre of the Western world. The appointment of Donato Bramante (c. 1444–1514) as architect of the new St Peter's in 1504, the commissioning of Pope Julius II's tomb to Michelangelo in 1505, and Raphael's move to Rome in 1509 set the seal on the city's pre-eminent position in Italian art.

We may nevertheless wonder whether, under different historical circumstances, Florence would in fact have proved capable of leading the Renaissance to its climax. However inexhaustible the wealth of new artistic forms which it developed over the centuries, Tuscany lacked the aptitude for classical equilibrium; at the heart of all the supreme achievements of Florentine art lay the dialectic principle of reason and emotion, and hence a constant layer of tension. It was no coincidence that, as "anti-classic" tendencies began to assert themselves, so Tuscany would once more return to the limelight.

In the awareness that any attempt at a broad definition inevitably involves simplification and thus approximation, we may say that the High Renaissance in Rome was concerned primarily with form, and in Venice with colour. In the sphere of painting, Leonardo was the only artist who married both at the highest level. At the same time as carrying the realistic tendencies of the 15th century to an extreme degree, he granted the geometry of the two-dimensional plane and the stereometry of three-dimensional space an importance unknown to the previous generation. Leonardo's *Last Supper* in the refectory of Santa Maria della Grazie in Milan (ill. p. 91) overwhelms the viewer with its apparent immediacy. In fact, however, the different perspective systems of real and painted space, the ideality informing even the very smallest detail of the composition, and the monumental scale of the figures ensure that we remain distanced from it. In his panel paintings, Leonardo combines these structural features with a revolutionary new use of colour. Going far beyond Piero della Francesca, Perugino and Giovanni Bellini, he increasingly replaces circumscribing, isolating line – i.e. drawing – with colour modulation. The transitions between figures and objects become fluid. Space is no longer established primarily through mathematical perspective, but by a lightening of the palette and a gradual dissolving of outlines.

Leonardo was the perfect embodiment of the ideal of the universal artist, active in every branch of art and at the same time educated in every field. Yet neither in Florence nor in Rome was he awarded the recognition he deserved. His departure for Upper Italy, ostensibly explained by his many important commissions for Francesco Sforza (1401–1466), Duke of Milan, may ultimately have been prompted by a different, inner logic: he would both be able to further his own development and influence others in the neighbouring art centre of Venice. When, in the work of Giorgione (c. 1477/78–1510) and the young Titian (c. 1473/90–1576), Venetian painting stepped fully into its very own speciality, colour, it was the culmination of a development which would have been unthinkable without the influence of Leonardo.

The other aspect of Leonardo's art, the ideality of form, was taken up in central Italy. In architecture, the centralized building – i.e. one which unfolds regularly on all sides around a static centre – had been increasingly perfected over

the course of the 15th century. Its counterparts in painting were symmetrical pictorial formats such as the square and the circle (tondo). The concept of centralized construction dominated not only the architecture of the High Renaissance – the plans by Bramante and Michelangelo for the new St Peter's included pure centralized buildings, possibly in a symbolic allusion to Rome as the centre of Christendom –, but also determined the thinking of painters. Since only a small number of the major building projects of the period around 1500 were actually executed, our knowledge of High Renaissance architecture is largely based on the "background scenery" found in pictures, which we can take as a direct reflection of contemporary building styles. More important however, is the fact that centralizing laws of architecture indirectly came to govern the pictorial composition as a whole: sphere and circle and their mutual interpenetration thereby serve to establish an inner kinship between the construction of the painting and that of the centralized building. In this context, the works of Raphael's mature period, and in particular his frescos in the Stanza della Segnatura in the Vatican, represent the pinnacle of High Renaissance painting.

Painting around 1500 north of the Alps

Towards the end of the 15th century, with civic culture flourishing at its peak, painting in Germany rose to heights unseen since the miniatures illuminating the magnificent manuscripts of Ottonian and Salian times. In contrast to the earlier part of the century, when German artists were overshadowed by the ground-breaking achievements of their Early Netherlandish contemporaries, the situation was suddenly and astonishingly reversed in an manner which has yet to be explained either in terms of art or cultural history. Did the creative unrest brewing in Germany in the period leading up to the Reformation release new forces in the country's centres of art?

Within this development, the figure of Albrecht Dürer (1471–1528) was of outstanding importance both in artistic and historical terms. Dürer initially remained indebted to the traditions of his teachers, using line as his primary means of expression, and his early work is correspondingly dominated by woodcuts and copper engravings. In 1496 and 1506/07, however, he made two trips to Italy that would decisively influence his art. Like Johann Wolfgang von Goethe (1749–1832) three centuries later, Dürer experienced in Italian art the holistic, organic approach to composition which lay at the opposite end of the spectrum to the art north of the Alps, where painting continued to be understood as the additive combination of individual elements. From the Venetians, and above all from Giovanni Bellini, he learned about modulating contours with colour. Finally, too, he recognized the necessity of a sound theoretical approach to the representation of objects which went beyond mere intuition. His

Madonna of the Rose Garlands (Prague, Národni Galeri), *Adoration of the Trinity* (ill. p. 118) – counterpart to Raphael's *Disputà* in the Vatican Stanze – and his *Four Apostles* (ill. p. 117) are outstanding examples of the fusion of the German and Italian feeling for form.

German painting around 1500 spanned an extraordinary breadth. If Dürer started primarily from line, Matthias Grünewald (c. 1470/80–1528) focused on composition with colour. His Isenheim Altar (ill. p. 120), begun around 1512, represents German art's most important contribution to the history of colour. The extent to which Grünewald drew upon the new colour theories of Leonardo and the works of Giorgione is something that deserves closer investigation.

Colour modulation was also the starting-point for the painters of the so-called Danube School, and in particular the young Lucas Cranach (1472–1553), Albrecht Altdorfer (c. 1480–1538) and Wolf Huber (c. 1485–1553), at whose hands landscape painting assumed an importance previously unknown north of the Alps. Confronted with the atmospheric landscapes produced by the Danube School, one

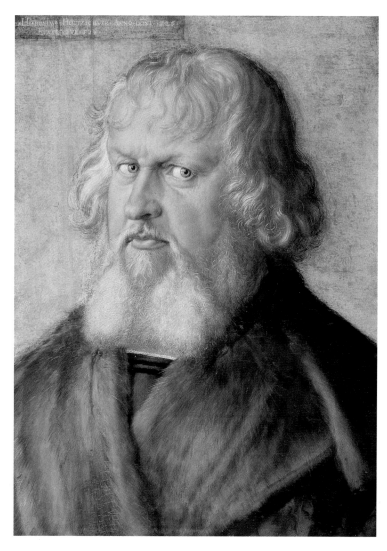

Albrecht Dürer
Portrait of Hieronymus Holzschuher, 1526
Oil on wood, 48 x 36 cm
Berlin, Gemäldegalerie, Staatliche Museen
zu Berlin – Preußischer Kulturbesitz

is tempted to speak of a first phase of "Romanticism" in German art.

Independent of direct contact with Italian art, meanwhile, a common tendency towards large, balanced form and towards the integration of the real and the ideal was also making itself felt elsewhere in Europe, as evidenced in the mature works of the Netherlandish artist Gerard David (c. 1460–1523), for example. David's works do not open up new avenues for the future, however, but look back to Jan van Eyck in their understanding of the human figure as a powerfully modelled volume.

Exchanges between north and south

The lively exchanges between the great art centres of Europe are generally considered to have begun with Dürer's Italian trips, whereby the north is widely seen as taking, and the south as giving. This view needs to be modified for two reasons. Firstly, we must assume that such exchanges would have already been taking place in the 14th and 15th centuries, via the heavily-plied trade routes from north to south and vice versa. We know that works by the great 15th-century Netherlandish artists were known and collected in Milan, Venice, Florence, Urbino and Naples. We also know that Rogier van der Weyden travelled across the Alps in

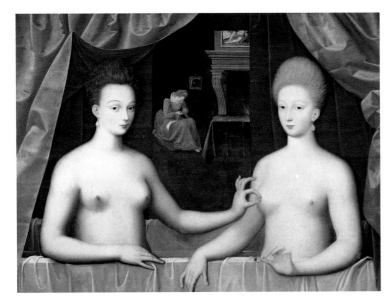

School of Fontainebleau
Gabrielle d'Estrées and One of her Sisters in the Bath, c. 1594–1599
Oil on wood, 96 x 125 cm
Paris, Musée National du Louvre

1450, that Joos van Gent was employed at the Urbino court from 1473 to 1480, and that artists living in the Alps, such as Michael Pacher (c. 1435–1498), established links with Upper Italy. The influence of Netherlandish painting is demonstrable in many examples of Italian Early Renaissance art. We do not know, on the other hand, whether the Italian masters of the 15th century also travelled north. When the

Venetian-born painter and engraver Jacopo de' Barbari (c. 1440/50–c. 1516) settled in Germany in around 1500, and later moved to the southern Netherlands, was he really the first to do so? It is a question which, together with the entire issue of possible Italian influence on art north of the Alps, needs more detailed investigation.

In addition to the migration both of works of art and of individual artists, from the middle of the 15th century there emerged another means of artistic exchange. At approximately the same time on both sides of the Alps, two printing techniques developed into artistic genres in their own right: the woodcut, which developed north of the Alps in the early 15th century, and – more important still – the copper engraving, whose origins probably also lay in the early 15th century in southern German art. The first dated example bears the year 1446. The earliest Italian copper engravings stemmed from the workshops of Andrea Mantegna (1431–1506) and Antonio Pollaiuolo (1432–1498). Prints provided an entirely new means of spreading artistic ideas into even the furthermost corners of Europe. The woodcut and the copper engraving thereby marked the beginning of the development of modern visual mass media.

By around 1500, it may be assumed that prints were available on a wide scale – so much so, in fact, that it frequently becomes hard to judge whether an artist has appropriated a new language of form into his own work as the result of direct or indirect confrontation with its source. Did the Augsburg artist Hans Burgkmair (1473–1531), for example, actually have to travel to Italy, as is generally supposed, in order to paint his *Crucifixion Altar* of 1519 (Augsburg, Bayerische Staatsgemäldesammlungen)? Or might he simply have encountered the holistic compositional approach of Italian art in prints, as recent research convincingly argues? The same question might be asked of Altdorfer. By the same token, we should not underestimate the extent of Italian artists' knowledge of Dürer's graphic works in the early 16th century.

Furthermore, a new, historically documented trend set in as from about 1510 which involved artists moving in both directions. Following the departure of Jan Gossaert (c. 1478/88–1533/36) for Rome in 1508, a trip to Italy became a standard part of every artist's training. This was particularly true for the so-called Romanists of the southern Netherlands. The spread of the Italian Renaissance north of the Alps was in turn encouraged by a number of important Italian painters who spent time abroad, in particular at the French court. Leonardo, who accepted an invitation from Francis I (1494–1547) to live in France in 1516, was followed in 1530 by Rosso Fiorentino (1494–1540) and one year later by Francesco Primaticcio (1504–1570) from Bologna. Rosso Fiorentino and Primaticcio's joint decoration of Fontainebleau palace would subsequently exert a profound influence even beyond the borders of France.

By the time European art began to experience this process of internationalization, however, the unity of the High Renaissance was already dissolving in a whirl of countercurrents.

Begin of the Late Renaissance

The great works of the Renaissance – Leonardo's *Last Supper* (ill. p. 91), Raphael's *School of Athens* (ill. p. 102), Giorgione's *Sleeping Venus* and Dürer's *Adoration of the Trinity* (ill. p. 118) and *Four Apostles* (ill. p. 117), for example – give the impression that they are definitive and complete in themselves, leaving no room for further development. It would be a misunderstanding, however, to view their progression as a more or less static line rather than as a sweeping curve. All these outstanding masters grew out of the traditions of the late 15th century, orchestrated their pictorial forces into a "classic" harmony and ultimately paved the way towards a new era in art. Their greatness lies not least in their power to transform, enabling them to confront and resolve ever new problems of composition.

For the twenty brief years of his artistic career, Raphael – whose work may be seen as the purest embodiment of the ideals of the High Renaissance – trod a path which took him, with an absolute inner logic, through a succession of entirely different landscapes. Having carried the High Renaissance to its supreme peak and defined it for all time in his frescos for the Stanza della Segnatura in the Vatican, he immediately proceeded to explore entirely new avenues in the neighbouring Stanza dell'Eliodoro. Compare, for example, the *School of Athens* with the *Expulsion of Heliodorus*: although their underlying compositional principles are related, the two scenes can only be described in downright contradictory terms, whereby we should not overlook the very different dramatic character of the events they depict. In the *Expulsion of Heliodorus*, we are immediately struck by Raphael's renunciation of harmoniously calculated proportions approximated to correspond with the semicircular format. Above all, however, the artist abandons the central point of focus towards which, in the *School of Athens*, all lines lead, and replaces it with a centrifugal composition which creates a powerful suggestion of recession in the perpendicular middle axis. The previously equal balance between plane and space is now tipped in favour of the third dimension.

The movement from foreground to background is accelerated by rapid switches between light and shade, whereby the harmony of line and colour simultaneously begins to yield to painterly effect. *The Release of St Peter*, also in the Stanza dell'Eliodoro, explores the same direction. For the first time in the history of the subject in art, Raphael takes the words of the Acts of the Apostles literally: "And all at once an angel of the Lord stood there, and the cell was ablaze with light... [Peter] followed him out, with no idea that the angel's intervention was real: he thought it was just a vision." Reality and supernatural experience here part com-

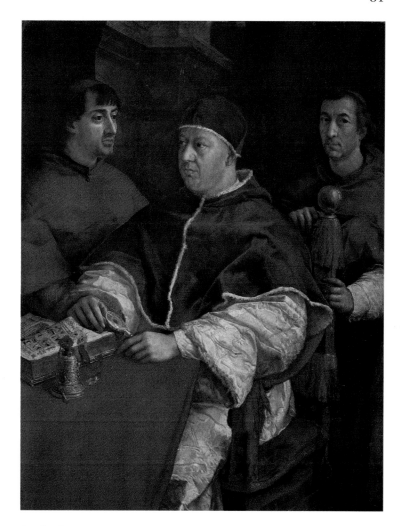

Raphael
Pope Leo X with Cardinals Giulio de' Medici
and Luigi de' Rossi, 1518/19
Oil on wood, 154 x 119 cm
Florence, Galleria degli Uffizi

pany, and the representation of painted light originating from within the picture marks a turning-point in the development of colour in Italian painting.

Raphael's journey culminated both logically and chronologically in his last work, *The Transfiguration* (ill. p. 102). The balanced weighting of the *School of Athens* here gives way to asymmetrical arrangement, while highly dynamic gestures and movements create a new form of pictorial unity which the spectator must actively assimilate. Raphael distinguishes between the two different planes of reality – that of the miracle and that of the earthly zone below – in the treatment of his figures and in the handling of his pictorial means. In the language of Wölfflin, there takes place in Raphael's œuvre a development from closed to open form, from plane to recession, from unity to multiplicity.

With the exception of the sculptures produced when he was barely thirty, such as the *David* (1501–1504), the œuvre of Michelangelo is the hardest to correlate with the normative ideals of the High Renaissance. Michelangelo was already overstepping the bounds of the High Renaissance in his frescos for the ceiling of the Sistine Chapel in the Vatican

(1508–1512). Contrary to first impressions, the enormous cycle does not obey a single system of perspective, but is composed "multi-perspectively" with individual sections each obeying their own laws. The striking contrasts in scale evident between the Sibyls and Prophets, the ignudi (the naked young men), and the figures in the story of Creation remove any impression of a closed order. The boundaries between architecture, sculpture and painting have become transparent. In the figures of the ignudi, Michelangelo liberates himself from the constraints of iconographical tradition both in terms of form and content. In the urgently increasing freedom which he grants to pose and movement, Michelangelo's future path lies revealed: the representation of the human figure as a statement of personal experience and suffering.

Leonardo, the oldest member of the great triumvirate of the Italian Renaissance, also crossed the border from the High to the Late Renaissance in his last works, insofar as he allowed his figures and objects to recede as if behind a veil – a technique which Vasari called *sfumato* (It. *sfumare* = to soften, shade off). In this Leonardo contradicted a fundamental principle of the High Renaissance that he had himself helped to establish: "classic art" was characterized not least by daylight clarity and tangibility.

North of the Alps, a tendency towards cool distance and scepticism, especially in portraiture, began to emerge amongst the younger members of Dürer's generation, in particular Hans Holbein (c. 1497/98–1543) and Hans Baldung Grien (c. 1484/85–1545), as well as in Altdorfer's late works. Hand in hand with this trend went a growing interest in secular subjects – Holbein's *Madonna of Mercy* (ill. p. 125) of 1528/29 would be his last religious painting! Erotic scenes, foreign neither to the Early Renaissance nor to the Middle Ages, assumed a previously unknown importance, particularly since they were frequently treated outside the mythological context to which they had traditionally been confined – another indication of the crack in the holistic vision which had been one of the foundations of the High Renaissance.

Mannerism: a name and a misnomer

The term Mannerism which is today widely used to describe the art of the Late Renaissance can be traced back, like the terms Gothic and Renaissance, to Vasari's *Lives of the Artists*, a selection of biographies of Italian artists from Cimabue to Vasari's own times, first published in 1550 and reprinted in a second, expanded edition in 1568. In his book Vasari wrote of Michelangelo's *maniera*, by which he simply meant "manner" in the sense of "style". Understood in this light, Michelangelo's *maniera* can indeed to be said to have influenced not just the 16th century but much of the Baroque era, too. Having a similar sound but a different meaning was the concept of *manière* which had existed in the history of French lit-

erature since the late Middle Ages. *Manière* denoted behaviour in accordance with one's social standing, and thus lay at the root of our own phrase "to have good manners".

Both words thus started out with thoroughly positive connotations. During the transition from the late Baroque era to early Neoclassicism in the second half of the 18th century, however, they came to be used in a derogatory sense to imply behaviour that was "mannered", in other words artificial, exaggerated and even peculiar. In the late 19th century, art historians adopted "Mannerism" as a pejorative term for the trends in art from around 1520 to 1600 which, from the standpoint of a classicist aesthetic, were perceived as corruptions of the High Renaissance. Since the opening years of the 20th century, however, recognition of the profound artistic innovations wrought by Mannerism has led the term once again to be used in an increasingly positive sense.

As a name for a stylistic phenomenon in European art, Mannerism nevertheless remains problematical. The common foundation of the art of the 16th century was the High Renaissance, even if its ideals and standards were frequently exceeded or even destroyed. In this respect, it was an era which virtually made contradiction one of its principles. It is nevertheless impossible to formulate a succinct definition of Mannerism – unless it be within a very general framework, reduced to the common denominator of contradiction or the self-contradictory. Rather than use the term Mannerism, we might more cautiously speak of a broad range of "mannerisms" in the art of the years between 1520 and 1600, whereby it should be remembered that the centre of European art in the 16th century, Venice, and its most important representative, Titian, both largely defy such categorization.

Forms of the Late Renaissance

By its very nature, representational art can capture either just one specific moment or, in what is known as continuous representation, several moments occurring in chronological succession. For the first time in the history of Western art, however, the painting and sculpture of the 16th century made the visual suggestion of movement their primary challenge. In painting, this particularly affected subjects involving the dimension of time, such as Ascensions of Christ or the Virgin, Depositions and Entombments. This development began during a period generally still identified as the High Renaissance. Its grandiose beginnings were provided by Titian's *Assumption of the Virgin* painted for Santa Maria Gloriosa dei Frari in Venice in 1516–1518, and Raphael's contemporaneous *Transfiguration* of 1517–1520.

Michelangelo Buonarroti
Last Judgement, 1536–1541
Fresco, 1375 x 1220 cm
Rome, Vatican, Sistine Chapel

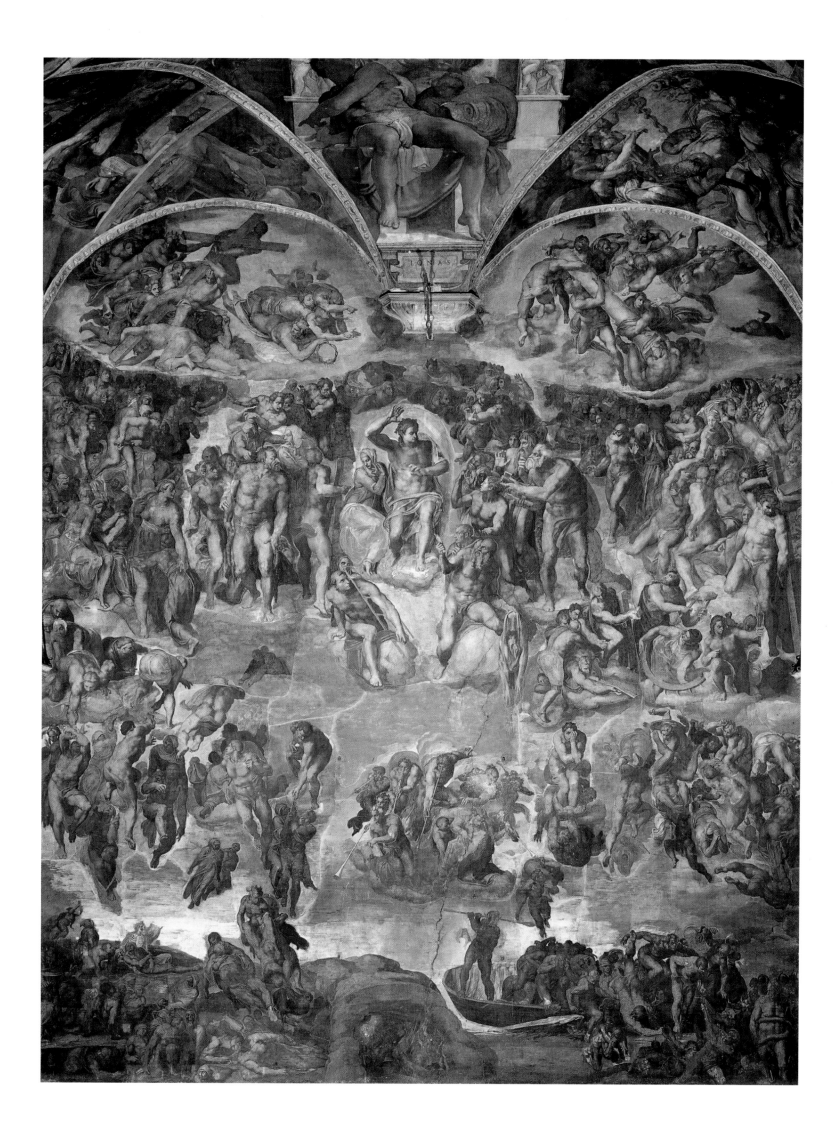

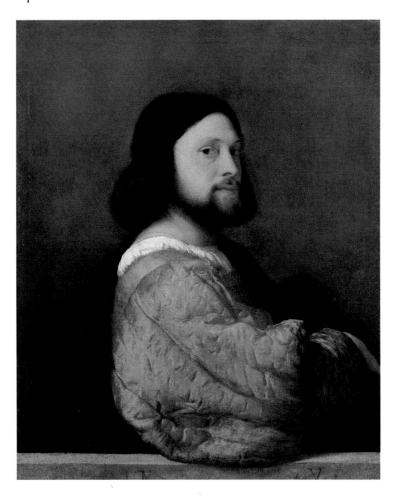

Titian
Portrait of a Bearded Man ("Ariosto"), c. 1512
Oil on canvas, 81.2 x 66.3 cm
London, National Gallery

Just how strongly the painting of the 16th century was gripped by the desire to render movement visible is demonstrated by the fact that it introduced a chronological dimension even into those pictorial themes which, by their very nature, seemed destined to remain static and still. This can be seen, for example, in *Sacra Conversazione* paintings of the Virgin and Child surrounded by saints. The *Madonna della Arpie* (1517; Florence, Galleria degli Uffizi) by Andrea del Sarto (1486–1530), Titian's *Pesaro Madonna* (1519–1526; Venice, Santa Maria Gloriosa dei Frari) and, already bordering on the eccentric, the *Madonna di San Gerolamo* (c. 1530; Parma, Pinacoteca) by Correggio (c. 1489–1534) herald the start of a development in which figures, while retaining their traditional air of introspective contemplation, are grouped within a dynamic circular or ascending compositional structure.

Florence now once again assumed a leading role. Returned to political stability and freed from the demand for classical equilibrium, the dialectic Florentine nature rose to the challenge of creating an art in which the contradictory was no longer integrated, but exposed in all its tensions. Under the leadership of Pontormo (1494–1556) and Rosso Fiorentino, Florentine Mannerism would make its influence felt far beyond the borders of Tuscany. In his *Visitation (c.* 1530;

Carmignano church, near Florence), Pontormo transformed a traditionally stately theme into an incessantly turning "roundelay" which, for all its stylistic differences, is closely related in its basic organization to Titian's *Christ Crowned with Thorns* (ill. p. 108) of 1576.

Closely related to the challenge of rendering movement visible was the 16th century's new approach to space. Both in architecture and painting, the Early and High Renaissance had established clear, defined space; in contrast to the diaphanous – i.e. largely dematerialized and transparent – wall systems employed in the Gothic era, the limits of space were experienced as finite and provided the viewer with a secure framework and a fixed point. In the course of the 16th century, however, the nature of pictorial space underwent a profound transformation. The two opposite poles of this development can be seen in Leonardo's *Last Supper* of 1496–1498 and the version which Tintoretto (1518–1594) painted a century later (1592–1594; Venice, San Giorgio Maggiore).

For all his virtuoso handling of perspective, Leonardo always keeps in sight the conditions imposed by the two-dimensional plane; Tintoretto, on the other hand, not only allows his space to recede into depths which the eye can no longer clearly grasp, but at the same time removes its lateral boundaries: space loses all rationally comprehensible dimension.

This development can be broken down into a series of chronological stages. In the first step, the balance between plane and space is relinquished in favour of the dominance of space. In a second stage, pictorial space is expanded seemingly to infinity; in many cases, the eye is drawn with confusing speed along a straight line in the central axis far into the depths of the painting. Instead of alighting upon a final "goal", however, it is left to lose itself in the distance. (Just how close painting can come to architecture in this respect is revealed by a comparison of Tintoretto's scenes from the legend of St Mark in Venice and the Uffizi in Florence, begun by Vasari in 1560.) Finally, not only is pictorial space granted unlimited depth, but its lateral boundaries are made permeable.

Painters north of the Alps used different means to create the impression of infinite space, since they did not have at their disposal the various methods of foreshortening which had been increasingly refined in Italy over the course of the 15th century. They developed instead a type of "global landscape" viewed from a bird's-eye perspective – a genre which must be seen as closely related to the history of the map. Netherlandish painting after Joachim Patinir (c. 1480–1524), in particular, took up this new landscape form. Dagobert Frey (1883–1962) summed up the situation in his recognition that the "representation of infinity" had become the new issue of art.

Just as portrayal of movement and infinity are mutually

interdependent, so the 16th century's new approach to space must be seen in causal relation to the desire to remove the barrier between art and reality, and between the different branches of art. Crossing what has been aptly decribed as the "aesthetic boundary" (E. Michalski) between artificial space and real space was something which had already been attempted by the Early Renaissance. It was thereby possible either to make real space appear to extend into the picture, as in Domenico Ghirlandaio's *Last Supper* in Florence (ill. p. 38), or to make elements or figures appear to extend out of the painting and into the space occupied by the spectator, as in Mantegna's frescos in the Camera degli Sposi in Mantua (ill. p. 45). We might speak here of actively or passively crossing the aesthetic boundary. The High Renaissance avoided such blurring of boundaries by giving painted space its own system of perspective no longer oriented to the viewer's eye level; Leonardo's *Last Supper* and Raphael's frescos in the Stanza della Segnatura are outstanding examples of this.

The 16th century, on the other hand, carried the principle of the fusion of real and artificial space far beyond the Early Renaissance. In the decorations which the Sienese artist Baldassare Peruzzi (1481–1536) carried out in 1508–1511 in the Sala delle Prospettive (Room of Perspectives) in the Villa Farnesina in Rome, painted architecture appears to open out onto a view of the surrounding Trastevere district. Vasari, too, plays upon spatial boundaries in his frescos for the main room of the Palazzo della Cancelleria in Rome, called the Sala dei Cento Giorni (Room of the Hundred Days) because the time it took him to paint it. The

Pontormo
Joseph in Egypt, c. 1515
Oil on wood, 96.5 x 109.5 cm
London, National Gallery

Tintoretto
The Origin of the Milky Way, c. 1575–1580 (?)
Oil on canvas, 148 x 165.1 cm
London, National Gallery

eye is thoroughly confused as walls appear to open up outwards even as stairs and figures appear to penetrate the real interior of the room. Paolo Veronese (1528–1588) would take this to an extreme in his decorative scheme for the Villa Barbaro in Maser, near Treviso, begun in 1561 (ill. p. 114), in which landscape views are combined with *trompe l'œil* architecture and figures created with purely painterly means.

Veronese is also an illustration of the blurring of boundaries of a different kind, namely those between the individual branches of art. The replacement of one genre by another – of sculpture by painting, for example, or of architecture by sculpture – was something that dated back to the late Middle Ages. Following the rise of grisaille (Fr. *gris* = grey) in Cistercian glass painting during the 12th century, sculpture was frequently imitated by painting. In the Early Renaissance, painted figures often resembled polychrome statues. Not until the 16th century, however, did this trend towards the interchangeability of the arts reach its fullest expression. In his work on the Sistine ceiling, Michelangelo drew increasingly closer to the category of the free-standing figure. In his decoration of the Camera di San Paolo in the convent of the same name in 1518/19, Correggio not only abolished fixed visual boundaries for the ceiling but used painting to suggest the presence of sculptures and architectural elements. It was Veronese in the Villa Barbaro, however, who once again went furthest towards dissolving the barriers between architecture, sculpture and painting

But boundaries were also being crossed in contexts which verged on the "abnormal": in the architecture taking the

form of figural sculptures in the Giardino della Monstre (Garden of Monsters) in Bomarzo near Orvieto, for example, in which it becomes possible to walk into sculpture, and in the sculptures in the park at Pratolino near Florence, which appear to grow directly out of nature and at the same time become nature.

The representation of movement and infinity, and the erasure of the boundaries between work of art and spectator and between the individual branches of art, represented ways of turning away from the idealized imagery of the High Renaissance. In the process, the foundations were laid for a new approach to the portrayal of the supernatural employing innovative means of composition.

Medieval painting communicated its vision of a heavenly world beyond our own in its combination of a generous gold ground with figures lacking in plasticity and a setting lacking in spatial depth. In the age of the High Renaissance, on the other hand, with the "rediscovery of the world and of man" (Burckhardt), Biblical events, miracles, visions, and everything that belonged to the spiritual sphere was subjugated to the three-dimensional systems of temporal space and figural representation. The miracle became "a process like

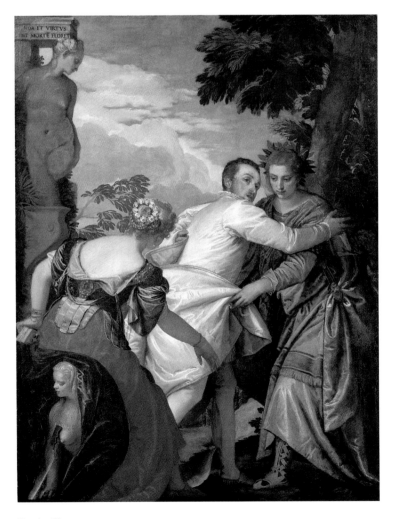

Paolo Veronese
Allegory of Vice and Virtue (The Choice of Hercules), c. 1580
Oil on canvas, 219 x 169.5 cm
New York, The Frick Collection

any other earthly event" (Frey), as the High Renaissance imposed the same artistic conditions on the sacred and secular sphere alike. In Raphael's *Disputà*, for example, the earthly and heavenly zones are treated with the same degree of realism.

The painting of the 16th century, on the other hand, developed new methods of making a visual distinction between the events of this world and the next. Here, "the spiritual breaks into the temporal" (Frey). This was made possible by a new philosophy of painting. A hundred years earlier, the Early Renaissance had been characterized by the dominance of line over colour. Line fixes an object on the plane and allows it to appear tangible and hence real. The renunciation of line in favour of colour modulation subsequently introduced by Leonardo liberated objects from their "tangibility". Furthermore, while line addresses itself primarily to the rational mind, colour speaks first and foremost to the emotions. Through this emotional force of colour, it thus now became possible for the spectator to be "overwhelmed" by the miracle portrayed in a painting.

In all its forms considered so far, the Mannerist art of the 16th century rejected the norms of the High Renaissance. Mannerism was fundamentally "anti-normative", albeit not yet "manneristic" in the modern sense of the world. "Mannered", on the other hand, is a term which can be applied to a series of phenomena which up till now have served to overly colour our opinion of the era.

The most important of these is the deformation of the ideal human figure, frequently as a means of heightening expressiveness. Thus Rosso Fiorentino, who undoubtedly studied the work of Michelangelo, transposed the latter's Herculean image of man into figures of seemingly arbitrary proportions and into forms whose details are often generously condensed. In Florentine painting especially, figures frequently possess elongated bodies with relatively small heads. This principle, which would be taken up by El Greco (c. 1541–1614) at the end of the century, was first exploited to particular effect by Pontormo.

In the *Self-Portrait in a Convex Mirror* (Vienna, Kunsthistorisches Museum) which he painted in 1523, Parmigianino (1503–1540) made the distortion of the human ideal cultivated by the High Renaissance his overt theme. The Milan painter Giuseppe Arcimboldo (c. 1527–1593) came close to surrealism in the heads which he composed entirely out of plant life (ill. p. 87) or which he placed in unreal, dreamlike settings.

Last but not least, this distortion of the human and natural image extended to anti-classic, unnatural colour combinations, as found in particular in 16th-century Florentine painting, and to the use of non-uniform systems of perspective and scale to subvert the logic of the whole.

To generalize, and hence inevitably to simplify, we may identify in the art of the Renaissance three successive stages

in the portrayal of the human figure. The ideal of the Early
Renaissance was man in his natural image. The ideal of the
High Renaissance was the idealization of that natural image,
the portrayal of man in the state of full harmonious develop-
ment which in real life he is prevented from attaining. The
"ideal" of Mannerism was go beyond and in part to distort
man's natural image in favour of heightened expression.

Forces behind the stylistic changes in the 16th century

The shift from the High to the Late Renaissance was a reflec-
tion of far-reaching religious, social and scientific develop-
ments. Unlike the reformist and "heretical" movements of
the Middle Ages, which had never seriously threatened the
power of Rome, when Martin Luther (1483–1546) nailed
his famous theses to the door of Wittenberg church in 1517,
he publicly signalled the start of a religious revolution
which would fundamentally challenge the validity of the
Catholic Church. The latter retaliated in the mid–16th cen-
tury with the reforms of the Council of Trent and, by sum-
moning all its forces, restored religious life in wide areas of
Europe. But the underlying damage had been done: the un-
questioning acceptance with which the Church had formerly
been greeted could never be restored. The 16th century was
thus filled with extraordinary religious tensions which
would destroy the balance between the secular and the
sacred sphere, between the real and the ideal, that had so
characterized the High Renaissance. These same tensions
helped to fuel the unrest in painting which expressed itself
in movement.

For the arts in Germany, the schism remained a constant
source of conflict throughout the following centuries. Lu-
ther's doctrine of the "freedom of the Christian", who is
granted responsibility for himself, undoubtedly represents
one of the greatest achievements in the history of German
thought. In two respects, however, it also harboured
dangers which would prove catastrophic on several occa-
sions in the future. Firstly, Luther's doctrine overestimated
the moral quality of humankind, a reflection of the fact
that Protestantism itself required an educated mentality in
order to be properly understood. Secondly, it restricted it-
self to man's inner freedom, while continuing to demand
strict obedience to secular power. In this way Protestantism
encouraged an acceptance of political authoritarianism
which would prevent the development of democracy for
many centuries.

Luther himself experienced the negative consequences of
the Reformation. Following earlier demands by rebels for
greater freedoms for the peasant classes, by 1526 the Peas-
ants' War was raging. Influenced by the new teachings, the
peasants wanted a role in state life and called for the aboli-
tion of serfdom and the secular dominion of the Church.
After initial successes, the rebels were crushed, primarily for
lack of a leader to co-ordinate their efforts. Luther initially

Giuseppe Arcimboldo
Spring, 1563
Oil on wood, 66.7 x 50.4 cm
Madrid, Real Academia de Bellas Artes de San Fernando

sought to act as mediator between the opposing sides but
then came down clearly on the side of authority.

The denunciation of image worship, voiced most vocifer-
ously by John Calvin (1509–1564), led in Germany and the
Netherlands to a violent wave of iconoclasm, comparable only
with the burning of Byzantine paintings in the 8th century.
The scale of the damage would only be surpassed by the dev-
astation wrought by the air raids of the Second World War.

The religious conflicts which lasted throughout the 16th
century would also have an enduring consequence for Ger-
man culture right up to the 20th century, as described by
Golo Mann (1909–1994): "Germany, which had previously
shared in all of Europe's major experiences – Romanization
and Christianity, feudalism and crusades, monasteries and
universities, cities and the middle classes, Renaissance and
Reformation – now failed to share the greatest experience of
all: the burgeoning Europeanization of the world. Her ships
plied neither the Atlantic nor the Indian Ocean. Her trading
activities dwindled, her cities grew poorer, her middle
classes fossilized. The invaluable education signified by col-
onization and the battle for the colonies, its broadening of
horizons and its material enrichment and intensification of
life – in all these things Germany took little part." In other
words, the Reformation ushered into German culture a cer-

Lorenzo Lotto
Portrait of a Young Man, c. 1506–1508
Oil on canvas, 53.3 x 42.3 cm
Vienna, Kunsthistorisches Museum

tain provincialism which it would be unable to shake off for centuries. The lack of major patrons was painfully evident. It was not by chance that Germany's greatest painter since Dürer, Hans Holbein, spent a large part of his life in England. Cranach, having been one of the most imaginatively talented artists around the turn of the century, descended into a cool, artificial aestheticism as court painter to Frederick the Wise of Saxony (1482–1532). The formal vocabulary of the Renaissance was explored predominantly in the ornamental sphere, whereby it was not even received directly from its Italian source, but only through the indirect channel of Netherlandish art.

Alongside religious upheavals, Italy also underwent sensitive political changes in the 1520s. In 1527, and thus at approximately the same time as the Peasants' War in Germany, Italy was profoundly shaken by the sack of Rome by the mercenary armies of Emperor Charles V (1500–1558). The event was widely seen as a chastisement for the relaxation in the country's moral standards and its indulgence in luxurious lifestyles. If Italy's suffering would appease the wrath of God, wrote Jacopo Sadoleto (1477–1547), bishop of Carpentras since 1517, in a letter to Pope Clemens VII (1478–1534) dated 1 September 1527, "if these terrible punish-

ments clear the ground for a return to better morals and laws, then perhaps our misfortune has not been of the greatest". Whatever the case, people's faith in the glittering face of secular power was profoundly shaken, all the more so as broad sections of Italy remained under Spanish rule.

The "crisis in the High Renaissance" was not only rooted in historical, religious and social changes, however, but was also, and in equal measure, the consequence of a new world picture. In 1492 Christopher Columbus (1451–1506) discovered America while attempting to reach India. Between 1497 and 1504, the Florentine explorer Amerigo Vespucci (1451–1512) mounted four voyages of discovery to Honduras and South America; his first name gave the "new" continent its name. In 1497/98 Vasco da Gama (c. 1460–1524) succeeded in sailing round the southern tip of Africa and in finally establishing the sea route to India. Amongst the new territories discovered by others charting the same course were southern China in 1517, New Guinea in 1526 and Japan in 1542. In 1519–1522 an expedition captained by Ferdinand Magellan (c. 1480–1521) embarked upon the first circumnavigation of the world – an astonishing achievement and an important milestone in the history of geography. It was finally proved that the earth was indeed round, as suspected since early Christian times. The vast new continent of America was explored in greater depth in the 1520s and 1530s; as from 1528, the Spaniards penetrated deep into North America from their outposts in Mexico, and in 1534 the French occupied parts of Canada.

In this respect, the 16th century was the era of a quite literally changing world view. The self-contained Old World was now obliged to recognize its relativity to the whole. It no longer ranked as the centre of the world fringed by a few more or less exotic outskirts, but simply as a comparatively small area within a large, for the most part unexplored horizon. The multiplicity of these newly-discovered landscapes, peoples and cultures cast into question the validity of Europe and its outlying regions as the measure of all things.

It was only logical, therefore, that a new definition should be required for the concept of virtually immeasurable dimensions, of infinity. It is undoubtedly here that we find the roots of the new approach to space demonstrated in the art of the epoch.

The world picture would also take a turn in another direction in the early 16th century when, following on from work already carried out by the German astronomer Regiomontanus (1436–1476), Nicolaus Copernicus (1473–1543) began to formulate his revised theory of planetary motion. The heavenly bodies revolved not around the earth, he argued, but around the sun; the earth, too, revolved round the sun and at the same time spun on its own axis. Some one hundred years later, in 1633, Galileo Galilei (1564–1642) would be forced to recant his belief in this heliocentric world picture!

The development of artistic theory

The stylistic transition from the High to the Late Renaissance was closely accompanied by a widening in the field of theoretical enquiry – a development which we can only touch upon briefly here. The Early Renaissance in Italy had chiefly studied the theory behind practical aspects of the representation of "reality", such as perspective, proportion, and anatomy. In the 16th century, this emphasis shifted towards questions of an aesthetic nature. The debate was dominated by the question of which should be given precedence: line or colour? While Florence argued passionately for the primacy of line, Venice equally vigorously defended the importance of colour as the supreme means of painting. The discussion that ensued would culminate in the 17th century in the heated disputes at the French Academy between the "Rubenists" and the "Poussinists", and would linger on in the tension between Neoclassicism and Romanticism in the 18th and early 19th century.

Closely related to the argument surrounding colour and line was the question of the order of importance of the various branches of art. Here, too, Florence and Venice represented the two opposite poles of opinion. Florence had always held sculpture to be the greatest of all the arts; from Giotto and Masaccio to Michelangelo, its major artistic achievements in all areas of art had been determined by sculptural thinking. Venice, on the other hand, which lent a "pictorial" emphasis even to its architecture and sculpture, saw painting as the supreme expression of all artistic endeavour.

An anecdote related by Paolo Pino (fl. 1534–1565) in his *Dialogo di pittura* (Dialogue on Painting, Venice 1548) makes these different attitudes clear. While engaged in conversation with a group of sculptors, the attempt was made to convince Giorgione of the superiority of sculpture by arguing that sculpture could show the human figure from all sides, whereas painting could only show it from one. Giorgione subsequently proceeded to paint a now vanished *St George* which astounded the sculptors. The knight was shown in armour, holding his lance, beside the waters of a spring in which his entire figure was reflected; leaning against a tree trunk further away was a mirror offering a full view of the saint from one rear side. A second mirror on the opposite edge of the painting reflected his other rear side. Giorgione thereby wanted to demonstrate that a painter could render a figure visible from all sides at once, whereas someone looking at a sculpture would first have to walk around it before they could appreciate it as a whole.

There will always be a temptation to explain the differences between the art centres of Florence and Venice in literal terms of their contrasting topographies. Surely the mountainous region of Tuscany, with its stereometric forms and its contours incisively modelled by light and shade, is primarily an incitement to sculpture, whereas the colours of the Venetian landscape, refracted in the waters of the lagoon, appeal first and foremost to the painter's eye rather than to the sense of touch?

Theoretical debates on the arts assumed various forms over the course of the 16th century. Giovanni Paolo Lomazzo (1538–1600) offers us a key to the understanding of the Late Renaissance – and the distance separating it from the High Renaissance – in his *Idea del tempio della pittura* (Idea of the Temple of Painting) of 1590, in which he discusses the relationship between the creative idea formulated by the artist (the *concetto*) and the natural model.

The "rediscovery" of Mannerism in the 20th century

Art history has so far made only limited study of the ways in which historical epochs and individual artists have been received and evaluated by theoreticians and practitioners of art. This largely unexplored field nevertheless promises to open up a wealth of new perspectives. Assessing the achievements of the past not only opens our eyes to facts previously unrecognized or perhaps not considered important, but contributes in equal measure to understanding the present. Both in the sphere of art history and art theory, the respective standpoint of the viewer can be shown in numerous cases

Agnolo Bronzino
Eleonora of Toledo and her Son Giovanni, c. 1545
Oil on wood, 115 x 96 cm
Florence, Galleria degli Uffizi

to have been influenced – whether consciously or unconsciously – by the artistic trends of the viewer's own day.

The re-appraisal of the "Mannerist" tendencies in the art of the 16th century by early Modernism in the 20th century is a typical example. The older writer Burckhardt, in his *Randglossen zur Skulptur der Renaissance* (Notes on Renaissance Sculpture) of 1894/95, spoke not without gentle irony of the "naïvety in Quattrocentro art which has recently come to be admired", and noted with regard to the Late Renaissance: "Those advanced enough in years, however, will already have seen opinions change in this fashion, and would not be altogether suprised to see a similar swing back in favour of Mannerist works, should the hunger for beauty transfer itself to the gleanings left behind after the harvest has long been taken in". This swing would indeed take place just ten years later.

In Mannerism's distortion and simplification of the natural model, Expressionism and Cubism recognized essential features of their own philosophy of art. Its abolition of rational, logical structures and its exploration of dream-like, subconscious levels of human emotion must similarly have struck a profound chord both with Surrealism and psychoanalysis. Its efforts to render sequences of movement visible to the eye were directly taken up by Italian Futurism between approximately 1900 and 1912.

Filippo Tommaso Marinetti (1876–1944) defined the goals of the movement in his *First Futurist Manifesto* of 1909: the formal reproduction of the *dinamismo* of modern technology and civilization, the dissolution of the static image, and the capturing of "the beauty of speed". When he continues: "We reject the right angle as devoid of passion. We desire the shock of the acute angle, the dynamic arabesque; the oblique lines which rain down on the viewer's senses like arrows coming out of the sky", he seems to be referring directly to the principles of artistic design found in the painting of the 16th century.

Late Renaissance and Baroque

In fact, however, the historical importance of the art of the 16th century had long ago become apparent with the transition to the Early Baroque. Its central concepts were taken up and developed further by the 17th century. Michelangelo da Caravaggio (1537–1610), for example, took his use of colour from the great Venetians, emphasized the miraculous dimension of his New Testament subjects for all their naturalistic details, and carried the suggestion of dynamic movement even further than his 16th-century predecessors (*Crucifixion of St Peter*, 1601, Rome, Santa Maria del Popolo, Cesari Chapel; *Deposition*, 1602–1604, Rome, Pinacoteca Vaticana). In 1600 the 23-year-old Peter Paul Rubens (1577–1640) made a trip to Italy, during which he was able to study at first hand the heritage of the 16th century; his assimilation and transformation of the influences he encountered would have profound consequences for the development of the Northern European Baroque. Neither the blurring of the boundaries between the different genres which took place in Baroque art nor its removal of the barrier between real and artificial space are conceivable without the achievements of the 16th century.

Every new development is characterized by the tension between profit and loss. The potential gains thereby offered by the painting of the 16th century lay above all in the dynamic means of composition with which it repealed the static laws of the High Renaissance. From a number of points of view, the Baroque era which began around 1600 can be seen as a synthesis of these means with the norms of the High Renaissance, whereby animated harmony was now replaced with harmonious movement.

In view of the wealth and scope of the developments which led from the High Renaissance to the Baroque, we would do better to abandon the largely misleading term of Mannerism and to call the art of the 16th century by its former name: the Late Renaissance.

LEONARDO DA VINCI

1452–1519

No other work in Western art has come to so typify its subject as Leonardo's *Last Supper*. Building upon the versions by Castagno and Ghirlandaio (ill. p. 38), Leonardo arrives at an entirely new and definitive solution. With its masterly creation of depth, the fresco initially gives the impression of being a real extension to the refectory; but the discrepancy in height between the point of station from which its perspective system is calculated and the viewer's eye, together with the monumental size of the figures, immediately re-establish its distance. The painted architecture of the background, almost austere in its simplicity, serves a single compositional function: all the vanishing lines meet in the seated figure of Christ, whose central thematic significance is additionally emphasized by the wider window and crescent-shaped moulding behind.

In a departure from his preliminary drawings for the fresco, which show Judas on the near side of the table in line with pictorial convention, Leonardo places him in the final version amongst the rest of the disciples. We are thereby shown a different moment in the events. Christ has just announced his impending betrayal, and the shocked disciples are reacting with the question: "Lord, is it I?". On either side of the triangular figure of Christ, further isolated within the composition by his red and blue robes, the apostles are grouped in threes. The range of their responses is reflected in their various movements and gestures – in line with Leonardo's insistence that a painter should express his subjects' thoughts not in their faces but in their poses and movements. As a result, the fresco – despite the poor condition in which it survives today – has lost none of its expressive power.

Despite the fact that only its underpainting was executed, Leonardo's *Adoration of the Magi* heralds the dawn of the High Renaissance. Its square format dictates the grouping of the figures: the kneeling kings form a triangle with the figure of Mary, whose head is both the apex of the triangle and the centre of the panel. The twisted, almost contrapposto pose of the Virgin and Child mediates between left and right in an unconstrained fashion – Mary might be described as the point of articulation at the heart of the pictorial organism as a whole. The powerful facial expressions recall the Portinari Altar by Hugo van der Goes (ill. p. 63), which had been installed in Florence a few years earlier, probably in 1478.

Why Leonardo never finished the painting is a question that remains unanswered. We do know, however, that in 1496 Filippino Lippi painted a new version of the same subject (today also in the Uffizi) for the same patron and the same destination (San Donato a Scopeto monastery, near Florence). Perhaps the graphic precision demanded by the jousting scene in the background could no longer be reconciled with Leonardo's theories of colour, according to which outlines and contours grow increasingly less sharp the further away they appear.

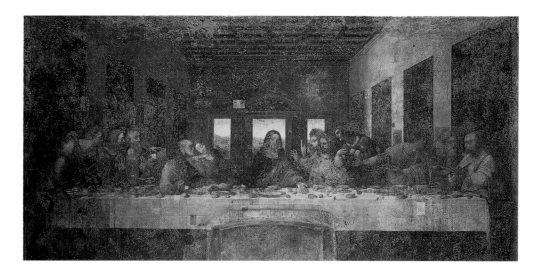

Leonardo da Vinci
Last Supper, 1495–1498
Oil tempera on plaster, 460 x 880 cm
Milan, Santa Maria delle Grazie, Refectory

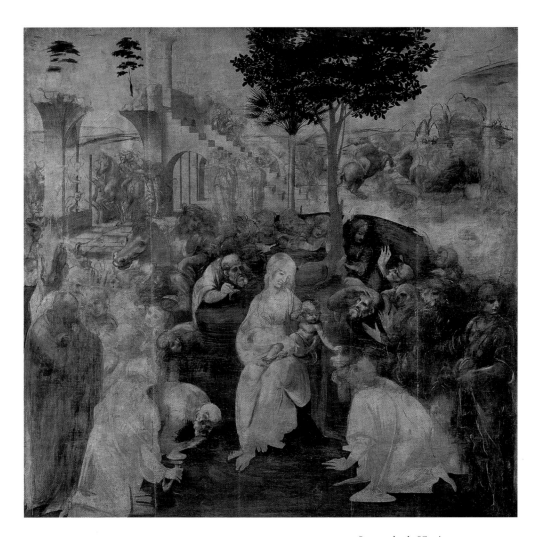

Leonardo da Vinci
Adoration of the Magi, c. 1481
Oil and bistre on wood, 240 x 246 cm
Florence, Galleria degli Uffizi

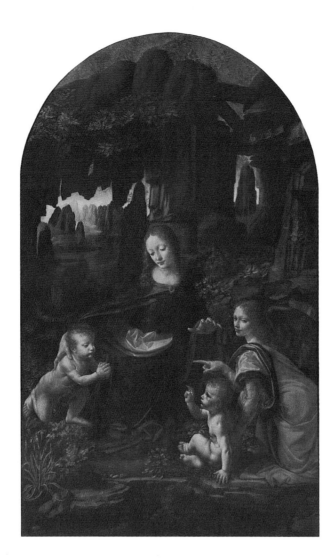

Leonardo da Vinci
Virgin of the Rocks, c. 1483
Oil on wood, transferred to canvas,
199 x 122 cm
Paris, Musée National du Louvre

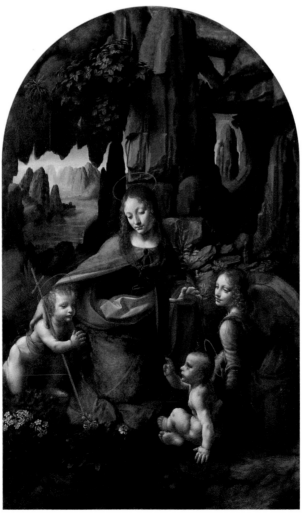

Leonardo da Vinci
Virgin of the Rocks, completed c. 1506
Oil on wood, 190 x 120 cm
London, National Gallery

LEONARDO DA VINCI

1452–1519

The *Virgin of the Rocks* has a number of icono-
graphical roots: the Adoration of the Child by
Mary and the young St John the Baptist; the
Nativity, which in Byzantine pictorial tradi-
tion took place in a rocky grotto; and finally a
powerful dream of walking through caves re-
corded by Leonardo himself.

 The composition is determined by the
triangle formed by the foreground group,
whereby any impression of rigid geometry is
avoided via asymmetries and a subtle stagger-
ing of the figures. Leonardo employs a highly
differentiated range of means to link space and
plane, the most important of which is the ana-
tomically elongated arm of the angel, a motif
which Leonardo studied in great detail in a
preliminary drawing. The head of the young
Jesus, the pointing hand of the angel and Ma-
ry's protective hand are together aligned into a
vertical running parallel to the pictorial plane.
The significance of this detail for the composi-
tion as a whole is made clear when we com-
pare this painting with the later verson
(below), in which the angel's gesture is
omitted.

Leonardo's palette reflects his new theories of
colour. The most brilliant draughtsman of his
day here renounces all use of linear definition.
In the distant background landscape, the
colours grow lighter as the contours grow in-
creasingly hazy.

 We can only guess at the reasons why Leo-
nardo should wish to follow his earlier version
of the subject with the present panel. The
figures have now acquired haloes; John the
Baptist is more clearly identified by his cross,
and the omission of the angel's pointing hand
allows Christ to emerge more strongly as the
main figure. What the London version loses in
compositional ideality, it gains in iconographi-
cal clarity.

Leonardo's *Virgin and St Anne* may be seen in
several respects as the counterpart to Michel-
angelo's *Doni Tondo* (ill. p. 97). In both cases,
three figures characterized by extremely com-
plex and largely contrary movements are com-
bined into a single group. But while Michel-
angelo is concerned above all with portraying
the third dimension, Leonardo binds the ges-
tures and poses of his figures into the geome-
tric forms governing the composition.

 Even more striking are the contrasts be-
tween the two artists' techniques. Whereas Mi-
chelangelo works primarily with line, leaving
colour to play simply a descriptive role, Leo-
nardo models both silhouettes and inner con-
tours purely out of colour – in this respect
already looking forward to the late works of -
Titian. He also employs colour to link the
foreground figures with the fantastical land-
scape behind.

Leonardo da Vinci
The Virgin and St Anne, c. 1508
Oil on wood, 168 x 130 cm
Paris, Musée National du Louvre

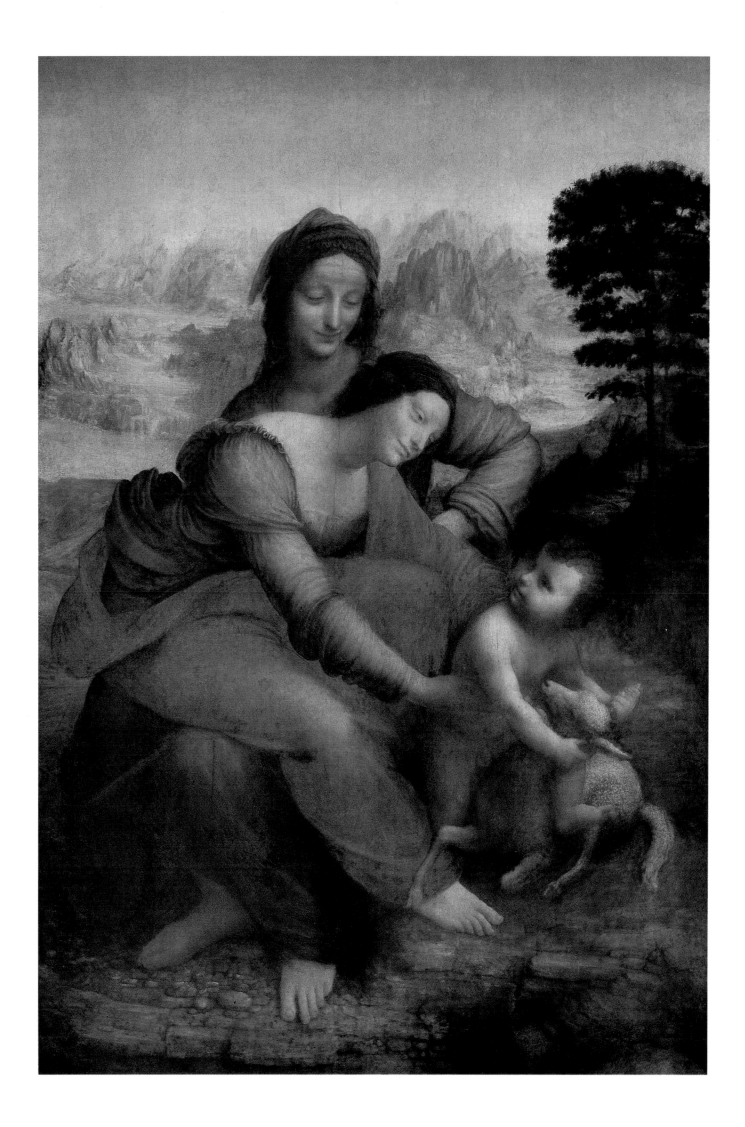

Giorgione
Virgin and Child with SS Francis
and Liberalis (Madonna di
Castelfranco), c. 1504/05
Oil on wood. 200 x 152 cm
Castelfranco Veneto, San Liberale

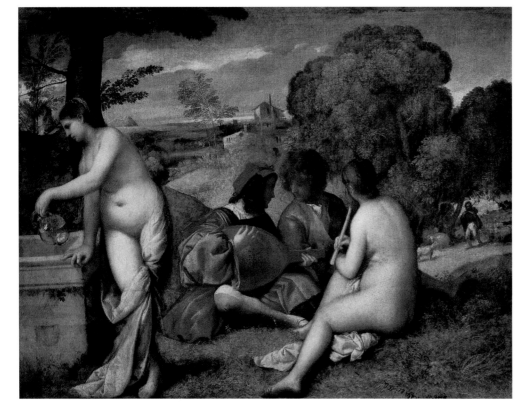

Giorgione
Concert Champêtre, c. 1510/11
Oil on canvas, 110 x 138 cm
Paris, Musée National du Louvre

GIORGIONE
c. 1477/78–1510

Giorgione's earliest authenticated work marks
a new stage in the evolution of the Venetian
Sacra Conversazione. Firstly, the Virgin is seated
above the saints on a throne too high to be
mounted in real life; secondly, she is portrayed
against a view of the landscape. The figures
are thereby staggered both in height and
depth.

The composition contains echoes of the
"crystalline" style of Antonello da Messina. In
the grouping of the figures, triangle and par-
allelogram overlap and thereby connect space,
confidently and logically constructed with per-
spective means, back to the plane. Antonello's
influence can also be seen in the sumptuous
fabrics and, on the base of the throne, the coat
of arms of the Costanzo family for whose pri-
vate chapel the panel was painted.

Line and colour modulation are still evenly
balanced, although indications of Giorgione's
future development are already present in the
knight's gleaming armour and in the diminish-
ing focus of the receding landscape. It should
thereby be remembered that Leonardo was in
Venice in 1501.

Precisely by whom and for whom this canvas,
so greatly admired by the French artists of
the 19th century, was actually painted are
questions that have yet to be satisfactorily an-
swered. Are we looking at the last known work
by Giorgione? Was it a collaborative effort
by Giorgione and Titian? Or did the painting
spring chiefly from Titian's brush? The uncer-
tainty surrounding the attribution of this
work is itself proof of the stylistic continuity
characterizing the development from Gior-
gione to Titian, and the importance of the for-
mer for the œuvre of the greatest European
painter of the Late Renaissance.

The blending of figures and landscape is
continued into the storm clouds, whereby the
sound of the music being played in the fore-
ground seems to find visual expression in the
background.

Insofar as figures in contemporary dress
are combined with female nudes, the artist of-
fers us a view of nakedness taken out of its
traditionally mythological context and
brought fully into the present. Unlike
Manet's much later painting *Déjeuner sur
l'herbe*, a direct descendant of this *Concert
Champêtre*, none of the figures seek to estab-
lish eye contact with the viewer. The closed
nature of the world inside the painting is
thereby preserved.

The allegorical meaning of the subject on the
right has yet to be deciphered. It was de-
scribed in around 1530 as a "Landscape on
canvas with storm, gypsy woman and soldier".
Efforts to interpret the painting were further
complicated when X-rays revealed that the art-
ist originally intended a second nude in place
of the soldier, and that the work was executed
in a number of stages – typical of the Venetian
artist's spontaneous and emotional approach to
the painting process, so different to that of his
more reflective Florentine colleagues.

This is undoubtedly one of Giorgione's last works. The relationship between figure and landscape is developed in pronounced favour of the latter, colour modulation almost entirely replaces line, and the literary subject is of secondary interest. In this respect there is good justification for the painting's present title, which dates back to the 16th century:

the representation of a natural event was certainly one of Giorgione's main concerns.

The fascinating way in which the artist dissolves fixed line into forcefully expressive colour, as seen in the soldier's clothing and the sky, for example, already looks beyond Titian's early work to the paintings of his mature years.

Giorgione
La Tempestà, c. 1510
Oil on canvas, 78 x 72 cm
Venice, Galleria dell'Accademia

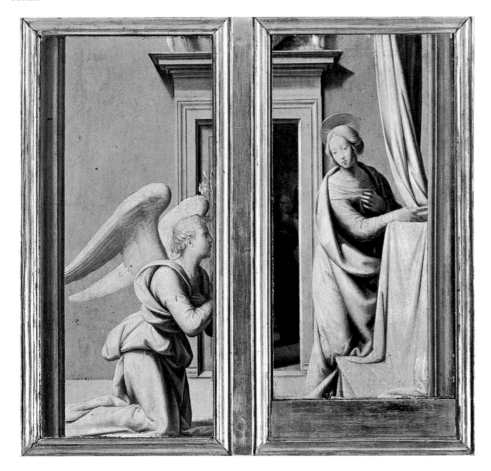

Fra Bartolommeo
Annunciation, c. 1500
Oil tempera on wood, each wing 20 x 10 cm
Florence, Galleria degli Uffizi

FRA BARTOLOMMEO
1472–1517

These two small panels number amongst the works which Bartolommeo executed before entering the convent of San Marco. The wings of a domestic altarpiece for Piero del Pugliese, they show the Nativity and Circumcision of Christ on their reverse and flank a relief of the Virgin by Donatello. Both panels were later cut down on all sides, upsetting the original relationship between the two figures, as established in particular by the angel's gesture of blessing, and restricting the view through the open door in the wall behind. The portrayal of the *Annunciation* in grisaille (grey monochrome) would have derived from a study of Netherlandish works (Bartolommeo knew the Portinari Altar by van der Goes, installed in Florence in 1478). In his approach to figures and space, however, the young artist is more strongly influenced by Perugino. Between the front edge of the painting and the rear wall running parallel to the plane, he creates a clearly defined "stage"; here, with the aid of sculptural draperies, he establishes the three-dimensional nature of his figures and allows them to unfold in free and unconstrained gestures. In establishing the sequence of their movement from left to right, Bartolommeo nevertheless respects the conditions of the two-dimensional plane, which also underlie the prieu-dieu at which Mary is kneeling, and which takes up the lines of the surrounding frame.

Andrea del Sarto
Pietà, c. 1519/20
Oil on wood, 99 x 120 cm
Vienna, Kunsthistorisches Museum

ANDREA DEL SARTO
1486–1530

In reducing the number of bystanders traditionally serving to reflect the event taking place, Andrea del Sarto creates a new type of Pietà in Florentine painting, in which he concentrates solely on the Virgin Mary and the dead Christ accompanied by two angels. The centre is dominated by Mary, her face wearing an expression of anguish. There is no longer a direct connection between mother and son, since Christ is lying on a bier in the foreground and seems to have overcome the suffering of death.

On the one hand, Sarto observes the norms of a "classic" composition: the figures are arranged one behind the other as if in two layers of relief and thereby confirm the laws of the plane, while the composition is equally weighted on the left and right without descending into rigid symmetry.

At the same time, however, the artist introduces a pulsating sense of unrest via the contrast between angular folds of drapery and soft modulations of colour in which contours are dissolved. The right-hand angel holding the instruments of Christ's Passion, in particular, gives the impression of constantly changing his pose and the direction of his gaze. The sweeping, abstract brushwork of the background is typical of Sarto's late works. The proportions and expressions of the faces reflect the influence of Pontormo.

MICHELANGELO BUONAROTTI
1475–1564

The only panel painting attributed beyond
doubt to Michelangelo has frequently been
criticized for the artificiality of its figural com-
position. The three main figures are combined
into an extraordinarily complex group in
which their natural proportions are of
necessity distorted – something which would
be copied by the Mannerists of the succeeding
generation. But to dismiss the tondo simply as
a feat of artistry would be to do it a grave in-
justice on several counts. Firstly, Michelangelo
is here concerned with overcoming the static
in favour of the transitory moment. Secondly,
he is attempting – as the outstanding sculp-
tural talent in Western art – to portray the
group in three-dimensional terms; the geomet-
ric triangle so beloved of High Renaissance
painting is here replaced by the stereometric
pyramid. And thirdly, the way in which Mary
lifts Jesus up may symbolize her acceptance of
his future sacrifice on the cross and his resur-
rection. This is also implied by the figure of
the young John the Baptist on the right who,
separated from his playmate by a wall, will go
out into the world to announce the coming of
Christ.

Nor should the line of breathtaking male
nudes in the background – recalling tondi by
Luca Signorelli – be seen as a secularization of
the subject, or as a reflection of the sculptor's
delight in plastic form, but as symbolizing the
sphere of the Old Testament.

The panel, which was probably painted to
mark the marriage of Agnolo Doni and Mad-
dalena Strozzi, has become known in the liter-
ature as the Doni Tondo.

In his cycle of Sibyls and Prophets in the Sis-
tine Chapel, Michelangelo undergoes a stylis-
tic evolution which leads from the relief to the
free-standing figure. Zechariah above the en-
trance wall and Jonah above the altar wall
mark the two poles of this development,
which goes hand in hand with an increase in
the scale of the figures.

Although the *Delphic Sibyl* was painted dur-
ing the first stage of the decoration of the Sis-
tine ceiling, it already clearly reveals this
trend towards increasing liberation from
painted architecture. The Sibyl turns right-
wards on her own bodily axis, while her left
arm, holding the scroll, reaches across left-
wards. A motif from the Doni Tondo is here
used to indicate a more powerful crossing of
space.

This effect is reinforced by the two putti in
the background, who no longer stand side by
side but at an oblique angle leading into the
picture, thereby helping to release the figure
from its architectural context. The relatively
cool palette also lends the Sibyl the character
of a painted marble sculpture. Never before
had painting been so dominated by sculptural
thinking as in Michelangelo's Sistine ceiling.

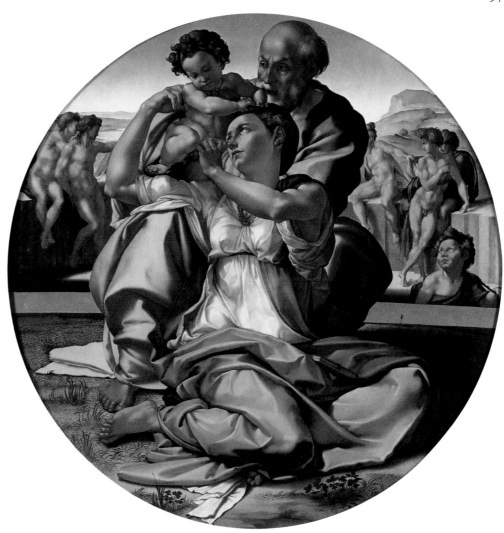

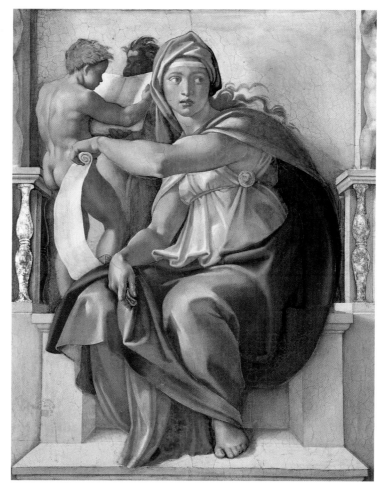

Above:
Michelangelo Buonarroti
Holy Family (Doni Tondo),
c. 1504/05
Oil tempera on wood,
diameter 120 cm
Florence, Galleria degli
Uffizi

Michelangelo Buonarroti
Delphic Sibyl,
c. 1506–1509
Fresco, c. 350 x 380 cm
Rome, Vatican, Sistine
Chapel

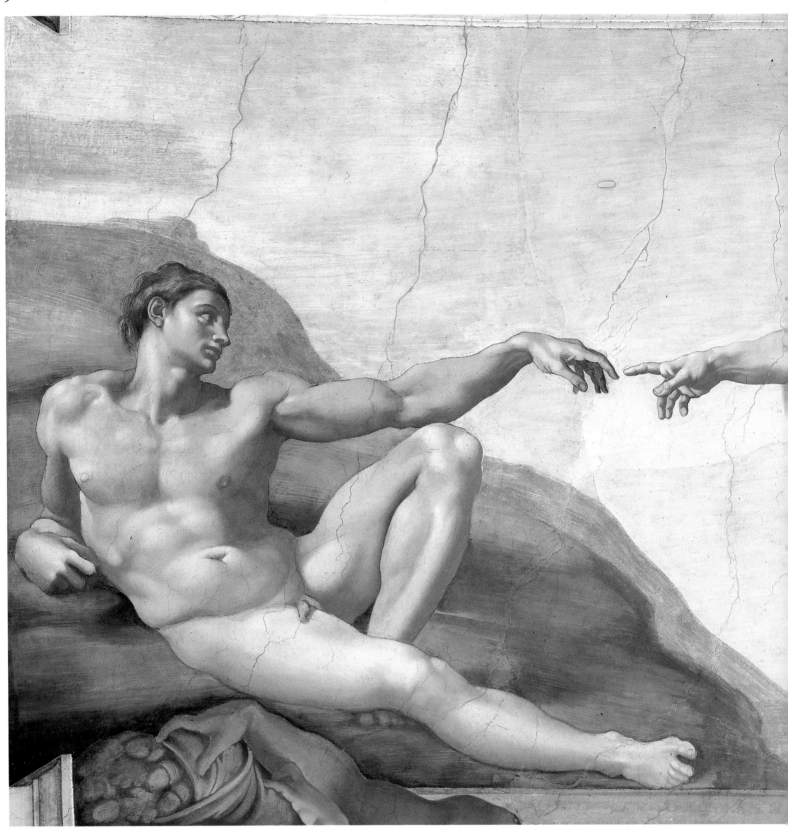

MICHELANGELO BUONAROTTI

1475–1564

In the entry for 2 December 1786 in his *Italienische Reise* (translated as *Letters from Italy*, 1901), Goethe wrote: "On the 28th [of November] we paid a second visit to the Sistine Chapel... all ... is fully compensated by the sight of the great masterpiece of art. And at this moment I am so taken with Michelangelo, that after him I have no taste even for nature herself, especially as I am unable to contemplate her with the same eye of genius that he did." Goethe here recognizes a fundamental phenomenon of the High Renaissance: its relationship to the portrayal of nature in the sense

of the "idea" behind every natural object. In its fusion of natural beauty with ideal beauty, Western painting finds itself for a brief moment in direct proximity to the art of Ancient Greece.

In chronological terms, *The Creation of Adam* probably marks the mid-way point in the Sistine ceiling. By now Michelangelo was increasingly enlarging the scale of his figures and abandoning scenic and landscape detail. For the first time in the history of this subject in painting, God the Father is horizontal, mirroring the reclining figure of Adam. Michel-

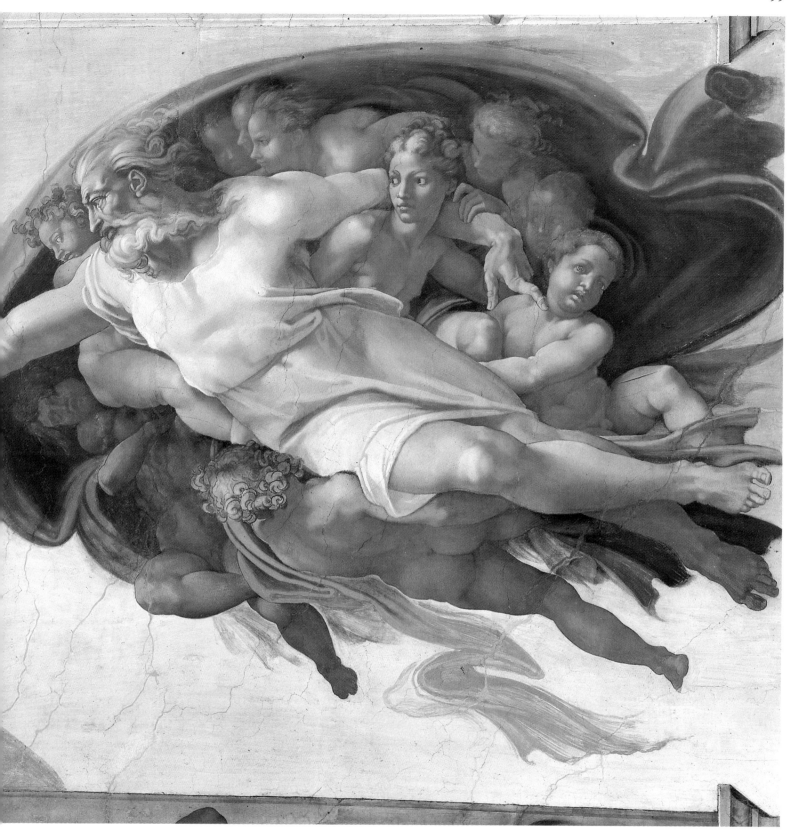

angelo thereby takes the words of the Bible literally: "So God created Man in his own image" (Genesis 1:27). The youthful Adam seems the definitive embodiment of the ideal male body. The precise observation of anatomical detail is not an end in itself as in the case of Luca Signorelli (cf. ill. p. 40), but serves to demonstrate the supreme harmony residing in the body's proportions. Maximum naturalness is combined with maximum artistic calculation: despite their wealth of movement in space, the main figures remain bound through their gestures to the plane. This is seen par-

ticularly clearly in the combination of Adam's gaze, left arm and raised knee.

Ground and clouds repeat in more abstract form the silhouettes of Adam and God the Father, whose two outstretched arms are set against a white background comparable in its charged atmosphere to an electric field.

"Nowhere else in the entire sphere of art is the metaphysical so brilliantly expressed in a physical moment of such utter clarity and forcefulness" (Jacob Burckhardt).

Michelangelo Buonarroti
The Creation of Adam, c. 1510
Fresco, c. 280 x 570 cm
Rome, Vatican, Sistine Chapel

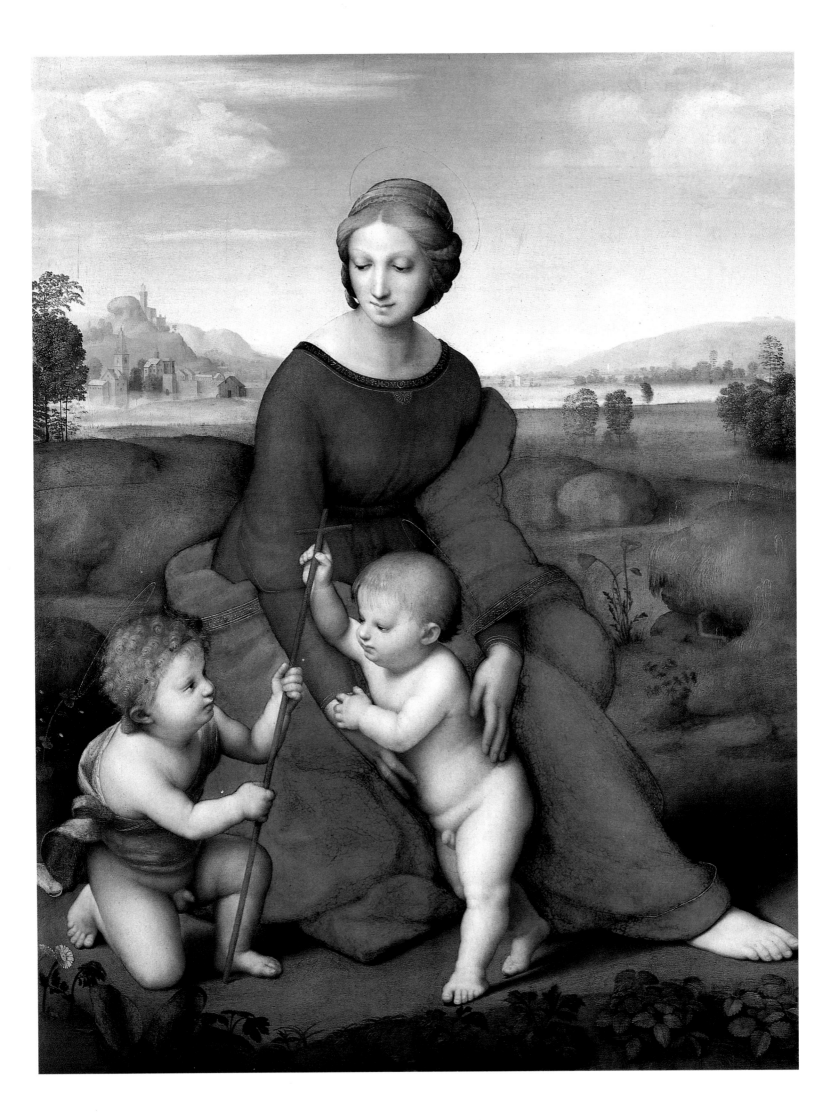

RAPHAEL

1483–1520

Over the course of his Florentine years, Raphael painted a number of versions of the Virgin with Christ and the young John the Baptist in a landscape. He thereby confronted the latest compositional problems relating to the portrayal of figures and space. The strongly contrasting directions combined within the pose of the present Madonna suggest the influence of Leonardo, in particular his studies for *The Virgin with St Anne*. The freedom of the figures in their relationship to space and plane is effortlessly combined with a precisely calculated composition. The two children in front of the Madonna are positioned to the left of centre, but are incorporated within the almost equilateral triangle describing the group as a whole.

Raphael's *Sposalizio* is a pictorial document of the first order, marking his transition from the Early to the High Renaissance. Although he adopts the overall composition and many of its details from a version of the same subject, also dating from 1504, by his teacher Perugino, the latter merely serves as the foil against which Raphael proves himself the representative of a new generation. The central group is clearly emphasized at the expense of the accompanying figures, and a previous episode in the events – the Virgin's rejection of other suitors – is more forcefully indicated in the young man in the right-hand foreground. Above all, however, Raphael frees himself from the older master's principle of building up his composition in layers of relief. The figures in the foreground are grouped in a concave semicircle which must be seen in conjunction with the landscape in the background, the dome of the building behind and the arching upper edge of the panel. The figures behind, on the other hand, curve towards the interior of the painting; they thereby correspond to the temple rotunda and combine with the landscape to trace the outline of a circle.

In the composition of the *Madonna di Foligno*, Raphael translates into panel painting the principle realized in the frescos of the Stanza della Segnatura, namely the perfect marriage of external format and inner content. The figures in the earthly zone take up the rounded top of the picture, complete the circle and simultaneously project it, through their own staggered positions within the foreground, into the third dimension. The shape of the circle is also taken up in the aureole around Mary and by the rainbow over the landscape. Despite the astonishing homogeneity of the composition, Raphael assigns different degrees of reality to the terrestrial and celestial zones. Through its increase in colour modulation and its wealth of painted light, the heavenly sphere seems to be placed beyond our earthly reach. In this respect, the panel represents a milestone in the history of Western painting.

Raphael
Madonna of the Meadows, 1505/06
Oil tempera on wood, 113 x 88 cm
Vienna, Kunsthistorisches Museum

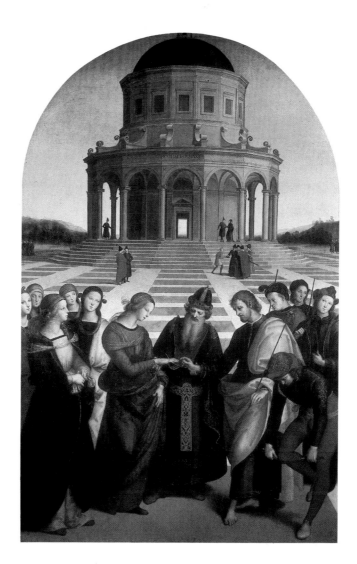

Raphael
Marriage of the Virgin
(Sposalizio della Vergine), 1504
Oil tempera on wood,
170 x 117 cm
Milan, Pinacoteca di Brera

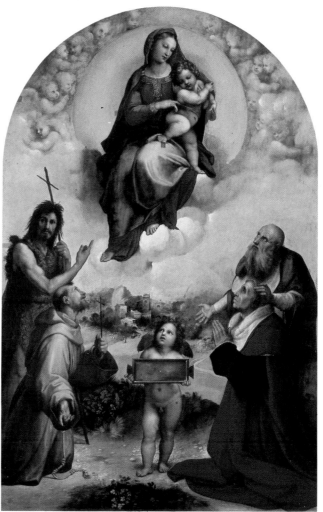

Raphael
Madonna di Foligno, c. 1512
Oil on wood, transferred to
canvas, 301 x 198 cm
Rome, Musei Vaticani,
Pinacoteca Vaticana

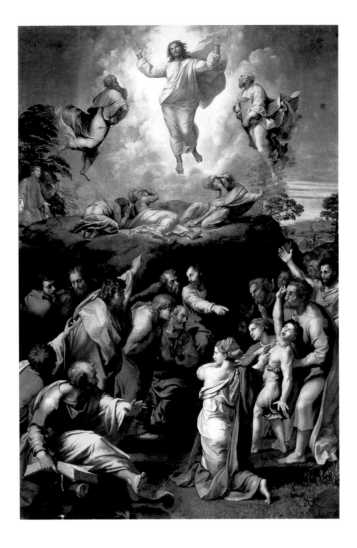

Raphael
The Transfiguration, c. 1517–1520
Oil on canvas, 405 x 278cm
Rome, Musei Vaticani,
Pinacoteca Vaticana

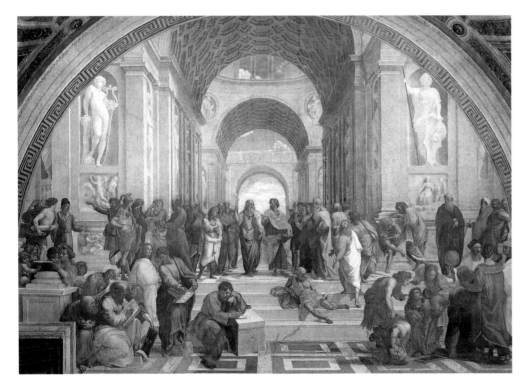

Raphael
The School of Athens, 1511/12
Fresco, width c. 800cm
Rome, Musei Vaticani,
Stanza della Segnatura

RAPHAEL
1483–1520

Raphael's last work is a summation of his entire artistic development and at the same time heralds the dawn of a new age. He treats his subject in a new fashion. In the top half of the picture, the transfigured Christ appears between the prophets Moses and Elijah above the rocky summit of Mount Tabor. The frightened disciples have flung themselves onto the ground beneath Christ's feet. In the lower zone, an epilectic boy is being presented by his distraught parents to the disciples, who can do nothing. Two events related in the Gospels as occurring in chronological succession are here combined into a single scene: Christ is rendered visible in his divine form as the only one who can offer help, whereby salvation is made a certainty. Raphael further amplifies the distinction between the earthly and the heavenly zone. The sculptural modelling and powerful colour harmonies of the lower half of the painting offer a pronounced contrast to the less solid figures of the Transfiguration scene, united by their paler hues.

Raphael nevertheless succeeds in establishing a visual connection between the two halves. Top and bottom are linked by the overall circle into which the figures above and below are grouped, by the numerous upward-pointing gestures made by those below, and above all by the dynamic slant which rises from bottom left to top right in the shadow cast by the rocky cliff. Members of Raphael's workshop, and in particular Guilio Romano, would have been involved in the completion of the lower half of the painting.

Between 1509 and 1512, on the walls of one of Pope Julius II's private rooms, Raphael depicted the four classical faculties, thereby exhibiting a large degree of intellectual freedom. The personification of ancient Philosophy is located on the wall directly opposite the *Disputà* (Theology), showing the veneration of the Holy Sacrament. In the centre of a large vaulted hall, its design indicating a knowledge of the architecture of Roman baths, stand Plato and Aristotle, considered the chief representatives of Greek philosophy throughout the entire Middle Ages. The figure of Socrates can be seen in profile on the left, while Diogenes reclines on the steps in an expression of his absence of material wants. In the left-hand foreground, a boy holds the tablet of musical harmony in front of Pythagorus. In the opposite corner, Euclid is drawing a geometric figure before a group of young men; the figure with the globe seen from behind is probably Ptolemy, with Zarathustra facing him with the sphere. The figure leaning on the block of marble (Heraclitus? Michelangelo?) is a later addition. Presented with this expansive composition, the spectator almost forgets that he is actually standing in an acute-angled, poorly lit room. Raphael does not lead the eye out into infinity, however, but yokes his pictorial space to the laws of the plane. The figures are arranged from left to right, while the recession of the architecture in the central axis is regularly checked by walls coming in from either side.

PALMA VECCHIO

1480–1528

This painting shows Diana bathing with her companions. The figure at the left-hand edge of the panel has been interpreted as Callisto, whose affair with Zeus – who is later supposed to have transformed her into a bear – has been discovered by Diana. Palma's entire œuvre was heavily influenced by Giorgione. The landscape occupies a significant proportion of the canvas; in the quality of its execution and the subtly differentiated colours of its trees and mountain ranges, it captivates the eye more strongly than the figures. Contours yield to delicate modulations of colour. Unlike Giorgione, however, the composition remains loose and the figures, in places grouped into twos and threes, are distributed freely across the pictorial plane. This may be partly explained by the fact that Palma drew a number of his figures from existing sources. The seated nymph combing her hair can be traced to an engraving by Raimondi while the figure of Callisto is seen as a variation upon the Aphrodite Kallipygos in Naples, and the figure viewed from the rear on the right as a modification of the Aphrodite of Melos. The work offers an interesting contrast to Titian, who always places his figures near the front edge of the painting and who only incorporates the background into the action to a much lesser degree. The substantial modelling of the female nudes places the painting amongst Palma's later works.

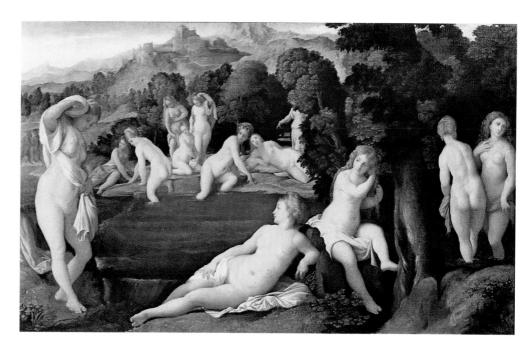

Palma Vecchio
Diana Discovers Callisto's Misdemeanour, c. 1525
Oil on canvas on wood, 77.5 x 124 cm
Vienna, Kunsthistorisches Museum

SEBASTIANO DEL PIOMBO

c. 1485–1547

The portrait of Cardinal Carondelet, probably painted at the beginning of Sebastiano's stay in Rome, is an exemplary illustration both of the talents and the limitations of this Venetian-born artist. In an allusion to Raphael, with whom he was briefly acquainted, Sebastiano expands his subject into a group portrait by including the Cardinal's secretary on the right and an unidentified figure on the left. The table and the Cardinal's right arm establish a strict boundary between the spectator outside and the scene inside the painting. The sitter's cool, almost expressionless, soberly observed physiognomy may be seen as a reflection of the atmosphere within the Curia before the Sack of Rome, namely one strongly characterized by secular interests. Pronouncedly secular, too, is the background setting: the colonnade seen in masterly foreshortening could be taken from a nobleman's palace in High Renaissance Rome.

At the same time, however, the technique used to paint the ermine-trimmed robes, together with the contrast between light and shade, are a reminder of the painter's apprenticeship in Venice. The view of the landscape behind the secretary is both a variation upon the landscapes also found on the right-hand side of works by Giorgione, with whom Sebastiano worked in Venice, and upon the landscapes found in the early works of Titian.

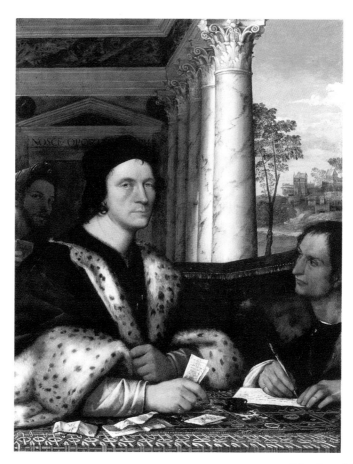

Sebastiano del Piombo
Cardinal Carondelet and his Secretary, c. 1512–1515
Oil on wood, 112.5 x 87 cm
Madrid, Museo Thyssen-Bornemisza

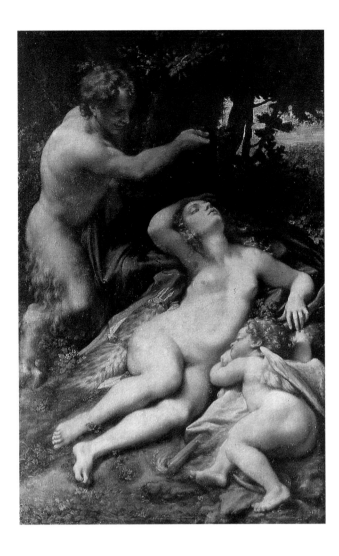

Correggio
Zeus and Antiope, c. 1524/25
Oil on canvas, 188 x 125 cm
Paris, Musée National du Louvre

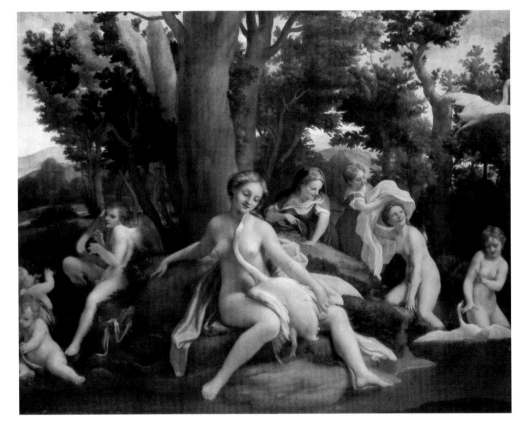

Correggio
Leda and the Swan, c. 1531/32
Oil on canvas, 152 x 191 cm
Berlin, Gemäldegalerie, Staatliche Museen
zu Berlin – Preußischer Kulturbesitz

CORREGGIO
c. 1489–1534

Zeus, disguised as a satyr, approaches Antiope, the daughter of Nycteus, regent of Thebes (according to another version of the myth, Antiope was the daughter of the river god Asopos). The sleeping Cupid signifies the union that is about to take place.

Correggio replaces the classical equilibrium of High Renaissance composition with asymmetry and portrays his figures in extremely complex poses. He nevertheless establishes a stable system of reference within the painting by means of the parallel lines at which the main characters are angled. Correggio's palette is developed out of his confrontation with Leonardo and the Venetian painters of the early 16th century, above all Giorgione. In place of colour contours, Correggio works exclusively with colour modulation, which together with the light infuses the figures with a distinct sense of weightlessness.

Correggio's portrayal of Leda, receiving Zeus in the shape of a swan, demands direct comparison with Michelangelo's versions of the same subject, which survive only in copies. While Michelangelo concentrates exclusively on the figural group, Correggio sets the scene in a wooded landscape and embellishes it with bathing nymphs, Cupid playing his harp, and putti.

By presenting Leda in a complex, twisting pose from the front, the artist grants the spectator the clearest possible view of her union with the swan, yet without approaching obscenity. The accompanying figures – some bathing, others holding their clothes, others again making music – play an important role in this regard. Above all, however, it is the landscape which, painted in the most delicate *sfumato*, lends the scene a thoroughly idyllic character.

The composition, which at first sight appears entirely improvised with its unrestrained sense of movement and free distribution of figures, is in fact carefully crafted. Leda is accentuated by the large tree trunk behind, slightly offset to the left of the central axis. Nymphs, Cupid and putti are arranged in a semicircle around the central group of trees and thereby lead the eye into the depths of the landscape, which is itself treated with a high degree of freedom in its renunciation of emphatic detail.

In *Io* and *Ganymede*, Correggio reaches the height of his artistic powers. The union of Zeus and the nymph Io, daughter of the river god Iachus, goes back in its present form to Ovid's *Metamorphoses*. Io flees before Zeus until the latter "casts darkness over the whole domain, checks the maiden's flight and conquers her modesty". While in Ovid's version Zeus makes himself invisible in the darkness, Correggio turns him into a cloud.

The artist thereby establishes a powerful contrast between the dark clouds filling the sky and the luminous figure of Io. Despite her animated pose, Io remains bound to the plane via her up-turned head and the position

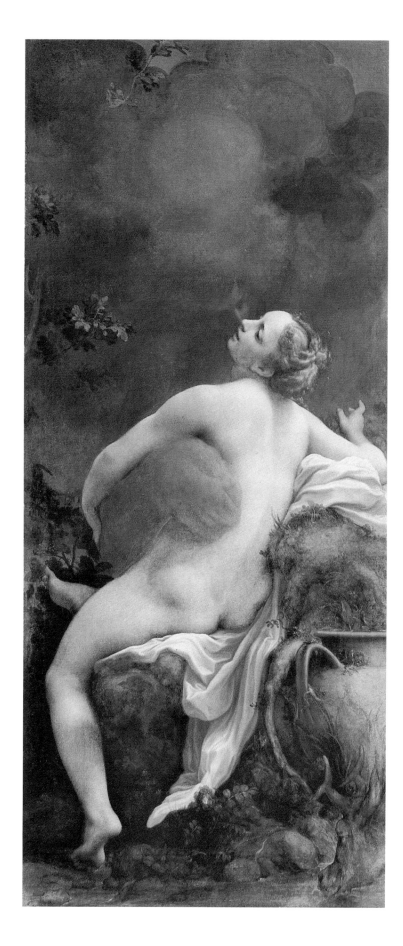

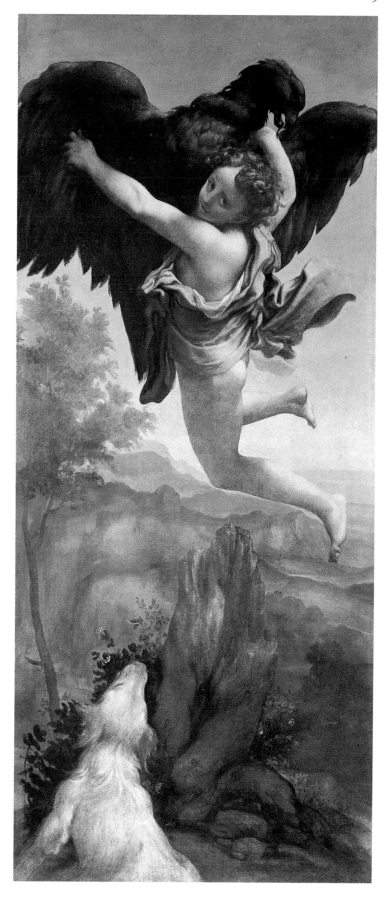

of her left arm and leg. The background, on the other hand, dissolves into indefinite depths through its rich, almost "proto-Impressionist" modulation – a removal of boundaries similar to that which Correggio had achieved shortly beforehand in his cupola frescos in Parma.

The two canvases were undoubtedly de-signed to be seen juxtaposed. The figure of Io anticipates that of the ascending Ganymede. The dog looking upwards at the handsome youth, together with the many verticals con-tained within the rocks, reinforce this sugges-tion of skyward movement, for which the ex-tremely tall and narrow formats are ideally suited.

Correggio
Zeus and Io, c. 1531/32
Oil on canvas, 163.5 x 74 cm
Vienna, Kunsthistorisches Museum

Correggio
The Abduction of Ganymede, c. 1531/32
Oil on canvas, 163.5 x 70.5 cm
Vienna, Kunsthistorisches Museum

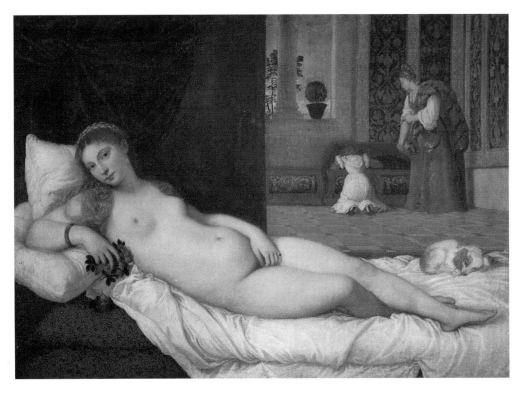

Titian
Venus of Urbino, c. 1538
Oil on canvas, 119 x 165 cm
Florence, Galleria degli Uffizi

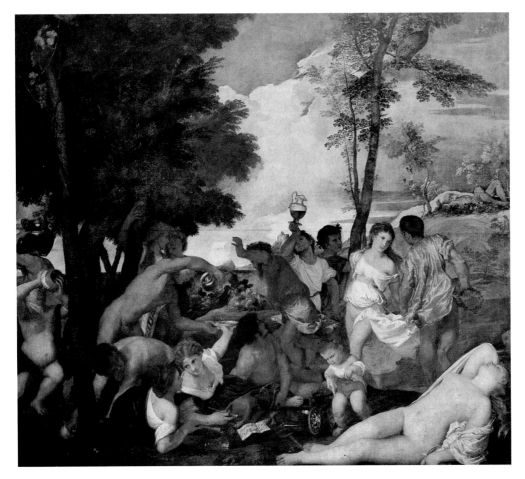

Titian
Bacchanalia (The Andrians), c. 1519/20
Oil on canvas, 175 x 193 cm
Madrid, Museo del Prado

TITIAN
BETWEEN 1473 AND 1490–1576

Titian's painting invites comparison with Giorgione's earlier *Sleeping Venus* (Dresden). The similarity in the poses extends right into the details, and Titian also adopts from Giorgione the contrast of red and white in the couch. Yet their very similarities also make the differences between the two works all the more evident. The replacement of the landscape background by the view of an interior re-establishes the connection with reality. Most significantly, however, Titian's figure is not seen sleeping, but turns her head to look out of the picture with an alert gaze. A direct relationship is thus established between the figure in the painting and the spectator. The ring on the little finger of Venus' left hand, the roses unfolding between the fingers of her right hand and the bracelet on her right wrist all reinforce the impression that this young woman belongs to the real world. The name Venus in fact arose out of a misunderstanding; this is the portrait of a beautiful courtesan, whose clothes are being laid out by the women in the background. Whereas Giorgione fuses figure and background, Titian's composition contrasts the two. Thus the foreground space is enclosed on the left and open on the right. The pale body and linen are set against the dark wall and curtain. The two paintings differ, too, in the relationship which they establish between the compositional means of line and colour. Whereas Giorgione maintained the two in balance, Titian uses colour modulation to delimit the individual elements of his picture.

The subject and composition of the *Bacchanalia* recall Giovanni Bellini's *Feast of the Gods* of 1514. Compared to his teacher's work, Titian's canvas seeks to infuse a new dynamism into the movements of the revellers and into the ascending line traced from left to right by the landscape and figures and terminating in the sleeping old man on the hill on the far right. The sensuality of the – in part, unaffectedly naked – figures is also lent far more direct expression. Insofar as none of the characters seek eye contact with the viewer, the self-contained nature of the world within the picture is nevertheless maintained. The deliberation with which Titian approached his composition is demonstrated by, amongst other things, the variation upon the motif of Venus seen in the sleeping woman in the bottom right-hand foreground, who serves to consolidate the internal boundaries of the composition.

With its harmonious proportions and natural expression, Titian's portrait of this unknown beauty still belongs to the tradition of the High Renaissance. The clear compositional structure is accompanied by a fine, rhythmical animation of space and surface. The magical nature of Titian's subtly gradated palette places *La Bella* amongst the most beautiful portraits of his mature years.

Titian La Bella, c. 1536
Oil on canvas, 100 x 75 cm
Florence, Galleria Pitti

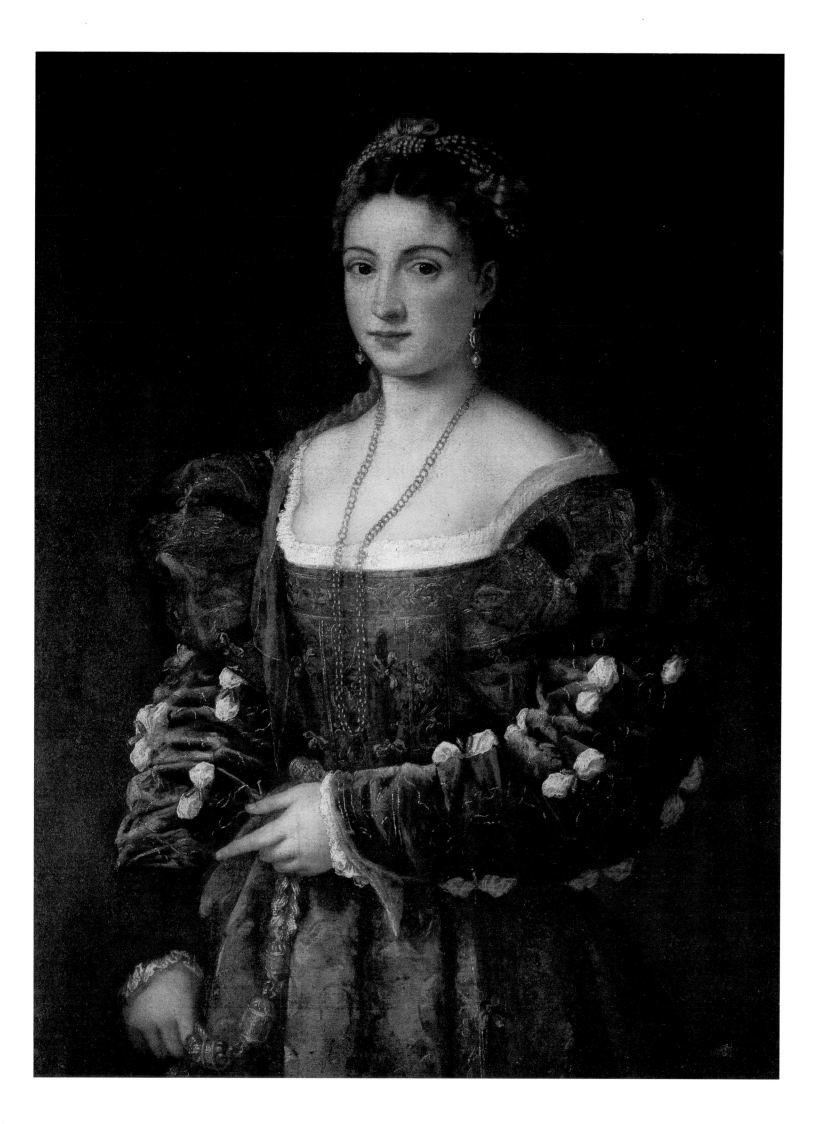

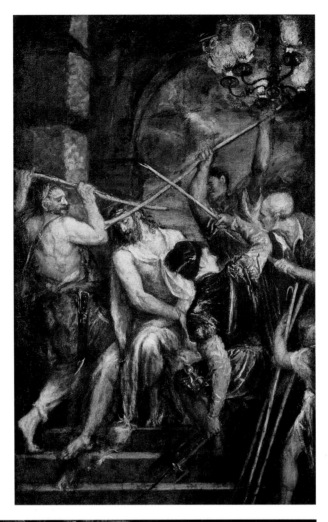

Titian
Christ Crowned with Thorns, c. 1576
Oil on canvas, 280 x 182 cm
Munich, Bayerische Staatsgemälde-
sammlungen, Alte Pinakothek

Below:
Titian
Pietà, c. 1573–1576
Oil on canvas, 351 x 389 cm
Venice, Galleria dell'Accademia

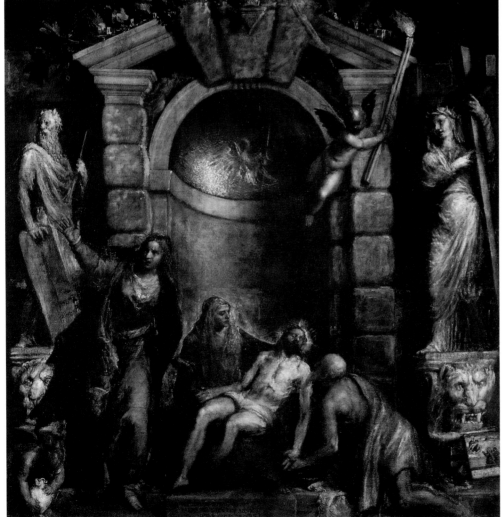

TITIAN

BETWEEN 1473 AND 1490–1576

Although Titian remained indebted through-
out his lengthy career to the compositional
and figural ideals of the High Renaissance, he
also succeeded in overcoming the static ele-
ment in composition. Here, the animated ges-
tures of the soldiers link them into a circle
around the "axis" of Christ. The impression of
constant movement is further heightened by
the fact that this axis itself seems to be rotat-
ing. The figures appear to be captured in mid-
action – their poses, momentarily frozen on
the canvas, must change in the next instant.
This destabilization is only made possible by
the artist's complete renunciation of fixating
line in his late works – the goal of a develop-
ment which he followed consistently through-
out the some seventy years of his career as a
painter.

In *Christ Crowned with Thorns*, composition
out of pure colour culminates in almost pre-
Impressionistic effects, which are further am-
plified by the unfinished state of the painting.
In this regard, it is significant to note that the
young Manet would later study and even copy
Titian's works in the Louvre.

Titian's last work, painted for the altar over his
tomb, was completed by Jacopo Palma the
Younger. In the bottom right-hand corner, be-
neath the Hellespont sibyl, we are shown a vo-
tive panel featuring the painter and his son
Orazio.

An apse filled with golden light, framed by
two columns made up of blocks of stone and a
broken pediment, establish the static element
of the composition. Against this foil, the
movements of the figures appear all the more
dynamic. On the far left and right stand the
painted statues of Moses with the tables of the
law and the Hellespont sibyl with the cross.

A diagonal descends from Moses to the
kneeling Nicodemus. The Lamentation theme
is thereby overlaid with a reference to the im-
pending Entombment. The body of Christ, on
the other hand, initiates an opposite line of
movement leading upwards to the right, activ-
ating the putto with the torch and continuing
on to the sibyl with the raised cross – a corre-
sponding reference to the coming Resurrec-
tion.

The pale, luminous body of Christ takes
up the stone-like colours of Moses and the
sibyl, while simultaneously contrasting with
the warm, dark reddish hues dominating the
other figures, and thus appears already
removed from this earthly life. Never before
had a Pietà illustrated the death of the Sa-
viour and his conquest of death in such a pro-
found manner.

The mood of the painting is essentially
characterized by the light and the palette,
whereby drawing gives way entirely to colour
modulation, as can be seen in Christ's right
arm, for example.

LORENZO LOTTO

C. 1480–1556

According to Roman legend, Lucretia, who was the wife of Lucius Tarquinius Collatinus, was raped by the son of the Roman king – a dishonour which subsequently resulted in her suicide. The event is supposed to have precipitated the collapse of the Etruscan royal line (510 BC) and thus to have led to the founding of the Roman Republic.

In the 16th and 17th century Lucretia was frequently portrayed as a symbol of purity. Lotto presents us with the three-quarter view of a woman dressed in fine, richly trimmed clothes. Turned slightly away from the viewer, in her left hand she holds a drawing of the naked Lucretia about to stab herself in the heart. An inscription in Latin on the sheet on the table reads: "Following Lucretia's example, no dishonoured woman should continue to live".

In the exquisiteness of its palette, the painting ranks amongst Lotto's greatest works. While the subject's face follows on from the tradition of Giorgione, the contrast between her brightly lit shoulders and the richly graded reds and greens of her dress is worthy of a Titian. The costly pendant suspended from the gold chain, its precious stones refracting the light, is virtually without equal in 16th-century Venetian painting.

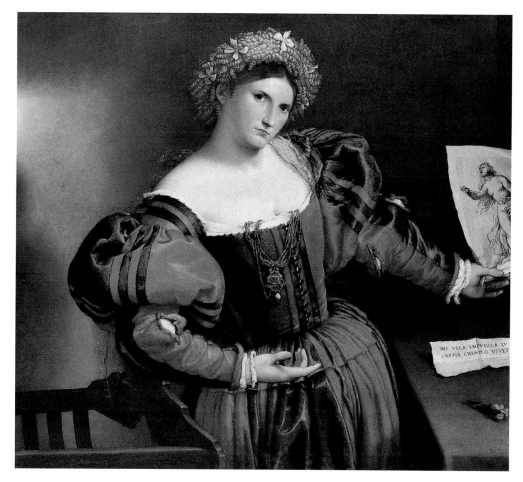

Lorenzo Lotto
Portrait of a Lady as Lucretia, c. 1530
Oil on canvas, 96 x 111 cm. London, National Gallery

JACOPO BASSANO

C. 1517/18–1592

This work belongs to the first phase of the painter's career. The figures crowd towards the front edge of the canvas. Landscape and sky are indicated only briefly in the background, at the top of the composition. There is as yet no sign of the bold perspective views of architecture and landscape found in so many of Bassano's later works. Out of the heaving mass of figures, some of them seen in twisted poses and lively foreshortening, Christ and Veronica emerge as the central focus, the shared direction of their movement establishing them as a closed group. Christ looks back towards Veronica, who holds out her veil to him with an expression of compassion and devotion.

The powerful pull towards the left is offset within the composition by the almost square format, the arms of the cross, and the line of heads rising to the right, terminating in the figures in the top right-hand corner. The soldier seen from behind in the centre of the canvas forms a sort of fulcrum, mediating between the opposing lines of movement within the composition. The handling of colour, particularly in the robes of Christ and Veronica, reflects the young artist's first exposure to Venetian painting.

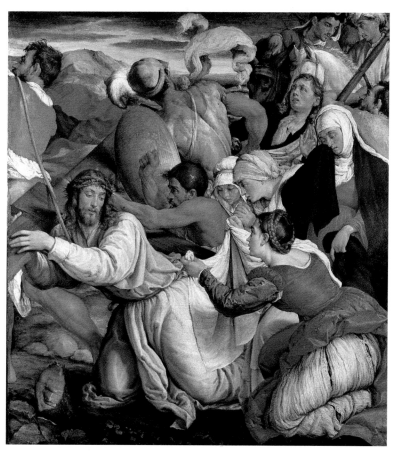

Jacopo Bassano
The Procession to Calvary, c. 1540
Oil on canvas, 145 x 133 cm
London, National Gallery

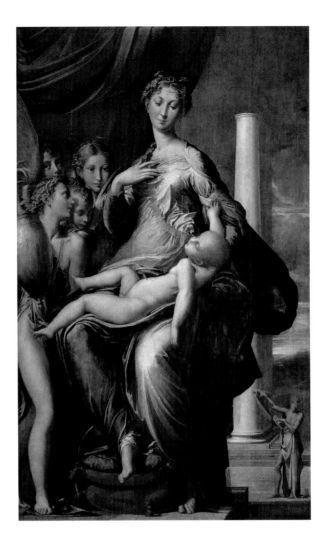

Parmigianino
Madonna of the Long Neck,
c. 1534–1540
(from the Servite church in Parma)
Oil on wood, 216 x 132 cm
Florence, Galleria degli Uffizi

PARMIGIANINO

1503–1540

This panel, whose right-hand side remains in-
complete, represents one of the most import-
ant examples of the anti-High Renaissance
tendencies which have become known as Man-
nerism. The very subject itself remains ulti-
mately undecided between a Virgin and Child
enthroned and a Pietà.

The complicated, in places almost affected
movements of the figures are combined with
the anatomical distortions to which the paint-
ing owes its title. The Madonna's robes have a
decorative value independent of the structure
of her body. In the absence of any solid
throne, she appears half-way between sitting
and floating.

The sense of "alienation" introduced by the
anatomy of the figures is echoed in the illog-
ical composition of space. Just as the precise
locality of the foreground angels is itself un-
clear, so the eye is utterly confused by the dis-
crepancies in scale between the main fore-
ground group, the small figure of the prophet
announcing the coming of Christ on the right-
hand edge of the panel, and the (unfinished)
columns towering behind.

It would be wrong, however, to see Par-
migianino's deviation from the norms of the
High Renaissance as purely formal in nature;
rather, he is here exploring a new means of ren-
dering visible a dimension beyond that of
earthly reality.

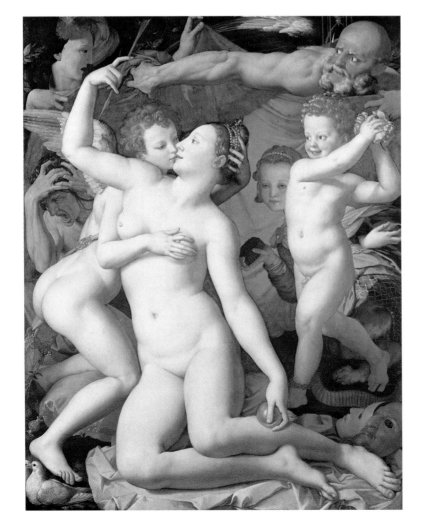

Agnolo Bronzino
An Allegory (Venus,
Cupid, Time and
Folly), before 1545
Oil on wood,
146 x 116 cm
London, National
Gallery

AGNOLO BRONZINO

1503–1572

Agnolo Bronzino here portrays an elaborate
allegory of the pleasures and pains of love.
In the foreground, the spiralling figure of
Cupid embraces Venus, whose upright figure
is turned frontally towards the spectator. A
boy arriving from the right is scattering
roses. In the background, meanwhile, we can
identify the figures of Old Age, Jealousy and
Deceit.

The composition is almost stilted in its arti-
ficiality: Venus' arms and legs run parallel to
the edges of the panel, while the background
assumes the staggered character of a relief.
The anatomically elongated arm of the old
man completes the figuration, which calls to
mind Theodor Hetzer's concept of "pictorial
ornament".

The palette, too, is artificial. Bronzino cre-
ates a smooth, enamel-like surface, for which
his choice of a wood panel is clearly more suit-
able than canvas. In its cool eroticism, the
painting bears witness to a specifically French
style of court art whose roots go back to Jean
Fouquet and the 15th century. As court
painter to the Medici, Bronzino executed large
numbers of portraits characterized by a formal
severity, a minute attention to detail and a
cool sophistication.

Since Bronzino painted the present panel
for King Francis I of France, it must have been
executed before 1545.

ROSSO FIORENTINO

1494–1540

This large altarpiece is one of the most typical and most important examples of so-called Florentine Early Mannerism. Rosso's early panel turns away from the norms of the High Renaissance, which were based on the reproduction of idealized nature. There is no logical spatial connection between the figures, the cross and the ladders; the size of the figures appears arbitrarily chosen, and their elongated bodies and overly small heads offer a distortion of "classical" proportions. Light and shade cannot be explained in terms of a single light source.

In addition, Rosso used boldly abbreviated forms tending towards geometric planes, both in the draperies (as in the case of Mary Magdalene and John in the right-hand corner) and in the modelling of the naked body (e.g. the figure seen from the rear on the ladder). Finally, the powerful local colours of the High Renaissance are replaced by a cool palette.

To assess Rosso's stylistic principles solely from the point of view of their formal qualities would be to misunderstand them. The poses of Mary Magdalene and John the Evangelist are visual statements of profound anguish and despair. Insofar as the viewer is no longer able to identify with the figures in the painting, the emotions they express emerge with all the greater purity, something that has lent Rosso's work a new relevance in our own century.

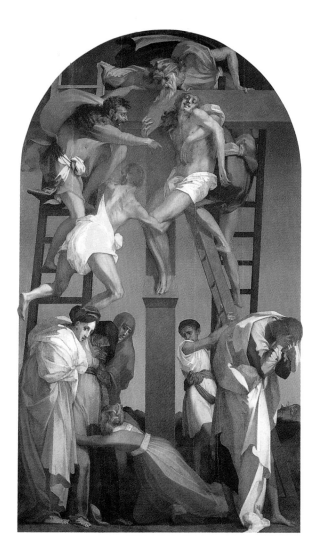

Rosso Fiorentino
Deposition, 1521
(from Volterra cathedral)
Oil on wood, 333 x 195 cm
Volterra, Pinacoteca Comunale

PONTORMO

1494–1556

Like Rosso's panel, Pontormo's *Deposition* represents the pioneering vehicle of an anti-classical style of painting. Even the subject is difficult to determine: for a Deposition, it lacks a cross, for an Entombment a grave, and for a Pietà or Lamentation the direct relationship between the Virgin Mary and Christ. Painting, by its very nature, can normally only capture a single moment. Pontormo fascinatingly attempts to overcome this limitation and to portray instead a sequence of movements. It is as if we see the individual stages of a Deposition combining themselves into the suggestion of a continuous downward motion. The figures are grouped into a large, serpentine curve whose descending path is lent particular emphasis via the figure of the Virgin Mary and the falling diagonal in the bottom right-hand corner.

The composition is devoid of stabilizing elements, unstructured either by architecture or landscape. It might be described as a skilful fusion of "unstable equilibria". The transparent and modulating palette, undoubtedly influenced by Rosso, robs the figures of their gravitational weight and distances them from reality.

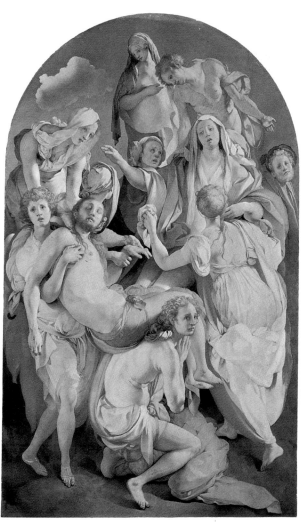

Pontormo
Deposition, c. 1526–1528
Oil on wood, 313 x 192 cm
Florence, Santa Felicità, Cappella Bardori

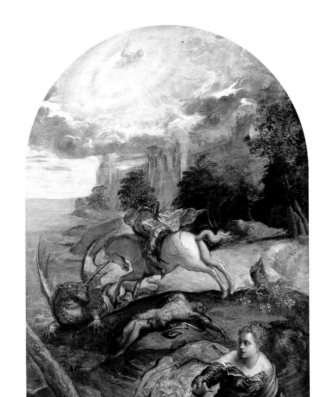

Tintoretto
St George and the Dragon, c. 1550–1560
Oil on canvas, 157 x 100 cm
London, National Gallery

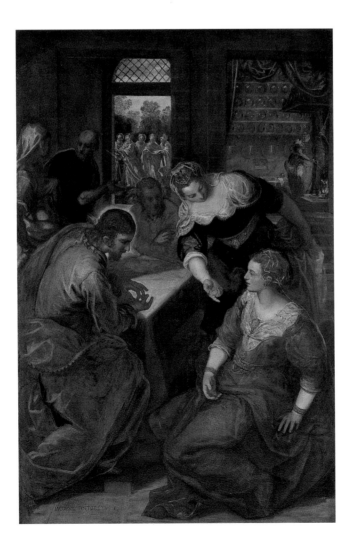

Tintoretto
Christ with Mary and Martha,
c. 1580
Oil on canvas, 200 x 132 cm
Munich, Bayerische Staats-
gemäldesammlungen,
Alte Pinakothek

TINTORETTO
1518–1594

This canvas dates from the start of Tintoretto's mature period, in which he finally relinquishes his ties to the plane in favour of a bold use of perspective. The eye is led from the figure of the fleeing princess, across the main group of St George and the dragon and the receding bulwarks of the castle, to the distant horizon of the sea. The striking differences in scale between the figures serve to accelerate this progression from front to rear.

Tintoretto thereby infuses his scene with a greater sense of drama than ever before in the history of the subject. The two different directions indicated by the princess in the bottom right-hand corner of the painting, fleeing towards the spectator, and the landscape leading into the depths behind, provide an exemplary demonstration of the principles of centrifugal composition, diametrically opposed to the classical mode of the High Renaissance. In his precipitous charge towards the left, we see the knight drawing upon all his forces to slay the dragon.

The corpse in the middle ground introduces a new iconographical element pointing to a previous episode in the story. The importance which Tintoretto attached to this figure is evidenced by a carefully executed study in the Louvre. The position of the body, lying on the ground with its arms outstretched, prompts associations with the figure of the crucified Christ. Is St George presented here as the vanquisher of evil in a parallel with Christ?

Tintoretto's palette shifts away from a Titianesque luminosity towards broken hues. Effects of light play a dominant role and lend a visionary character to the heavenly apparition in the light-filled clouds.

While Tintoretto demonstrated the principles of Mannerism most emphatically of all the great Venetian painters of the 16th century, in his late works he frequently moved beyond them towards a style closer to the dawning age of the Baroque.

Numerous other contemporary renditions of the present subject, especially in Netherlandish painting, show the kitchen in the foreground and the main events taking place on a miniature scale in the doorway behind. Here, by contrast, the monumentality of the three main figures ensures that the central theme is directly apparent. While Christ and the two sisters are individually developed, they are also mutually integrated in a fashion which appears as spontaneous as it is skilful. A significant role is thereby played by the correlating colours of their clothing.

Tintoretto nevertheless remains true to his principle of composition, based on often dramatic foreshortening. The line passing from Christ, across the table top, and on to the open doorway and the kitchen in the background draws the eye irresistibly into the depths of the painting – another visual expression of movement, as also suggested by the circle formed by the heads of the main figures.

In the painting of the 16th century, the relationship between Venus and Mars – portrayed by Botticelli in idealized, neo-Platonic terms – assumed a strongly erotic flavour. It is typical of Tintoretto, with his preference for drama, that he should choose to portray the moment not of the lovers' union, but of their discovery by Vulcan, Venus' ageing husband. Vulcan, still in mid-step, lays bare Venus' sex, while Mars hides under the bed.

The room recedes at an angle from front left to rear right. Its pronounced asymmetry is established by the foreshortened wall on the left, reinforced in the figure of Cupid, and by the tiles leading into the neighbouring chamber beyond. A similar extension of space is suggested by the mirror, which simultaneously aligns itself with the main figures into another diagonal. The mirror also serves a second important funtion: it transforms the figure of Vulcan, already rendered substantial by his animated pose, into a "sculpture" visible from all sides at once – an impression further reinforced by his muscular modelling, based on studies by Michelangelo. The nude Venus, probably inspired by Titian's *Andromeda*, appears almost boyishly demure by contrast. Venus provides the compositional counterweight to the powerful diagonal recession into the depths.

The Berlin Kupferstichkabinett houses a preliminary study for this painting in the shape of an ink drawing of great spontaneity, unique in Tintoretto's œuvre in its technique and its exploration of the background. The figures of the reclining Venus and of Mars under the bed are missing, however.

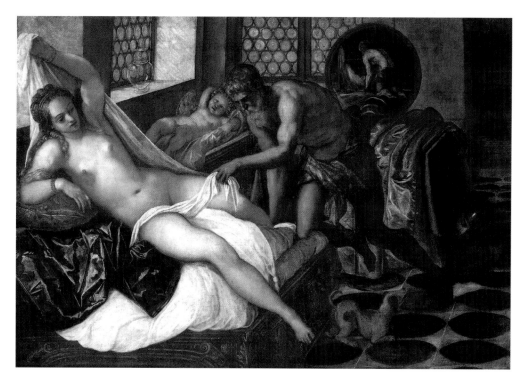

Tintoretto
Vulcan Surprises Venus and Mars, c. 1555
Oil on canvas, 135 x 198 cm
Munich, Bayerische Staatsgemäldesammlungen,
Alte Pinakothek

Ignoring the moralizing tendencies of other interpretations of this subject, with their emphasis, for example, on the punishment meted out to the two lecherous old men, Tintoretto concentrates exclusively on the erotic nature of the scene. The brightly lit, naked figure of Susanna, a young woman ripened to full maturity, is the chief focus of the composition and the point to which the eye is constantly returned. Unconstrained in her pose and modelled with powerful plasticity, she may be seen in stylistic terms as the link between Michelangelo and Rubens.

The toilet articles, items of jewellery and reflections in the water are rendered with a precision unusual in Tintoretto's œuvre. The painter thereby almost creates a still life between Susanna and the hedge.

Even in this painting, however, Tintoretto remains true to his almost manic desire to guide the eye into the compositional depths, if not indeed into infinity. The edge of the bath, the rose hedge, the abrupt difference in scale between the two old men and the view into the distant park landscape combine to propel the pictorial surface into the third dimension in as many ways as possible.

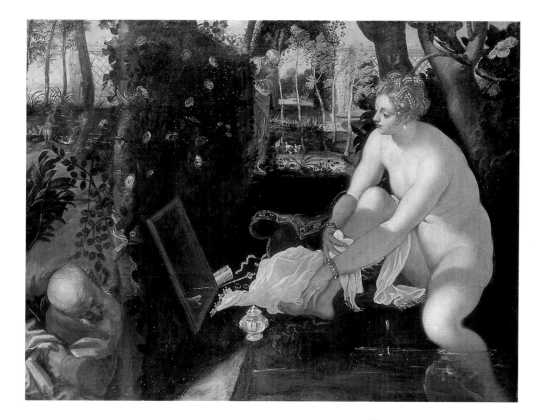

Tintoretto
Susanna at her Bath, c. 1565
Oil on canvas, 147 x 194 cm
Vienna, Kunsthistorisches Museum

Paolo Veronese
Giustiana Barbaro and her Nurse, c. 1561/62
Fresco (detail)
Maser (Treviso), Villa Barbaro

Paolo Veronese
Allegory of Love: Unfaithfulness, c. 1575–1580
Oil on canvas, 189 x 189 cm
London, National Gallery

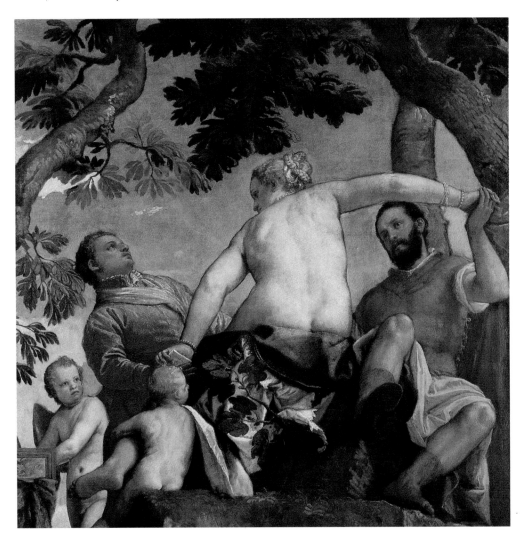

PAOLO VERONESE
1528–1588

In Veronese's frescos for the Villa Barbaro completed by Palladio in 1559, the boundaries between appearance and reality are erased to a degree unsurpassed either in the 16th century or even by the Baroque. Seemingly tangible architecture and sculptures are just as much creations of paint as views into neighbouring rooms and into the surrounding parkland. This is equally true of the balconies in the Hall of Olympus. Behind a skilfully foreshortened balustrade, whose individual members are additionally modelled by light and shade, stands a young, well-dressed woman – traditionally identified as the mistress of the house – and her nurse, whose dark skin and simpler style of dress clearly assign her to a different social class. The life-size scale of the two women makes it all the easier for the viewer to accept them as real.

Despite the fact that the fresco technique required him to work at speed, Veronese achieves a fascinating wealth of colour gradations and painted effects of light.

Unfaithfulness is one of a cycle of *Four Allegories of Love* probably commissioned by Emperor Rudolf II in around 1580. Veronese places the woman, seen in rear view, at the centre of the composition. While she restrains her husband with her right arm, she turns her face and body towards her lover on the left. The arching line traced by the figures within the pictorial plane is simultaneously projected into their crescent-shaped arrangement in space. As always in Veronese, the landscape elements serve not merely to describe the setting, but also to reinforce the lines of movement within the scene – here emphasized by the directions indicated by the tree trunks and branches.

Rarely has *The Finding of Moses* received such a festive treatment as here. In growing fear of the constantly increasing numbers of Israelites, the Pharaoh ordered all new-born sons to be put to death – the Old Testament counterpart to the slaying of the infants of Bethlehem by Herod. Moses' mother hid her baby in a bulrush cradle amongst the reeds of the Nile, where he was found by the Pharaoh's daughter and adopted as her own child. The composition combines movement of the most natural and unselfconscious kind with the ordered arrangement established by the harmonious relationship between the figures and the landscape. Particularly important in this respect are the two foreground trees, whose diverging V-shape echoes the poses of the main figures. In the delicate luminosity and subtle gradations of its rich palette, the painting occupies a unique position in Veronese's œuvre and seems to look forward to Velázquez.

Paolo Veronese
The Finding of Moses, c. 1570–1575
Oil on canvas, 50 x 43 cm
Madrid, Museo del Prado

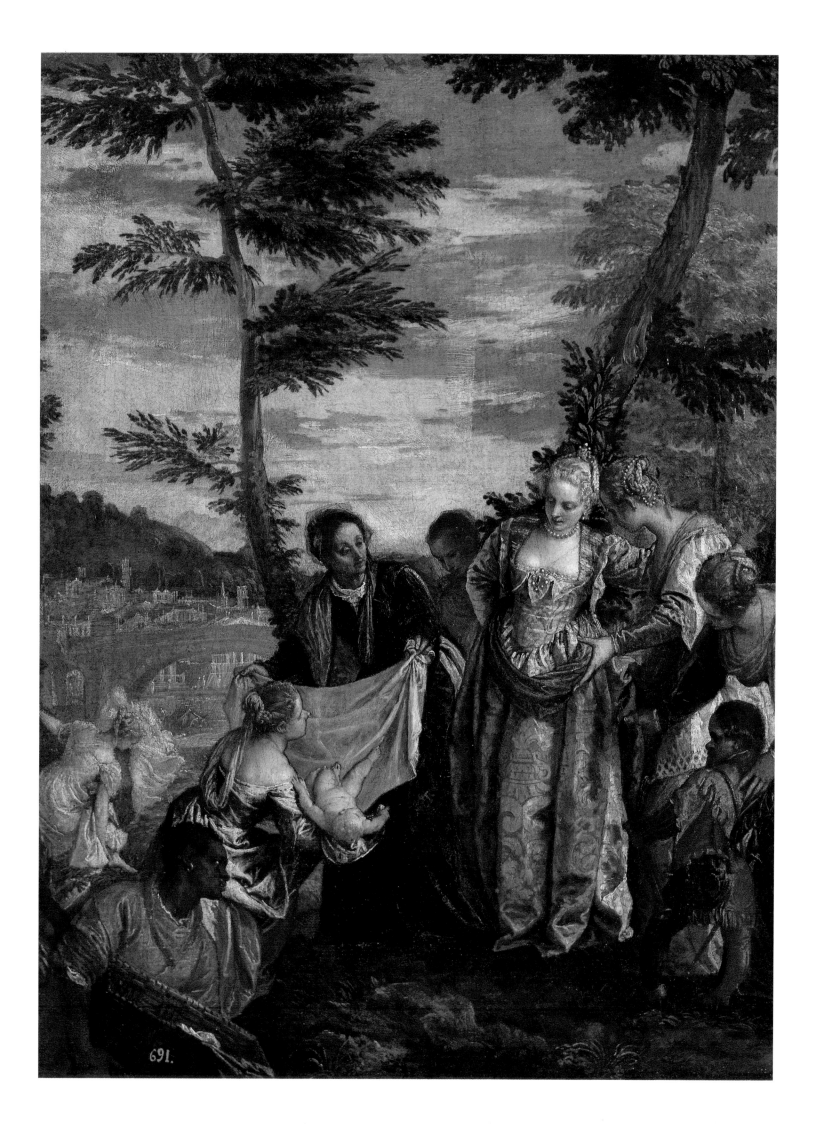

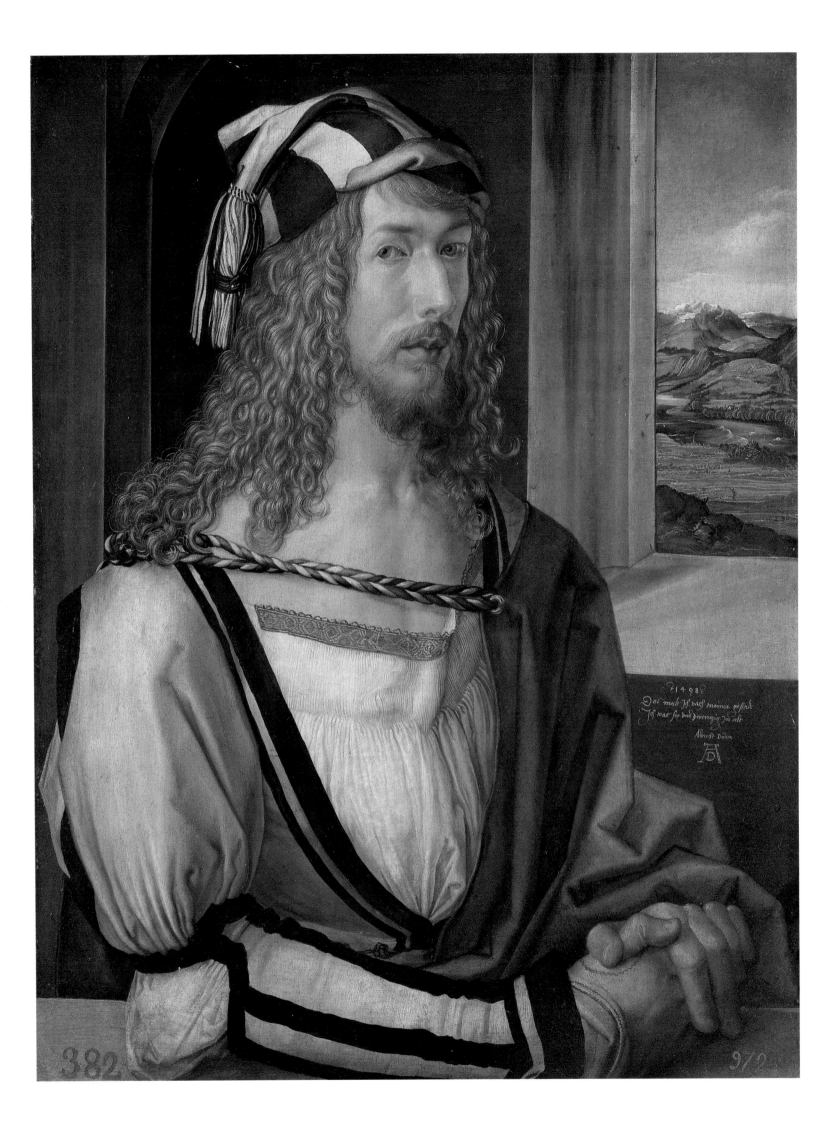

ALBRECHT DÜRER

1471–1528

Dürer was the first painter in Western art to regularly depict himself in self-portraits, providing us with an invaluable record of his personal development over the years.

In his Prado self-portrait in elegant dress, reminiscent of that of a nobleman, and with carefully coiffured hair and beard, the 26-year-old shows himself striving to rise above the status of artisan. We are reminded of a letter which he wrote to his friend Willibald Pirckheimer seven years later from Venice: "Here I am a master, at home a parasite."

Although seen in three-quarter view – a position reinforced by the view of the landscape on the right –, Dürer ties the figure to the plane by means of the right arm resting on the ledge, the plaited cord of the cloak and the unforeshortened folds of the left sleeve above the sitter's hands. The frame-like setting of the portrait corresponds to Italian models.

In comparison to the self-portrait of seven years earlier, Dürer has here become much freer in the handling of his pictorial means – a result of the influence of Venetian painting. The angle of the young woman's pose is uniformly indicated by the head and shoulders, while the proportions of the head and body are also more natural. Aided by the use of delicate glazes, colour modulation plays an equal role within the composition alongside precisely-observed drawing.

The two panels portraying the apostles John, Peter, Paul and Mark signify both the climax and the conclusion of Dürer's work in oils. The monumental format is combined with a sculptural approach to the figures, and together with the composition, in which colour modulation dominates over drawing, reflects the artist's assimilation of Venetian influences. Although, contrary to former opinion, Dürer's panels were probably never planned as the wings of a triptych, their immediate models can be seen in the two wings of Giovanni Bellini's triptych of 1488 for the Frari church in Venice. At the same time, however, Dürer demonstrates his northern heritage in the richly varied expressions of the faces and in his love of detail.

According to one interpretation, the four figures embody the four humours: in the left-hand panel, John is sanguine and Peter phlegmatic, and in the right-hand panel Mark choleric and Paul melancholy.

Dürer probably dedicated the panels to his native city as an admonition to hold steadfastly to the true Lutheran faith.

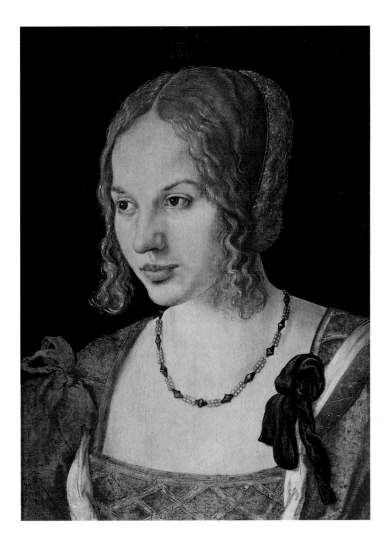

Albrecht Dürer
Portrait of a Young
Venetian Woman, 1505
Oil on wood, 35 x 26 cm
Vienna, Kunsthistorisches
Museum

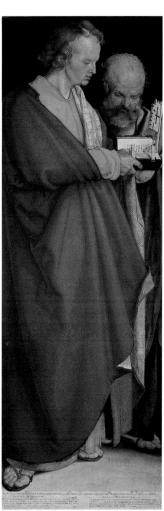

Albrecht Dürer
Self-portrait, 1498
Oil on wood, 52 x 41 cm
Madrid, Museo del Prado

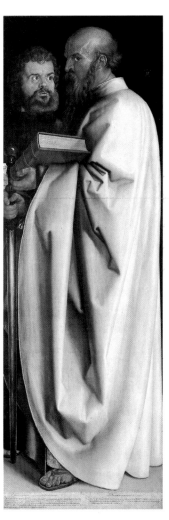

Albrecht Dürer
Four Apostles (John, Peter,
Paul and Mark), 1526
Oil on wood, 215.5 x 76
and 214.5 x 76 cm
Munich, Bayerische Staats-
gemäldesammlungen, Alte
Pinakothek

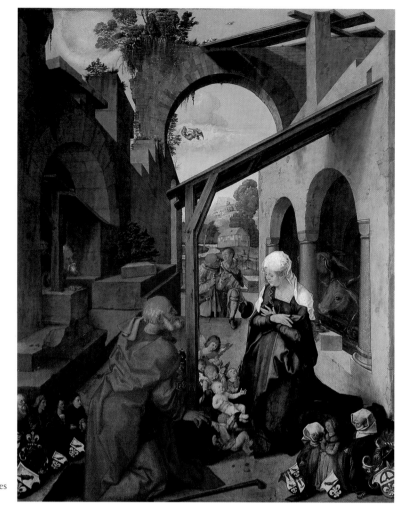

Albrecht Dürer
The Nativity,
c. 1502–1504
(central section of the
Paumgartner Altar)
Tempera on wood,
155 x 126cm
Munich, Bayerische
Staatsgemälde-
sammlungen, Alte
Pinakothek

Below:
Albrecht Dürer
The Adoration of the
Trinity, 1511
Oil tempera on wood,
135 x 123cm
Vienna, Kunsthistorisches
Museum

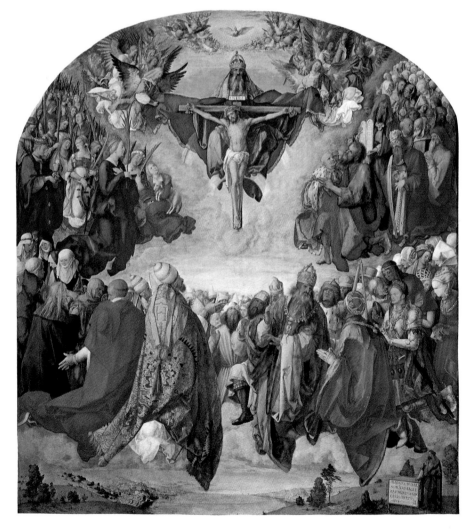

ALBRECHT DÜRER

1471–1528

The Paumgartner Altar, a triptych, was prob-
ably commissioned around 1497 for St Cather-
ine's church in Nuremberg. The central panel
is flanked by two wings showing St George
and St Eustace – probably portraits of members
of the Paumgartner family. Although the two
saints turn towards the Nativity scene in the
central panel, the differences in their scale and
in the composition of the ground and back-
ground leave the viewer with the overall im-
pression of three independent paintings. This
impression is reinforced by the contrast be-
tween the statuesque saints and the lively nar-
rative style of the central Nativity.

In compositional terms, the central panel re-
mains the additive sum of its parts, namely the
figures and the various components of the land-
scape and architecture. In this regard Dürer
still falls fully in line with 15th-century tradi-
tion, something he would not leave behind
until works such as the *Adoration of the Trinity*
below, in which he embraces a new holistic ap-
proach to composition. In the grouping of the
figures in the present panel, however, he con-
tinues to employ the medieval scale according
to which size indicates significance. The hand
of the great draughtsman and graphic artist is
betrayed in the precision of the drawing, which
reinforces the separateness of the individual ele-
ments, even though the different parts of the
composition are fused together by the arches in
the background ruins and by perspective means.

Matthäus Landauer commissioned this panel
for the Trinity chapel in the House of the
Twelve Brethren which he had founded in Nu-
remberg in 1501. The institution was in-
tended to provide accommodation for twelve
elderly craftsmen who through no fault of
their own had fallen upon hard times.

A preliminary sketch showing the magnifi-
cent frame which originally contained the panel
is dated 1508 (Chantilly, Musée Condé). Clearly,
therefore, the commission had already been
awarded by that time and the chief elements of
the composition had already been planned. The
original frame is today housed in the Germani-
sches Nationalmuseum in Nuremberg.

The panel portrays the Holy Trinity – God
the Father, Christ, and the dove of the Holy
Ghost – being worshipped by the *civitas dei*
(the inhabitants of the kingdom of God on
earth). Both the subject and the composition
recall Raphael's *Disputà* in the Stanza della
Segnatura in the Vatican, which Dürer never-
theless could not have known, since it was
only begun in 1509. Rather, Dürer's panel is
part of an international trend towards "classic"
form, albeit one inconceivable north of the
Alps without the influence of Italy.

The isolated treatment of individual ele-
ments in Dürer's earlier paintings is here over-
come through the means of colour modulation
and, above all, composition. In a similar
fashion to Raphael, circular – i.e. geometric –
and spherical – i.e. stereometric – segments
mutually overlap. At the same time, the top,
arched edge of the painting is incorporated
into the internal composition.

HANS BURGKMAIR The Elder

1473–1531

There is scarcely a more impressive portrayal
in the whole of German painting of St John
writing the Book of Revelations while receiv-
ing his visions. The monumentality and pa-
thos of the figure each heighten the other. The
fragmented detail characterizing Burgkmair's
earlier works here gives way to the large, ho-
mogeneous form.

The dramatic train of movement estab-
lished by the contrasting directions indicated
by John's leg, gestures and head must have
been inspired at least indirectly by Italian
models. The powerful tree trunks serve as
framing elements which lend stability to the
composition, while their leaning branches
place visual emphasis upon the message is-
suing from the angel appearing in the clouds
above left.

Although Burgkmair's inclusion of palms
and exotic birds is an allusion to the Greek is-
land setting, he nevertheless betrays a roman-
tic awareness of landscape which can be traced
back to the Danube School. He probably based
the tropical vegetation on plant studies made
in the gardens of the Augsburg Fugger family.

The panel forms the central section of a
triptych, whose wings when open depict
St Erasmus and St Martin.

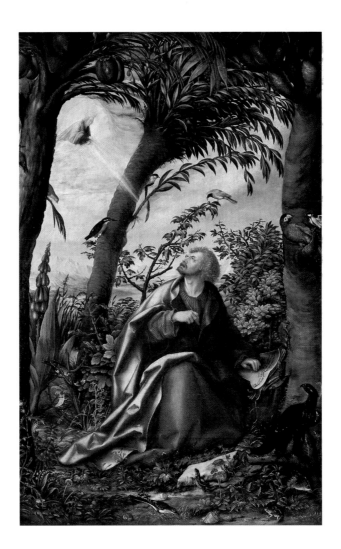

Hans Burgkmair the Elder
John the Evangelist on Patmos, 1518
(central section of the St John Altar)
Oil on wood, 153.1 x 127.2 cm
Munich, Bayerische Staatsgemälde-
sammlungen, Alte Pinakothek

HANS BALDUNG

C. 1484/85–1545

By electing to portray the main figures simply
and quietly at the back of the stable, Baldung
draws the eye first to the ruined architecture
and the ox and ass seen in larger scale on the
left. His construction of the interior embraces
the opposite poles of precise foreshortening –
as in the incisively drawn plinth in the fore-
ground – and perspective uncertainty, some-
thing heightened by the differences in scale be-
tween the animals and the figures. Viewer irri-
tation and Mannerist alienation are quite
clearly not the artist's aims, however.

With the help of painted light, whose
source seems to lie beyond the natural world,
Baldung portrays the miracle of the Holy
Night with what is for him an unusual depth
of feeling. The infant Jesus, held in his swad-
dling bands by putti, seems to radiate light
onto Joseph's red coat and Mary's hands and
face. Through the brick archway in the
cracked, plastered wall, we glimpse a second
miraculous vision: an angel encircled by a
radiant glory is appearing to a shepherd watch-
ing his flock. The fusion of light and shade
and the soft modulation of the contours sug-
gest that Baldung may have come into contact
with the Danube School.

Hans Baldung (Grien)
The Nativity, 1520
Oil on wood, 105.5 x 70.4 cm
Munich, Bayerische Staatsgemälde-
sammlungen, Alte Pinakothek

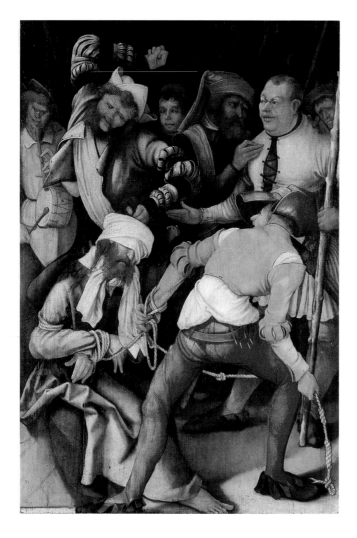

Matthias Grünewald
The Mocking of Christ, c. 1503
Oil tempera on wood, 109 x 73.5 cm
Munich, Bayerische Staatsgemälde-
sammlungen, Alte Pinakothek

Matthias Grünewald
Crucifixion, 1512–1516 (central section of the Isenheim Altar)
Oil on wood, 269 x 307 cm. Colmar, Musée d'Unterlinden

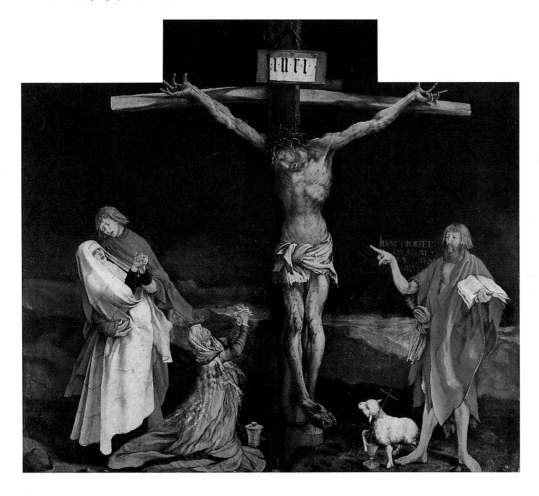

MATTHIAS GRÜNEWALD

C. 1470/80–1528

In *The Mocking of Christ*, the first work that can be definitely attributed to Grünewald, the painter gives vent to the primeval force of emotion dominating his art and thereby carries the scene to previously unseen heights of dramatic intensity. Christ, his hands and arms tied and his eyes bound, is helplessly exposed to the blows of the soldiers, whose faces are an expression of pure brutality unmitigated by any trace of human sympathy. The hatred portrayed here is emphasized almost to the point of caricature. Parallels have justifiably been drawn with Hieronymus Bosch and the physiognomic studies of Leonardo.

The composition already looks ahead to Grünewald's later development. While careful attention is still paid to the rendering of individual details, large-area use of colour is already giving way to iridescent transitions and softly flowing contours.

The famous *Crucifixion* from the Isenheim Altar portrays the agony of Christ with a penetrating forcefulness seen neither before nor since. The tortured body, with its bowed head and skin almost grey in pallor, its strained sinews and muscles and its fingers seemingly frozen rigid in cramp, bears witness to Christ's suffering. The slight sag in the arms of the cross reinforces the impression that the body is hanging heavily downwards. The terrible nature of the scene is reflected in the stormy night landscape and the intense expressions and poses of the Virgin Mary, John and Mary Magdalene.

Unique in the expressive force of its poses and gestures, Grünewald's panel acquires its "overwhelming" character first and foremost from the eruptive power of colour and colour contrasts. None of the great German painters of Dürer's era matched Grünewald in evoking the emotions of the spectator through colour rather than through drawing.

This solemn and stately panel occupies a unique position within Grünewald's œuvre. The two main figures dominating the foreground resemble polychrome statues. By avoiding any emphasis upon the central axis, Grünewald overcomes the danger of a static composition; instead, the Moorish saint appears to have just arrived from the right.

Through the smaller scale and less clearly defined contours of the figures behind, Grünewald creates an impression of rapidly receding depth. The painterly execution of the bishop's robe and the knight's armour ranks amongst the supreme achievements of German art in the age of Dürer.

Matthias Grünewald
The Meeting of St Erasmus and St Maurice,
c. 1520–1524
Oil on wood, 226 x 176 cm
Munich, Bayerische Staatsgemäldesammlungen,
Alte Pinakothek

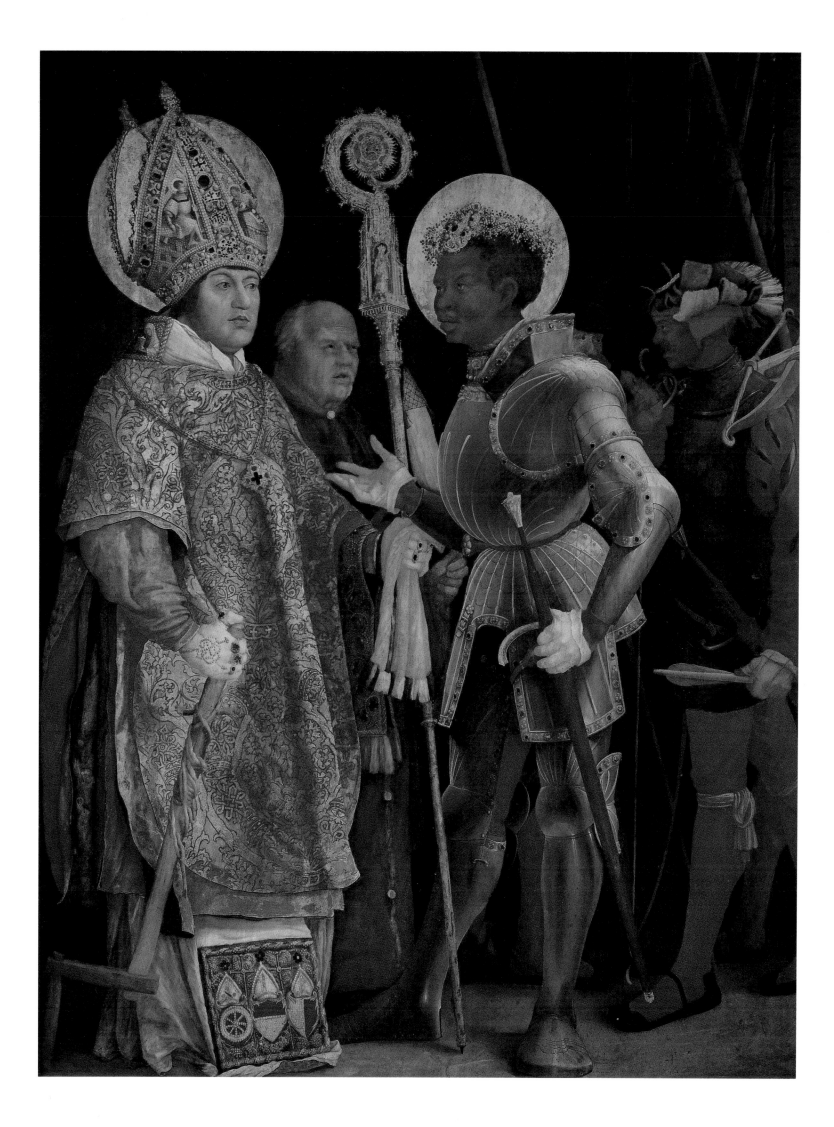

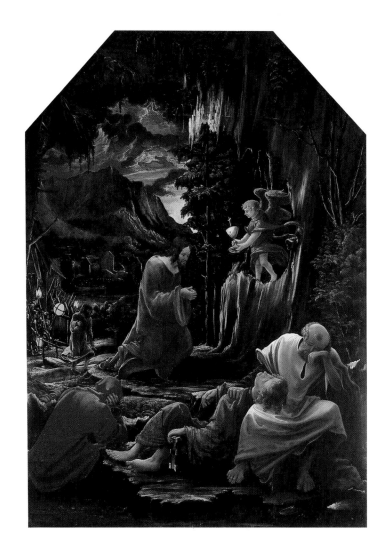

Albrecht Altdorfer
The Agony in the Garden,
c. 1515
(panel from the St Florian
Altar)
Oil on wood, 128 x 95 cm
St Florian, Augustiner-
Chorherrenstift

Albrecht Altdorfer
Susanna at her Bath and
The Stoning of the Old
Men, 1526
Oil on wood,
74.8 x 61.2 cm
Munich, Bayerische
Staatsgemäldesammlun-
gen, Alte Pinakothek

ALBRECHT ALTDORFER
C. 1480–1538

In the landscapes portrayed in the panels of
the St Florian Altar, the "romantic" character-
istics of the Danube School reach their high
point. The present scene is set in a fantastical
rocky landscape whose burning red sky casts
an emphatically unnatural light. Christ kneels
humbly behind the group of sleeping disciples
and seems unaware of the angel holding out
the cup in front of him.

The main lines of the composition – indic-
ated by the row of disciples and the diagonal
running from the approaching soldiers,
through the figure of Christ, to the angel –
rise from left to right and hence upwards in
the direction of the light. They thereby point
beyond the approaching Passion to Christ's fu-
ture resurrection and ascension, as reinforced
by the luminous yellow above Christ's head.

The story of the two lecherous old men who
spied on Susanna while she was bathing and
who were subsequently punished by stoning
(as seen on the terrace in the right-hand side
of the picture) is here lent the atmosphere of a
fairy-tale seen in the colours of a dream. The
fact that Altdorfer succeeds in maintaining
compositional unity despite the multiplicity
of figural, architectural and landscape details
can be traced back to the intensive series of
preliminary studies which he made for the
panel. The palace complex, with its ostenta-
tious display of the artist's perspective skills,
may have been inspired by Upper Italian,
probably Venetian, influences.

No history painting had ever before attempted
to suggest such a seemingly infinite number
of soldiers and thereby to give the impression
of a real battlefield. Altdorfer's talent as an art-
ist lay not least in his ability to combine such
a wealth of minutely-executed detail into a ho-
mogeneous composition. Most significant of
all is the setting: from an elevated viewpoint,
we look across a landscape which has been con-
vincingly interpreted as a representation of the
entire Mediterranean region. In the middle
ground we see the eastern Mediterranean with
Cyprus; beyond the isthmus the Red Sea;
beside it on the right Egypt and the Nile,
whose delta is accurately shown with seven
arms; left the Gulf of Persia; and in the needle-
like mountain beneath, the Tower of Babylon.

In contrast to the fixed boundaries of High
Renaissance space, Altdorfer here seeks to por-
tray infinity in a "global landscape". His com-
bination of precision of line with richness of
colour modulation identifies him as one of the
greatest masters in the history of German
painting.

Albrecht Altdorfer
Alexander's Victory (The Battle on the Issus), 1529
Oil tempera on wood, 158.4 x 120.3 cm
Munich, Bayerische Staatsgemäldesammlungen,
Alte Pinakothek

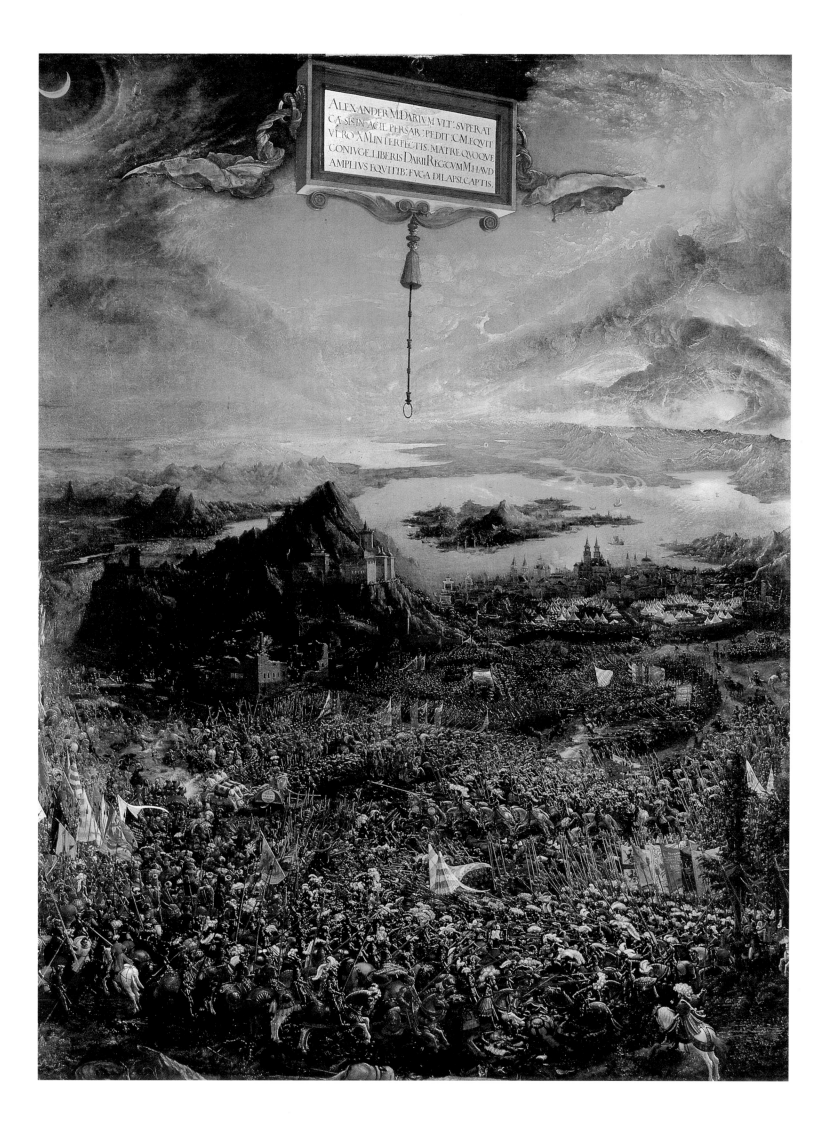

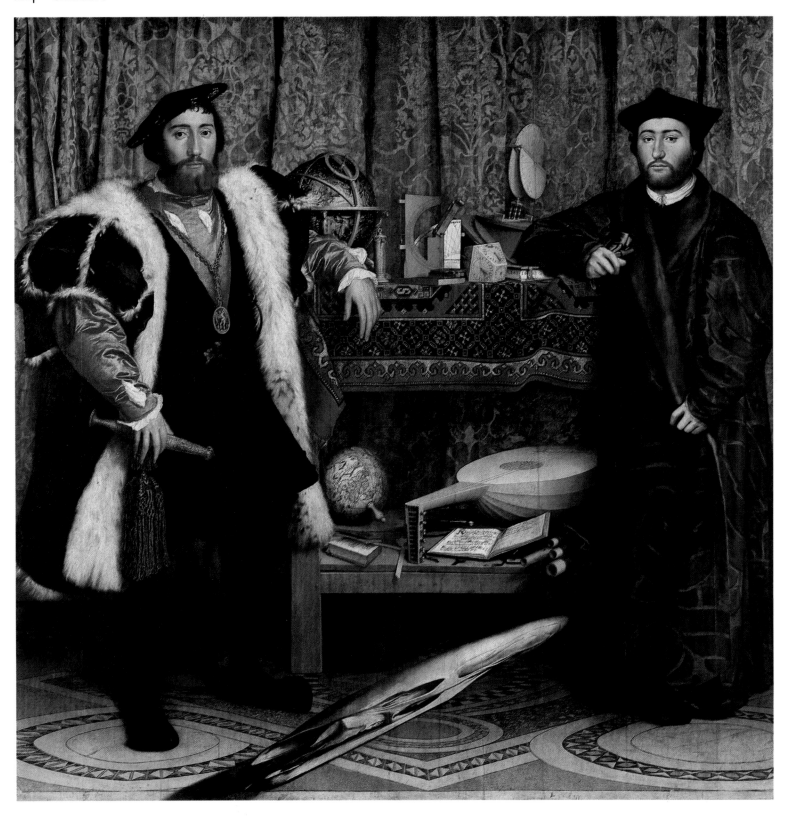

Hans Holbein the Younger
The Ambassadors (Jean de Dinteville and
Georges de Selve), 1533
Tempera on wood, 207 x 209.5 cm
London, National Gallery

HANS HOLBEIN The Younger

C. 1497/98–1543

This panel was probably painted in April
1533, while bishop Georges de Selve (right)
was in London visiting his friend Jean de Din-
teville, French ambassador to England.

The square format which Holbein chose for
his painting was one popular in the High Re-
naissance. Here it forms the starting-point for
a carefully structured composition. The two
men assume a framing function within the pic-
ture. Right and left, top and bottom are
linked by means of verticals and horizontals,
whereby the few diagonals present introduce a
certain element of relaxation. The objects on
the shelf and table incorporate themselves into
this overall structure, each charged with a spe-
cific symbolism which in some cases has yet to
be understood. There is clear preference for ob-
jects from the world of geometry and astro-
logy. The distorting mirror in the foreground
and the broken string of the mandolin are ref-
erences to death. The open book shows an ex-
tract from Johann Walter's *Geystliche Gesänge*
(Sacred Songs) published in Wittenberg in
1524 – an allusion to the mediating position
which the two noblemen occupied between
Catholicism and Protestantism.

This panel marks the last of Holbein's religious commissions. It shows Jakob Meyer, mayor of Basle, and his family under the protection of the Virgin, and was executed for the donor's private chapel. Sadly, we have no information regarding its original frame. Was the monumental, painted scalloped niche continued in a carved or sculpted frame, so that — in a similar fashion to the Venetian *Sacra Conversazione* — pictorial space was extended into real space? And what was the original function of the background views of vegetation and sky on the left and right?

Holbein's composition is precisely calculated. The diagonal leading out of the picture, indicated by the group on the left, is balanced by the position of the Madonna, who is turning towards the right. Here, the group of women provide the composition with a stable conclusion. The motif of the Virgin's protective mantle is taken up in the projecting volutes which in turn enfold the figures.

An astonishing feature of the present panel, when compared to Holbein's earlier *Solothurn Madonna*, for example, is the condensed arrangement of the figures. Space exists only insofar as it is created by the statue-like modelling of the figures. This has led some to suspect that Holbein studied sculpture (including works by Michel Colombe, for example) during his stay in France. In addition, there are echoes of Leonardo in the faces of the Virgin and the donor's elder son. Holbein establishes a deliberate contrast between the idealized figure of the Virgin and the pronouncedly individual faces of the members of the donor's family.

Hans Holbein the Younger
Madonna of Mercy and the Family of Jakob Meyer zum Hasen (Darmstadt Madonna), c. 1528/29
Gum tempera on wood, 144 x 101 cm. Darmstadt, Großherzogliches Schloß

Below:
Hans Holbein the Younger
Portrait of the Merchant Georg Gisze, 1532
Oil on wood, 96 x 86 cm
Berlin, Gemäldegalerie, Staatliche Museen zu Berlin – Preußischer Kulturbesitz

This portrait shows Holbein at the height of his powers. The dominating figure of the sitter, silhouetted by means of just a few clear lines, forms the central focus of an interior filled with a seemingly random arrangement of objects. The angled table and the position of the sitter, turned slightly inwards, are combined into a skilful spatial composition. Holbein observes his model with the same cool, searching gaze with which the sitter looks at us.

The objects on the table reflect an enduring delight in the portrayal of still-life detail — something which Holbein inherited not just from the German painting of the 15th century, but more especially from the Netherlands.

While the individual objects — the vase of flowers, the cashbox, the items carved of wood, the books and the writing implements — may not reveal the warm luminosity so characteristic of Early Netherlandish artists from Jan van Eyck to Hugo van der Goes, Holbein nevertheless demonstrates supreme sophistication in his use of colour. This can be seen not least in the iridescent white heightening on the sitter's red sleeves, in the elaborate, almost palpable weave of the tablecloth, and in the shimmering glass vase.

Here as in his other portraits, Holbein combines the monumentality of Italian form with the "detail realism" of the style of painting north of the Alps. The painting must be counted amongst the most outstanding works to be found in German portraiture.

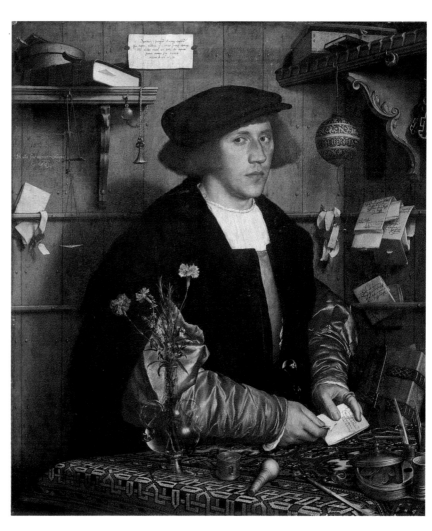

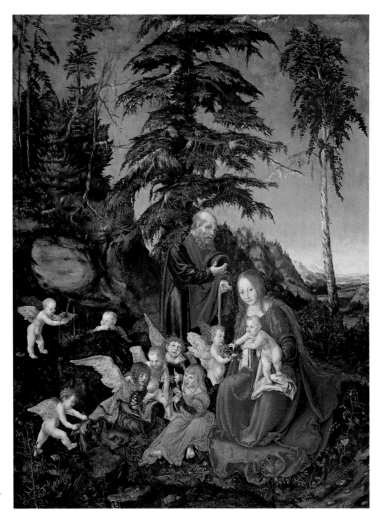

Lucas Cranach the Elder
Rest on the Flight to Egypt,
1504
Oil tempera on wood,
69 x 51 cm
Berlin, Gemäldegalerie,
Staatliche Museen zu Berlin –
Preußischer Kulturbesitz

LUCAS CRANACH The Elder
1472–1553

Executed shortly before the artist was ap-
pointed court painter at Wittenberg, the
panel shows Lucas Cranach at the height of
his creative powers. The composition com-
bines clarity with uncoerced organization.
The figures are grouped in a loose triangle
whose vertical middle axis is accentuated by
Joseph and the tree behind, but whose
slightly offset position avoids any introduc-
tion of geometric rigidity. The backdrop of
nearby trees on the left is harmoniously com-
plemented by the unimpeded view of the dis-
tant landscape on the right.

Cranach demonstrates an astonishing free-
dom in the handling of his compositional
means, whereby the dominant role played by
colour modulation in the landscape evokes a
romantic mood as characteristic of the Danube
School.

Whether *Rest on the Flight to Egypt* is indeed
an accurate title for this panel is a question
that must remain open. Are we not in fact
looking at a Holy Family surrounded by
angels making music and playing games, their
fairy-tale character echoed in the appearance of
the landscape?

Whatever the case, Cranach includes
neither a donkey nor baggage; the only indica-
tion that this might be a stop on a journey is
the stick in Joseph's hand. The scene is set
with the greatest candour in a mountainous
Southern German landscape.

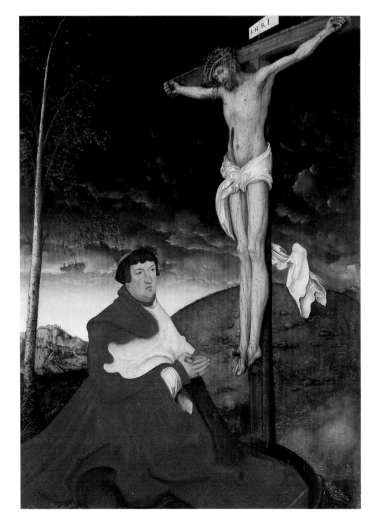

Lucas Cranach the Elder
Cardinal Albrecht of Branden-
burg before the Crucified
Christ, c. 1520–1530
Oil on wood, 158 x 112 cm
Munich, Bayerische Staats-
gemäldesammlungen, Alte
Pinakothek

This painting occupies a unique position
within Cranach's artistic development. The
dignified and stately style demanded of a
court painter is here combined for one last
time with the stormy spontaneity of the young
master.

Far removed from the donors of medieval
painting, the Cardinal is the largest figure in
the composition, his emphatically red robes
filling virtually the entire foreground. Kneel-
ing in a pose of worship, he turns not towards
the crucified Christ but looks diagonally out
of the picture. Cranach here presents the mas-
terly portrait of a Renaissance man who is ulti-
mately devoted not to the spiritual life but to
the pleasures of the world.

The contrast presented by the thin, out-
stretched body of Christ, who resembles a
carved crucifix from the Late Gothic era, could
not be more extreme. His unbroken silhouette
might in other circumstances evoke a certain
sense of calm, were it not for the arms of the
cross and the fluttering loincloth pointing to
the events behind. Like the wan colours of the
barren mound of Calvary, the thunder-black
sky – alongside Grünewald's Crucifixions, the
most dramatic portrayal of a storm in German
Renaissance painting – charge the scene with
expression. Once again Cranach proves himself
the great master of the Danube School,
whereby his landscape and figures have now
become the vehicles of separate and different
emotions.

In order to be cured of a serious illness, Hercules was instructed by the Delphic Oracle to sell himself into slavery for three years. While in the service of Omphale, Queen of Lydia, he performed great deeds, killing and capturing the Cercopes, killing the exiled Syleus and his daughter, destroying the city of the Itons and finally killing the great snake. According to various Roman authors, during his enslavement in Lydia Hercules was obliged to wear women's clothing, play musical instruments and sing in order to please his mistress.

The renunciation of a scenic representation in favour of a "group portrait" is a characteristic feature of Cranach's late work. In this case, he chooses a genre-like situation in which Hercules is seen at the distaff while ladies of the court tie a scarf around his head. Like Niklaus Manuel (cf. ill. p. 128), Cranach transposes a subject from Greek mythology into a contemporary setting north of the Alps. Cranach demonstrates less originality than Manuel, however – an indication that his powers of imagination, formerly so impulsive, were now fading. As an upright German citizen "dressed up" by Omphale's ladies-in-waiting, Hercules verges on caricature. Ophale herself appears in the figure of the richly dressed woman in the upper right-hand corner.

Faces and gestures are affected and in places almost laboured. The panel's quality lies in the execution of its details – the still life of the birds on the left, the clothes, and above all the finery and hat worn by Omphale.

Lucas Cranach the Elder
Hercules and Omphale, 1537
Oil tempera on wood, 82 x 119 cm
Braunschweig, Herzog-Anton-Ulrich-Museum

Whether this panel should be attributed to the elder or the younger Cranach is still the subject of debate – something which demonstrates the stylistic continuity between the two. The landscape prompts associations with the early œuvre of Cranach the Elder as one of the chief representatives of the Danube School. The fact that the overall composition is essentially "totalled up" out of numerous individual elements, however, together with a certain clumsiness in the portrayal of the figures, points to a weaker hand. It is possible that both father and son collaborated on the picture.

The painting draws upon the mythical belief in the purifying and revitalizing properties of water for its subject, and upon medieval bathing scenes for its formal composition. It is striking that all those bathing are female. The elderly women being brought to the pool in wheelbarrows and carts on the left can be seen emerging from the water rejuvenated on the right, where they are directed by a nobleman into tents in order to dress. In the middle ground on the right we are shown the youthful pleasures of food, music and love. Coming off badly out of all of this are the men who have not been rejuvenated, and who must now watch from a distance as their foolish desires are punished.

The direction in which the events unfold from left to right is countered by the foreshortened pool, which leads the eye into the far landscape. Anecdotal detail dominates over overall form.

The erotic atmosphere exuded by the panel is characteristic of Cranach's late work and the somewhat decadent tastes of his noble patrons.

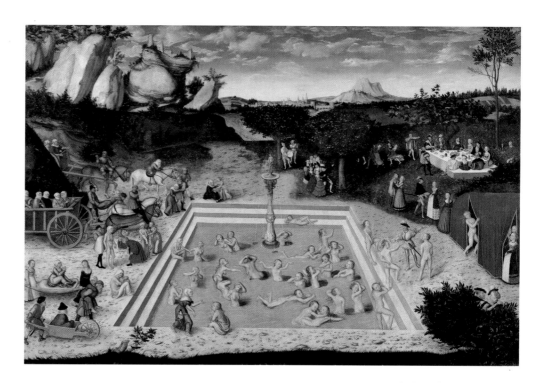

Lucas Cranach the Elder or
Lucas Cranach the Younger
The Fountain of Youth, 1546
Oil on wood, 121 x 184 cm
Berlin, Gemäldegalerie, Staatliche Museen
zu Berlin – Preußischer Kulturbesitz

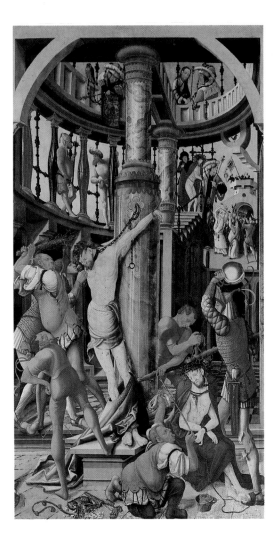

Jörg Ratgeb
The Flagellation of Christ, 1518/19
(wing of the Herrenberg Altar in
Herrenberg parish church)
Oil tempera on wood, 262 x 143 cm
Stuttgart, Staatsgalerie Stuttgart

JÖRG RATGEB
C. 1480–1526

The Herrenberg Altar reflects the religious
and social unrest of its day with a directness
unequalled in any other work of German paint-
ing. Here, at an early point in time, the har-
mony of the High Renaissance has been de-
stroyed in every respect. The panels of the
altar, which is signed 1519, depict scenes from
the childhood and Passion of Christ. A fantast-
ical rotunda provides the architectural frame-
work not just for the Flagellation in the
centre, but also for Christ's crowning with
thorns (front right), presentation to the popu-
lace (on the steps in the background) and inter-
rogation by Pilate (on the top storey).

With no knowledge of Italian art, the artist
takes up some of the fundamental principles
of Florentine Early Mannerism: the disruption
of logical spatial relationships through the use
of drastic foreshortening and enormous differ-
ences in scale between the figures; an asymme-
trical composition combined with an em-
phatic spiralling movement around the central
pillar; the distortion of natural proportions to
heighten expressiveness; and finally a bright,
iridescent palette.

With its manifold foreshortenings, vistas
and staggered levels, the complex architecture
might be seen as a distant forerunner of the vi-
sionary, surreal interiors of Giovanni Battista
Piranesi's *Carceri d'invenzione* (Imaginary
Prisons).

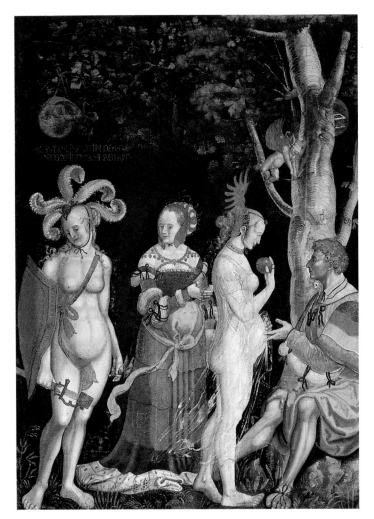

Niklaus Manuel (Deutsch)
The Judgement of Paris,
c. 1517/18
Tempera on canvas,
223 x 160 cm
Basle, Öffentliche
Kunstsammlung Basel,
Kunstmuseum

NIKLAUS MANUEL
C. 1484–1530

This scene from Greek mythology is trans-
ported in a highly personal fashion to a Ger-
man forest with contemporary figures. Paris
appears as a Swiss country gentleman who has
just presented Venus with the apple as her
prize. Juno and Minerva have turned aside fol-
lowing their defeat.

Juno corresponds with Paris in the colours
of her clothes, while Minerva is similarly re-
lated to Venus. From a branch of the tree,
blindfolded Cupid – a symbol of love, which
blinds – shoots an arrow at Paris. The two
coats of arms hanging from the boughs belong
to the family of Benedicht Brunner, a council-
lor of Berne, who in all probability commis-
sioned the painting.

There is a strange discrepancy between the
classical theme and the thoroughly anti-clas-
sical female ideal represented by the women,
whose curved bellies can be traced back to
Dürer. Manuel compensates for his difficulties
with anatomy in the extreme delicacy with
which he draws the faces.

Employing the unusual technique of tem-
pera on canvas, Manuel invokes a pastel-like
palette of great charm. In details such as Ve-
nus' diaphanous dress he demonstrates the
sophistication of his art. The composition, in
which the figures are arranged as if in relief
against the shadowy background of a wood,
recalls Gobelin tapestries.

GERARD DAVID

c. 1460–1523

Comparable with Italian *Sacra Conversazione* compositions from around 1500, David's panel is characterized by a happy balance between stillness and movement, between space and plane, and between the overall homogeneity of the composition and the careful execution of its details.

The starting-point for the present picture was probably Jan van Eyck's *Virgin and Child and Canon van der Paele*. Here, however, the arrangement of the figures in a concave curve is freer, the anatomical detail more animated. The kneeling donor, with his powerful plastic modelling and portrait-like features, is set against the aristocratically refined figures of the saints. The facial types employed for the women recall Hans Memling, whose leading position in Bruges painting was inherited by David.

The painter renounces virtually all movement. St Catherine, identified as a princess by her crown, turns shyly towards Christ, who places a ring on her finger. The exquisite execution of details – accessories, clothes, the carpet hanging behind the Virgin and the still lifes of flowers on either side of the throne – once again points to the influence of Jan van Eyck. A tendency towards multiplicity and diversity is evinced by the townscape seen over the city wall, where secular buildings are combined with grandiose civic architecture in what were then modern architectural forms. The lower storeys of the tower possibly contain a reference to the belfry in Bruges.

The *Baptism of Christ* forms the central section of a triptych commissioned by the treasurer of the city of Bruges, Jean Trompes. The wings show the donor's family and patron saints on the inside, and the Virgin and Child and the donor's second wife with St Elizabeth on the outside. Nowhere does the artist demonstrate more clearly both his talents and his limitations. The present scene contains virtually no action. The kneeling figures of John the Baptist and the angel dressed in a sumptuous cope reveal a mutual correspondence in their approximate symmetry and subtly differentiated positions. The panel's central axis is strongly emphasized by the figure of Christ, the dove of the Holy Ghost and the apparition of God the Father.

The painting's charm lies first and foremost in its broad landscape, interspersed with scenes from the life of the Baptist. The still life of flowers in the foreground is characterized by a dazzling wealth of minute detail. "Gentle, luminous colours infuse this rich, beautiful world of landscapes, figures and objects with a silver shimmer which transports the viewer to a different reality. Filled with a calm grandeur, the elements combine into solemn harmonies. Human warmth infuses the dignified tone." (Wolfgang Schöne)

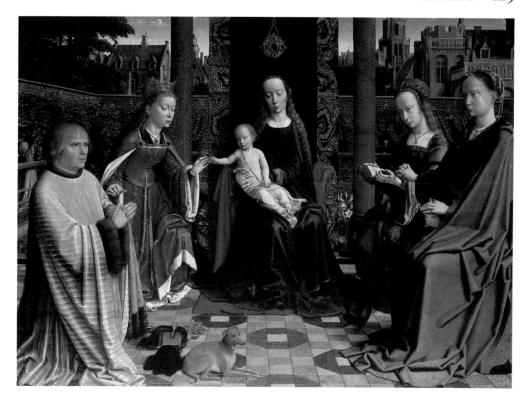

Gerard David
The Mystic Marriage of St Catherine, c. 1505–1510
Oil tempera on wood, 106 x 144 cm
London, National Gallery

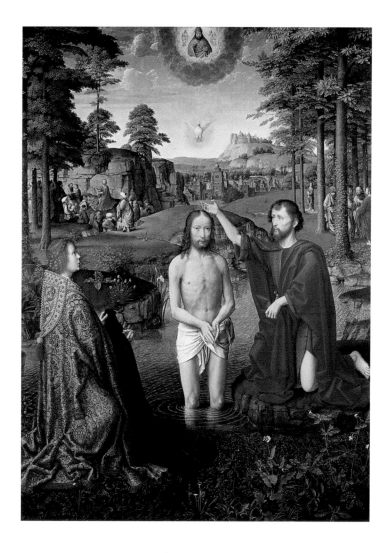

Gerard David
The Baptism of Christ,
c. 1505
(central section of a
triptych)
Oil on wood, 128 x 97 cm
Bruges, Groeningemuseum

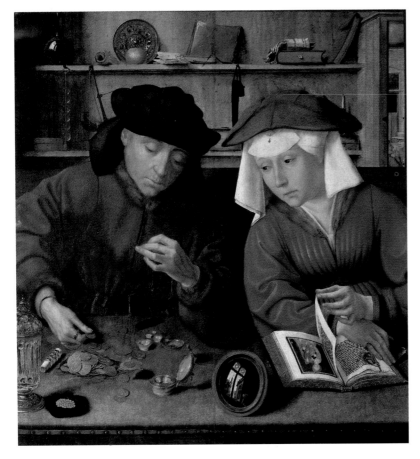

Quentin Massys
The Money-changer and his Wife, 1514
Oil on wood, 70 x 67 cm
Paris, Musée National du Louvre

QUENTIN MASSYS
c. 1465/66–1530

To a certain degree in opposition to the Romanists amongst his contemporaries, Massys held fast to the traditions established by Early Netherlandish art. Italian influences, to which he was only indirectly exposed, nevertheless make themselves felt in the monumentalization of his figures

The Money-changer and his Wife is an early example of the genre painting which would flourish in Flanders and the northern Netherlands over the course of the 16th century. Seated behind the table, and each sliced on one side by the frame, the figures are set back from the front edge of the painting. Although sophisticated in their nuances of colour, the faces wear an expression of relative indifference. Full of their own life, on the other hand, are the still-life details – the lavishly illuminated codex through which the wife is leafing, the angled mirror, which reflects the outer world into the picture in masterly foreshortening, and the glass, accessories and coins gleaming on the table and on the shelves against the far wall. In the dominant role which it grants to these objects, the painting marks an important step along the path towards the pure still life.

By inserting his own likeness into the painting – reflected in the convex mirror – Massys recalls the use of this device by Jan van Eyck in *The Arnolfini Marriage* (ill. p. 53) of 1434.

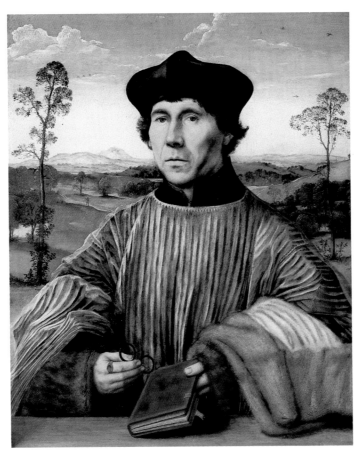

Quentin Massys
Portrait of a Canon, c. 1510–1520 (?)
Oil on wood, 60 x 73 cm
Vaduz, Collection of the Prince of Liechtenstein

In contrast to the painting above, Massys here demonstrates his confident abilities as a portrait painter. The canon calmly surveys the outside world, but his thoughts seem to be turned inwards. Sebastiano del Piombo's more or less contemporaneous portrait of *Cardinal Carondelet and his Secretary* (ill. p. 103) offers an interesting comparison in this respect. The Cardinal observes the external world with cool, calculating eyes, but without the kindliness suggested by Massys' canon. The secularity of Carondelet and his setting is diametrically opposed to the personality of the canon, rooted in the Christian faith.

In his composition, Massys achieves a homogeneity and grandeur only rarely paralleled in his œuvre. The half-length figure is contained within the approximate volume of a pyramid, dominating the pictorial field. Massys avoids any sense of ridigity, however, by slightly offsetting the sitter to the left of the central axis and by showing his head slightly turned.

The sensitive handling of paint evidenced in the iridescent hues of the cape and in the light and shade which model the head is on an equal par with contemporary Venetian painting, which Massys would probably not have known. There is a melodious harmony, too, in the relationship between figure and landscape. From a slightly elevated standpoint, we look out across a broad expanse of hills and meadows towards the hazy distant mountains. Nature is filled with the same quiet calm as the canon himself.

JOACHIM PATINIR

C. 1480–1524

As in the majority of his works, Joachim Patinir uses a narrative event as a pretext to portray a landscape seen from an elevated standpoint. This is an early example of the genre in Netherlandish painting known as the "global landscape", whose roots can be traced back to the first half of the 15th century and Jan van Eyck's *Virgin of Chancellor Rolin*, for example (ill. p. 53). An outstanding example in German painting is Albrecht Altdorfer's *Alexander's Victory* (ill. p. 123).

In a curious mixture of Christian iconography (the angel apparently standing guard on the left bank; the underworld portrayed as Hell on the right) and classical mythology (Charon and the bark in which he ferries the dead across to Hades), Patinir seeks to communicate the gloomy nature of events through the mood of the landscape. The river extends into the depths of the picture and beyond the visible horizon and thereby points to the spherical shape of the earth and at the same time to infinity.

The gathering storm clouds become one with the smoke billowing from the fiery furnaces of the underworld. The influence of Hieronymus Bosch can be seen not just in the ghostly apparitions of Hell, but more particularly in the stylistic treatment of silhouettes and contours, which grow increasingly hazier towards the background.

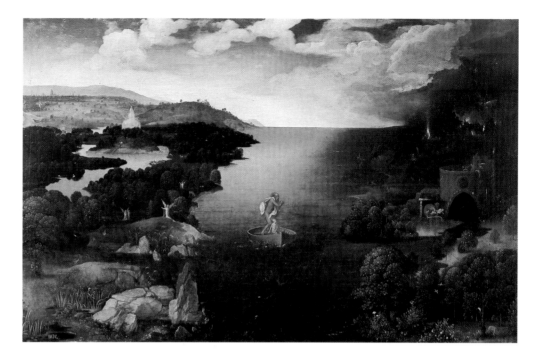

Joachim Patinir
Landscape with Charon's Bark, c. 1521
Oil on wood, 64 x 103 cm
Madrid, Museo del Prado

JAN GOSSAERT

C. 1478/88 – C. 1533/36

Depicted is the semi-naked figure of Danaë receiving Zeus in the form of a golden shower, as recounted in Greek legend. The columned niche with its numerous Renaissance elements reflects the influences to which Gossaert was exposed during his trip to Rome. Echoes of Italy are also evident in some of the buildings in the city behind. Gossaert nevertheless draws no closer to the archeologically faithful rendition of Roman architecture so typical of his countryman Maerten van Heemskerck than to the holistic compositional approach of Italian High Renaissance painting. He simply employs individual details like words whose context he has failed to understand. As a consequence, the overall composition remains the additive sum of its parts.

The clarity of the drawing, the cool smoothness of the painting and the restrained palette are all typical features of Gossaert's œuvre. Danaë's draperies, however, veil a flawed mastery of anatomy, while the integration of her plastic volume within the perspective construction of the interior and background lacks conviction. The panel also lacks the erotic tension introduced so masterfully into similar subjects by painters such as Correggio and Titian.

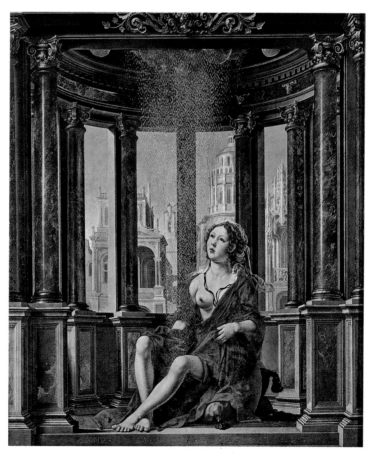

Jan Gossaert, called Mabuse Danaë, 1527
Oil tempera on wood, 113.5 x 95 cm
Munich, Bayerische Staatsgemäldesammlungen, Alte Pinakothek

Lucas van Leyden
Lot and his Daughters, c. 1520
Oil on wood, 48 x 34 cm
Paris, Musée National du Louvre

Below:
Bernaert van Orley
Holy Family, 1522
Oil tempera on wood,
90 x 74 cm
Madrid, Museo del Prado

LUCAS VAN LEYDEN
1494–1533

The story of the destruction of Sodom, Lot's escape, and his subsequent seduction by his two daughters is told in Genesis. Lot and his family were allowed to leave the city on condition that they did not look back. Lot's wife disobeyed the instruction and was turned into a pillar of salt. Lot continued on with his daughters. Since their husbands had not fled with them, the daughters said to each other: "Our father is old and there is not a man in the country to come to us in the usual way. Come now, let us make our father drink wine and then lie with him and in this way keep the family alive through our father." The sons born of this union subsequently founded the tribes of the Moabites and the Ammonites.

Both as a strongly erotic group painting and as a history painting, the subject was a popular one in the 16th and 17th century. This painting, whose attribution to van Leyden – said to have executed his first commission at the age of twelve – is not altogether certain, falls into the second category. Alongside the group in the foreground, the destruction of Sodom seen in the left-hand background establishes a second point of focus. Influenced by Patenier, the painter portrays a kind of "global landscape" extending from the front left-hand corner into the depths of the composition. He thereby devotes particular care to the execution of the landscape details.

BERNAERT VAN ORLEY
c. 1488–1542

The infant running to his mother initiates a diagonal train of movement which leads through Mary to the kindly, ageing Joseph behind. The grouping of the main figures thus introduces both asymmetry and depth to the pictorial plane. With great artistic intelligence, Orley balances this on the left by means of the two angels parallel to the plane, one approaching with a wicker basket of flowers and one hovering overhead and bearing a golden crown. Christ serves to link together the various elements of the painting. His left hand reaches up to his mother's shoulder, his eyes are raised towards the crown with which he will one day make Mary Queen of Heaven, while his right arm gestures towards the apple in Joseph's hand – a symbol of the sin which Jesus has come to conquer.

Orley can here be seen as a painter mediating between two stylistic eras. While lovingly executed details of material and texture remain the prominent focus of his interest, he also acknowledges the masters of the High Renaissance in his skilful balancing of depth and plane and in his delicate gradation of colour in the receding landscape. Orley is known both as a painter of large altarpieces and as a portraitist.

JAN VAN SCOREL

1495–1562

Scorel was influenced more strongly than his
contemporaries by the time he spent in Italy:
under the Netherlandish pope Adrian VI, he
succeeded Raphael as superintendant of the
Vatican collection of antiquities, a post he
held until 1524. Italian influence is evident
here in both the formal composition and the
artist's use of colour. As a means of enlivening
the composition, Mary Magdalene is seated
slightly to the right of the perpendicular
middle axis. Balance is established within the
pictorial plane by the tree on the right whose
branches extend across the upper half of the
canvas, almost reaching the rocky outcrop
which provides a solid conclusion to the com-
position on the left. Mary Magdalene's
shoulders are turned slightly in the opposite
direction to her head. Her left arm and the jar
of ointment round off the balanced relation-
ship between space and plane.

Scorel's familiarity with Venetian painting
finds its echo in the delicately gradated hues of
the landscape, in which drawing increasingly
yields to colour modulation as the background
recedes. The confident composition and vir-
tuoso handling of paint are unable to disguise a
certain secular element within the subject.
Were it not for the exquisite jar of ointment
identifying her as Mary Magdalene, the sitter
might well be mistaken for the portrait of a
young lady from a well-to-do household.

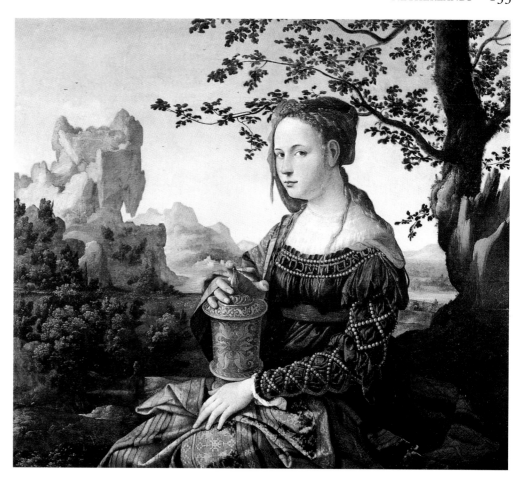

Jan van Scorel
Mary Magdalene, 1529
Oil on canvas, 67 x 76.5 cm
Amsterdam, Rijksmuseum

MAERTEN VAN HEEMSKERCK

1498–1574

This painting of an unknown family is one of
the most important works of portraiture in
16th-century Netherlandish art. It also pro-
vides an exemplary illustration of the possi-
bilities offered by the combination of Early
Netherlandish tradition, Italian influences and
creative talent.

The clear compositional structure, sta-
bilized by its "corner posts" of father and
mother yet with no sense of rigidity, reflects
both the influences with which Heemskerck
was confronted in Rome and his own endeav-
ours to lend plastic conviction to his figures
and objects. The richly decked table, on the
other hand, with its carefully executed table-
ware and food, takes up the love of detail so
characteristic of Early Netherlandish painting.
It is but a short step from here to the emer-
gence of the still life as a genre in its own right.

While the different ages of the three chil-
dren are accurately characterized, the figures
nevertheless remain coolly distanced from the
spectator. The inner world of the painting re-
mains hermetically sealed, an impression rein-
forced by the technique employed for the back-
ground, whereby the paint is applied in thin,
smooth layers in pale forms which seem to be
abstracted from clouds.

Heemskerck's *Family Portrait*, one of his
greatest works, was for a long time attributed
to his fellow Dutchman Jan van Scorel.

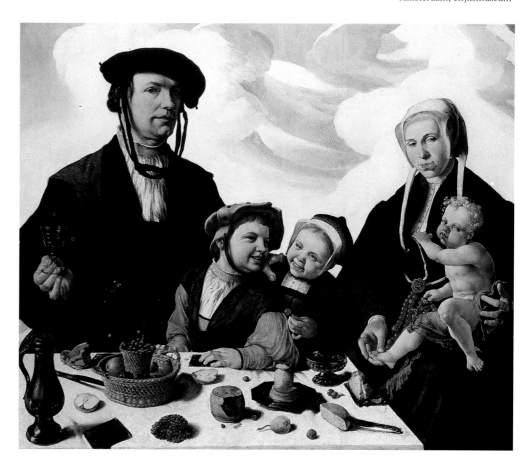

Maerten van Heemskerck
Family Portrait, c. 1530
Oil on wood, 118 x 140 cm
Cassel, Staatliche Gemäldegalerie

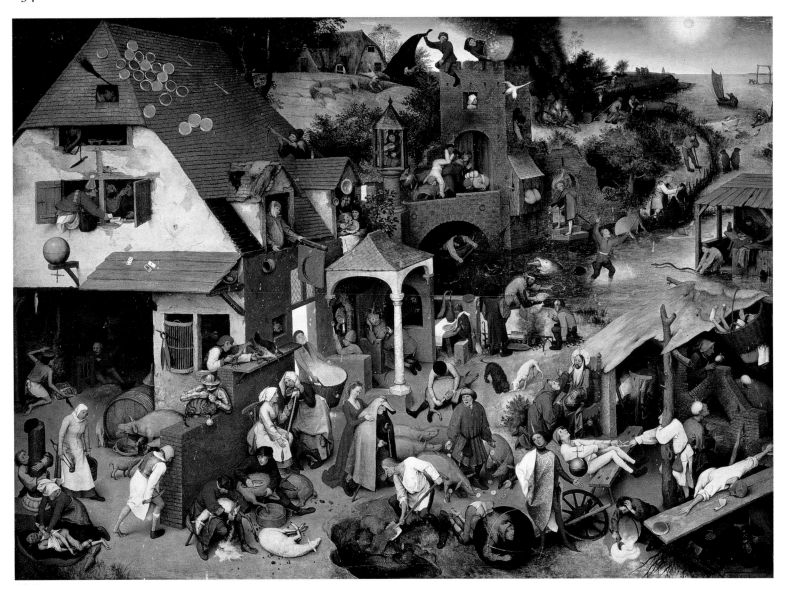

Pieter Brueghel the Elder
Netherlandish Proverbs, 1559
Oil on wood, 117 x 163 cm
Berlin, Gemäldegalerie, Staatliche Museen
zu Berlin – Preußischer Kulturbesitz

PIETER BRUEGHEL The Elder

c. 1525/30–1569

The follies of humankind were amongst Brueghel's favourite subjects in painting. He treated them both singly, as in *The Fall of the Blind* (1568; Naples, Museo Nazionale di Capodimonte), and in densely-populated compositions combining several at once, in what might be called cyclical form. Brueghel thereby directly takes up the tradition of Hieronymus Bosch. It is quite safe to assume that the content of his pictures would have been immediately obvious to his contemporaries.

Brueghel probably made no more use of a specific source for his *Netherlandish Proverbs* than for his *Children's Games* (1560), *The Fight between Carnival and Lent* (1559; both Vienna, Kunsthistorisches Museum) and *Dulle Griet* (*Mad Meg*, c. 1562; Antwerp, Museum Meyer van den Bergh), which were painted around the same time and which – in view of their similar scales – perhaps form part of a cycle. Rather, he drew upon contemporary thinking and translated it into paint.

The present panel is distinguished by the admirable homogeneity of its composition, which embraces a wealth of small and complex detail. Brueghel achieves this homogeneity first and foremost by organizing the scene along a powerful diagonal running from bottom left to top right. The warm, luminous palette, dominated by browns of every shade, also serves to establish a harmonious atmosphere in which figures, buildings and landscape are integrated.

Some one hundred proverbs have been identified in the picture, all of them related to the concept of the "The World Turned Upside Down", as the painting is also sometimes known. This is directly illustrated in the globe and cross hanging upside-down above the entrance to the large house on the left. In the bottom right-hand foreground, a man is trying to crawl through another globe (a man must "bow and scrape" if he is to "get on in the world"). On top of the crenellated tower in the rear of the picture, a man is "trimming his sails to the wind". Out in the bay in the top right-hand corner, a small boat is demonstrating the advantages of "sailing with the wind", while on the peninsula to the left, one blind man is leading two others (a miniature interpretation of the later *Fall of the Blind*). In focusing on the painting's content, we should not overlook the high degree of artistry with which Brueghel treats even the smallest details.

The story of the Tower of Babel, told in Genesis 11, took place at a time when everyone on earth spoke just one language. The people decided to build a new and magnificent city and at its centre would be a mighty tower which would reach up to Heaven. Angered by their arrogance, Yahweh, the God of the Old Testament, punished the people by confusing their language so that they were no longer able to understand one another's speech. He then scattered them all over the world. The tower itself remained unfinished. The story is first found illustrated in 6th-century manuscript illuminations. In the 16th century the Tower of Babel became a popular subject of panel painting, functioning as a warning both to the secular and the sacred authorities not to fall victim to haughtiness and pride.

Brueghel bases his composition, whose details are executed with the greatest of care, on that of the "global landscape" seen from an elevated standpoint. Respect for the large form is upheld in the tower, whose various stages of construction are nevertheless portrayed in great detail. The cut-away view into the exposed top part of the tower reflects a knowledge of Roman architecture, such as the Colosseum, while the use of brick masonry clad on the outside with finished stone is also adopted from Rome. The cloud encircling the left-hand side of the uppermost storeys serves to indicate that the tower is indeed reaching up to Heaven.

Buildings of this type are known to have existed amongst the early cultures of the Mediterranean region. One such was the *ziggurat* (temple tower) dedicated to the moon god Nanna in Ur (2250–2233 BC), whose lower storeys are still preserved today.

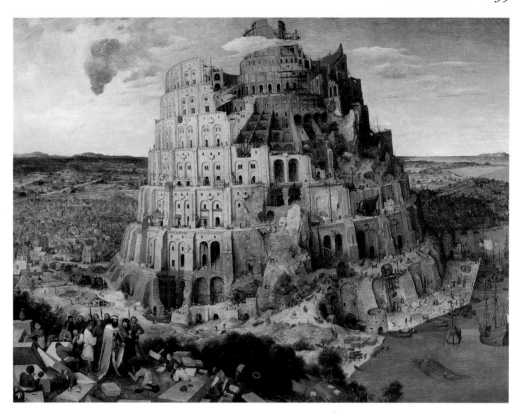

Pieter Brueghel the Elder
The Tower of Babel, 1563
Oil on wood, 114 x 154 cm
Vienna, Kunsthistorisches
Museum

This panel belongs to the group of allegorical subjects in which Brueghel castigates the follies and excesses of the world. In contrast to his earlier *Proverb* paintings, however, Brueghel employs in his later works a monumental scale which almost seems to burst out of the confines of the small format. The main "actors" here are three stout men lying either asleep or incapacitated at the foot of a table, on which can be seen the remains of a meal and an overturned flagon. Clearly identified by their clothing as belonging to different classes (knight, peasant and scholar or cleric), the boldly foreshortened figures are grouped like the spokes of a wheel. Brueghel thereby creates a sense of rotation around an axis, a sequence of movement which recalls the compositional principles employed by Italian Mannerism.

Anecdotal details such as the empty egg on two legs, the roast sucking pig and the gingerbread house should not lead us to overlook the skilfulness of the composition and the technical sophistication of its execution. We may admire, for example, the almost tangible texture of the fur-lined coat spread out beneath the refined and – as indicated by his book – learned man on the right.

The precipitous drop down to the lake in the background may be an allusion to the destiny of a humankind devoted solely to material pleasures. Hans Sachs' comic story, *Schlaraffenland* (The Land of Cockaigne), published in 1530, probably provided the literary source for this painting.

Pieter Brueghel the Elder
The Land of Cockaigne, 1567
Oil on wood, 52 x 78 cm
Munich, Bayerische Staatsgemäldesammlungen,
Alte Pinakothek

Pieter Brueghel the Elder
The Corn Harvest, 1565
(the month of August from the cycle Paintings of the Months)
Oil on wood, 118 x 161 cm
New York, The Metropolitan Museum of Art

Pieter Brueghel the Elder
The Hunters in the Snow, 1565
(the month of January from the cycle Paintings of the Months)
Oil on wood, 117 x 162 cm
Vienna, Kunsthistorisches Museum

PIETER BRUEGHEL The Elder

c. 1525/30–1569

Brueghel, in the past nicknamed "Peasant Brueghel" in a profound misunderstanding of his historical importance, for he was the greatest European landscape painter of the 16th century. However much landscape was being cultivated in Venetian painting, it nevertheless remained merely the backdrop to the main scene. In Brueghel, the reverse is true: it is the figures who are the props within the landscapes forming one of the central themes of the painter's œuvre.

In his *Schilderboek* (Book of Painting) of 1604, Carel van Mander describes the profound impact which the Alps made on Brueghel during his trip to Italy in 1554: "As he crossed the Alps, he swallowed up all the mountains and rocks, which he then spat out again in panels after his return home."

The Corn Harvest illustrates August in a cycle of *Months* which also includes *Hunters in the Snow* (January), *The Gloomy Day* (February), *The Return of the Herd* (October or November; all in the Kunsthistorisches Museum, Vienna) and *Haymaking* (July; Národni Galeri, Prague).

In an achievement which fits none of the categories of Mannerist painting, Brueghel succeeded in replacing the multiple, small-scale elements of the "global landscape" so popular in the Netherlands with monumental forms. In this respect, his landscapes represent an important preliminary stage in the evolution of Baroque painting, in particular the landscapes of Rubens.

As in *The Corn Harvest*, the main subject of the present panel is the landscape, with the scenic elements – the hunters setting off with their pack of hounds, the skaters – simply providing supplementary details. Even without any figures in the picture at all, the spectator would associate the snow-covered fields and mountains, frozen stretches of water and bare trees with winter.

With the same technique that he uses elsewhere to portray sunlight, Brueghel here evokes the overwhelming impression of frost. The landscape unfolds in a similar fashion to that of *The Corn Harvest*: from an elevated foreground, the eye is led over an abrupt drop and across lower-lying fields to the hills rising in the background. Not until the Baroque era would landscape be continuously developed from the front edge of the picture rearwards in a smooth fusion of foreground, middle ground and background.

A grid of vertical and diagonally descending and ascending lines provides the composition with a stable basic framework. The dominant axis is the emphatic diagonal leading from the pack of hounds bottom left to the mountain range top right. In a masterly demonstration of Brueghel's feeling for pictorial space, the landscape – which, for all its detail, seems empty – is lent depth by the bird in mid-flight.

JEAN CLOUET

C. 1475 – C. 1540/41

Although Clouet left not a single signed work after his death, his authorship of the present portrait is relatively certain, particularly in view of the close links which he enjoyed with the French court.

While the expression on the sitter's face remains little more than flat, his dress and golden chain are executed with careful attention to detail. The sumptuous colours of his clothes, alternating between gold and brown, stand out in all their splendour against the red brocade of the background, decorated with the royal insignia. There is no depth to the composition other than the space occupied by the figure himself between the parapet and the neutral foil of the tapestry.

Clouet was undoubtedly influenced by the School of Fontainebleau. The luminosity of the palette and the unnatural relationship between the relatively small proportions of the head and the monumental trunk are inconceivable without a knowledge of the Italian Mannerists working for the French court around this time.

Clouet probably painted several other portraits of the French royal family, such as the *Equestrian Portrait of Francis I* (Florence, Galleria degli Uffizi), the portrait of the *Dauphin François* (Antwerp, Koninklijk Museum) and the portrait of Francis I's daughter, *Charlotte* (Chicago, Epstein Collection).

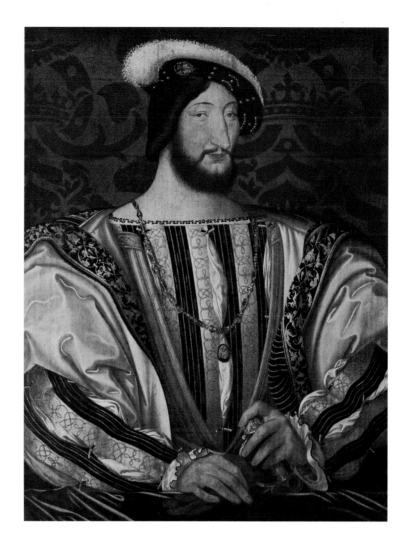

Jean Clouet
Portrait of Francis I,
King of France, c. 1535
Oil on wood, 96 x 74 cm
Paris, Musée National
du Louvre

FRANCOIS CLOUET

C. 1505/10–1572

In seeking to establish a tension between erotic appeal and cool distance, Clouet clearly reflects the influence of Italian painters such as Bronzino. The almost square format becomes the starting-point for an emphatically asymmetrical composition, in which the main figure is located in the front right-hand corner and further accentuated by a large gap in the red curtains. Just as a tension is thereby created between pictorial format and composition, so the same tension arises between plane and space. The beautiful woman in the foreground turns towards the viewer in such a way that her lower and upper arms repeat the horizontal and vertical sides of the frame. The outlines of the curtains further serve to bind the composition to the plane. In diametric opposition to this, however, the eye is drawn almost forcefully into the depths on the left, whereby the distance suggested by the smaller scale of the seated woman in the background is not supported by the perspective construction.

Contradiction is also the keynote of the palette, as seen in the brightly lit nude set against a shadowy ground. Although lagging behind his father Jean in terms of technique, François Clouet surpassed him in artistic invention. Diane de Poitiers, the mistress of Henri II, probably provided the model for the bathing woman.

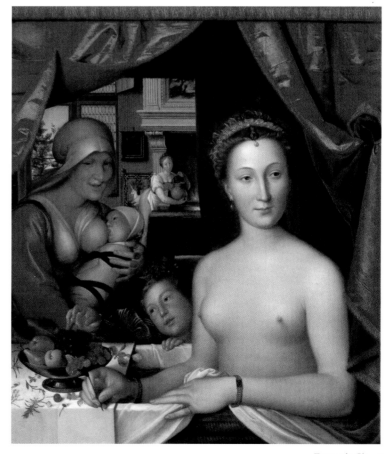

François Clouet
Lady in her Bath (Diane de Poitiers?), c. 1570
Oil on wood, 92 x 81 cm
Washington, National Gallery of Art

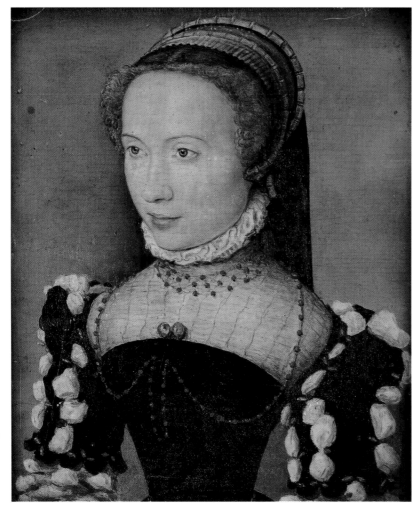

Corneille de Lyon
Portrait of
Gabrielle de Roche-
chouart, c. 1574
Oil on wood,
16.5 x 14cm
Chantilly, Musée
Condé

CORNEILLE DE LYON

C. 1500/10 – AFTER 1574

While its attribution is not undisputed, this portrait is closely related to a group of miniature-like portraits ascribed to Corneille. Typical features include the neutral, somewhat iridescent grey-green background and the slight turn in the upper body and head, whose connection to the plane is re-established by the fall of the veil.

The cool, distanced expression on the noblewoman's face, the precise drawing of her eyes, nose and lips, and the smooth planes of her forehead and cheeks assign this panel to the sphere of French court painting. Yet there is a contradiction in the loving execution of the details of her clothes. Are we seeing here a reflection of the artist's Netherlandish heritage (Corneille de Lyon was born in The Hague)? This tendency towards "detail realism" nevertheless draws upon new technical means. The pale, puffy elements protruding from the sleeves of the dark dress are daubed on in an "Impressionistic" style, richly modulated and without clear boundaries.

Was the artist, whose work is still surrounded by many unanswered questions, familiar with Venetian painting? Whatever the case, a contemporary source tells us that Corneille painted the entire court and that he rose to become "Peintre et Valet de Chambre du Roi", the highest post that a painter could attain at court.

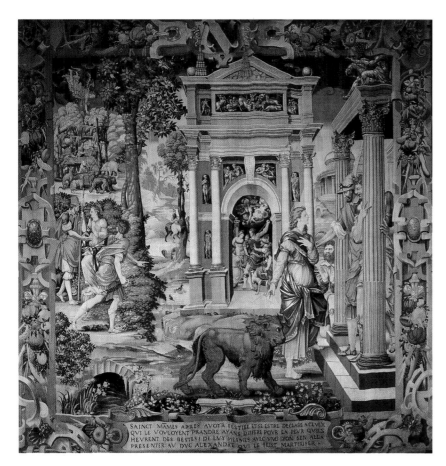

Jean Cousin the Elder
St Mammès and Duke Alexander, 1541
Tapestry, 440 x 450cm. Paris, Musée National du Louvre

JEAN COUSIN The Elder

C. 1490/1500 – C. 1560

According to legend, St Mammès was martyred under Emperor Aurelian in Cappadocia in around 275. He was highly revered in Asia Minor in early Christian times and described as a "great martyr". In the 8th century his relics were taken to Langres in France and he became patron saint of Langres cathedral.

In around 1540 eight tapestries depicting scenes from his life were woven for the chancel. Three still survive, two in Langres and one in the Louvre. After the saint had addressed the wild animals (the subject of one of the two tapestries in Langres), he went on, accompanied by a lion, to visit Duke Alexander (according to the inscription woven into the bottom of the present tapestry; strictly speaking, however, it should be Aurelian), who condemned him to death. The saint's execution can be seen in the temple-like building in the middle ground.

The expansive landscape, the confident handling of perspective and the classicizing architecture all point to Italian influences, which may have come from the School of Fontainebleau. This is also suggested by the decorative embellishment of the buildings and the rich ornamentation of the frame. Its astonishing wealth of nuances of colour lead the tapestry to resemble a painting on canvas.

SCHOOL OF FONTAINEBLEAU

C. 1530 – C. 1570

As with the *Landscape with Threshers* below, precisely who executed this painting remains unknown. The slender proportions of the figure, with its small head and its extremely complex pose, point to the influence of the first School of Fontainebleau surrounding Rosso Fiorentino and Primaticcio. While Diana is effectively seen in profile, walking from right to left, this side view is skilfully manipulated. Thus the slight twist of her shoulders in the opposite direction to her step allows us to see her spine, while her head is turned in the opposite direction to her shoulders.

Typically Mannerist is the contrasting intensity of the movements made by Diana and the dog beside her. In the juxtaposition of the goddess's slow step and the bounding hound, two different rhythms are captured in the same instant.

The group of trees in the background and the view of the landscape are executed in the same generous, sweeping style as the *Landscape with Threshers* – a distinctive feature of the second School of Fontainebleau and something which would form one of the foundations of the French landscape painting of the 17th century.

The delicate, cool eroticism evident in *Diana the Huntress* is characteristic of many of the works by the School of Fontainebleau and fell fully in line with French tastes of the day.

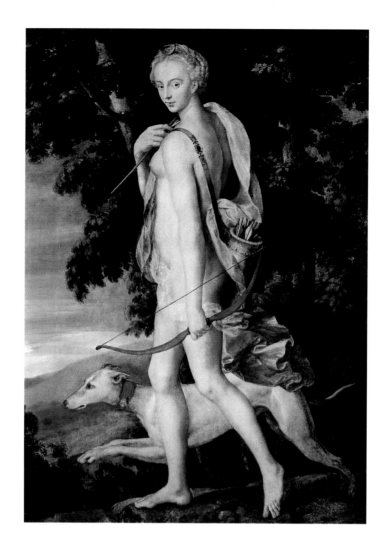

School of Fontainebleau
Diana the Huntress, c. 1550
Oil on wood, transferred to
canvas, 191 x 132 cm
Paris, Musée National du
Louvre

This canvas occupies a position of outstanding importance within the landscape painting of the 16th century. Up till now, however, no one has even come close to solving the problem of its authorship. The suggestion that it should be attributed to Niccolò dell'Abbate is refuted by a comparison with the latter's known works (*The Finding of Moses*, Paris, Louvre; *Aristaeus and Eurydice*, London, National Gallery). It is hard to believe that his son Guilio Camillo could have produced a work of such artistic quality, while the Frenchman Etienne Delaune is known to us chiefly as a copperplate engraver.

The most useful comparison is offered by Brueghel's more or less contemporaneous cycle of *Paintings of the Months* (cf. ills. p. 136). Here as there, the figures serve merely as props; here as there, the eye is led from an elevated standpoint overlooking the foreground, across a valley, and on to mountains behind. Unlike the diagonals favoured by Brueghel, however, the present artist adopts a centralized composition. The hay stack forms the approximate axis around which the figures and landscape elements rotate. The triangle of figures on the left reappears inverted in the right-hand middle ground. The artist is also more successful in integrating the different pictorial grounds, something he achieves using a "pseudo-Impressionist" technique which is unique in 16th-century painting. The painted light looks forward to Claude Lorraine. Without wishing to venture an attribution, one is tempted to think of the execution of the backgrounds in the portraits of Corneille de Lyon.

School of Fontainebleau
Landscape with Threshers, c. 1555–1565
Oil on canvas, 85 x 112 cm
Fontainebleau, Musée National du Château

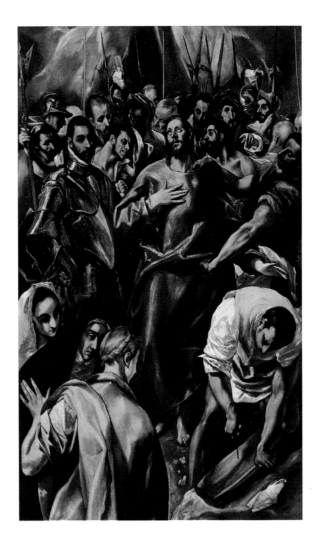

El Greco
The Despoiling of Christ
(El Espolio), c. 1590–1600
Oil on canvas, 165 x 99 cm
Munich, Bayerische Staatsgemälde-
sammlungen, Alte Pinakothek

El Greco
The Agony in the Garden, c. 1595
Oil on canvas, 102 x 114 cm
Toledo (OH), Toledo Museum of Art

EL GRECO
c. 1541–1614

The present canvas with its larger than life-size figures is one of three versions which El Greco painted of the subject. The impressions of the artist's Venetian years, and particularly the works of Titian, can still be felt in the strictly centralized composition, in the relatively plastic modelling of the figures, and above all in the sophistication of the palette. The way in which the figures below left are sliced by the frame, and the slight foreshortening employed in the figure of Christ, who appears to be leaning backwards into the picture, suggest that the canvas was destined to be hung at some height. If we consider in this regard the luminous red of Christ's robe, by which he is made to stand out from the crowd, and the multiple verticals of the figures and lances, the painting seems to point beyond its immediate subject to the coming ascension.

When compared to *The Despoiling of Christ*, *The Agony in the Garden* testifies to an astonishing artistic development. The Italian influences recede to the same degree as El Greco frees himself from his obligation to nature. The figures lose their sense of substance, while their expressiveness is amplified by the unreal shapes assumed by the landscape. Thus Christ is literally heightened by the rock behind him, while the disciples are seen in a sheltering cave as a symbol of sleep. The figures are absolved from logical relationships of scale. The falling diagonal which leads from the angel, through Christ, to the soldiers on the right-hand edge of the painting is a visual statement of the inevitability of Christ's fate. Such departures from the natural model, also evident in the visionary apparition of the moon, were one of the major reasons for the revival of interest in El Greco's work around 1900.

The inscription beneath this altarpiece describes the legendary events taking place. During the burial of the devout Count Orgaz in the first half of the 13th century, St Stephen and St Augustine are supposed to have come down from Heaven and placed the body in the tomb themselves.
El Greco paints a fascinating vision in which the earthly and heavenly worlds are both contrasted and at the same time unified. Surrounded by clergy and nobles, the two saints lower the body into the grave. A boy in the left-hand foreground – El Greco's son? – looks out at the spectator and points to the events taking place. All spatial depth and background detail is renounced. This enables the heavens to open directly overhead, revealing Christ seated in judgement with Mary and John the Baptist as intercessors for humanity. The upward train of movement indicated in the celestial sphere complements the lowering movement of the main group on the ground: death and resurrection are simultaneously portrayed.

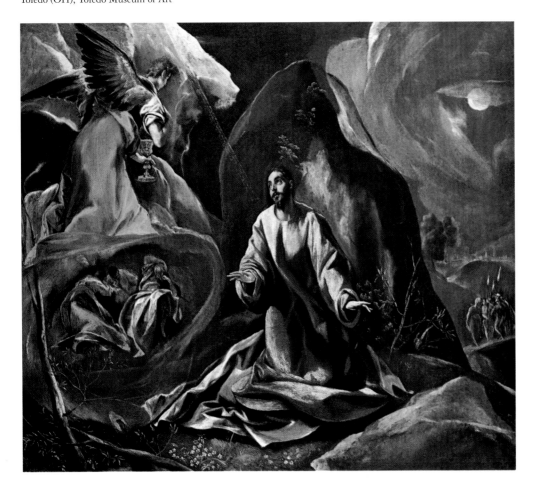

El Greco
The Burial of Count Orgaz, c. 1586
Oil on canvas, 488 x 360 cm. Toledo, Santo Tomé

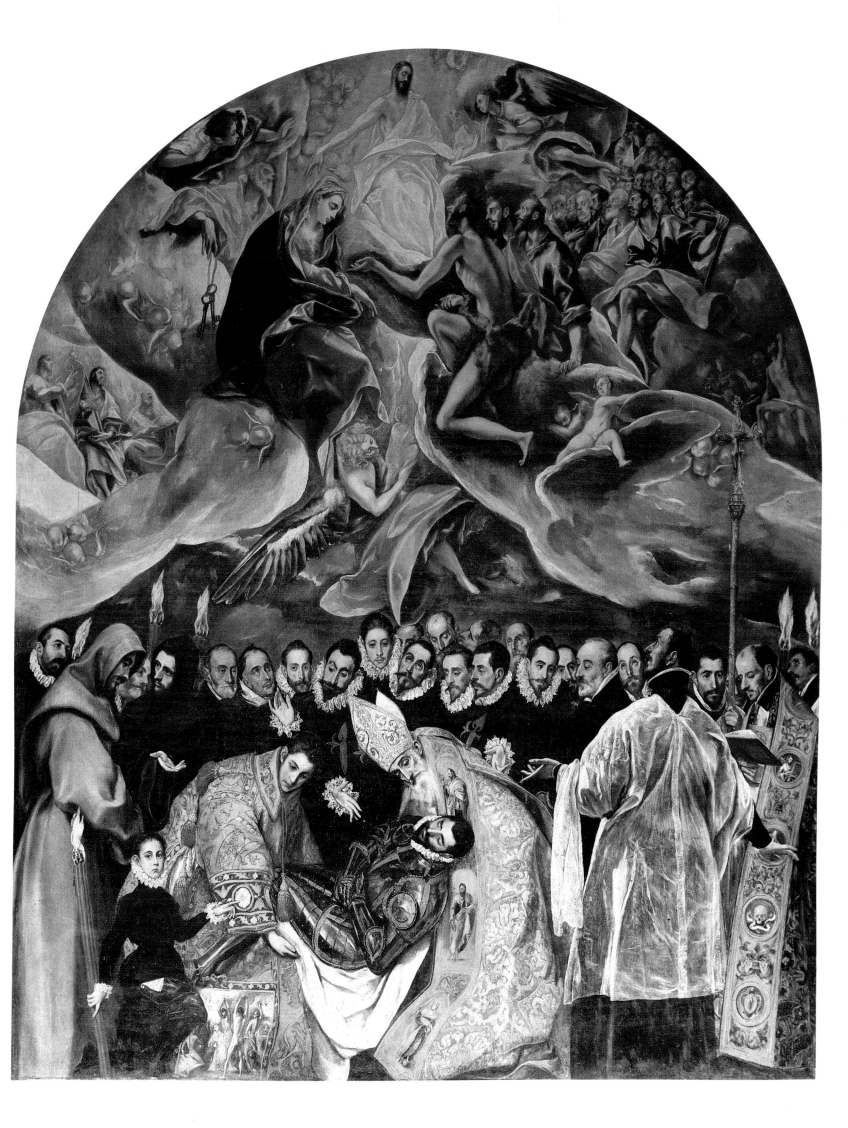

El Greco
The Holy Family with St Anne and
the Young St John Baptist,
c. 1594–1604
Oil on canvas, 107 x 69 cm
Madrid, Museo del Prado

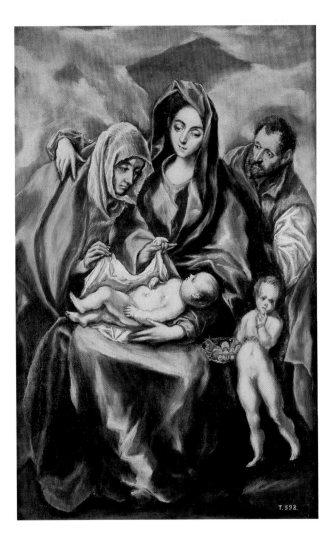

Below:
El Greco
View of Toledo, c. 1604–1614
Oil on canvas, 121 x 109 cm
New York, The Metropolitan
Museum of Art

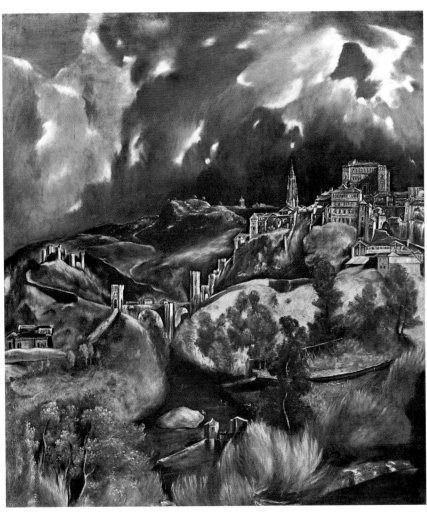

EL GRECO
C. 1541–1614

El Greco painted the Holy Family with St
Anne on a number of occasions. Whereas the
version in the Hospital di San Juan Bautista in
Toledo, probably executed some ten years earl-
ier, employs a bright, almost cheerful palette,
the present canvas is strikingly darker in
colour, its effects of light suggestive of a
storm. The inclusion of the young John the
Baptist, pointing heavenwards with the index
finger of his left hand, allows the painting to
be seen as a vision of the future Passion.

The five figures in this painting are
grouped closely together, however, the spatial
relationships between them are of a compli-
cated nature. St Anne, her daughter's arm
lying around her shoulders, is bending down
over the infant Jesus lying in his mother's lap –
a reminder of Pietà representations and thus
again of the Passion of Christ. Joseph, com-
plementary to St Anne, looks towards Christ
from behind. By avoiding all direct eye con-
tact between the figures, El Greco evokes a
strangely unreal, dream-like atmosphere.

El Greco renounces all detail in his descrip-
tion of objects. The robes are treated broadly,
while contours and outlines are blurred –
something particularly apparent in the model-
ling of the two children. El Greco is already
moving towards the style of his late work, in
which he would increasingly turn away from
the portrayal of idealized nature.

Towards the end of his career, El Greco
painted his chosen home of Toledo in what is
the only example of pure landscape painting
in his entire œuvre. From a low standpoint,
the eye is led up the hill to the city centre,
dominated by the Alcazar and the cathedral.
The dynamic train of movement from bottom
to top and from foreground to background is
joined by a diagonal which runs from the left-
hand edge of the canvas, across the bridge
spanning the Tajo valley, along the city wall
and up to the cathedral spire.

Unconcerned with representational detail,
El Greco blurs the transitions between trees,
meadows and distant mountains. The individ-
ual monuments of the cityscape thereby stand
out all the more sharply in their ghostly light.
The broad expanse of the sky, in which clouds
and buildings are interwoven, corresponds to
the free, increasingly abstract style of his late
works.

The painting is both a "landscape portrait"
and at the same time an interpretive study
filled with tremendous natural forces.
Thunderclouds as black as night are gathering
over the cathedral and the fortress, the sacred
and secular centres of the city. Whether the
artist thereby intended to deliver a specific
message is something on which history is si-
lent.

El Greco's *View of Toledo* was greeted as a
revelation by the painters of Expressionism
and Surrealism.

ALTDORFER Albrecht

c. 1480 Regensburg (?) –
1538 Regensburg

Altdorfer is one of the most talented painters in the whole of German art. Although also a draughtsman and engraver, his importance lies in the field of coloured representation. Here, only Grünewald can be compared to him because all other contemporary painters were committed to the conventions of outline and drawing qualities. Altdorfer achieved, through his colour modulation, completely new ways of expression directed at the emotions. His tendency towards the "romantic" is particularly noticeable in his landscapes. Thus it was he who painted the first picture in European art that is purely a landscape ("Danube Landscape near Regensburg", Munich, Alte Pinakothek, c. 1530), and in many of his other paintings figure and landscape merge in such a way that the scenic becomes background ("St George in the Forest", Munich, Alte Pinakothek, 1510). Altdorfer, who travelled in the Alpine countries in 1510, became the leading light of the so-called "Danube School".

There is no actual proof that he went to Italy. This seems highly probable, however, when looking at his virtuoso handling of spatial construction in the St Florian passion altar panels (after 1510). In his later work Altdorfer moves towards Mannerism in his complex depiction of moving elements, the daring approach to depth and new handling of colour.

Nothing is known about the painter's formative years and early beginnings. There is evidence that in 1505 he lived in Regensburg, where he bought property in 1513. His election to the town council in 1519 and to the inner council in 1526 shows his good standing. At the same time he served as civic architect. There is no information about his architectural work, but it is possible that he was involved in the design of the pilgrim church "Zur Schönen Madonna" (now the new Neupfarrkirche) at Regensburg.

Illustrations:

122 The Agony in the Garden, c. 1515
122 Susanna at her Bath and The Stoning of the Old Men, 1526
123 Alexander's Victory (The Battle on the Issus), 1529

ANTONELLO DA MESSINA

c. 1430 Messina – 1479 Messina

Antonello was born c. 1430 in Messina where he studied under local artists. His creative talent developed and found direction during his years of travel which took him as far as northern Italy. He probably worked in Naples around 1450. Here, the young painter was able to study major works of the Netherlandish school of painting, as King Alfonso I possessed a good collection of paintings by Jan van Eyck and Rogier van der Weyden. It is also thought that the painter Colantonio, who had studied the art of the Netherlands, taught Antonello in Naples. It was in this environment that Antonello discovered his talent for fine detail, whose textual reality is achieved by adding oil as binder, thus allowing the application of several transparent coats of colour. Learning about artistic devices employed in the Netherlands was so important that Vasari later, in the mid-16th century, assumed that Antonello must have visited Flanders, studying under Jan van Eyck (which in terms of time alone could not have been the case).

On his northern travels Antonello met Piero della Francesca in Urbino, whose works taught him the art of perspective and clear geometric disposition of space. With this combination of talents unique in 15th-century Italian painting, he reached Venice in 1475 where he stayed until 1476. His arrival must have been a revelation to the Venetian painters. He acted as catalyst, helping Venetian art to come into its own: colour modulation instead of the hitherto predominant outline. Because of this function, and the equally important one of mediator between north and south, Antonello is regarded as one of the most important figures in early Renaissance painting.

Illustrations:

46 St Jerome in His Study, c. 1456
46 Virgin Annunciate, c. 1475
47 St Sebastian, c. 1476
47 Sacra Conversazione, 1475/76

ARCIMBOLDO Giuseppe

(also: Arcimboldi)

c. 1527 Milan – 1593 Milan

His father Biagio Arcimboldo was descended from a noble Milan family and worked as a painter on the Milan Cathedral. From 1549 to 1558 Arcimboldo was assistant to his father at the Milan

Cathedral workshops and engaged in designing stained-glass windows. In 1562 he was called to the court of Ferdinand I in Prague as a portrait and copy painter. In 1563 Arcimboldo painted his first set of "Seasons". The unique artistic conception of these pictures established his fame even then as master of the fantastic art of composing portraits, still lifes, landscapes and allegories consisting of plants, animals and everyday objects. In 1566 he painted the four "Elements", and there is evidence that he went to Italy in the same year.

In 1569, on New Year's day, the "Seasons" and the "Elements" were presented to Ferdinand's successor, Emperor Maximilian. At the court Arcimboldo worked as architect, stage designer, engineer, art expert and organiser of festivities and tournaments. In the early seventies he produced several replicas of his "Seasons" pictures. In 1587 he left the court of Rudolf II, the successor to Maximilian, to return to Milan. As a mark of recognition he received 1550 florins from the Emperor. In 1591 he sent to Prague a portrait of Rudolf II depicted as *Vertumnus*. In the following year the Emperor bestowed on him the non-hereditary title of count palatine. The Surrealists regarded him as one of their precursors.

Illustration:

87 Spring, 1563

BALDUNG Hans

(called: Grien)

c. 1484/85 Schwäbisch Gmünd – 1545 Strasbourg

Baldung probably completed his apprenticeship in Strasbourg at the early age of 15, when he was given the byname "Grien" (Green) because of his

youth. In 1503 he entered the workshop of Dürer in Nuremberg to become one of his most prominent pupils. As one of the most eminent German artists of the 16th century, both as painter and as master of the graphic arts, his works are remarkable for their unusual combination of unveiled sensuality and dispassionate intellect which often produces a "cold fire". Besides religious commission work, Baldung preferred secular themes in which the female body, worked up into a demonic frenzy in his witch scenes, is given a major role.

He was also highly regarded as a portraitist, and from about 1530 he was considered to be one of the best artists on the Upper Rhine. His development leads from the latest Gothic forms via the Italian Renaissance, whose harmony he never strove to achieve, into Mannerism. In his treatment of colour he rejected the conventional norm of clear, harmonious tones in favour of dissonance alien to nature. In this respect he represents a parallel to the masters of early Florentine Mannerism (Pontormo, Rosso Fiorentino).

Illustration:

119 The Nativity, 1520

BARTOLOMMEO Fra

(Bartolommeo di Pagola del Fattorino, known as: Baccio della Porta)

1472 Soffignano (near Florence) – 1517 Florence

The twelve-year-old Bartolommeo, called "della Porta" because his family home was at the Porta di San Pier Gattolino, was sent to the workshop of Cosimo Rosselli, where he was given an education in the full spirit of the late 15th century. In 1490 he founded his own workshop, together with Mariotto Albertinelli. Evidently equipped with a social sense and filled with religious fervour, he became a follower of Savonarola and entered the Dominican order in the late nineties. His creative work, briefly disrupted, led him to abandon tradition in the early years of the 16th century, and to come under Flemish influences. He explores Perugino in his representations of landscape and his drawings; he becomes fascinated with Giovanni Bellini while in Venice in 1508; and on his return studies Leonardo's new colour theories. The combined effect of these influences resulted after 1512 in works which stand out in the art of the Florentine High Renaissance.

Bartolommeo not only made a lasting impression on Raphael, but as a teacher also gave direction to Rosso Fiorentino, Pontormo and the Sienese painter Domenico Beccafumi.
Illustration:
96 Annunciation, c. 1500

BASSANO Jacopo
(Giacomo da Ponte)
c. 1517/18 Bassano – 1592 Bassano
Bassano stems from a family of painters and received his training from his father, Francesco. In 1530 he was apprenticed for 5 years to the Venetian painter Bonifazio de' Pitatis. In 1549 he was appointed a councillor and consul of his home town, whose name he adopted and where he lived all his life, untroubled by great events. Bassano had a large workshop, where later four of his seven children worked. Here he produced about 180 paintings which would not have been feasible without assistance. His works show the influence of Titian and Lorenzo Lotto and late Venetian Renaissance art (Tintoretto and Veronese), whose insights he developed further.

The strength of his work lies in the concentration on objects and in telling a story simply but effectively. In his realistic representation of landscape Bassano developed a style of his own; genre painting outweighs work with religious content.
Illustration:
109 The Procession to Calvary, c. 1540

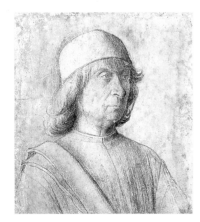

BELLINI Gentile
1429 Venice – 1507 Venice
Gentile, who was somewhat older than Giovanni, was trained at the workshop of his father Jacopo. The keenness of observation with which he rendered perspective, scenery or antique fragments in his sketches became a decisive factor in his artistic development. It predestined him to be the most important portraitist of Venetian art in the 15th century. From 1450 until his death Gentile acted as official painter to the Republic. He was sent to Constantinople in 1479/80, as the Signoria of Venice had been requested by Sultan Mehmed II to send him the best portraitist. The famous portrait of this oriental potentate is now in the National Gallery, London.

Next to portraiture, Gentile also excelled at large-scale historical scenes painted in the style of the early Venetian Renaissance. There is nothing in Venice to equal his panels with scenes from the Legend of the True Cross, painted c. 1500. The faithful and precise rendering of St Mark's Square and the medieval Rialto bridge make him the forerunner of Canaletto. It is true that in terms of coloration he remains well within the boundaries of 15th-century traditions, whereas his younger brother was even then opening up new fields in colour modulation. Gentile's most significant pupil and successor was Carpaccio.
Illustration:
48 Procession in St Mark's Square, 1496

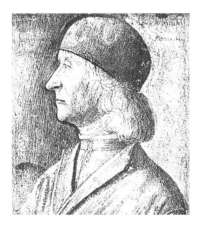

BELLINI Giovanni
(also: Giambellino)
c. 1430 Venice – 1516 Venice
Giovanni was initially taught by his father Jacopo whose drawings of almost icon-like precision in the traditional 14th-century method and manner influenced his early work. When Giovanni's sister Nicosia married Andrea Mantegna in 1453, close relations between Venice and Padua were established, and Giovanni began to explore the physical and spatial representation of the Early Renaissance. Under Mantegna's influence his style assumes temporarily a certain calligraphic precision ("Transfiguration of Christ", Venice, Museo Correr, c. 1460; "The Mount of Olives", London, National Gallery, c. 1470.)

The visit of Antonello da Messina to Venice in 1475/76 seems to have liberated Giovanni's innermost talents. Without abandoning the rational structure and interaction of form and space, his colours gain in luminosity and depth; modulation of tone increasingly replaces the dividing outline, light floods the canvas. The landscape, as can be seen in many of his representations of the Virgin and Child and the Pietà, achieves a quality that marks Bellini as the most important Italian landscape painter of the Early Renaissance. His ability to endow his figures with an expression of quiet contemplation while fully conveying movement and human anatomy, remains a secret that raises him above all his contemporaries. The great works of his late art, in particular his portrayals of the Sacra Conversazione, already cross the border from Early to High Renaissance in the way artistic freedom and convention merge. As teacher of Giorgione and Titian, Giovanni, whom Dürer on his second visit to Venice from 1505 to 1507 still called the greatest painter of his time, was of immeasurable significance for Venetian art in the 16th century.
Illustrations:
14 St Francis in the Wilderness, c. 1480
50 Sacra Conversazione (Pala di San Giobbe), c. 1487/88
50 Transfiguration of Christ, c. 1460
51 Portrait of Doge Leonardo Loredan, c. 1501–1505
51 Christian Allegory, c. 1490

BERRUGUETE Pedro
c. 1450–1455 Parades de Nava – c. 1504 Avila (?)
The combination of a great variety of traditions makes Berruguete one of the most versatile and important Spanish painters of the 15th century. Having been raised in the cultural ambience of the court of the Castilian "Catholic Kings", who collected pictures in Granada from the Netherlands as well as employing painters from the North, he became, after a lengthy stay in Italy, one of the most important mediators between Spanish art and the Italian Early Renaissance. In 1477 he worked with Justus of Ghent at the court of Urbino. Here Berruguete painted his portraits of famous figures, using with great sensitivity the innovations of the Italian Early Renaissance regarding form and space. Clearly he was highly thought of in Italy, not only receiving stimulation but also giving it to others, such as at the court of Ferrara.

In 1483 he returned to Toledo. Unfortunately his frescos in the sacristy and cloister of Toledo Cathedral did not survive, but his mature works, including the altarpieces for the monastery of Santo Tomás and for Avila Cathedral show to this day his symbiosis of Spanish medieval tradition, Dutch faithfulness in detail, and Italian clarity of composition. Pedro was the father of the sculptor Alonso Berruguete.
Illustration:
68 Court of Inquisition Chaired by St Dominic, c. 1500

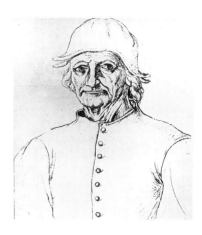

BOSCH Hieronymus
(Iheronymus van Aken)
c. 1450 s'Hertogenbosch – 1516 s'Hertogenbosch
Bosch, a contemporary of Leonardo da Vinci, is one of the great European painters of his time. The need to decodify his symbolic language, which is no longer generally accessible, although it is essential to an understanding of the spirit of the time, often deflects from the great artistic worth of his works. Bosch's training and early work remain largely in the dark. His attention to minute detail, which also characterises his large triptychs, has led to the assumption that he was trained as miniaturist ("The Garden of Delights", ill. p. 65; the "Haywain" triptych, several versions, of which one at the Prado, Madrid; "Last Judgement", Vienna, Gallery of the Akademie der Bildenden Künste). There is no proof of this, however. The disturbing world of his paintings, which often scourges the moral decadence and folly of the world, may have been induced by religious unrest before the Reformation. In the course of his development, Bosch increasingly refined his devices until he achieved a distinctive way of handling colour, combined with an equally distinctive clear outline. This marks him as a contemporary of Leonardo, whose works he may or may not have known. Bosch was, besides Geertgen tot Sint Jans, the great landscape painter in the Netherlands in the 15th and early 16th centuries. He gave the impetus to the development of the "world landscape" – such as by Patinir – and also of the autonomous landscape, such as Pieter Brueghel's Seasons. It is significant that Bosch, already highly regarded in his lifetime, should have found particular favour with his "morality" pictures in the very place where the 16th-century Inquisition had its worst excesses: in Spain.
Illustrations:
65 The Garden of Delights, c. 1510
66 The Ship of Fools, after 1490
67 St Jerome, c. 1500

BOTTICELLI Sandro
(Alessandro di Mariano Filipepi)
1445 Florence – 1510 Florence
After an apprenticeship as a goldsmith, which was to influence his entire work, he became the pupil of Filippo Lippi from whom he took over the madonna

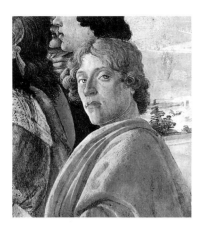

and angel figures, but giving them more expression. There is no proof that he worked under Verrocchio, though this is probable for stylistic reasons. There he would have perfected his talent as master of the sensitively drawn line. His early work takes up the plastic realism of the past generation: the "Adoration of the Magi" (Florence, Uffizi, c. 1475) is characteristic with its clear composition, three-dimensional figures, strong, bright colours and individual treatment of the faces (Medici portraits). Later, the interest in space and physical form diminishes in favour of the richly moving line of slender figures and fine detail of jewels and richly embroidered dress ("Birth of Venus", "Primavera", ill. p. 37). But as his three frescos begun in 1481 on the lower wall of the Sistine Chapel show, Botticelli was well able to achieve monumental effects. He soon became a master of the large format: in his "Cleansing Sacrifice of the Lepers" the centre emerges naturally, the multi-figured groups connect, giving unity to the scene, and foreground, middle ground and background merge into each other.

In his late work the line gains in sensitivity (92 silver point drawings for Dante's *Divine Comedy*) and in emotional expressiveness ("Annunciation", Florence, Uffizi, 1490–1495). The religious fervour depicted in these later works may have been the result of Savonarola's sermons calling for repentance, but this tendency was already noticeable in his mature work. With his death in 1510 the 15th-century period of Italian painting came to a close.

Illustrations:
20 Camilla and the Centaur, c. 1482
34 Venus and Mars, c. 1480
36 Madonna del Magnificat, c. 1481/82
36 Pietà, after 1490
37 La Primavera (Spring), c. 1477/78
37 The Birth of Venus, c. 1485

BOUTS Dieric
(also: Dierick, Dirk)
c. 1410–1420 Haarlem – 1475 Leuven
Bouts can, besides Memling, be considered the most significant successor to van der Weyden. Little is known about his training and early work. It is not clear whether he was Rogier's pupil or not, but this painter's work

certainly became a lasting influence. Bouts developed Rogier's style almost to a radical degree in his verticalization of architecture and figures, the minute rendering of costly garments behind which the body recedes, and the reduction of the individualistic in favour of typification. It is difficult to decide whether Bouts was the representative of a specific, Protestant art of the northern part of the Netherlands, or whether he was caught up by the wave of "re-gothicisation" sweeping over Europe after the mid-century. In any case, the characteristics already described, intensified, from the Lord's Supper altar in Leuven (1464–1467) to the justice pictures in Brussels (begun 1468). In 1475 Bouts' name first appears in the records of Leuven, where he married Katharina van der Brugghen. He worked in Leuven and became a highly respected painter. His last mention in the records dates from 17 April 1475. As to his work, a clear line still cannot be drawn between his own work and that of others, including his son Dieric Bouts the Younger. It is therefore impossible to make a fair assessment of his art. If the winged altar at Munich known as "the pearl of Brabant" is indeed by his hand, then he must have been one of the greatest landscape painters of his generation.
Illustrations:
60 The Empress' Ordeal by Fire in front of Emperor Otto III, c. 1470–1475
60 Last Supper, 1464–1467

BRONZINO Agnolo
(Agnolo Tori, Agnoli di Cosimo)
1503 Monticelli (near Florence) – 1572 Florence
After an apprenticeship with Raffaelino del Garbo, the young Bronzino assisted Pontormo in 1522 with the frescos in the Certosa di Galuzzo near Florence, where he received decisive artistic impulses for his future. But he moved increasingly away from Pontormo's spiritual tendencies, favouring a highly refined, detached aestheticism. In 1539 he participated in the decorations for the wedding of Cosimo I de' Medici with Eleonora of Toledo and won such favour that he became their court painter and portraitist. His portraits, usually painted in cool colours and in which the figures are placed silhouette-like before the background,

are the most refined of their kind in the 16th century. During his visit to Rome from 1546 to 1548 Bronzino studied in particular the works of Raphael and Michelangelo, from whose novel ways of portraying the figure he benefited, as is apparent in such works as the fresco "Martyrdom of St Lawrence" (Florence, 1565–1569). In his later work he developed under the influence of what were then the latest theories seeking to unlock the code of allegorical representation. In these works he manages to balance cool sensuality with an elaborate composition. The colour surface often attains an enamelled smoothness.
Illustrations:
89 Eleonora of Toledo and her Son Giovanni, c. 1545
110 An Allegory (Venus, Cupid, Time and Folly), before 1545

BRUEGHEL Pieter the Elder
(also: Bruegel, Breughel, Breugel)
c. 1525–1530 Breda (?) – 1569 Brussels
His nickname "Peasant Brueghel" harks back to his depiction of peasant life, proverb and genre scenes, unduly diminishing the importance of this great Netherlandish painter of the 16th century. In his representations of the life of peasants and the underprivileged, Brueghel penetrated the outer shell, converting them to images applicable to human life in general, such as in the folly of the World ("Country of the Blind", Naples, Museo Nazionale di Capodimonte), the transience of material values ("The Land of Cockaigne", ill. p. 135), or the fate awaiting the power-greedy (various versions of the "Tower of Babel", ill. p. 135).

In some respects Brueghel takes up the concerns of Bosch. He undoubtedly belongs to the phase of European Mannerism in breaking up the composition into small parts ("Proverb" pictures), or the suggestion of movement ("Country of the Blind"). On the other hand, with his later works which show a new overall unity of structure and also greater use of large figures, he paves the way for the Baroque north of the Alps. His visit to Italy in the 1550s, which took him to the far South, might have contributed to this change. His significant place as a landscape painter in the whole of European art in the 16th century is undisputed. In the "Months" pictures created around 1565, colour developed into an ele-

mental force, pointing far into the 17th century.
Illustrations:
134 Netherlandish Proverbs, 1559
135 The Tower of Babel, 1563
135 The Land of Cockaigne, 1567
136 The Corn Harvest, 1565
136 Hunters in the Snow, 1565

BURGKMAIR Hans the Elder
1473 Augsburg – 1531 Augsburg
After an initial training by his father, Burgkmair was apprenticed to Schongauer at Colmar, whose style influenced his early work. After 1490 he probably travelled in Northern Italy, spending time in Venice. In 1498 he finally settled in Augsburg and took over his father's workshop. His reputation grew rapidly judging by the commissions he received (e.g. "Basilica Pictures" for the Catharine Foundation, today at Augsburg, Altdeutsche Galerie, 1501–1504).

These are still in the tradition of the late 15th century, as fine detail still dominates the overall structure and composition. With the knowledge gained in Italy, Burgkmair later explored the monumental form of the High Renaissance, combining it with a brilliant, warm coloration. (St John's Altar, ill. p. 119). He also made drawings for woodcuts, especially from 1512 to 1518 with his contributions to the large commissions for Emperor Maximilian (Weißkunig, Theuerdank, Triumphal Procession of the Emperor Maximilian). Burgkmair was a key figure in opening the Augsburg art world to the Renaissance.
Illustration:
119 John the Evangelist on Patmos, 1518

CAMPIN Robert
c. 1380 Tournai (?) – 1444 Tournai
Recent research is agreed on the identification of Robert Campin as the painter who was long called "Master of Flémalle" (named after a triptych said to have been in the Abbey Flémalle near Liège, now kept at the Städelsche Kunstinstitut at Frankfurt/Main). Some of the problem remains unsolved, however: although he is referred to in documentary records, none of his signed works survives. Sometimes he has been placed alongside the young van der Weyden, but stylistic differences speak against this.

Rather, a teacher-pupil relationship should be assumed. Campin was born in about 1380 in Tournai, where he was made master in 1406/07 and presumably taught van der Weyden from 1427 to 1432. Together with the brothers van Eyck he can be considered the founder of the Early Renaissance in Netherlandish painting. Evidently outgrowing the Burgundian art of the brothers Limburg, whose influence could still be felt in Campin's early work ("Betrothal and Annunciation of Mary", Madrid, Prado, c. 1410), he soon turned to three-dimensional figure representation and the exploration of depth ("Adoration of the Shepherds", Dijon, c. 1420). These are late works, when the painter was almost obsessed with all aspects of perspective (e.g. the Mérode altar, so called after its original location; now in New York, Metropolitan Museum, c. 1430; Werl altar, ill. p. 56) Terborch.

Illustrations:
16 Annunciation, undated
56 St Barbara, 1438
56 Portrait of a Man, c. 1435

CARPACCIO Vittore

c. 1455 (1465 ?) Venice (?) –
1526 Venice
Carpaccio was the principal pupil of Gentile Bellini. In his workshop he learned the precise observation of detail, the "staging" of multi-figured historical scenes and the composition of large-scale paintings. Artistically, however, teacher and pupil differed widely. While Bellini can be considered the "chronicler" of Venice in the late 15th century, Carpaccio was the born "novelist", intermingling freely what was actually before his eyes with his own inventions or with the material of legends. At a higher level he could be called the Benozzo Gozzoli of Venetian art. If Bellini's panels of the "Legend of the True Cross" can only be imagined in their large format, it is possible to see Carpaccio's efforts as book illustrations. This impression is reinforced by his choice of colours, sometimes bordering on pastel shades, as opposed to his teacher's adherence to those colours which are typically associated with the subject matter. Carpaccio created all his major works for Venice: one of the earliest consisted of nine large panels depicting scenes from the legend of St Ursula (ill. p. 52); from 1502 to 1507 followed the scenes from the Lives of Saints George and Jerome for the Scuola di San Giorgio degli Schiavoni. A great number of panel pictures, mostly of religious content, are to be found in collections all over Europe. His mode of telling a story still belongs to the Early Renaissance, but in his brilliant rendering of the light and atmosphere of landscape and interiors, as well as in his handling of perspective, Carpaccio is already abreast of the innovations of the late work of Giovanni Bellini.

Illustration:
52 Scenes from the Life of St Ursula, c. 1491

CASTAGNO Andrea del

c. 1421–1423 Castagno near Florence (?) – 1457 Florence
Castagno's work must be seen in close connection with the older painter Uccello. In their major work, both take as starting point Masaccio and the great sculptors of the Early Renaissance. If Uccello's greatest concern was the art of perspective, Castagno strove to make his figures appear solid and real, although, of course, these two aspects often overlap. We know nothing of Castagno's training. When painting the prophets in the vault the of Capella di San Tarasio on the Santa Zaccaria in Venice in 1442 – the first influx of the Florentine Renaissance into Venetian art – his style was already established. Castagno's art was closest to Donatello. It was probably between 1445 and 1450 that he received a commission for frescos from the monastery Santa Apollonia in Florence. His Last Supper in the refectory represents an important step towards Leonardo's work in Milan. The "naturalness" of the frescos is due to the virtuosity of construction in which perspectival elements and real space merge, giving the illusion of great depth, as well as the lively movement and gestures of the life-sized, ample figures. Probably shortly after 1450 he painted the "Uomini famosi" fresco series in the Villa Pandolfini at Legnaia near Florence (ill. p. 28) for which the sculptural style had been prescribed. Castagno's interest in sculpture and its effect on painting were central to his work.

Illustration:
28 Farinata degli Uberti. From the series "Uomini famosi", c. 1450

CHRISTUS Petrus

(also: Cristus)
between 1415 and 1420 Baerle (Brabant) – 1472 or 1473 Bruges
After a long period in oblivion, Christus is today regarded as Jan van Eyck's successor. He was probably van Eyck's pupil, and on his death took over the workshop and completed van Eyck's unfinished work. His significance today lies in his further development of the art of perspective. He was the first painter in the North who arrived empirically at the law of linear perspective and who applied it. His significant portraits are marked by their concentration on just a few characteris-

tic details. He was also the first Dutch master to place the sitter not before a neutral background but in front of a recognisable interior. After he was made master and burgher of Bruges in 1444, van Eyck's influence waned and was replaced by his interest in van der Weyden and Campin. His representation of background, often in the form of landscapes in a mood of quiet harmony, influenced later Netherlandish painters, in particular Bouts, Ouwater and Geertgen. There was no further development in his later work, of which only six signed and dated pictures survive.

Illustration:
64 Portrait of a Lady, c. 1470

CLOUET François

(also: François Janet)
c. 1505–1510 Tours (?) – 1572 Paris
Clouet was trained by his father Jean Clouet, but little is known of the life of either of them. François went to the French court at an early age, and on the death of his father about 1540 was granted a salary by Francis I.

His successor Henry II appointed Clouet *valet de chambre* and painter-in-ordinary. Contemporary documents give evidence of his high reputation. Only two pictures of importance remain: the "Portrait of Apothecary Pierre Quthe" (Paris, Louvre, 1562) and the "Lady in her Bath" (ill. p. 137). Both works prove Clouet's involvement with the Italian Renaissance, in particular with Leonardo's Lombardic successors. The painter may also have had contacts with the School of Fontainebleau.

Illustration:
137 Lady in her Bath (Diane de Poitiers ?), c. 1570

CLOUET Jean

(also: Jean Janet)
c. 1475 Brussels – c. 1540/41 Paris
The origins, training, life and work of the elder Clouet lie largely in the dark. He was probably born in Flanders and perhaps trained by Quentin Massy or one of his circle. On moving to France, he rose to become court painter to King Francis I. The works attributed to him show an undeniably Netherlandish influence, particularly in the rendering of detail. While not a single signed or reliably authenticated work exists, a great number of drawings survive – probably from the period 1515–1540 –

which give an insight into his artistic temperament and stylistic development. These drawings formed the basis of the attribution of paintings; no documentary records survive. It is a fact that Clouet was an accomplished, sought-after portraitist. His works appeal on account of their elegance and a quality of portrayal which is personal and yet presented with a cool detachment.

Illustration:
137 Portrait of Francis I, King of France, c. 1535

CORNEILLE DE LYON

(Corneille de La Haye)
c. 1500/10 The Hague – after 1574 Lyon (?)
The life and work of this master, who was not rediscovered until the end of the 19th century, even now remain obscure. A number of stylistically related, miniature-like portraits painted against a usually light, neutral background, are attributed to him. Corneille is first mentioned in 1534 in Lyon, where in 1541 he became painter to the dauphin, later King Henry II.

In a document dated 1547, The Hague is given as his birthplace. In 1564 Katharina de'Medici is said to have visited Lyon in order to see the painter and his work. The last record dated 30th March 1574 confirms his privileges as painter and *valet de chambre* to the King.

Illustration:
138 Portrait of Gabrielle de Rochechouart, c. 1574

CORREGGIO

(Antonio Allegri)
c. 1489 Correggio (near Modena) – 1534 Correggio
After his training, probably in Bologna and Ferrara, Correggio developed his own style based on Leonardo and 16th-century Venetian painting. His innovations were of the utmost importance to European art. He developed new ways of handling light and colour, creating the illusion of open walls and ceilings. Stimulated by the treatment of light by Mantegna (Camera degli Sposi in Mantua, Palazzo Ducale) and Leonardo (Sala delle Asse, Milan, Castello Sforcesco), Correggio opened up the refectory ceiling in the Convento di San Paolo

in Parma (1518/19) purely by using his new painterly devices. The cupola frescos in San Giovanni Evangelista (Christ ascending to heaven, 1521–1523) and in Parma Cathedral ("Ascension of Christ in Glory", 1526–1530), show that he did away completely with the upper margin so that his frescos cover the entire cupola.

In his altar pieces and mythological scenes Correggio increasingly abandoned outline, using colour and light to balance forms and in this way achieving an overwhelming radiance. The High Renaissance structure, whose principle was founded on the antithesis of statics and dynamics, was transformed by Correggio to asymmetry and movement, as shown by his foreshortened figures whose posture is often complicated.("Madonna and St Sebastian", Dresden, Gemäldegallerie, c. 1525; "Madonna and St Jerome", Parma, Galleria Nazionale, c. 1527). Correggio's treatment of light and shade ("The Nativity", Dresden, Gemäldegalerie, c. 1530; "Zeus and Io", ill. p. 105) was to point far into the future.

Illustrations:
104 Leda and the Swan, c. 1531/32
104 Zeus and Antiope, c. 1524/25
105 Zeus and Io, c. 1531/32
105 The Abduction of Ganymede, c. 1531/32

COSSA Francesco del

1436 Ferrara – 1477/78 Bologna
With Cosmè Tura and Ercole de' Roberti, Cossa was one of the great trio of the Ferrara school of painting. Although less fantastic in temperament than Tura, it is sometimes difficult to distinguish the one from the other. For example, the "Allegory of Autumn" has been variously ascribed to either, but the powerful, statuary representation, the purity of outline reminiscent of Piero della Francesca, the brilliance of colour and the abundance of light flooding the landscape – which can also be traced back to Piero – point to Cossa rather than Tura (Berlin, Gemäldegalerie). Very possibly Donatello's work in Padua also played an important role in formulating the young painter's style.

In his early work he endeavoured to create solid figures despite the dominance of dress, using the devices of perspective in his construction of space. In the 1460s he collaborated with Tura on the most important project of the Early Renaissance in Ferrara: the decoration of the Sala dei Mesi in the Palazzo Schifanoia. Although only fragments of it survive, Cossa's contribution depicting the months of March, April (ill. p.43) and May fortunately remain in good condition. It appears that Cossa, though a master of the fresco, received less recognition and financial reward than Tura. He moved to Bologna where he died in 1477/78.

Illustration:
43 Allegory of the Month of April, 1470

COUSIN Jean the Elder

c. 1490/1500 Soucy (near Sens) – c. 1560 Paris
Cousin achieved high recognition during his lifetime. Registered as master in his Paris guild in 1538, he received all kinds of commissions from representative bodies, including some for panel pictures, decorations for festivities, tapestry cartoons and clerical dress designs. There was no need for him to serve at the court and so he was able to live the independent life of a prosperous burgher. His book on perspective, *Livre de perspective*, was for a long time a kind of textbook used in French workshops. The extent of his œuvre is as yet unclear. His best-known panel painting, "Eva prima Pandora" (Paris, Louvre, c. 1550), encourages the assumption that he was connected with the School of Fontainebleau. In any case, the plastic rendering of figures as well as the coloured modulation of outline indicate his interest in the art of the Italian High Renaissance.

Illustration:
138 St Mammès and Duke Alexander, 1541

CRANACH Lucas the Elder

1472 Kronach – 1553 Weimar
Lucas Sunder or Müller, who named himself after his Upper Franconian home town Kronach, probably spent his first years of training in his father's workshop. Nothing is known about his further training and his years of travelling. There is evidence that he worked c.1500–1504 in Vienna, making drawings for woodcuts and also painting. He had evidently studied Dürer's graphic art intensively.

In his paintings, however, he showed at this time an imagination tending towards "romanticism", combined with an emotionalism heightened by colour – characteristics which formed the basis of his genius ("Crucifixion", Vienna, Kunsthistorisches Museum, c. 1500; "Crucifixion", Munich, Alte Pinakothek, 1503; "Resting on the Flight to Egypt", ill. p. 126). In the works of this period, today regarded as the "true" Cranach, landscape and theme are brought to an atmospheric unity which must have impressed the young Altdorfer deeply. Cranach can be regarded as one of the founders of the Danube school.

In 1504 he moved to Thuringia, following an invitation to become court painter to Frederick the Wise, and in 1505 settled permanently at Wittenberg. This concluded his first creative phase in which he produced his most important work belonging to the Dürer era. This gave place to a completely new style for which the courtly climate must at least in part have been responsible.

A visit to the Netherlands in 1508 brought him into contact with Dutch art and indirectly with the conventions of the Italian Renaissance. Cranach's love of fine detail increased at the same rate as his intellectual perception of construction ("Torgau Altar", Frankfurt am Main, Städelsches Kunstinstitut, 1509), proportionally losing the rapt spontaneity of his early work. There is a faint echo of it in some works, such as his picture of "Cardinal Albrecht of Brandenburg before the Crucified One" (ill. p.126). Cranach soon gained great esteem in Wittenberg. As a friend of Luther, he became the great portraitist during the Reformation without, however, committing himself to any particular confession. In the second quarter of the 16th century, while his workshop was flourishing, Cranach increasingly favoured a style tending towards the over-refined and Mannerist. This is especially noticeable in his depiction of the female nude, such as the panels of the Fall of Man and of Venus and Lucretia. This, too, may have been partly induced by courtly life with its predilection for erotic representation.

Illustrations:
126 Rest on the Flight to Egypt, 1504
126 Cardinal Albrecht of Brandenburg before the Crucified One, c. 1520–1530
127 Hercules and Omphale, 1537

CRANACH Lucas the Younger

1515 Wittenberg – 1586 Weimar
Cranach the Younger was a pupil of his father. In the mid-1530s he began to play an increasingly important role in his father's workshop, finally taking it over at his death. Although generally just as successful as his father, he never achieved his artistic greatness. Because he adopted his father's late style, there have been problems with attributing some of the works ("The Fountain of Youth", ill. p.127; "Portrait of Lucas Cranach the Elder, Florence, Uffizi, 1550). His work, however, lacked the breadth of emotion and imaginative spontaneity which mark his father's art. His best works include portraits and simple versions of allegorical and mythical scenes.

Illustration:
127 The Fountain of Youth, 1546

CRIVELLI Carlo

c. 1430–1435 Venice – before 5 August 1500 Ascoli Piceno (?)
Although an outstanding talent within Venetian art of the Early Renaissance, Crivelli never succeeded in achieving a synthesis of his artistic abilities. He received his decisive impressions by working within the circle surrounding the workshop of Francesco Squarciones at Padua and studying the early works of Mantegna. The school of Ferrara, in particular Cosmè Tura, also became important in his later work, not only in developing his "goldsmith's style", but also in his combined depiction of several unrelated scenes set in unreal spatial surroundings ("Madonna della Passione", Verona, Museo di Castelvecchio). He lived in Venice until 1457 and then went into exile after being threatened with imprisonment, working first at Zara (today Zadar, Dalmatia), then in the late 1460s at Ascoli Piceno where he painted his major works. The large polyptych in the cathedral of Ascoli Piceno (1473) is characteristic of his style: sharply-angled, modelled figures clad in stiff-textured garments, often as if made of metal, which in this way create a unity with the splendour of the painted jewels and carved frame.

Illustration:
42 Annunciation with St Emidius, 1486

DAVID Gerard

c. 1460 Oudewater (near Gouda) – 1523 Bruges
David is the only Dutch painter who, without direct knowledge of Italy, achieved an overall unity of structure comparable to that of the Italian High Renaissance. For his starting point he went back over two generations to the brothers van Eyck, combining their concept of reality with current ideas on the representation of space and figure in 15th-century Netherlandish painting. It is not known where David received instruction, but the influence of Rogier van

der Weyden and Hugo van der Goes in his early work is undeniable. In 1484 he was registered as a member of the Bruges guild. His commissioned work was predominantly for ecclesiastical clients and reached its highest perfection when the subject matter portrayed a certain fixed state (triptych "The Baptism of Christ", ill. p. 129).

Scenic elevation did not always suit his temperament ("The Wedding at Canaan", Paris, Louvre, c. 1503). David's great skill in unifying figure and landscape was of great importance for future development. Many followed his example in Bruges, particularly in book illumination.

Illustrations:

129 The Mystic Marriage of
 St Catherine, c. 1505–1510

129 The Baptism of Christ,
 c. 1505

DOMENICO VENEZIANO
(Domenico di Bartolomea da Venezia)
c. 1410 Venice or Florence –
1461 Florence

Although Domenico was a highly important painter, few of his works survive. He called himself a Venetian yet we do not know whether he was born in Venice or whether his father moved from Venice to Florence before his birth. But it is not unreasonable to assume that his background was such as to promote an artistic talent which made him a unique figure in the development of colour in early 15th-century Florentine painting. Little is known about his life. In the 1430s he worked in Perugia. In 1438 he wrote to Piero de'Medici, asking for help in obtaining commissions in Florence and expressing his intention of producing work comparable to that of the greatest living masters – Fra Angelico and Filippo Lippi. The choice of names was significant. Domenico was not primarily interested in problems of space and figure treatment, but in those of colour. His letter of application was evidently successful.

In about 1440 he painted the frescos in San Egidio (now Santa Maria Nuova) with the assistance of his greatest pupil, Piero della Francesca. Not a trace of them has survived. Its loss may have left what is possibly the greatest gap in our knowledge of the development of Florentine Early Renaissance painting. With his signed "Sacra Conversazione" (ill. p. 28) he proves himself as a painter of the highest order. Although he had studied Masaccio, Uccello and Castagno with regard to the representation of space and figure, his first concern was to find new ways of colour treatment. The intensity of colour can be increased by adding more oil as binder, and this technique was used in modern times to create "atmospheric" light effects.

Illustrations:

21 Portrait of a Young Woman,
 c. 1465

28 Madonna and Child with Saints
 (St Lucy Altarpiece),
 c. 1442–1448

DÜRER Albrecht
1471 Nuremberg – 1528 Nuremberg
Dürer's work is often, and quite rightly, regarded as the quintessence of the spirit of German art. A master of the graphic arts as well as painting, Dürer, through his extraordinarily dynamic development, laid the foundations of the German High Renaissance. He was the most important mediator between Italian and German art, and it could be said that there was an interactive effect. While Italian art opened up for him new vistas of artistic conception and painterly representation, Dürer's graphic art acted as a stimulus on Italian painting of the 16th century. In his late period he began to assess in his theoretical writings his new insights on realistic representation as well as the problems posed by it, a process whose intellectual penetration had already been set in motion in Italy three generations earlier.

As the son of a Hungarian goldsmith who settled in Germany, he may well have learned his father's craft before entering the workshop of Nuremberg's leading painter, Michael Wolgemut, in 1486. In 1490 he went on tour through the south-western parts of the country, also visiting Basle and Colmar where he discovered that Schongauer, whom he admired and who had given him direction in his early work, was no longer alive. In 1494 he went to Venice for the first time. A year later he opened his own workshop in Nuremberg and became acquainted with a circle of humanists, one of whom, Willibald Pirckheimer, was to become a life-long friend. Graphic works featured largely in his early period. The linear design of his fifteen woodcuts of the "Apocalypse" achieved a height of expression never reached before. This was followed by sets of woodcuts entitled "The Great Passion" (1498–1500) and the "Life of Mary" (1501–1511).

His second visit to Italy from 1505 to 1507, which again centred on Venice and where he studied in particular Giovanni Bellini, brought his development to maturity, making him one of the great European painters of the High Renaissance. His "Feast of the Rosary" (Prague, Národni Galeri), which he painted for the German merchant group in Venice, is the first proof of his new conception. Apart from a visit to the Netherlands (1520/21), Dürer remained in Nuremberg, highly es-

teemed and becoming a great supporter of the Reformation in the last decade of his life. There he produced his major works ("The Adoration of the Trinity", ill. p. 118; "Four Apostles", ill. p. 117), also painting many portraits, including "Hieronymus Holzschuher" (ill. p. 79). His famous, so-called master engravings date from the period 1513/14 ("The Knight, Death and the Devil", "Melancholia", "Jerome in his Cell"). Dürer's aquarelles depicting topographically accurate views represented a first step in the development of pure landscape painting. The extent of his surviving work is astounding: about 70 paintings, 350 woodcuts, 100 copper engravings, 900 drawings plus the watercolours. Dürer's influence on subsequent generations was immense. In the 19th century, when German "medieval" art was rediscovered, a veritable Dürer renaissance occured which often led to a falsified image of the artist.

Illustrations:

79 Portrait of Hieronymus Holz-
 schuher, 1526

116 Self-Portrait, 1498

117 Portrait of a Young Venetian
 Woman, 1505

117 Four Apostles (John, Peter, Paul
 and Mark), 1526

118 The Nativity (Paumgartner
 Altar), c. 1502–1504

118 The Adoration of the Trinity,
 1511

EYCK Jan van
c. 1390 Maaseyck (near Maastricht) –
1441 Bruges
Jan van Eyck can claim as much importance for northern painting as must be conceded to Masaccio in Italian art. His mastery in rendering the human figure, his modern understanding of portraiture, his minutely observed landscapes and brilliant perspectival construction of interiors combine to give a suggestion of reality which can only be called "Renaissance" to distinguish it from medieval art. In addition, van Eyck was the principal representative of a new epoch in colour technique. Though not the inventor of oil-painting, as Vasari assumed, van Eyck was the first master of this medium and developed a process, called glazing, in which successive transparent layers of paint are applied to the canvas, thus achieving a high colour depth. He used this method with very great suc-

cess, particularly in imparting an amazing degree of realism when painting jewels and richly adorned fabrics. He was highly respected and esteemed. Until 1422 he served at the court of Duke Johann of Bavaria in The Hague, painting and restoring pictures. He was also highly regarded at the court of Philip the Good of Burgundy who entrusted him with various diplomatic missions. From about 1430 he lived and worked in Bruges as painter to the court and city. His overall contribution to Flemish painting in the first half of the 15th century remains unclear as long as there is no authenticated work by his brother Hubert, with whom he collaborated on the famous altarpiece in the cathedral of Ghent (ill. p. 55) which was completed in 1432 and bears his brother's inscription. As Hubert died in 1426, Jan van Eyck continued to work alone on the altar for another six years on his own to complete it.

Illustrations:

17 Portrait of Cardinal Nicola
 Albergati, c. 1432

53 Giovanni Arnolfini and His Wife
 Giovanna Cenami (The Arnolfini
 Marriage), 1434

53 The Virgin of Chancellor Rolin,
 1434–1436

54 Madonna in a Church,
 c. 1437–1439

54 The Virgin and Child in a
 Church, 1437

55 Ghent Altar (central section),
 1432

FOUQUET Jean
c. 1415–1420 Tours (?) – c. 1480 Tours
Historical records give us almost no direct information about the life and work of the most famous French painter of his day. The only authenticated works are the miniatures in the "Antiquités judaïques" (Paris, Bibliothèque National). Documentary sources of the 15th and 16th centuries show that he was a painter of international repute, and these allow a reconstruction of his artistic development. Fouquet probably received instruction in the illumination of manuscripts under Flemish-Burgundian masters, possibly the brothers von Limburg. In any case, the decoration of precious manuscripts took a prominent place throughout his life. In the 1440s Fouquet went to Italy where he painted a portrait (now lost) of Pope Eugene IV,

who died in 1447, which provides a clue to when Fouquet must have stayed there. A commission from this high quarter allows us to assume that the painter must have been of an age to justify his reputation. Fouquet's contact with Italian art – in particular with Uccello's and Castagno's advanced treatment of figures – were decisive in developing his style further. As court painter to the French monarch from 1475, he succeeded in combining these diverse influences to achieve a courtly classicism, marked by a certain detachment and severe construction, which is unique in the art of the 15th century.

Illustrations:
70 Madonna and Child, c. 1450
70 Portrait of Guillaume Juvenal des Ursins, c. 1460

FROMENT Nicolas

c. 1430 Uzès (Gard) – c. 1485 Avignon
Together with the Master of the Annunciation of Aix and Enguerrand Quarton, Froment explored the artistic possibilities of 15th-century Provençal painting. Thanks to its geographical location, Provençe was open to the most diverse influences. As Froment painted the Lazarus triptych (Florence, Uffizi) for the Minorite monastery in Mugello near Florence in 1461, his first authenticated work, his date of birth may be assumed to have been around 1430 at the latest. Although this work must have been produced in Italy, it shows no Italian influence whatsoever, but rather points to his training in the Netherlands in the neighbourhood of Bouts. Records show Uzès as his place of birth. The possession of several houses in Uzès about 1470 indicates prosperity obtained through substantial commissions. Since 1475/76 he worked for King René, who commissioned the surviving major work, the Moses triptych in Aix-en-Provence (ill. p.71). He then decorated the King's palace in Avignon, and his name appears repeatedly in account books until 1479. Unfortunately none of these works, nor his designs for tapestries and festive decorations, have survived. Froment, whose work consists mainly of unauthorised attributions, remained all his life a follower of the Dutch school. However, his few authenticated works show a dynamic development towards a more liberal treatment of space and landscape and a more realistic approach to detail.

Illustration:
71 Moses and the Burning Bush, 1476

GEERTGEN TOT SINT JANS

(Gerrit van Haarlem)
c. 1460–1465 Leiden (?) – before 1495 Haarlem
Geertgen's great importance for late 15th-century Dutch painting is in inverse proportion to the small number of authenticated works. Probably born in Leyden, he may have been trained in the southern parts of the Netherlands, perhaps under Aelbert van Ou-

water. But more important to his art were van der Weyden and van der Goes. Geertgen's reputation rests equally on the expressive gravity of his figures and on his masterly skill in landscape painting. In his early works, such as the "Three Kings" triptych (Prague, Národni Galeri), Geertgen drew on van der Weyden, but interpreting his style to suit his generation's courtly, refined, more elaborate taste. The "Crucifixion" altar painted for Haarlem's St John's church, probably after 1484, of which only the right wing of the Lamentation survives (Vienna, Kunsthistorisches Museum), shows a freer arrangement and treatment of figures with regard to size as well as expression, and also his characteristic depiction of landscape which was to culminate in the small panel of "St John the Baptist" (ill. p.64). With these tendencies Geertgen seems to have represented an opposing current to that of contemporaries who, like him, worked for the order of the Knights of St John at Haarlem, and from which his name derived. His "Nativity" (London, National Gallery), with its amazing chiaroscuro, also shows how difficult it is to put Geertgen into a general category.

Illustration:
64 St John the Baptist in the Wilderness, c. 1485–1490

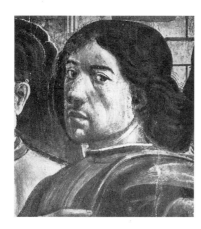

GHIRLANDAIO Domenico

(Domenico di Tommaso Bigordi)
1449 Florence – 1494 Florence
Ghirlandaio was the antithesis to Botticelli in Florentine painting of the second half of the 15th century. Botticelli's refined, courtly art stands in juxtaposition to Ghirlandaio's depiction of the prosperous middle class, where love of detail is dominated by brilliantly marshalled mass scenes. In his lavishly decorated "contemporary" architecture and distant landscapes, Ghirlandaio owed more to the traditions of the first half of the century. Above all, he is the one painter of his generation in Florence to have been destined for large-scale work, and therefore a born fresco painter. Already in 1481 he was one of the circle of selected artists to paint the lower half of the Sistine Chapel. His second major work was the decoration of the private chapel of the Sassetti family at Santa Trinità in Florence from 1483 to 1485. Scenes from the Life of St Francis were given the setting of

15th-century Florence, and even now some of his views of the city are of particular value as a historical source. Ghirlandaio told his stories in a lively manner, easily grasped by the imagination. Some details, such as figure arrangement, point to a Dutch influence, as demonstrated by his altar picture in the Sassetti chapel. The Last Supper fresco in the refectory of Ognissanti painted in 1480, a subject he used again in San Marco, was important in the way Ghirlandaio succeeded in bringing actual architecture into the scene. His creativity reached its culmination with his work in the main choir of Santa Maria Novella (1485–1490).

Illustrations:
38 Last Supper, 1480
38 Old Man and Young Boy, 1488

GIORGIONE

(Giorgio Barbarelli, Giorgio da Castelfranco)
c. 1477/78 Castelfranco Veneto –
1510 Venice
In the development of Venetian painting Giorgione's work provides the link between Giovanni Bellini and Titian. Giorgione was trained by Bellini, who also provided a decisive stimulus. Giorgione's "Madonna di Castelfranco" (ill. p.94) shows the influence of both Bellini and Antonello da Messina in its clarity of composition and richness of colour scale, while already revealing greater dynamism in the articulation of surface and less dependence on the drawing. In subsequent works, landscape gains in importance, by far exceeding Bellini's possibilities. The aim was not, however, to create "pure" landscape, as was the case north of the Alps with Dürer, Altdorfer and Wolf Huber. Giorgione's starting point was always the representation of the human being, whose moods and dreams are reflected in the landscape. But this was not the only way in which he achieved the fusion of figure and landscape; rather, it was done through acute sensitivity of colour aimed at producing the right atmospheric effect ("La Tempesta", ill. p.95; "Concert Champêtre", ill. p.94, perhaps completed by Titian; "Venus", Dresden, Gemäldegalerie, c. 1505–1510). Giorgione's works are often mysterious in subject matter. He certainly exercised a lasting influence on the younger Titian with his soft modelling of forms in which line is re-

placed by colour. Giorgio Vasari stated with great admiration that Giorgione would put brush straight to canvas without preliminary sketch.

Only a few of his paintings survive, although it is difficult to identify those works that can be attributed to him with certainty. The versatility of his talent can be assessed only from the remaining frescos for the facade of the Fondaco dei Tedeschi (Hall of the German Merchants in Venice, 1508). His most significant contribution was the representation of the figure in space, freely moving and from all sides visible, and this idea was further developed by the great Venetian painters of the 16th century.

Illustrations:
94 Virgin and Child with SS Francis and Liberalis (Madonna di Castelfranco), c. 1504/05
94 Concert Champêtre, c. 1510/11
95 La Tempesta, c. 1510

GOES Hugo van der

c. 1440–1445 Ghent –
1482 near Brussels
Van der Goes is, apart from the somewhat younger Bosch, the most important Dutch painter in the second half of the 15th century. Little is known about his life, and his artistic origins are also unclear. A certificate of 1480 confirms that his home town was Ghent, and as he was granted the master title in Ghent in 1467, he must have been born about 1440–1445. As early as 1477 he abandoned his workshop, entering the Red Monastery near Brussels where he died in 1482 after a severe mental illness. His masterpiece, known as the Portinari Altarpiece (ill. p.63) is the only surviving work that can be attributed to him with absolute certainty, although there are others that can be assigned to him with some safety (Monforte Altarpiece, ill. p.62; diptych depicting the "Fall of Adam, the Lamentation of Christ and St Genoveva", Vienna, Kunsthistorisches Museum, ill. p.62). Hugo van der Goes had at his disposal all the techniques of the earlier Dutch masters, in particular Rogier van der Weyden, as regards spatial disposition, the true-to-life construction of the human body and the representation of luxurious detail to look like the real thing. Yet he handled these devices in a completely different sense, putting to service the heightened expressiveness of gestures

and faces, and not excluding the "uncomely". With his Portinari Altarpiece he brought about a revolution in Florentine painting, as the works of Ghirlandaio and Filippino Lippi demonstrate, but which becomes most evident in Leonardo da Vinci's work.

Illustrations:
62 The Fall of Adam, before 1470
62 Adoration of the Magi (Monforte Altar), c. 1470
63 Adoration of the Shepherds (Portinari Altar), 1476–1478

GOSSAERT Jan
(called: Mabuse)
about 1478/88 Maubeuge (Hennegau) – about 1533–1536 Breda (?)

It is not known where Gossaert was trained, and the stylistic assessment has not yet offered many clues about this. From 1503 to 1507 he lived and worked in Antwerp. Decisive in his development was a visit to Rome in 1508/09 in company with Philip of Burgundy for whom he had to draw ancient architecture and sculpture. On his return he nevertheless adhered at first to the traditions of the Dutch masters, copying the works of Jan van Eyck, for example. However, after 1515 his Italian experience gradually took effect as can be seen particularly in his depiction of architecture as well as his interest in three-dimensional figure painting. His "Neptune and Amphitrite" (Berlin, Gemäldegalerie, 1516) reflects, in the Herculean representation of the nude figures, the impressions Gossaert had received from Michelangelo's ceiling in the Sistine Chapel. When called in 1515 by Philip of Burgundy to decorate the Soubourg palace near Middelburg, Gossaert was able to carry out court commissions without being bound by Guild regulations. He concentrated on mythological scenes and portraiture, favouring large-scale, "statuary" figures which, although modelled on the ideal body of Italian antiquity, nevertheless bear traces of ordinary characters of the day. Gossaert played an important role in introducing a northern Renaissance style with an Italian flavour.

Illustration:
131 Danaë, 1527

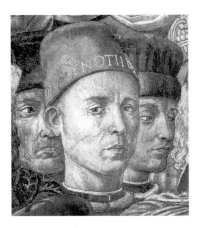

GOZZOLI Benozzo
(Benozzo di Lese di Sandro)
1420 Florence – 1497 Pistoia

Like many other painters of the early Renaissance, Gozzoli initially trained as a goldsmith, which enabled him to work in Ghiberti's workshop, 1444–1447, and assist him on the Paradise Gates. At the age of 27 he began to work with Fra Angelico in Orvieto and Rome. Both these masters were to influence his entire work. From Ghiberti he learned precision in depicting the finest detail and how to tell a story vividly, and Fra Angelico's legacy was his bright coloration, which Gozzoli succeeded in transmitting to the art of fresco painting. It is an astounding phenomenon that Gozzoli, the greatest "fanatic of detail" amongst all the Florentine masters of the early Renaissance, should have been primarily involved in the field of monumental painting. His first major independent commission was the fresco work in the choir of San Francesco in Montefalco with scenes from the Life of St Francis (1450–1452). This cycle could have helped him to secure another commission in 1458, the decoration of the chapel of the Medici Palace (ill. pp. 10, 32). Stimulated by the prestige attached to this commission and the abundance of materials at his disposal (including gold), Gozzoli created the most fascinating "story" of a 15th-century Florentine. His subsequent cycles were of an equally high standard. Sienese and Umbrian art of later generations derived a great stimulus from Gozzoli's work.

Illustrations:
10 Procession of the Magi (detail), 1459–1461
32 Procession of the Magi (detail), 1459–1461

GRECO El
(Domenikos Theotokópoulos, called: "El Greco", The Greek)
c. 1541 Phodele (Crete) – 1614 Toledo

As a most unusual phenomenon in 16th-century European painting, El Greco combined the strict Byzantine style of his homeland with influences received during his studies in Venice and the medieval tradition of his country of adoption, Spain. El Greco obtained his training as icon-maker in a monastery. He then went to Venice where Titian became his greatest mentor. In Titian's workshop he developed the brilliance of colour which became a lasting element in his entire work. But he was also moulded by Tintoretto's

Mannerist style, as is shown in his delight in bold perspectival foreshortening, the complicated movements of figures and groups of figures, the elongation of proportions and his strong chiaroscuro.

In 1570 El Greco went by way of Parma to Rome, where he met Michelangelo. He criticised his "Last Judgement" severely, offering to produce a better composition. This attitude is a particularly telling example of historical irony. The only painter of the very highest order to come from the land where the art of classical antiquity was born, failed to understand the High Renaissance ideal of bodily beauty. El Greco's acquaintance with Spanish humanists in Rome and the expectation of commissions in connection with the rebuilding of the monastery of El Escorial might have been what led him to migrate to Spain in 1577. At first he was in the service of Philip II ("Dream of Philip II", El Escorial, 1580), then settled in Toledo in 1580 where he received a great number of church commissions and also became a popular portraitist. Historical records tell us of many disputes with commissioners about inappropriate interpretation of religious themes, unusual coloration, elongation of figures, but also old-fashioned representation.

In the course of his development El Greco became gradually detached from the reality of representation. He distorted the human figure, abandoned logical space construction and also used colour no longer objectively. It is possible that his Byzantine legacy may have been responsible for his growing asceticism. For a long time almost forgotten, interest in him revived in the early 20th century on account of his tendency towards the abstract and his depiction of dream-like scenes. He is now considered as one of the most important representatives of European Mannerism.

Illustrations:
140 The Despoiling of Christ (El Espolio), c. 1590–1600
140 The Agony in the Garden, c. 1595
141 The Burial of Count Orgaz, c. 1586
142 The Holy Family with St Anne and the young St John Baptist, c. 1594–1604
142 View of Toledo, c. 1604–1614

GRÜNEWALD Matthias
(Mathis Gothart Nithart)
c. 1470–1480 Würzburg (?) – 1528 Halle

Joachim von Sandrart entered this painter's name erroneously as Grünewald in his *Teutsche Akademie* (1675). His real name was Mathis Neithart or Nithart, and he later called himself Gothart. Grünewald is, beside Dürer, the most important representative of Northern painting at the turn of the 15th to the 16th century, and he is also Dürer's complete opposite. As Dürer's foremost artistic device was the line, so was Grünewald's colour, which

he used to achieve new heights of expressiveness. And while Dürer turned to the new discoveries of the Renaissance in the course of his development, Grünewald generally continued to adhere to the Middle Ages. Tradition and "progress" cross each other in unexpected ways in the works of these two masters. And yet Grünewald was a man of the Renaissance in the way he lived and applied his many talents. In 1509 he became court painter to archbishop Uriel von Gemmingen at Aschaffenburg, and in this capacity he had to supervise the rebuilding of the palace there. In 1516 he started on a fixed income at the court of the elector Albrecht von Brandenburg where he worked as a painter and architect and also as a designer of fountains. He had to leave this post in 1520 because of his Lutheran convictions.

His major works include the "Isenheim Altar" (ill. p. 120), "The Mocking of Christ" (ill. p. 120) and the "Erasmus-Mauritius" panel (ill. p. 121); two pictures of the Crucifixion (Basle, Kunstmuseum, 1505; Washington, National Gallery, c. 1520); four figures of saints in grisaille for the wings of Dürer's Heller Altar (Donaueschingen, Fürstliche Gemäldegalerie, and Frankfurt am Main, Städelsches Kunstinstitut, 1501–1512); the "Stuppach Madonna" (Stuppach, Pfarrkirche) which formed part of the Maria-Schnee-Altar in Aschaffenburg (1517–1519), as did the "Founding of Santa Maria Maggiore" (Freiburg, Augustinermuseum); and the "Crucifixion" and "Christ Carrying the Cross" of the Tauberbischofsheim Altar (Karlsruhe, Kunsthalle, c. 1525).

Illustrations:
120 The Mocking of Christ, c. 1503
120 Crucifixion (Isenheim Altar), 1512–1516
121 The Meeting of St Erasmus and St Maurice, c. 1520–1524

HEEMSKERCK Maerten van
1498 Heemskerk (near Haarlem) – 1574 Haarlem

Heemskerck is one of the main representatives of the so-called Netherlandish Romanists. After training in Haarlem and Delft he entered the workshop of Jan van Scorel, only by a few years his senior, in 1527, probably working as his assistant rather than pupil. He visited Rome in 1532 and remained there probably until 1537. The exact

archaeological precision of his drawings of ancient structures makes them highly valuable source documents on Roman monuments at the time. He was certainly back in Haarlem in 1538 as he received a commission for a winged altar with scenes of the Passion of Christ and the Legend of St Lawrence in that year. He soon acquired a high reputation as a painter of altarpieces and portraits. His contact with Haarlem humanist circles was reflected in his allegorically encoded representations. In 1540 he was appointed deacon of the Lukas Guild in Haarlem and was granted tax exemption in 1572 on account of his artistic achievements. After his period in Rome, Michelangelo's influence made itself felt in Heemskerck's three-dimensional modelling of figures. His coloration was often cool and his painting technique smooth, to suit the wooden panel rather than the canvas.
Illustration:
133 Family Portrait, c. 1530

HOLBEIN Hans the Younger
c. 1497/98 Augsburg – 1543 London
Amongst the great German masters of the 16th century Holbein may be singled out without reservation as the only Renaissance artist. Unlike any other he was, both in education and career, a cosmopolitan. At the early age of sixteen, after instruction by his father, he went off as a journeyman with his brother Ambrosius. He is first mentioned in 1515 in Basle, where he entered the workshop of Hans Herbster. His first public commissions were carried out in Lucerne in 1517. From there he probably visited Lombardy and Emilia in northern Italy. This is not supported by documentary evi-

dence, but it is reflected in his work of the early 1520s. In 1519 Holbein became a member of the painters' guild in Basle, and in 1524 he stayed in France. The watershed of his career was his journey to England in 1526, where he went by way of the Netherlands, equipped with a letter of recommendation from Erasmus of Rotterdam. There he lived from 1532, despite tempting offers from the city of Basle. Between 1515 and 1528 he carried out a number of outstanding religious commissions ("Madonna of Solothurn", Solothurn, Städtisches Museum, 1522; "The Dead Christ in the Tomb", Basle, Kunstmuseum, 1521). In the Basle painting one can see in his powerfully expressive depiction of Christ a parallel to Grünewald, which Holbein succeeded in combining with razor-sharp observation, which showed his genius for portraiture.

From 1528 he indeed concentrated solely on portrait painting. In London he executed portraits of the German merchants of the Steelyard, then soon came to the notice of Henry VIII and members of his court. His observation of detail, psychological penetration of his sitters and superb handling of colour made him the greatest portrait painter of German art. He also produced excellent graphic work (e.g. the series of woodcuts "Dance of Death", completed about 1526; 91 woodcut designs on the *Old Testament*, completed 1538).
Illustrations:
124 The Ambassadors (Jean de Dinteville and Georges de Selve), 1533
125 Madonna of Mercy and the Family of Jakob Meyer zum Hansen (Darmstadt Madonna), c. 1528/29
125 Portrait of the Merchant Georg Gisze, 1532

HUGUET Jaume
(Jaime)
before 1414 Valls (near Tarragona) – 1492 Barcelona
Huguet is the principal representative of 15th-century Catalan art, which remained almost untouched by the innovations of the early Renaissance and so continued in the medieval tradition. There are no records documenting his work before the year 1448, when he received a commission for the James altar at Arbeca. Until 1486 he produced a great number of multi-sectioned altar retables, including those of St Abdon and Sennen (today in Santa María at Tarasa, 1458–1460) the the Three Kings altar (Barcelona, Museo de Historia de la Ciudad, 1464). Huguet's style was not remarkable; he kept to a background of gold, with a minimum of spatial features and little indication of depth. The growing abundance of commissions led over time to an ever-increasing share of work being done by assistants in his workshop. This in turn led to the use of stereotyped characters and a loss of painterly quality.
Illustration:
68 Last Supper, after 1450

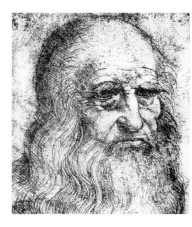

LEONARDO DA VINCI
1452 Vinci (near Empoli, Tuscany) – 1519 Cloux (near Amboise, Loire)
Leonardo was the embodiment of the Renaissance ideal of the universal man, the first artist to attain complete mastery of all branches of art. He was a painter, sculptor, architect and engineer besides being a scholar in the natural sciences, medicine and philosophy. He received his artistic training under Verocchio in Florence, with whose workshop he retained contacts even after having become an independent master. He left Florence for Milan in 1482, working at the court of Duke Lodovico Sforza in the capacities of painter, sculptor and engineer until 1499. When the French invasion of the city caused the Duke to leave, Leonardo returned to his home ground, but worked again in Milan from 1506 to 1513. In 1513 he went to Rome, and in 1516, at the invitation of King Francis I, to France as court painter.

With his "Last Supper" in Milan (ill. p.91) Leonardo created the first work of the High Renaissance. His representation of the theme has become the epitome of all Last Supper compositions. Even Rembrandt, generally standing aloof from Italian art, was unable to resist its impact. Leonardo's work revolutionised both pictorial and painterly possibilities. While drawing had dominated over colour in the Early Renaissance, with Leonardo the outline was increasingly replaced by the use of mellowed colours which allowed one form to merge with another.

Leonardo was never quite understood in Florence, but this was more than made up for by his influence on 16th-century Venetian art. His theories on art too were influential. He also supported his new ideas about painting with a sound theoretical basis. A number of projects remained uncompleted, such as the wall painting of the Battle of Anghiari in the Palazzo Vecchio in Florence, the numerous designs for the two equestrian monuments of Lodovico Sforza and Marshal Trivulzio in Milan, and also some architectural designs (Pavia cathedral).
Illustrations:
76 Virgin and Child with St Anne and St John the Baptist, c. 1495
78 Mona Lisa, c. 1503–1505
91 Last Supper, 1495–1498
91 Adoration of the Magi, c. 1481
92 Virgin of the Rocks, c. 1483

92 Virgin of the Rocks, completed c. 1506
93 The Virgin and St Anne, c. 1508

LEYDEN Lucas van
1494 Leiden – 1533 Leiden
Besides being taught painting in his father's workshop, the young Lucas also learned the goldsmith's and armourer's craft which must have brought his outstanding talent in the art of engraving to its full development. He certainly was exceedingly precocious in that art, as Carel van Mander confirmed. After 1508 Lucas worked in the workshop of Cornelis Engelbrechtsz. His passion for the realistic depiction of figure, landscape and architecture became merged with the coloration and characteristic outline of Italian Mannerism after his meeting with Gossaert around 1527.

Problems still exist with the attribution of his painted works and their stylistic development. But he left a great number of engravings which were greatly influenced by Dürer, whom he had met on his visit to Antwerp in 1521.
Illustration:
132 Lot and his Daughters, c. 1520

LIPPI Filippino
c. 1457 Prato – 1504 Florence
The son of Fra Filippo Lippi studied under his father, assisting on his last work, the apse decoration in Spoleto cathedral. In 1472 he is mentioned in connection with Botticelli, who influenced him greatly. His earliest panels are hardly distinguishable from those of his great master. Around 1481 Filippino must already have had

a reputation in Florence as he was commissioned to complete the fresco cycle in Brancacci chapel which Masaccio and Masolino had left unfinished. By incorporating Flemish elements which determined the brilliance of his colours, the young painter reached the pinnacle of his career over the next few years ("The Vision of St Bernard", ill. p. 39).

In the 1490s Filippino intensified Botticelli's melodious lines to convey a feverish unrest ("Adoration of the Magi", 1496). While in Rome, where he studied ancient monuments with great passion, he painted the frescos in the Caraffa Chapel of Santa Maria sopra Minerva. In these, he explored antiquity, but appointed it a place restricted to detail, and in the overall conception and exuberant ornamentation brother all principles of this era's art. He again adopted this manner in the Strozzi Chapel of Santa Maria Novella in Florence, completed in 1502. In these works the vitality of the figures, the freedom of line and the complexity of architecture often seem to approach a complete lack of restraint. Here, the gates were thrown open for the "anti-classical" stance of 16th-century art, where Mannerism would find its stimulus; even Michelangelo must have acquainted himself with Filippino's repertoire of figures before embarking on the Sistine Chapel in 1506.
Illustration:
39 The Vision of St Bernard,
 c. 1486

LIPPI Fra Filippo
c. 1406 Florence – 1469 Spoleto
Lippi is one of the most important successors to Masaccio. In 1421 he entered the monastery of Santa Maria del Carmine in Florence and was able to observe the decorative work in progress in the Brancacci Chapel. He used this experience in his first work, the frescos in the cloisters of the monastery (1432), now only surviving in fragments, with their plastic figures and individual facial expressions. His Madonna of Tarquinia, 1437 (Rome, Galleria Nazionale), is in her clear articulation reminiscent of Masaccio's altarpiece in Pisa. In the 1440s, complex movements and a restless treatment of drapery are discernible ("Annunciation", Florence, San Lorenzo). These were the elements on which his great pupil Botticelli in-

formed himself. With the decoration of the cathedral choir in Prato between 1452 and 1465, his artistic development reached its culmination, ranking him with Fra Angelico among the most outstanding fresco painters of his time.

Lippi was chaplain to Santa Margherita in Prato from 1456, but he had to leave the order as he had formed a relationship with the nun Lucretia Buti, who bore him a son, Filippino (born about 1457), who as a pupil and assistant of Botticelli was to give the latter's late style certain Mannerist features. In his own late period Lippi painted various versions of the "Adoration of the Child", the most famous being the one produced for the house chapel of the Palazzo Medici (now in Berlin, Gemäldegalerie). With its fairytale atmosphere created by light and shade, the rich use of gold and the magnificent flower carpet, this panel represents one of the finest achievements of the period.
Illustration:
32 The Feast of Herod. Salome's
 Dance, c. 1460–1464

LOTTO Lorenzo
c. 1480 Venice – 1556 Loreto (Marches)
Lotto, one of the most important 16th-century Venetian painters, lived an unsettled life far away from his home town. He grew up in Venice under the influence of Giovanni Bellini and the works of Antonello da Messina before travelling in the Marches and being introduced to the works of Melozzo da Forlì and Signorelli. These sharpened his understanding of perspectival construction and precise presentation of human movement.

His work in the Vatican (1509–1511), of which no traces remain, indicates early success which, however, did not endure. Although recognised while working in Bergamo from 1513 to 1525, his lack of success in Venice caused him to retire to the Marches in 1549. In his religious works Lotto abandoned traditional patterns of composition. He was also an outstanding portraitist.
Illustrations:
88 Portrait of a Young Man,
 c. 1506–1508
109 Portrait of a Lady as Lucretia,
 c. 1530

MANTEGNA Andrea
1431 Isola di Carturo (near Padua) – 1506 Mantua
Together with Giovanni Bellini, albeit with different artistic aims, Mantegna was largely responsible for spreading the ideas of Early Renaissance painting in northern Italy. He studied in Padua under Francesco Squarcione, who also collected and sold antiquities and coins, thus introducing his pupil to this field. But most important for Mantegna's artistic development was the sculptor Donatello, who from 1443 created the high altar for San Antonio in Padua. From him he learned how to paint anatomically cor-

rect figures, how to achieve precision when tracing details, and not least how to compose a picture with accurate perspective. By 1448 the young painter showed himself almost independent in style when decorating the Ovetary Chapel of the Eremitani Church in Padua (most of it destroyed in World War II). In 1460 Mantegna became court painter to the Gonzaga family in Mantua. There he painted the frescos of the Camera degli Sposi in the Castello, whose illusionistic ceiling painting and other elements point forward to the structural problems of Mannerism and the Baroque (ill. p. 45).

In about 1490 Mantegna began to produce engravings of great artistic and technical perfection which contributed greatly to the dissemination of Early Renaissance innovations north of the Alps.
Illustrations:
15 Portrait of Cardinal Ludovico
 Trevisano, c. 1459/60
44 Agony in the Garden, c. 1460
44 Dead Christ, c. 1480
45 The Gonzaga Family and Retinue,
 finished 1474

MANUEL Niklaus
(called: Deutsch)
c. 1484 Berne – 1530 Berne
Equally talented as painter, draughtsman and woodcarver, Manuel was also a statesman, reformer and poet. He was probably trained as a glass painter. His early works, documented from about 1515, point to the tradition of late Gothic, Swiss painting. Manuel later developed in the direction of the Danube School, with strong, atmospheric emphasis on landscape and lively movement of figures ("Death as Mercenary Soldier Embracing a Girl", "Bathsheba in the Bath", Berne, Kunstmuseum, both 1517). Sudden foreshortenings also show the Mannerist influence. His later works deal mainly with secular subjects. Like all artists of his generation, Manuel was deeply interested in political and religious affairs of the day. In 1516 he joined the French army during the Lombardic war. From 1518 he travelled on political missions and became one of the principal representatives of the Swiss Reformation.
Illustration:
128 The Judgment of Paris,
 c. 1517/18

MASACCIO
(Tommaso di Ser Giovanni di Simone Guidi
Cassai)
1401 San Giovanni Valdarno (Arezzo) – 1428 Rome
Masaccio is considered the greatest master of Italian Early Renaissance painting. Within a time span of about five years he practically formulated the programme for future generations. Little is known about his training. Decisive for his development were the great Florentine sculptors Donatello and Nanni di Banco, and he also explored the early works of Brunelleschi. In the field of painting the only adequate comparison possible is with Giotto: over a period of about a century, Masaccio was the only painter whose work ranked with that of Giotto, in that Masaccio used all painterly devices at his disposal to convey genuine human feeling. In 1422 he was appointed master of the Florentine guild. From 1424 he worked with Masolino on the decoration of the Brancacci Chapel in the Carmine in Florence (ill. p. 23 ff.), creating a little later the great fresco of the Holy Trinity in Santa Maria Novella. With these works he achieved the high point of his artistic creativity, showing absolute assurance in the use of the perspective system together with the ability to suggest the mass and volume of objects in the round. Architecture and landscape appear natural but do not serve as ends in themselves. As in the works of Giotto, they are used to heighten the central scene, further emphasised by a completely novel handling of light and shade.
Illustrations:
12 Adoration of the Magi, 1426
23 The Trinity, 1425/26
23 St Peter Distributes the Goods of
 the Community and The Death of
 Ananias, c. 1426/27
24 The Tribute-Money, 1426/27

MASSYS Quentin
(also: Matsys, Metsys)
c. 1465/66 Leuven – 1530 Antwerp
Massys probably received his training in Leuven under the influence of Bouts. His work remained rooted in Netherlandish art, but he adopted elements of the Italian Renaissance to which he must have been introduced indirectly. Little is know about his early work. His "Anna Altar" (Brussels, Musées Royaux, 1507–1509) shows his fully

developed style. Elements of van der Weyden and the use of new insights into figure and space representation are combined in his "St John Altar" (Antwerp, Koninklijk Museum voor Schone Kunsten, 1508–1511). For Massys, the figure, often monumentalised, formed the central point of his work. Hence his talent for portraiture, which he sometimes used as the starting point in his genre paintings.
Illustrations:
130 The Money-Changer and his Wife, 1514
130 Portrait of a Canon, c. 1510–1520 (?)

MASTER OF MOULINS
(Jean Hay or Hey)
active c. 1480– after 1504
A French painter and miniaturist of Dutch origin, he was named after a triptych in the cathedral of Moulins. The portraits on the altarpiece of the patrons Duke Peter II of Bourbon and his wife Anna would indicate that the painter worked in court circles, and from about 1483 in the province of Bourbonnais. In contrast to the somewhat older Fouquet, the Master of Moulins rejected a worldly approach. To the number of late 15th-century panel paintings grouped around the triptych also belong, amongst others, "Charles II of Bourbon, Cardinal Archbishop of Lyon" (Munich, Alte Pinakothek), "Joachim and Anna Meeting at the Golden Gate" (London, National Gallery, 1500) and "St Mauritius with Patron" (Glasgow, Art Gallery and Museum, c. 1500). It cannot be accepted that the Master of Moulins was identical with Jean Perréal, who worked for the Bourbons about 1500 and subsequently for the French royal court until his death in 1529. Instead, it now seems certain that he was the Dutch painter Jean Hay (or Hey). His oil tempera technique shows Dutch influences, as does his emphasis on sumptuous detail, while the clarity of composition indicates a knowledge of Italian art. The reticence of expression and discipline of construction anticipate "classicist" tendencies, which were to determine French painting in the 16th and particularly the 17th centuries.
Illustrations:
19 The Virgin in Glory, surrounded by Angels, c. 1489–1499
71 The Nativity of Cardinal Jean Rolin, c. 1480

MELOZZO DA FORLÌ
1438 Forlì – 1494 Forlì
Melozzo came from an artistic family: his uncle was an architect, his brother a goldsmith and his brother-in-law a painter. He was trained in his home town by the painter Ansuino da Forlì, who introduced him to perspectival principles as developed by Mantegna and Piero della Francesca. He first worked in Forlì, then in the 1470s and early 1480s mostly in Rome, where he painted several frescos of which only fragments survive.

Around 1475 and then again after 1480 he collaborated with Justus van Gent on the portraits of scholars and allegories of the "Liberal Arts" for the Palazzo Ducale in Urbino. In 1484 Melozzo returned to Forlì where he worked on frescos in the churches of Loreto and Forlì. His work is noted for its precise representation of character and mastery of perspective laws, which make him the precursor of illusionistic ceiling painting.
Illustration:
33 Sixtus IV; his Nephews, and his Librarian Platina, c. 1480

MEMLING Hans
(also: Memlinc or Hemling)
c. 1430–1440 Seligenstadt (Main) – 1494 Bruges
After having long been regarded as the greatest Dutch painter of the late 15th century, Memling is now less admired. Little is known about his training and early work. Perhaps he was trained in Cologne or one of the workshops in the Rhine region, before moving to the Netherlands. In 1465 he is mentioned in Brussels; from 1466 he worked in Bruges. He was possibly a pupil of Rogier van der Weyden; in any case, Memling's earliest authenticated works were greatly influenced by him. He also drew on Bouts, as shown in his altarpiece of the Life of Mary, 1468 (London, National Gallery). However, he soon developed his own style which is characterised by the great charm of the figures in movement and expression, beautiful colours and narrative richness.

Memling could be called the Dutch Gozzoli except that he did not achieve the latter's depth of expression and great skill in figure arrangement. His paintings form the sum of accurately observed and life-like details ("Scenes from the Life of Mary", Munich, Alte

Pinakothek, 1480), but there is generally little personal development. His late work shows elements of the Early Italian Renaissance ("Madonna and Child", Florence, Uffizi).
Illustrations:
61 The Martyrdom of St Ursula's Companions and The Martyrdom of St Ursula, consecrated 1489
61 Portrait of a Praying Man, c. 1480–1485

MICHELANGELO BUONARROTI
(Michelagniolo di Ludovico di Lionardo di Buonarroti Simoni)
1475 Caprese (Tuscany) – 1564 Rome
As western art's giant of sculpture, no equal can be found for Michelangelo except in classical art. His painting as well as his architectural design was always based on plastic concepts.

Though intended by his father to be a scientist, the boy's passionately felt vocation for art soon put an end to any such plans. When aged thirteen, he was allowed to become an apprentice in the workshop of the painter Ghirlandaio, where he probably only learned basic skills.

Michelangelo greatly admired Giotto and Masaccio, as his early drawings after their works testify. He might also have known the famous goldsmith and bronze caster Bertoldo di Giovanni. His first works, the bas-relief "Battle of Centaurs and Lapiths" and the "Madonna on the Staircase" (Florence, Casa Buonarroti) reveal the true sources of his plastic art: on the one hand antiquity, and on the other the highly expressive works of Donatello. Lorenzo de' Medici, showing uncanny intuition for spotting artistic talent, accepted the promising youth to work in the school in the Medici garden which contained a collection of classical sculptures.

Michelangelo reinforced these early impressions while in Rome from 1496 to 1501. Here he created the "Pietà" for St Peter's, his only signed work. Returning to Florence, aged 25, he was next engaged on the colossal "David". In this work he fully realised his perception of the human figure born in the spirit of antiquity, which filled his contemporaries with an uneasy reverence. Between 1501 and 1505 he also received his first painting commissions, including the only authenticated panel of the "Holy Family" (so-called "Doni-Tondo", ill. p.97). The fresco "Battle of

Cascina", of which detail drawings for the cartoon survive, was never executed. In 1505 Michelangelo was summoned to Rome by Pope Julius II to design his sepulchral monument – a gigantic venture which was thwarted by lack of finance and eventually by the Pope's death. Meanwhile the Pope had a new project in mind. In 1508 Julius asked Michelangelo to paint the ceiling of the Sistine Chapel (ill. p.97 ff).

Michelangelo had completed this monumental task by 1512, after having done the work in two stages and under great pressure. As a painter he had produced his masterpiece with its great interpretation of Genesis, the whole concept being conveyed by the human figure and gesture alone.

Michelangelo's subsequent works were also dominated by the human figure. In 1534 he finally settled in Rome. Required to paint the altar wall of the Sistine Chapel, he produced a second masterpiece, the "Last Judgement" (ill. p.83), 1536–1541. He also painted the frescos for the Vatican's Capella Paolina of the "Martyrdom of St Peter" and the "Conversion of St Paul" (1542–1550). As distinct from all Last Judgement representations that had gone before, Michelangelo's rendering of the subject, which covers the entire altar wall (14.83 x 13.30), is a vision of the end of the human race in which the light of redemption cannot overcome the powers of darkness. With this work he overstepped the limits of contemporary religious understanding; his naked figures in particular were thought offensive. In 1559 the first alterations were made to it by Daniele da Volterra at the behest of Pope Paul IV; after that, the work was four more times overpainted. It remains in this state to this day.

In his later life Michelangelo devoted himself increasingly to architectural projects. In 1546 he directed the building of the Palazzo Farnese and began the new design of Capitol Square. A year later he was made chief architect of St Peter's. With his design for the dome he gave the Eternal City its distinctive landmark. But just as the painter in Michelangelo could never forget the born sculptor, neither could the architect: he did not create "rooms" in the ordinary sense, but "modelled" walls and surfaces.

As no artist before him, Michelangelo threw off the shackles of tradition, opening up entirely new worlds of artistic expressiveness. His work bears witness to his own lived-through experiences and sufferings, and no-one knew better from bitter experience what abandoning the rules meant. There were immense dangers in shaking off restrictions in order to broaden the scale of expression, even when upholding artistic tradition at the same time. With Michelangelo a new kind of artist was born, and he has had an enormous influence on artists ever since. Rubens, who during his 8 years in Italy studied Michelangelo with an intensity and devotion as no other, carried over many of his innovations into the Baroque.

MULTSCHER Hans

c. 1390 Reichenhofen – c. 1467 Ulm
Together with Witz, Multscher is regarded as the most important German painter and sculptor of the first half of the 15th century. During the iconoclastic disruptions his first signed work, the sculpted Karg altarpiece in Ulm Cathedral, was badly damaged in 1531. All that remains is the spatial structure divided into several levels, with the window opening backwards, and some figures of angels. The Man of Sorrows on the central pillar of the Western portal of the Cathedral probably dates from the same period. The sandstone model for the sepulchral monument of Duke Ludwig the Bearded (Munich, Bayerisches Nationalmuseum) can be dated around 1434.

While the master endowed this work with painterly qualities which hint at his sculptural interests, his painted panels of 1447 of the Wurzach altarpiece are full of sculptural vitality. (It is presumed that this altarpiece came from the parish church in Landsberg on the Lech, ill. p. 73). In the 1450s Multscher added woodcarving to his repertoire. The figures of St Barbara and St Magdalen (Rottweil, Lorenzkapelle) let the structure of the body show under the folds of the drapery, the latter being no longer just purely ornamental. Multscher's finest work was the main altar for the Frauenkirche in Sterzing, 1456–1459. Unfortunately this work, too, has been tampered with. The shrine figures, however, are still in place. They differ from the Rottweil figures in that they look immensely lively, almost passionate, in movement and rendering of drapery, reaching almost a Baroque richness. The panels are closely related to those at Wurzach in terms of motif, but suggest the han of a younger master.
Illustration:
73 Resurrection, 1437

ORLEY Bernaert van

c. 1488 Brussels – 1542 Brussels
Orley holds an important position in Flemish painting at the transition from Early to High Renaissance. Trained to follow the example of the great "old" Flemish masters, as his early works demonstrate ("Lamentation of Christ" from the triptych of Philippe de Hanetou, Brussels, Musées Royaux, c. 1515), he increasingly adopted the classical form language of the Italians ("Last Judgement Altar", Antwerp, Koninklijk Museum voor Schone Kunsten, 1525). It is not known whether he had ever been to Italy, but he met Dürer on his visit to Holland in 1521, and this could have had a mediating influence. Noted both for his great altarpieces and fine portraits, Orley enjoyed early high esteem in his native town and was appointed painter to Margaret of Austria, the governess of the Netherlands.
Illustration:
132 Holy Family, 1522

PACHER Michael

c. 1435 Bruneck (Tyrol) –
1498 Salzburg
Pacher was one of the few 15th-century artists equally gifted in painting and wood sculpture. His training and early work are still a matter of conjecture. His altarpiece in the Liebfrauenkirche of Sterzing, completed in 1457/58, may have been inspired by Multscher. Records show that Pacher was active in Bruneck in 1467, where he ran a large workshop. His altarpiece depicting the crowning of Mary in the shrine of the parish church in Gries near Bozen, begun in 1471, was a preliminary step to his masterpiece in St Wolfgang in the Salzkammergut (ill. p. 74), a winged altar combining reliefs, statues and panel paintings. For this, the contract was signed in 1471, and Pacher himself had to deliver the work, signed 1481, to St Wolfgang and to install it.

In this work, the crowning of Mary interweaves with the rich forms of the tracery into a unified pattern of lines, and light and shade create the suggestion of unlimited depth. The life-size figures, in particular those of St Wolfgang and St George beside the closed shrine, reveal Pacher as a contemporary of Verrocchio and Pollaiuolo: both north and south of the Alps, efforts were being made to depict the human figure moving in space and seen from different angles. The paintings of the altar wings are reminiscent of the works of Mantegna in their bold treatment of perspective, which Pacher could possibly have studied in Verona, Mantua and Padua. And while Pacher in his capacity of carver introduces elements of this art into painting, the painter in Pacher uses his insight into carving to deal with surface. With the "Church Fathers Altar" (ill. p. 74) created in 1483 for the Neustift monastery near Brixen, Pacher reached a point at which the borders between painting and sculpture in the north were no longer clearly distinct.
Illustrations:
74 The Resurrection of Lazarus (St
 Wolfgang Altar), 1471–1481
74 St Augustine and St Gregory
 (Church Fathers' Altar), c. 1480

PALMA (IL) VECCHIO

(Jacopo Negretti)
1480 Serina near Bergamo –
1528 Venice
Probably in the 1490s Jacopo was already apprenticed to Francesco di Simone da Santacroce in Venice, and there picked up the basic techniques of painting. But for composition, coloration and the portrayal of the human character, his inspiration came from the somewhat older Giorgione and Titian.

In 1513 Palma became a member of the Scuola di S. Marco which commissioned a history painting from him. He enjoyed high esteem in Venice, commanding fees comparable to those of Titian. Many of his commissions came from churches for paintings in the classical Renaissance style in the manner of Giorgione, and in Palma's work this style came to a full flowering, particularly in terms of coloration. His religious themes, of which Mary and the Child surrounded by saints was a subject often repeated, are characteristic in their well-balanced composition and lack of drama. He was particularly noted for his fine portraits.
Illustration:
103 Diana Discovers Callisto's
 Misdemeanour, c. 1525

PARMIGIANINO

(Girolamo Francesco Maria Mazzola)
1503 Parma – 1540 Casalmaggiore
(near Parma)
In following the style of Correggio, Parmigianino also became his most significant successor in 16th-century painting in the Emilia region. His "Self-Portrait before a Convex Mirror" (Vienna, Kunsthistorisches Museum, 1523), which was to recommend him to the Pope, already shows him at the height of his art. The wealth of imagination and delicacy of approach shown in this work already hint at the dissolution of the ideal of High Renaissance portraiture.

During his visit to Rome from 1524 to 1527 he was particularly impressed by Raphael and Giulio Romano. This did not, however, cause him to abandon his Mannerist tendencies. On his return to Emilia he worked predominantly in Parma and surroundings, carrying out many notable religious works and portraits. He also executed several frescos, and in this field he contributed greatly in removing the division between painting and sculpture (Scenes from the story of "Diana and Actaeon", Fontanellato, Kastell, c. 1523; "Virgins carrying Urns", Parma, Santa Maria della Steccata, between 1531 and 1539). Parmigianino was influential both in his native region and in Venice.
Illustration:
110 Madonna of the Long Neck,
 c. 1534–1540

PATINIR Joachim

(also: Patenier)
c. 1480 Dinant, near Namur (?) –
1524 Antwerp
No records exist about Patinir's training and early work. In 1515 he was elected as master to the Antwerp Lukas Guild. He is noted as one of the earliest painters to make landscape a main element in pictorial composition, developing a so-called "world landscape", a bird's-eye view, with a seemingly endless horizon. This brought him international fame during his lifetime.

Thus, three of his paintings were mentioned in 1523 in the records of the Palazzo Grimani in Venice, and Dürer also frequently mentioned him in his notes on his travels in the Netherlands. Patinir had a huge influence on succeeding generations as well as on his contemporaries. About twenty of his signed paintings cannot be regarded as pure landscape. He mostly depicted religious scenes, but his figures seem incidental to his landscapes.
Illustration:
131 Landscape with Charon's Bark,
 c. 1521

PERUGINO Pietro

(Pietro di Cristoforo Vannucci)
c. 1448 Città della Pieve –
1523 Fontignano
Perugino was one of the masters who widened the scope of the Umbrian school, making Perugia an artistic centre of great excellence and thus paving the way to the High Renaissance. Today his fame has been eclipsed by Raphael, who was his greatest pupil and owed much to him. Perugino probably studied under Benedetto Bonfigli, but more important was his long stay in Florence from 1472. There he may have worked in the workshop of Verrocchio and have been introduced to the new developments in depicting space and the physical form. But his lasting influence was Piero della Francesca, who taught him how to balance surface with space and to structure large-scale compositions. Perugino became one of the greatest fresco painters of his time (in 1481 he was one of the artists chosen to embellish the Sistine Chapel; Crucifixion in the chapter house of Santa Maria Maddalena dei Pazzi, Florence, 1493–1496; frescos in the Collegio del Cambio, Perugia, from 1499). His panel paintings already show an almost classical balance in their composition. This harmony is also reflected in the expression, movement and gestures of his figures and not least in his landscapes which succeed in heightening the overall atmosphere.
Illustrations:
41 Christ Giving the Keys to St Peter, c. 1482
41 The Vision of St Bernard, 1489

PIERO DELLA FRANCESCA

(Piero di Benedetto dei Franceschi)
c. 1420 Borgo San Sepolcro (near Arezzo) – 1492 Borgo San Sepolcro
Piero was probably trained in a Sienese-Umbrian workshop, where he developed his power as a colourist and his interest in landscape painting. Between 1439 and 1445 he explored the new ideas on space and physical form of the Florentine Early Renaissance, and he experimented with colour while assisting Domenico Veneziano with the now lost fresco cycle in San Egidio (now Santa Maria Nuova). By adding a larger proportion of oil as binder it was possible to achieve atmospheric lighting effects. As Veneziano's successor, Piero became a pioneer in this field. After 1452 he created his most famous fresco works in S. Francesco of Arezzo, "The Discovery of the Wood of

the True Cross" (ill. p.30). These show not only Piero's advanced knowledge of perspective and mastery of colour, achieving almost luminous effects as never before in fresco painting, but also his geometric orderliness and skill in pictorial construction. With his innovations he paved the way for the High Renaissance. From 1469 mention was made of him at the court of the Montefeltre in Urbino, where he came into contact with Dutch art. Already celebrated in his lifetime, Piero was greatly influential in northern Italian art in the second half of the 15th century. Later, he also set down his theoretical ideas in writing.
Illustrations:
13 Senigalla Madonna, c. 1460–1475
29 The Baptism of Christ, c. 1440–1450
29 Double Portrait of Federigo da Montefeltro and his Wife Battista Sforza, c. 1470
30 The Discovery of the Wood of the True Cross and The Meeting of Solomon and the Queen of Sheba, after 1452

PIERO DI COSIMO

(Piero di Lorenzo)
1462 Florence – 1521 Florence
Piero came from an artistic family and at the age of 18 entered the workshop of Cosimo Roselli, whose name he adopted and with whom he travelled to Rome in 1481/82 to assist in painting the frescos in the Sistine Chapel at the Vatican. He specialised in the decoration of Cassoni, heavy chests, whose unusual format he covered with skilled compositions. His early work was influenced by Filippino Lippi; later he received stimulation from the works of Ghirlandaio and Dutch masters. At the turn of the century he followed Leonardo, who had again returned to Florence, in his treatment of colour. Piero di Cosimo knew how to combine these varied strands, producing atmospheric and dramatic moments occasionally bordering on the grotesque. For this reason his work was highly valued by the Surrealists.
Illustrations:
42 Death of Procris, c. 1510
42 Venus and Mars, c. 1498

POLLAIUOLO Antonio del

(Antonio di Jacobo d'Antonio Benci)
1432 Florence – 1498 Rome
Trained as a goldsmith, then probably the pupil of Donatello, Pollaiuolo was one of the most versatile talents to exercise influence on the future development of 15th-century Florentine art. The moving physical form in space was a subject he explored as a sculptor in bronze, and as a painter, engraver and draughtsman. The aim was no longer to produce a vigorously modelled, polychrome "statue", but sculpture in the round. His small bronzes in particular became desirable objects for collectors, a field which he helped to open up. But his talent for small-format work, applying his early training in the goldsmith's workshop, was an expression of only one aspect of his skill. His artistic development culminated in his two

great monuments for St Peter's in Rome (Popes Sixtus IV, completed 1492, and Innocent VIII, completed 1496). While the figures in relief are reminiscent of the northern Schongau school in the handling of contour and drapery, the figure of Innocent, reaching far out into space, does not appear old-fashioned today in the vicinity of Lorenzo Bernini's Baroque monuments. His younger brother Piero (1443–1496) worked alongside Antonio in the Pollaiuolo workshop. From 1460 Antonio also turned to painting, engaging in themes similar to those of his sculpture.
Illustration:
33 The Martyrdom of St Sebastian, 1475

PONTORMO

(Jacopo Carrucci da Pontormo)
1494 Pontormo (near Empoli) –
1556 Florence
Pontormo can be regarded as one of the most interesting figures in 16th-century Italian art and also as an exponent of Florentine Mannerist painting. Like Rosso Fiorentino, a pupil of del Sarto, his early work still reflected the High Renaissance, apart from increased movement (fresco of the "Visitation" in the forecourt of Saint Annunziata, Florence, 1514–1516). In subsequent years Pontormo abandoned this style, with its balanced composition, logical construction, idealised figure representation and clear coloration ("Sacra Conversazione", Florence, San Michele in Visdomini, 1518).

Pontormo's fresco cycle in the cloister of Certosa di Galluzzo near Florence, 1530, draws on an intensive study of Dürer's graphic art. Then, in the following period, Pontormo increasingly set out to portray movement in all its forms and directions ("Visitation", Carmignano parish church, near Florence). By distortion of the ideal physical proportions – elongated figures with small heads – exaggerated perspective and use of relatively harsh, vivid colours, he transposed traditional pictorial themes into a new sphere in some respects related to medieval art. His late works, particularly in the rendering of figures, strongly reflect Michelangelo's influence, whom he met around 1530 in Rome. A favourite of the Medici, he carried out much important fresco work, which has, however, not survived. Pontormo's portraits

belong to the greatest achievements in this field in Florentine painting.
Illustrations:
85 Joseph in Egypt, c. 1515
111 Deposition, c. 1526–1528

QUARTON Enguerrand

(also: Charonton, Charton, Charretier)
c. 1410 Diocese of Laon –
1461 or later Avignon (?)
No other work in European painting of the Early Renaissance has presented as many research problems as the large panel painting of the "Pietà" (ill. p. 69). This work came from Villeneuve-lès-Avignon and was rediscovered at the "Les primitifs français" exhibition in Paris in 1904. In an endeavour to place this work, it has been attributed to various artists, including the Catalan master Bartolomeo Bermejo and the great Portuguese painter Nuño Gonçalves. The painting cannot be compared with any other work from around 1450–1460, with its utter lack of physical effect and the depth of emotion shown in the faces and gestures of the figures, each seemingly isolated in their own grief. It must be assumed that the painter knew Italian art (unity of composition), Catalan painting (ascetic severity of the heads), and also Dutch works (precision of detail). Only in recent times has it been possible to attribute the work to Quarton, a major master of the Avignon school. Records show that he lived in Aix-en-Provence before 1440 and from 1447 to 1466 in Avignon. In collaboration with Pierre Villate he painted the "Madonna with the Mantle" in 1452 (Chantilly, Musée Cluny) and around 1453/54 the "Coronation of the Virgin" (ill. p. 69).
Illustrations:
69 Coronation of the Virgin, c. 1453/54
69 Pietà, c. 1460

RAPHAEL

(Raffaello Santi)
1483 Urbino – 1520 Rome
Raphael's fame as the greatest painter of the Western world will continue despite certain detracting voices which made themselves heard at the beginning of the 20th century. He began his apprenticeship with his father Giovanni, learning basic manual skills, but would have had greater artistic and educational benefits from the circle surrounding the court of Montefeltre. Fundamental to his development was his training under Perugino, whom he later assisted. Here Raphael learned the art of composition and gained the knowledge which enabled him to merge landscape and figure sensitively, and so develop the dreamy sensitivity of expression so characteristic of his work, particularly of his Madonnas.

His move to Florence in 1504 at the age of 21 marked a decisive period in his stylistic development. There a large field of artistic possibilities opened to him, particularly with regard to design and form, which he was capable of as-

similating within a few years. Figure and space were at the heart of his learning. Raphael had an extraordinary power of assimilation without falling into the trap of eclecticism. In exploring the works of the past and present he only adopted such elements which served to perfect his own original artistic personality.

Already in 1508 his fame began to spread when Pope Julius II called him to Rome for the decoration of apartments at the Vatican. His fellow countryman Donato Bramante, who was engaged in the rebuilding of St Peter's, may have helped to secure this commission. His first large work in the Stanza della Segnatura (1509–1512, ill. p. 102) already shows his personal conception of design and form with figures combining statuesque dignity with freedom of movement. However, with his decoration of the Stanza d'Eliodoro (1512–1514) he achieved further heights in dramatic expression, suggestion of depth and colour modulation (the "Liberation of Peter" is the first large "night picture" of European art). Raphael crossed the border between High Renaissance and Mannerism as demonstrated in the large panel paintings of his late period ("Sistine Madonna", Dresden, Gemäldegalerie, 1512/13; group portrait "Pope Leo X with Cardinals Giulio de' Medici and Luigi de' Rossi", ill. p.81; "Transfiguration", ill. p. 102).

The large number of commissions for fresco cycles (Loggias at the Vatican, Farnesina) and other works resulted in the organisation of a large workshop. Of great importance for Raphael's work was his contact with antiquity while in Rome (in 1514 he was appointed prefect of the Roman antiquities). His significance as an architect can now only be traced in outline. In 1514 he became chief architect of St Peter's; in 1515/16 he built the Palazzo Madama in Rome and designed the Palazzo Vidoni-Caffarelli, also in Rome (1515) as well as that of the Pandolfini in Florence (1517–1520). In just two decades of creativity Raphael's work made unique, influential history, outgrowing the 15th century, leading the High Renaissance to its peak and finally paving the way for Mannerism, often leaping ahead to the Baroque.
Illustrations:
81 Pope Leo X with Cardinals
 Giulio de' Medici and Luigi de'
 Rossi, 1518/19

100 Madonna of the Meadows,
 1505/06
101 Marriage of the Virgin (Sposalizio della Vergine), 1504
101 Madonna di Foligno, c. 1512
102 The Transfiguration,
 c. 1517–1520
102 The School of Athens, 1511/12

RATGEB Jörg
c. 1480 Schwäbisch Gmünd –
1526 Pforzheim
Nothing is known about Ratgeb's early life and training. He was one of the most unconventional artists during the Dürer period and was evidently inspired by Grünewald. As a journeyman he went to Flanders and northern Italy, as shown by the handling of colour and composition of his first authenticated work (Catherine Altar in the parish church of Schwaigern, 1510). From 1514 to 1517 Ratgeb painted in the cloisters and refectory of the Carmelite monastery in Frankfurt/M one of the most important fresco cycles of the time, with scenes from salvation history (severely damaged in 1944).

Ratgeb's predilection for foreshortening and for exaggerated figure movement is most marked in the Herrenberg Altar (ill. p. 128). During the Peasants' Revolt he vigorously supported the side of the peasants and was executed in 1526.
Illustration:
128 The Flagellation of Christ,
 1518/19

ROSSO FIORENTINO
(Giovanni Battista Rossi)
1494 Florence – 1540 Paris
Rosso was one of the few Italian painters of the 16th century who refused to work within the rules of the High Renaissance. His tendency to distortion, to breaking up the human body into geometrical areas, and his unconventional treatment of colour, meant that due recognition was withheld until the beginning of the 20th century. It was only when art turned away from its traditional aim of creating ideal representations of what we see, that Rosso's work became interesting to such groups as the Expressionists, Cubists, and particularly the Surrealists. However, the modern view of Rosso's work was again based on a misconception. His intention had not been to create an aesthetically pleasing work, but to find a new way of expression that transcended realistic experience. Like Pontormo, to whose early work Rosso's coloration and figure representation have an affinity, Rosso was probably a pupil of del Sarto. Under this master Rosso would have been fully trained in the art of the High Renaissance and its further possibilities. Already in his first work, the fresco of the "Assumption" in the forecourt of Saint Annunziata in Florence (1517), his Mannerist tendencies were detectable, and this development established itself in his great altarpieces of the following years. While in Rome, 1524–1527, he also became strongly influenced by Mi-

chelangelo, whose Sistine ceiling he had studied.

In 1530 he received a call from King Francis I to Paris, and during the following decade he was mostly engaged in decorating the Palace of Fontainebleau. His principal contribution was the design of the gallery of Francis I, in which he created a unity of frescos, decorative elements and plasterwork. Together with the Bolognese painter Primaticcio, he founded the School of Fontainebleau, which did much to disseminate Renaissance ideas north of the Alps.
Illustration:
111 Desposition, 1521

SARTO Andrea del
1486 Florence – 1530 Florence
The son of a tailor (hence the nickname del "Sarto"), he was trained by Piero di Cosimo in the late 15th-century tradition, but after studying the works of Leonardo, Raphael and Michelangelo, he developed around 1505 his own style which made him a major representative of the Florentine High Renaissance. From about 1517 he began to break through these conventions ("Madonna delle Arpie", Florence, Uffizi), moving towards Mannerism ("Sacrifice of Isaac", Dresden, Gemäldegalerie, c. 1527). Equally brilliant in drawing as in painterly techniques, he exercised a strong influence on Rosso and Pontormo, who, in turn, inspired his own late work.

The range of his development becomes apparent by a comparison of frescos of the life of San Filippo Benizzi (Florence, forecourt of Saint Annunziata, 1508–1510), which seem to consist of many small parts, and those of the life of St John the Baptist in the Chiostro dello Scalzo in Florence (1514–1526), which are monochrome and give an impression of overall unity.
Illustration:
96 Pietà, c. 1519/20

SCHONGAUER Martin
c. 1450 Colmar – 1491 Colmar
His name probably derives from the town of Schongau, although the family are recorded among the gentry of Augsburg since 1329. Schongauer's father Caspar, evidently a well-known goldsmith, moved from Augsburg to Colmar in 1445. Martin was first sent to study at the University of Leipzig, then

learned engraving and drawing in his father's workshop before being trained as a painter, probably under Caspar Isenmann in Colmar. Schongauer is the most outstanding engraver and draughtsman in German art before Dürer. So far 115 engravings and 52 drawings by him have been authenticated, and added to these innumerable copies after his works have survived. He was a master of fine detail and most imaginative in his handling of line. In this he followed the general tendency of European art in the 1470s and 1480s – comparable, perhaps, to the somewhat older Botticelli in Italy. Major elements in his figurative and landscape painting make it reasonable to assume that he visited the Netherlands, where he might have gained particular inspiration from van der Weyden and his followers.
Illustration:
73 Madonna of the Rose Bower, 1473

SCHOOL OF FONTAINEBLEAU
c. 1530 – c. 1570
This name is given to the group of artists, predominantly from Italy, who were involved in the decoration of the palace of Fontainebleau, begun in 1528 under Francis I. They brought Mannerist style elements to France and contributed greatly to their introduction north of the Alps. With the arrival of Rosso Fiorentino in 1530, Primaticcio in 1531, and Niccolò dell'Abbate in 1552, Fontainebleau became the centre of exchange between Italian and French art. Notable works combining various artistic branches are the galleries of Francis I (Rosso) and Henry II (Primaticcio).

During the so-called second school of Fontainebleau (from 1590) a decorative style was developed under the leadership of the Antwerp artist Ambroise Dubois and two French painters, Toussaint Debreuil and Martin Fréminet, which through printed copies became widely distributed all over Europe. It is not always possible to determine the relative degree to which Italian, French and Dutch masters contributed.
Illustrations:
80 Gabrielle d'Estrées and One of
 her Sisters in the Bath,
 c. 1594–1599
139 Diana the Huntress, c. 1550
139 Landscape with Threshers,
 c. 1555–1565

SCOREL Jan van

1495 Schoorl (near Alkmaar) –
1562 Utrecht

After an apprenticeship with Jacob Cornelisz in Amsterdam, Scorel went south on an extended tour, visiting Dürer in Nuremberg, painting his first representative work in Obervellach in Austria ("Sippenaltar", 1520), then travelling via Venice to Rome. Here Pope Adrian VI, a native of Utrecht, appointed him painter to the Vatican and successor to Raphael as Keeper of the Belvedere. From Rome he went on a pilgrimage to the Holy Land.

In 1524 he settled in Utrecht and as the leading Netherlandish "Romanist" developed a brilliant career as a painter and teacher. Highly educated, equally endowed with intellect and spontaneity, he created a wealth of altarpieces and portraits in which Italian art merged with native tradition.
Illustration:
133 Mary Magdalene, 1529

SEBASTIANO DEL PIOMBO

(Sebastiano Luciani)
c. 1485 Venice – 1547 Rome
Sebastiano was trained in the workshop of Giovanni Bellini and under Giovanni Battista Cima. He had close contacts with Giorgione, after whose death he went to Rome in 1511 to carry out fresco decorations of mythological themes for the banker Agostino Chigi in the hall of the Villa Farnesina. In Rome he met Raphael, whose style is reflected in some of Sebastiano's portraits. Their friendship turned into enmity in 1515, and Sebastiano turned to Michelangelo, whose formal ideas he expressed in some of his religious works. After a visit to Venice he returned to Rome in 1528/29, where in 1531 he became keeper of the papal leaden seal, hence his name. Sebastiano became famous as a portrait painter; his mythological and religious paintings showed too often a dependence on the works of his two famous friends.
Illustration:
103 Cardinal Carondelet and his
 Secretary, c. 1512–1515

SIGNORELLI Luca

(Luca d'Egidio di Maestro Ventura
de' Signorelli)
c. 1450 Cortona – 1523 Cortona
Born in the borderland between Tuscany and Umbria, it is likely that Signorelli received his artistically formative training in Florence, where he would have come under the influence of Florentine sculpture, particularly bronze casts. He probably studied under Pollaiuolo and Verrocchio for some years. Signorelli's special interest was the human figure in action. One of the main concerns of Florentine painting of the early 15th century had been the plastic, convincing rendering of the human body on the flat canvas, and this theme was taken up again by Signorelli; no longer, however, in an endeavour to depict three-dimensional forms, but rather to record exact details. His religious and secular subjects demonstrate his mastery in this field. Already in 1481 he was one of the artists chosen to participate in the fresco cycle below the window area in the Sistine Chapel (amongst others, Botticelli, Ghirlandaio and Perugino were engaged in this work). Piero della Francesca's influence on Signorelli should not be over-emphasised. Although his tendency to abstract composition ("Virgin and Saints", Perugia, Domopera, 1484) and his handling of lighting effects may have been influenced by Piero, Signorelli's intention was not to create an atmosphere flooded with light, but to use strong light and deep shadow to model the forms of the body. Signorelli reached the height of his development with his frescos depicting the Last Judgement in Orvieto cathedral (1499–1504, ill. p.40).
Illustrations:
40 Portrait of a Lawyer, c. 1490–1500
40 The Damned Cast into Hell
 (detail), 1499–1503

TINTORETTO

(Jacopo Robusti)
1518 Venice – 1594 Venice
In the great triad of 16th-century Venetian art, Tintoretto upheld Mannerist principles more rigorously than either Titian or Veronese. Jacopo Robusti, called Il Tintoretto because his father was a dyer by trade, was trained in the workshop of Titian. He was first mentioned as master in 1539. Between 1548 and 1563 he painted several large-scale pictures of the "Miracle of St Mark". They stand out in their vehement dynamism achieved by bold foreshortening and exaggerated gestures. This was new in Venetian painting, as was the plastic modelling of the forms which went beyond Michelangelo's inventions. Also, the overall unity of the composition was disturbed by flickering light. It is not known whether Tintoretto ever went to Rome, but he is said to have made studies of copies of Michelangelo's and Giambologna's paintings and of ancient art, even for his later works, when light became the determinant factor in his art. According to Marco Boschini, Tintoretto used to set up a scene with small wax figures equivalent to the painting he had in mind, and then experimented with light sources.

From 1564 to 1587 he was engaged in the decoration of the Scuola di San Rocco; the comprehensive scope of this work demonstrates the quality and range of his talents. Alongside works of the highest order stood those in which the virtuoso effect gained the upper hand. But it has to be taken into account that Tintoretto had a large workshop and inexhaustible energy which made any commission welcome.
Illustrations:
85 The Origin of the Milky Way,
 c. 1575–1580 (?)
112 St George and the Dragon,
 c. 1550–1560
112 Christ with Mary and Martha,
 c. 1580
113 Vulcan Surprises Venus and
 Mars, c. 1555
113 Susanna at her Bath, c. 1565

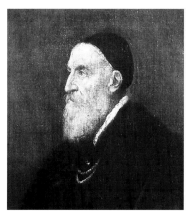

TITIAN

(Tiziano Vecelli)
between 1473 and 1490 Pieve di Cadore (Venetia) – 1576 Venice
Titian was the most outstanding painter of the 16th century. At a time when Mannerist tendencies became prevalent, he took over the heritage of the High Renaissance and carried it further. Although the standards of "classical art" of about 1500 were his guideline, he endowed them with a new dynamism for greater effect. He played a unique role in the history of colour and found ways of achieving unprecedented freedom in pictorial composition, making him not only the most important precursor of European Baroque (Rubens), but also a lasting influence on painters until the late 19th century. Manet, for example, studied and copied his work in the Louvre.

Titian's training under Giovanni Bellini was decisive for his career. In his workshop he probably also worked with Giorgione, his senior by ten years. The artistic temperament of these two young painters was obviously closely related, because to this day their contributions are inseparable in some pictures. Titian's "Assumption of the Virgin" altarpiece in Santa Maria dei Frari in Venice (1516–1518) represented an important innovatory development in Venetian painting, both in composition and handling of colour. With this work, he had created an entirely new type of altarpiece which was to set a standard for the future, also in terms of dimension and the way it merged with the space of the building. It ushered in a "proto-Baroque" phase in Titian's development. His "Madonna with Saints and members of the Pesaro family" (1519–1528, also in Frari) represented a similar milestone in the "Sacra Conversazione" field. Apart from altarpieces Titian painted religious pictures, mythological, poetical and allegorical subjects, and excelled as a portrait painter. The constant refinement of his painterly devices made the canvas his ideal medium, according the fresco a background role.

Already in 1530 Titian had become of European eminence. In 1533 the Emperor Charles V called him to his court and made him a Count Palatine. But Titian never left Venice for very long. In his late work colour achieved an almost "Impressionistic" effect ("Annunciation", Venice, San Salvatore, 1565; "Christ Crowned with Thorns", ill. p. 108). By abandoning all outlines, he contrived to let air, light and colours unify the scene, so transcending earthly experience.
Illustrations:
2 Flora, c. 1514
84 Portrait of a Bearded Man
 ("Ariosto"), c. 1512
106 Venus of Urbino, c. 1538
106 Bacchanalia (The Andrians),
 c. 1519/20
107 La Bella, c. 1536
108 Christ Crowned with Thorns,
 c. 1576
108 Pietà, c. 1573–1576

TURA Cosmè

(Cosimo)
c. 1430 Ferrara – 1495 Ferrara
About the middle of the 15th century Ferrara developed under the rule of Borso d'Este into a cultural centre of the first order, particularly in the field of painting. Here an independent school evolved which stood in sharp contrast to those in Tuscany, Lombardy and Venice. Of this, Tura was the leading master and oldest representative. Being of about the same age as Mantegna, he had, as Mantegna, studied under Francesco Squarcione in Padua, where he had obviously taken a great interest in the works of Donatello. On his return to Ferrara in 1456 he was appointed court painter to Borso d'Este. Unfortunately details on his manifold activities there are scanty, but his surviving panel paintings give a glimpse of his artistic personality. Architectural elements inspired by Antiquity (organ wing depicting the Annunciation, in the cathedral museum, Ferrara, 1469),

fantastic landscapes, sharply outlined almost like etchings, and brilliant perspectival constructions which defy logical spatial unity, add up to a style which in varying degrees characterised the artists of the Ferrara School (Francesco del Cossa, Ercole de'Roberti). Tura's Roverella Altarpiece, dating from before 1474 (only the central panel with the Madonna Enthroned survived, now in London, National Gallery), exemplifies his style in its abstract spatial composition and ornamental grouping of figures reminiscent of heraldic principles. Between 1460 and 1470 Tura collaborated with Cossa in painting the Pictures of the Months in the Palazzo Schifanoia; their respective contributions cannot always be separated (ill. p.43).
Illustration:
43 St George and the Dragon and The Princess, c. 1470

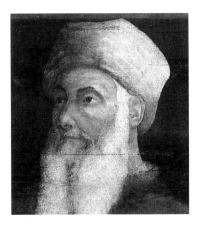

UCCELLO Paolo
c. 1397 Pratovecchio (near Arezzo) – 1475 Florence
Uccello was one of the most versatile founders of the Italian Early Renaissance, although his later reputation did not reflect his true significance. His first formative experience came from working with Ghiberti, whom he assisted with the decoration of the paradise doors of the Florence baptistry. Nothing survives of his contribution to the mosaics of San Marco in Venice, but his frescos of the Genesis in the Chiostro Verde of Santa Maria Novella in Florence (c. 1430) show that he was a follower of Ghiberti and that he was firmly rooted in the International Gothic style (Gentile da Fabriano, Pisanello). It comes therefore as a great surprise to note his change of direction in the 1430s. Developing an intense interest in perspective under the influence of Masaccio's and Donatello's works, he became engrossed in the problem of rendering figures that would stand out in space and appear solid and real. His first great achievement was the equestrian picture of John Hawkwood (ill. p.26), followed by the Noah scenes in the Chiostro Verde in Santa Maria Novella (c. 1450), which anticipate Mannerist pictorial construction, such as the spatial "crater" in the Flood scene with its effect of compelling the eye to travel down into the depth. Proof of Uccello's obsession with perspective are his drawings in the Uffizi

of objects which he made look transparent in order to be able to show them in their stereometric complexity. Unfortunately he outlived his own time: after painting his three battlepieces of "Battle of San Romano" (ill. p.97), commissions dwindled away as general taste changed and demanded courtly refinement.
Illustrations:
26 Equestrian Portrait of Sir John Hawkwood, 1436
26 St George and the Dragon, c. 1456
27 Battle of San Romano (left panel), c. 1456
27 Battle of San Romano (centre panel), c. 1456
27 Battle of San Romano (right panel), c. 1456

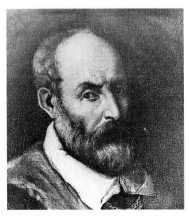

VERONESE Paolo
(Paolo Caliari)
1528 Verona – 1588 Venice
Veronese studied under Antonio Badile in Verona from 1541, but his true masters were the Venetian painters Titian and Tintoretto as well the painters of the Emilia region, including Parmigianino. In 1553 he went to Venice, where he was called Veronese after his place of birth. Veronese was the opposite of Tintoretto: while the latter moved into Mannerism, Veronese's art was securely rooted in the Italian High Renaissance. His works not only reflect the religious and political unrest of his time, but also the love of pomp and worldly splendour of Venetian life. In so far as content often seems to have been subordinated to form in his works, he was also a typical representative of 16th-century art. This is why three centuries later Cézanne saw him as the precursor of pure form.
His first large commission was the decoration of the sacristy and ceiling in San Sebastiano, Venice, in 1555/56. For this he executed a great many pictures on canvas with bold perspectival views and foreshortening of figures. During a visit to Rome in 1560 he studied in particular Michelangelo's work in the Sistine Chapel. In subsequent works the impressions he received there found application in the plastic modelling of figures in movement and the further development of illusionistic spatial depth. A major example of this period are his frescos in the Villa Barbaro in Maser executed in the early 1560s (ill. p.114). Veronese's influence reached far beyond

his time. The virtuosity of his composition not only played an important part in the works of Rubens and Tiepolo, but also had many followers amongst the European painters of the Baroque; and his handling of colour remained of importance in French art until the 19th century.
Illustrations:
86 Allegory of Vice and Virtue (The Choice of Hercules), c. 1580
114 Giustiana Barbaro and her Nurse, c. 1561/62
114 Allegory of Love: Unfaithfulness, c. 1575–1580
115 The Finding of Moses, c. 1570–1575

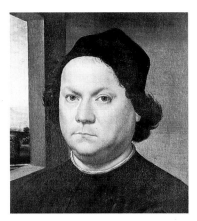

VERROCCHIO Andrea del
(Andrea di Michele Cione)
c. 1435 Florence – 1488 Venice
Verrocchio was a goldsmith, sculptor, carver and painter, but it was in the field of sculpture that he excelled in the second half of the 15th century. After his training under the goldsmith Giuliano del Verrocchio, whose name he adopted, he schooled himself in the works of Donatello, not in a pupil-teacher relationship, however, but in a spirit of idealised rivalry which seeks completely new solutions for one and the same task (statue in bronze of David, c. 1476; equestrian statue of Colleoni in Venice, 1480–1488). While Donatello's approach conveyed a closed, solid strength, Verrocchio excelled in expressing an almost nervous, concentrated energy. And instead of a fixed aspect, he presented his subject from nearly all aspects, and later even all aspects, anticipating the 16th-century Mannerist approach.
Little is known about his early work. It was not until 1472 that he made his mark as a leading master of his generation with his sepulchral monument for Piero and Giovanni de'Medici (San Lorenzo, Old Sacristy). The culmination of his achievement was the bronze group "The Incredulity of St Thomas" (1464–1482) at Or San Michele. From about 1475 Verrocchio's workshop became a kind of academy of arts comparable to that of Lorenzo Ghiberti in the second quarter of the century. It is difficult to separate Verrocchio's works in the field of painting from that of his pupils: a number of important painters were trained at his workshop, Leonardo da Vinci being the most famous of them, and they remained in his work-

shop longer than was required. Other painters who emerged from this workshop include Lorenzo di Credi, Perugino and Signorelli. Verrocchio's paintings "The Baptism of Christ" (ill. p.39) and the "Sacra Conversazione" in Pistoia cathedral (1478) are the finest representations of these subjects in Early Renaissance Florentine art, alongside those of Domenico Veneziano.
Illustration:
39 The Baptism of Christ, c. 1475

WEYDEN Rogier van der
c. 1400 Tournai – 1464 Brussels
Rogier was the leading Dutch painter to follow in the tradition of the brothers Jan and Hubert van Eyck. Unlike any other painter of the 15th century outside Italy, he extended Dutch art in respect of both composition and figure development, and his innovations became widespread in northern art. His influence spread as far as Italy, particularly with respect to his painting techniques, and he was much respected there. Surprisingly late, in 1427, he became a pupil of Campin. To identify his early work as that of his master, as has been attempted, is not tenable. In 1432 he became an independent master, and in 1436 official painter to Brussels city. A visit to Rome in the Holy Year of 1449/50 brought about the most fruitful exchange between northern and Italian art in the 15th century. Rogier continued what Campin and also Jan van Eyck had begun, perfecting anatomical considerations and the perspectival representation of interior space and landscapes. Direct references to the older masters, such as in his various representations of St Luke painting the Madonna, which hark back to van Eyck's Rolin Madonna (ill. p.53), became far less frequent from about 1440 as he strove to find an artistic balance between space and picture plane. The figures are more sparsely proportioned, interiors and drapery become more elegant, and the realistic depiction of detail gains in importance in the overall design.
Illustrations:
18 Crucifixion in a Church, c. 1445
57 Madonna with Four Saints (Medici Madonna), c. 1450
57 Descent from the Cross, c. 1435–1440
58 Adoration of the Magi (Columba Altar), c. 1455
59 Mary Magdalene, c. 1452
59 Entombment, c. 1450

WITZ Konrad
c. 1400 Rottweil – 1445 Basle or
Geneva
Witz was the most versatile of Ger-
manic artists in the first half of the 15th
century. In various respects his signific-
ance was comparable to that of Masaccio
and Jan van Eyck. His birthplace Rott-
weil was an important trading centre
lying outside the boundaries of feudal or
ecclesiastical rule, which might have
played a part in Witz's artistic approach

to life, although little is known about
his early training. Historical records
give only a few clues about his life and
work. In 1434 he was accepted by the
Basle Guild as "Meister Konrad von
Rotwil", and in the same year was
granted citizenship by the city. His sig-
nature and the date 1444 on his paint-
ing "Miraculous Draught of Fishes" (ill.
p.72) on the Geneva altarpiece represent
the last news of his life and work. Witz
was as much concerned with the plastic

modelling of figures as with perspecti-
val problems. With his rendering of the
polychrome "statue" ("Mirror of Salva-
tion" altarpiece) Witz went far beyond
the inventions of both Masaccio and van
Eyck. It has been mooted that he might
also have worked at woodcarving, but of
this no proof exists. The handling of per-
spective in his interiors ("Annunciation"
in Nuremberg; "Mary and Catharine in
Church", Strasbourg) may just be based
on experience and judgement, but the

resulting suggestion of depth is remark-
able. In his landscapes and renderings of
architecture he always aimed at giving a
true and accurate picture of what he saw.
It is certain that he had knowledge of
Dutch art and possibly also of Italian
painting.
Illustrations:
72 Sabobai and Benaiah,
 c. 1435
72 The Miraculous Draught of
 Fishes, 1444

Photo credits

The editor and publisher wish to express their gratitude to the museums, public
collections, galleries and private collectors, the archivists and photographers, and
all those involved in this work. The editor and publisher have at all times endeav-
oured to observe the legal regulations on the copyright of artists, their heirs or
their representatives, and also to obtain permission to reproduce photographic
works and reimburse the copyright holder accordingly. Given the great number
of artists involved, this may have resulted in a few oversights despite intensive re-
search. In such a case will the copyright owner or representative please make ap-
plication to the publisher.

The locations and names of owners of the works are given in the captions to the
illustrations unless otherwise requested or unknown to the publisher. Below is a
list of archives and copyright holders who have given us their support. Informa-
tion on any missing or erroneous details will be welcomed by the publisher. The
numbers given refer to the pages of the book, the abbreviations a = above, b =
below, c = column.

Antella (Firenze), Scala Istituto Fotografico Editoriale S.p.A.: 30f, 32a, 32b, 43a,
43b, 48f, 83, 94a, 97a, 102b – Berlin, Archiv für Kunst and Geschichte: 52, 74a,
91a, 91b, 133b, 134, 143c1, 144c1a, 154c4a, 154c4b, 155c3, 157c1, 158c2,
158c4 – Berlin, Bildarchiv Preußischer Kulturbesitz (Photo: Jörg P. Anders):
62b, 127b – Città del Vaticano, Monumenti Musei e Gallerie Pontificie (Photo:
A. Bracchetti/ P. Zigrossi): 97b, 98f – Florence, Raffaello Bencini: 24/25 – Lon-
don, National Gallery: 34f – Marburg, Bildarchiv Foto Marburg: 145c2, 145c4,
153c1, 156c3, 156c4 – Milano, Gruppo Editoriale Fabbri: 38a, 40b., 43b, 45,
47a, 47b, 63, 96a, 96b, 101a, 101b, 113b, 114a, 126a, 127a, 130a, 132a, 132b –
Munich, Archiv Alexander Koch: 33a, 34f, 36b, 42a, 44a, 46a, 53a, 56a, 56b,
57b, 61b, 66, 67, 68b, 70b, 72b, 74b, 108a, 113a, 114b, 117b, 118a, 119a,
119b, 120a, 122a, 122b, 123, 124, 125a, 125b, 126b, 128a, 131a – Munich, In-
terfoto: 143c2, 146c2, 146c3, 146c4, 149c2, 150c2, 153c2 – Paris, © Réunion
des Musées Nationaux: 138b – Peißenberg, Artothek: 2, 57a, 73b, 112b, 115,
116, 121, 127b – Paris, Roger-Viollet: 147c3, 147c4, 149c4 – Vanves (Paris),
Photographie Giraudon: 138a – Venise, Osvaldo Böhm: 50a, 50b.
The remaining illustrations used belong to the collections mentioned in the
captions or to the editor's archive, the archive of the former Walther & Walther
Verlag, Alling, the former archive of KML, Munich, and the archive of Benedikt
Taschen Verlag, Cologne.